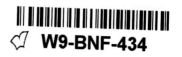

SPIRIT OF AN AGE

NINETEENTH-CENTURY PAINTINGS FROM THE NATIONALGALERIE, BERLIN

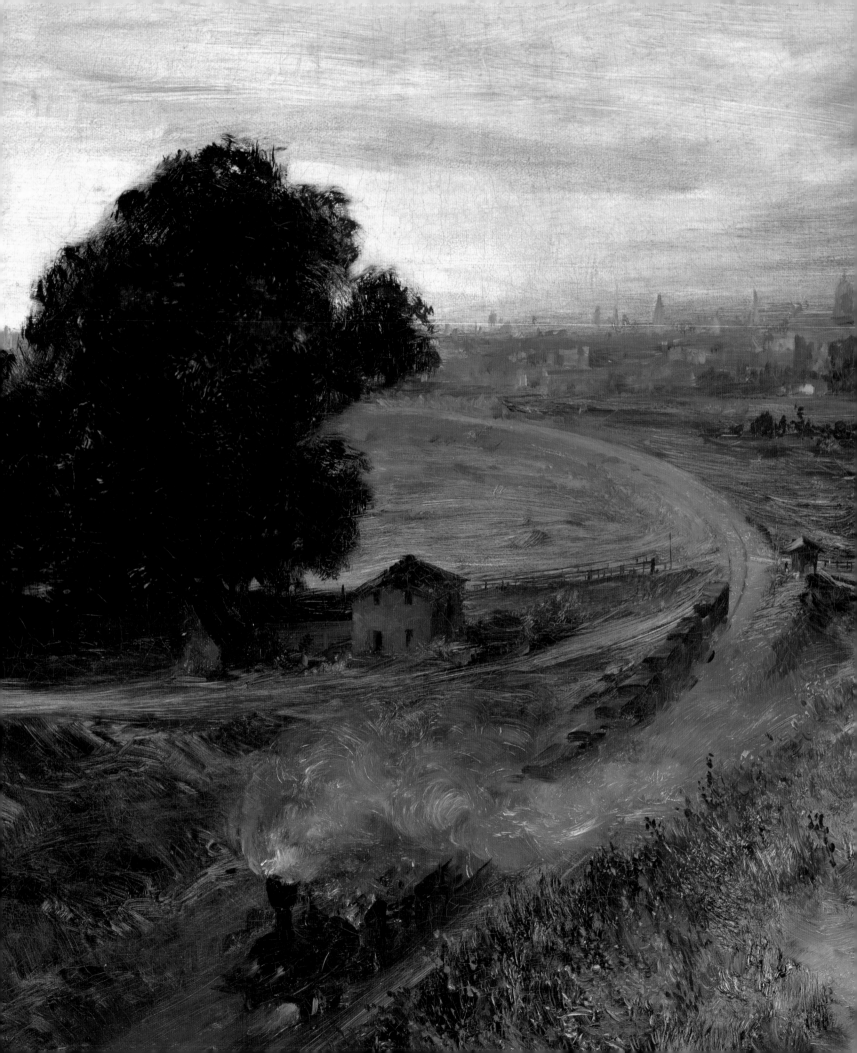

SPIRIT OF AN AGE

NINETEENTH-CENTURY PAINTINGS FROM THE NATIONALGALERIE, BERLIN

Françoise Forster-Hahn Claude Keisch

Peter-Klaus Schuster Angelika Wesenberg

With contributions by Christopher Riopelle Birgit Verwiebe

NATIONAL GALLERY COMPANY, LONDON

This book was published to accompany an exhibition at the National Gallery, London
8 March – 13 May 2001
and at the National Gallery of Art, Washington, D.C.
10 June – 3 September 2001

The exhibition in London is supported by the Corporate Members
of the National Gallery

The exhibition in Washington is supported by an indemnity
from the Federal Council on the Arts and the Humanities

Project Manager Paul Holberton
Managing Editor Kate Bell
Designer Roger Davies
Picture Researcher Xenia Geroulanos
Translator Judith Hayward
Chronology and Bibliography Lucy Williams

Printed and bound in Great Britain by
Butler & Tanner, Frome and London

Title page: Adolph Menzel, *The Berlin–Potsdam
Railway* (detail), cat. 30
Page 6: Anselm Feuerbach, *Memento of Tivoli*
(detail), cat. 51

Authors' abbreviations:
Claude Keisch CK
Christopher Riopelle CR
Birgit Verwiebe BV
Angelika Wesenberg AW

First published in Great Britain in 2001 by
National Gallery Company Limited
St Vincent House, 30 Orange Street, London WC2H 7HH

ISBN 1 85709 981 8 Paperback
525077

ISBN 1 85709 960 5 Hardback
525078

British Library Cataloguing-in-Publication Data
A catalogue record is available from the British Library
Library of Congress Catalog Card Number 2001086195

Contents

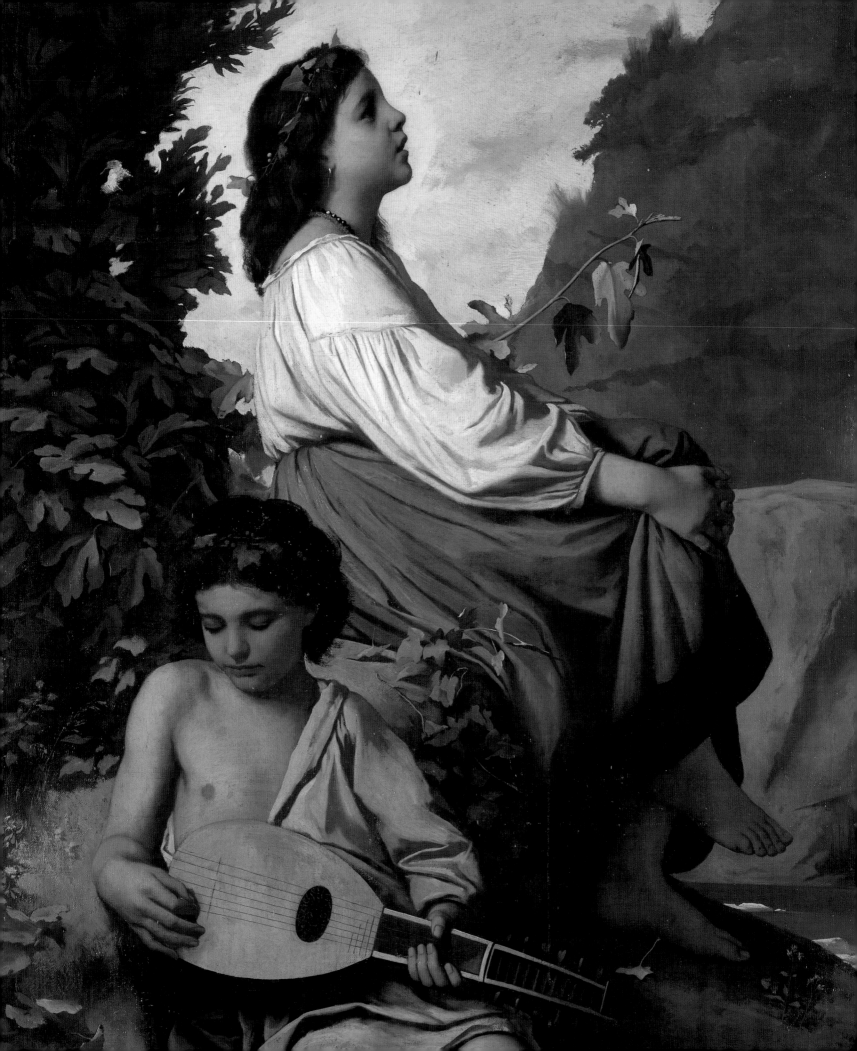

Directors' Foreword

One hundred and twenty-five years ago, in 1876, the Nationalgalerie in Berlin opened its doors as the national gallery of modern German art, during a decade when Prussia had assumed leadership of the recently united German nation. In the 1890s the far-sighted director Hugo von Tschudi began to expand the collections, not only to include earlier German artists – such as the Romantic generation of Caspar David Friedrich, or the private, informal works of Adolf Menzel – but also the art of modern French artists, such as Cézanne, Monet and Manet. Tschudi was one of the first museum directors anywhere to acquire the work of such advanced French painters.

Situated on the Museumsinsel (Museum island) and known in our time as the Alte Nationalgalerie (to distinguish it from Mies van der Rohe's Neue Nationalgalerie, opened in 1968), the magnificent Neoclassical museum designed by Friedrich August Stüler is undergoing renovation, along with the overall rehabilitation of the Museumsinsel. This is part of the larger reorganisation of all Berlin's museums, which has been in progress since reunification in 1990.

'Spirit of an Age' is made possible by the temporary closure of the Alte Nationalgalerie. The exhibition traces the development of nineteenth-century German painting – and indeed the history of Germany itself – through the story of this remarkable institution, presenting a selection of some seventy of the most important paintings normally displayed there. The works range from the sublime canvases of Friedrich and other Romantic painters to scenes of industrial Berlin and the brilliantly observed paintings of the Naturalists in the 1840s and 1850s, ending with the Impressionist and Post-Impressionist innovations of French and German artists that so startled Berlin around 1900, when the Nationalgalerie acquired them against the wishes of the highly conservative and anti-French Emperor William II. Richly detailed cityscapes by Eduard Gaertner and Johann Erdmann Hummel provide wonderful views of mid-century Berlin. Powerful works by Max Beckmann and Lovis Corinth anticipate the Expressionism of the twentieth century. The exhibition focuses on works acquired for the Nationalgalerie during approximately the first fifty years of its existence, but its approach to collecting has remained international, while retaining an emphasis on German art of the nineteenth and early twentieth centuries.

In London and Washington we are enormously grateful to our colleagues in Berlin for enabling us to share with our visitors an important aspect of nineteenth-century European art that is too rarely seen in Great Britain and the United States. We would like to thank especially former Generaldirektor Wolf-Dieter Dube and the present Generaldirektor and Director of the Nationalgalerie, Peter-Klaus Schuster, and also the scholarly curators in Berlin and London who have written for the catalogue. We extend our special thanks to the exhibition's curator in Washington, Philip Conisbee, whose encouragement and support have been tireless. Significant works by nineteenth-century German painters in our two countries are few and far between, so we believe that this generous exhibition will be the perfect opportunity for us to become better acquainted with a school we have neglected for too long, and will also introduce us to one of Berlin's greatest museums.

NEIL MACGREGOR, *Director of the National Gallery, London*
EARL A. POWELL III, *Director of the National Gallery of Art, Washington, D.C.*

An Outline Chronology for German Painting 1800–1914

1808 Lukasbund (Brotherhood of Saint Luke) formed in Vienna by Friedrich Overbeck and Franz Pforr; the 'brothers', known as 'Nazarenes' after they had settled in Rome in 1810, included Peter Cornelius, Wilhelm Schadow and Julius Schnorr von Carolsfeld (see pp. 79ff.)

1810 Two paintings by Caspar David Friedrich bought by King of Prussia (see p. 22)

1815 Schinkel makes first designs for the Neue Wache (New Guardhouse), the first of a series of monumental buildings transforming the centre of Berlin
'Biedermeier' era opens in art and furniture (see pp. 116f.)

1820s The so called Düsseldorf School, centred on the Düsseldorf Academy of Art, known for its genre pictures, becomes active

1822 Schinkel initiates designs for a new museum on the Lustgarten beside Berlin Cathedral and opposite Berlin Castle as part of his plans for the development of the centre of Berlin. Completed in 1830, and now known as the Altes Museum, it was the first of the series of museums to be built on the site better known today as the Museumsinsel (Museum island; see pp. 12–13)

1825 Schinkel builds and landscapes Charlottenhof for Crown Prince Frederick William – part of a continuing programme of leisure residences for the Prussian royal family at Potsdam, about 15 miles outside Berlin

1826 Ludwig I of Bavaria opens the royal collection to the public by establishing two museums in Munich, the Glyptothek (for sculpture) and the Pinakothek (for painting), completed in 1836

1839 Two paintings by John Constable (who had died in 1837) are exhibited in Berlin and noted by Adolph Menzel

1842 The completion of Cologne Cathedral according to the original medieval design is undertaken

1846 The Neue Pinakothek, for more recent painting, opens in Munich

1848 Founding of Pre-Raphaelite Brotherhood in England. In France the 'Barbizon School' of artists are painting landscapes near Fontainebleau

1851 The Great Exhibition opens in Joseph Paxton's iron-and-glass Crystal Palace, London

1854 Grand Duke of Baden founds an art school at Karlsruhe; Grand Duke of Saxe-Weimar follows his example at Weimar (1858)

1855 World Exhibition, Paris. Menzel visits Paris and shows one of his Frederick II pictures (see cat. 30f.) at the Salon. In his own 'Pavilion of Realism' Gustave Courbet exhibits his Real Allegory

1858 A first pan-German exhibition of contemporary art is held in Munich (see pp. 40ff.)

1861 Konsul Wagener's collection of nineteenth-century German art is bequeathed to the King of Prussia and will form the nucleus of the Nationalgalerie, Berlin, of which building begins in 1865 to designs by Friedrich August Stüler (see pp. 11ff.)

1863 Protest at large-scale rejections by conservative selectors for the Paris Salon prompts the Salon des Refusés, where Edouard Manet's work is the sensation

1869 International Art Exhibition, Munich: Courbet exhibits, and visits Munich, where he meets Wilhelm Leibl and other artists (see cat. 56ff.)

1873 Claude Monet paints Impression: Sunrise, from which 'Impressionism' is nicknamed. The first independent 'Impressionist' exhibition in Paris follows in 1874. Siegessäule (Victory column), commemorating the outcome of the Franco-Prussian War, is erected in Berlin, with designs by Anton von Werner

1878 Exposition Universelle, Paris: German art is officially represented

1889 Exposition Universelle, Paris: the German government refuses to participate, but Max Liebermann organises an exhibition of contemporary German art there
A small group of French artists in Brittany, influenced by Paul Gauguin, form a Symbolist group, the 'Nabis'

1891 The art journal Die Jugend, from which the Art Nouveau style will take its name in Germany (Jugendstil) is founded

1892 Munich Secession is founded – the first of several 'split-away' groups of artists in Germany and Austria determined to set up promotion and exhibition opportunities outside the control of the ruling academies

1895 Avant-garde art journal Pan is founded

1896 Hugo von Tschudi appointed Director of Nationalgalerie, Berlin; buys French work, including Impressionists, and eventually, in 1908, resigns on the issue of the purchase of French art
Art journal Simplicissimus founded in Munich

1897 Vienna Secession is founded

1898 Berlin Secession is founded

1905 An association of artists calling themselves Die Brücke (The bridge – to the future) is formed in Dresden

1906 At Nationalgalerie, Berlin, Centenary Exhibition of art from 1775 to 1875 're-discovers' the work of several early nineteenth-century artists, including Friedrich, Blechen and Waldmüller

1910 Berlin Secession rejects work of Die Brücke, and the Neue Secession is founded

1911 Wassily Kandinsky publishes Über das Geistige in der Kunst (Concerning the Spiritual in Art), and co-founds the 'almanac' Der blaue Reiter in Munich

CULTURE

1804 Ludwig van Beethoven composes *Third Symphony*, elevates the symphonic form to its premier place in classical music
Johann Christoph Friedrich von Schiller writes the historical verse drama *Wilhelm Tell* (William Tell)

1808 Johann Wolfgang von Goethe publishes first part of his tragedy *Faust*
J.G. Fichte delivers a series of *Addresses to the German Nation* (*Reden an die Deutsche Nation*), declaring a German national spirit superior to that of other nations

1810 Two series of lectures Schlegel gives in Vienna between 1810 and 1812 develop his concept of a 'new Middle Ages'

1811 Goethe, aged 64, completes his autobiography, *Dichtung und Wahrheit* (*Poetry and Truth*)

1813 A new dance craze, the waltz, sweeps European ballrooms. Friedrich de la Motte Fouqué's novel *Der Zaubbering* (The magic ring) is published (see cat. 16)

1814 Franz Schubert begins composing *Lieder*, lyrical songs in the Romantic tradition

1825 Stockton to Darlington railway is opened in England with Stephenson's locomotive

1826 First photograph by Nicéphore Niepce

1827 Felix Mendelssohn's *A Midsummer Night's Dream* is first performed

1832 Goethe, icon of German culture, dies

1837 First steam railway in Germany, from Nuremburg to Fürth

1839 Louis-Jacques Daguerre introduces 'Daguerrotype'

1840 Edgar Allan Poe publishes *Tales of the Grotesque and Arabesque*

1847 Karl Marx and Friedrich Engels publish the *Communist Manifesto*

1848 Richard Wagner begins his series *Der Ring des Nibelungen*

1857 Charles Baudelaire publishes *Les Fleurs du mal*
Robert Wilhelm Bunsen publishes *Gasometrische Methoden*, on analysis of gases

1860 Jacob Burckhardt's *Die Kultur der Renaissance in Italien* becomes a model for the treatment of cultural history

1864 Leo Tolstoy begins *War and Peace*

1867 Karl Marx publishes first volume of *Das Kapital*.
Johann Strauss composes Blue Danube Waltz

1868 Johannes Brahms completes his *German Requiem*

1877 First complete performance of Richard Wagner's operatic Ring cycle in Germany

1878 London has electric street lighting
Theodor Fontane writes his acclaimed historical novel about the Prussian nobility, *Vor dem Sturm* (Before the storm)

1881 Electric tramway built in Berlin

1883 Friedrich Nietzsche publishes *Also Sprach Zarathustra* (*Thus Spake Zarathustra*)

1884 Automatic machine-gun invented

1885 Emile Zola publishes *Germinal*

1886 Karl Benz of Mannheim patents his newly invented internal combustion engine

1895 Theodor Fontane writes *Effi Brest* (dealing with position of women in German society)

1896 First department store opens in Berlin

1898 Paris Métro opens

1899 Sigmund Freud publishes *Die Traumdeutung* (*The Interpretation of Dreams*)

1901 Thomas Mann publishes *Buddenbrooks*

1905 Albert Einstein proposes Theory of Relativity

HISTORY

1806 French conquest of Germany. Napoleon marches through Brandenburg Gate in Berlin

1810 Queen Luise of Prussia dies

1813 After his defeat in Russia Napoleon's European empire unravels. He is defeated in the Battle of the Nations at Leipzig
Frederick William III, King of Prussia, re-enters Berlin

1814 German Confederation is established

1814–15 Congress of Vienna divides and re-integrates Europe

1815 Napoleon is defeated at Battle of Waterloo by British, Dutch and German troops

1825 Ludwig I accedes to the throne of Bavaria

1820s Repression of so-called 'patriots' and 'demagogues' in German states

1830 Revolution in Paris: Charles X is ousted, Louis Philippe is enthroned
Riots in Hanover result in modest constitutional reforms (annulled in 1837)

1832 Modern independent state of Greece is founded with support of Western powers. Prince Otto of Bavaria becomes King of Greece

1833 Prussian General Karl von Clausewitz's *Vom Krieg* (On war) is published

1838 Queen Victoria accedes

1840 Frederick William IV succeeds his father as King of Prussia

1843–7 Widespread famine in Europe caused by potato disease and the failure of the grain harvest

1844 Revolt by weavers in Silesia

1848 Year of Revolutions: unrest in much of Europe. The King of Prussia is temporarily ousted from Berlin. Ludwig I of Bavaria abdicates

1858 Frederick William IV succumbs to mental illness; his brother William becomes Regent

1861 William I accedes to the throne of Prussia

1862 Otto von Bismarck appointed Premier by William I

1864 Ludwig II accedes to throne of Bavaria
Red Cross founded in Geneva

1866 Bismarck takes Prussia to war with Austria, forcing Austria from German Confederation

1870–1 Franco-Prussian War. Victorious at the Battle of Sedan, German troops, led by William I, march through Paris

1871 Germany is unified under Prussian hegemony; the Second German Empire is proclaimed. William I becomes Emperor, Bismarck is Chancellor of Germany. *Gründerzeit* (Founding period) opens. German industry is boosted by French war indemnities

1872 Strikes break out in Germany. Boom is followed by bust (*Gründerkrach*) in 1873. Nevertheless, and despite social tensions, Germany's industry continues to develop

1879 Bismarck engineers Austro-German Alliance, one of a series of alliances which prefigure the battlelines of the First World War

1888 On the death of William I Crown Prince Frederick succeeds but dies within the year. His son William II succeeds as Emperor (Together William II's and his grandfather's reigns are known as the 'Wilhelmine' period)

1890 Bismarck resigns. William II increasingly takes over government. His regime is politically and socially conservative and aggressive in foreign policy

1894 Alfred Dreyfus is condemned for passing French military secrets to Germany. French society is riven by the Dreyfus Affair, and Jewishness is an issue all over Europe

1905 Russian Revolution

1914 Assassination in Sarajevo. The First World War is unleashed

The Birth of a Nation from the Spirit of Art
The Nationalgalerie in Berlin on its 125th Anniversary

PETER-KLAUS SCHUSTER

A GERMAN LONGING

There are few words that are so charged with meaning in Germany as 'nation' and 'art'. These are almost sacred ideas, and their real meaning has been correspondingly uncertain. The unity of the nation was a German dream that was fulfilled very late – and overdue – in 1871, when the German Empire under the leadership of Prussia was proclaimed in the Hall of Mirrors at Versailles.

The date of the founding of the Empire, with the words 'to German art', is inscribed on the pediment of the Nationalgalerie (National gallery) on the Museumsinsel (Museum island) in the centre of Berlin: *Der Deutschen Kunst MDCCCLXXI* (fig. 1). This political inscription had in fact nothing to do with the creation of the Museum. For this temple to art, erected on a high plinth so that it towers above life below like a monument, had been planned and designed earlier, in 1865, by Friedrich August Stüler, a pupil of Berlin's great architect Karl Friedrich Schinkel, as a German 'national gallery' for contemporary painting, graphic art and sculpture. In crucial contrast to other peoples, who by virtue of history or geography had long since been able to achieve national unity, the Germans, split up into a large number of small states and a small number of medium-sized ones such as Bavaria, Württemberg, Saxony and Prussia, initially attained culturally, in the founding of a museum, the national unity they longed and hoped for politically.

It may be imagined what an aura the idea of nationhood therefore took on in Germany, but also what problems it entailed. It may be imagined, too, what a burden of proof was thereby loaded on to art. Art was required, first, to show the Germans who they now were, who they had been and who they wanted or ought to become. From this arose the new problem, so conspicuously headlined on the pediment of the Berlin Nationalgalerie: what is German art? Or what should German art be, and what should it not be? And who would decide? The extent to which the anticipation of political nationhood in a museum would inevitably lead to neurosis over the aesthetics of nationality can easily be inferred, and inevitably it did lead to conflict: museum issues became political issues.[1]

THE CREATION OF A NATIONAL GALLERY IN BERLIN

The immediate impetus behind the project for a national gallery in Berlin was a bequest in 1861 of 262 contemporary paintings collected since 1815 by the banker Konsul Joachim Wagener, who had made them available to public view in his rooms (see further the essay in this volume by Claude Keisch). Associated with the bequest was the injunction that the Prussian state should found a 'national gallery' for contemporary art in a building specially assigned to it, with this collection as its starting-point.[2] Wagener's desire for such a gallery went back to the climate of ideas of the citizens' revolution of 1848. It was felt by many artists and liberal politicians in Germany in the aftermath of 1848 that the state should fulfil its national duty to foster contemporary art by setting up a national gallery in which it should be displayed, thus becoming a public provider of commissions and an instrument conferring recognition.

Fig. 1
The Alte Nationalgalerie, Berlin
Architect Friedrich August Stüler;
construction 1865–76
Photograph, 2000

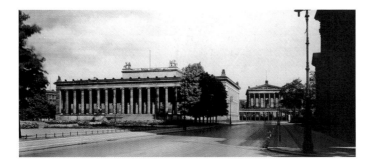

Fig. 2
The Altes Museum, with the Nationalgalerie in the background
Architect Karl Friedrich Schinkel; construction 1825–30
Photograph, c. 1935
Humboldt-Universität, Berlin

This civic ideal of nationhood in the realm of art was first realised in 1852 with the founding of the Germanisches Nationalmuseum in Nuremberg.[3] Considerably in advance of German political unity, it was conceived as an encyclopaedic visual archive of the cultural history of the whole German-speaking area, comprising all forms of activity. Housed in the Gothic buildings of a former Carthusian monastery in the *altdeutsch* (Old German) city of Nuremberg, Dürer's city, the Germanisches Museum provided a seductive image of an integrated, bourgeois German culture of the past. The young, new city of Berlin, however, could announce the definitive presence of a German national culture on the modern scene, in a national gallery in classical style sited in the centre of the newly built Museumsinsel, a sacred precinct devoted to all the arts and civilisations of the world.

Without taking account of its setting in the Museumsinsel (figs. 2 and 3) one cannot appreciate the unbounded ambition and cultural-political pretensions of the Nationalgalerie.[4] The Nationalgalerie was the third museum to be founded on this island on the river Spree in the centre of Berlin. The first, Schinkel's Museum on the Lustgarten, now called the Altes Museum, was built after the victorious Wars of Liberation against Napoleon, opening in 1830. According to Schiller, in his letters *Über die ästhetische Erziehung des Menschen* (On the aesthetic education of man; 1795), human beings can develop towards moral perfection and freedom only through art and in the realm of beauty. In real life they are debarred from doing so by the constraints and injustice of society. Only in the realm of the arts, as is proclaimed by Schinkel's museum, in deliberate antithesis to its neighbours Berlin Castle and Berlin Cathedral, sites of political power and ecclesiastical authority respectively, only in the realm of the arts are men free.[5]

Dedicated not to his countrymen but to all humanity, Schinkel's museum housed classical art and in its upper galleries Old Masters. Its

collections rapidly expanded as Prussia prospered, and in 1841 King Frederick William IV decided that the whole area behind Schinkel's museum should be set aside as a 'sanctuary for art and science', to be used only for the building of further museums and cultural institutions. Prussia's capital, this 'new Berlin', would no longer be a Sparta but an Athens on the Spree, a military state no longer but one dedicated to the Muses. Of course, Frederick William IV was prompted to develop the Museumsinsel in this way by the impressive expansion of Munich into a capital of the arts being promoted by his brother-in-law Ludwig I of Bavaria. The transformation of Berlin would have been inconceivable without the earlier bid by Munich to become an Athens on the Isar.

Inspired by Schinkel's earlier ideas, and ultimately by Friedrich Gilly's turn-of-the-century design for a monumental temple to Frederick the Great, a master plan for the Museumsinsel was drawn up by Stüler, the court architect. In 1845 the so-called Neues (new) Museum was begun by Stüler immediately behind Schinkel's museum, and linked to it by a bridge. The new building was intended to house the Egyptian collection, rapidly expanding as a result of expeditions, also prehistoric finds, ethnological exhibits, and the collection of engravings. In significant contrast to Schinkel's Altes (old) Museum, a temple of devotion to art, Stüler's Neues Museum was a richly decorated temple of education and historical knowledge. The cult of art that had inspired Schinkel, and stemmed from Goethe and the Weimar classical movement, was replaced by Hegel's philosophy of history.

Stüler's master plan conceived from the beginning that there should be a third building, in the form of a temple set on a plinth, in the exact centre of the Museumsinsel, which would serve both art and science, combining the functions of museum and university. Here the art-loving public of the rapidly growing city would undergo instruction and enjoy, gathered in the Berlin collections, the arts and culture of the entire world. This 'centre for the humanities', as we would now call it, intended to foster the appreciation of art, education, tolerance and humanity, was to be linked with the Altes and Neues Museums to form a colonnaded forum enclosing an Arcadian garden, like a sacred grove. Frederick William IV, who was an amateur architect, a pupil of Schinkel, himself made a design (fig. 4) for such a building, again an antique temple set on a high monumental plinth. But it had remained no more than a project owing to lack of funds. After the quite unexpected donation of the Wagener collection and its acceptance by the Prussian state in 1861, the projected building was given a new role, that of Deutsche Nationalgalerie für zeitgenössische Kunst (German national gallery for contemporary art), at the express command of the crown. With extensive reference to Frederick William IV's plan, the building

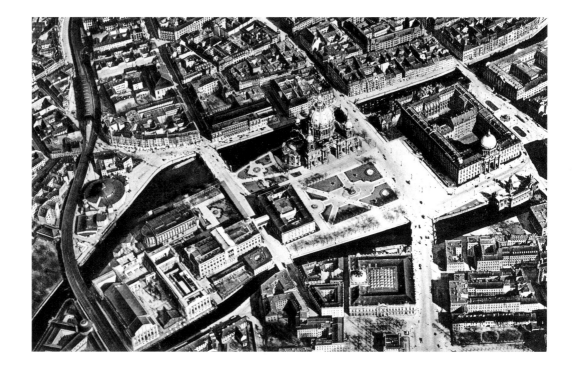

Fig. 3
The Museumsinsel (Museum island),
Berlin
Aerial photograph, 1929

The river Spree divides to form the
Museumsinsel. At its southern end (right
of picture) stood the square enclosure
of the royal residence, Berlin Castle
(destroyed in World War II). Beside it,
the domed Cathedral occupies the east
side of the Lustgarten (Pleasure
garden), formerly a parade ground.
Schinkel's Museum, now called the Altes
Museum, faces the site of the Castle
across the Lustgarten. Behind Schinkel's
Museum were placed the other
museums: the Neues Museum
immediately behind, the Nationalgalerie
to the north-east, the Pergamon
Museum behind both of these to the
north. The Bode Museum occupies the
remaining part of the Museumsinsel, on
the other side of the railway line.

was then redesigned by Stüler in 1865; after his death the detailed building work was supervised by the court architect Johann Heinrich Strack until its completion in 1876.[6]

WHAT IS 'DEUTSCH'?

Art, knowledge, nationhood – this trinity of crucial nineteenth-century ideas was given impressive visual expression in the three museum-temples on the Museumsinsel, as nowhere else in Germany. Special guardianship over the arts seemed to have been endowed on the German nation, and the Nationalgalerie, visible from afar on its plinth, seemed to be its crown. This brought with it, of course, considerable risk, since such a prestigious setting ensured that the full pressure of tradition would be exerted on a national gallery which, unlike almost all other national galleries, did not consist of a collection of past masterpieces, but was devoted solely to the art of the present. One could indeed say that the shining light of *Deutsche Kunst* was really only a stalking horse for Prussian ambition, and the delicate question has to be asked, whether its 'German' identity was not a figment of an invented history. But it is scarcely possible to exaggerate what it would have meant for a newly constituted nation if it had not been able to display the latest works of its own art. The role of art was, above all, to supply a national iconography – even if at great cost to itself!

Hitherto Prussia – unlike Bavaria – had erected virtually no national monuments or buildings, and the Nationalgalerie was the state's first act of architectural self-glorification as the standard-bearer that had led the way to German unity. Prussia's role was clearly stated by the erection in 1886 of an equestrian statue of Frederick William IV, by Alexander Calandrelli, on the flight of steps in front of the Museum (fig. 1).[7] By installing, in front of its temple façade and under its inscription *Der Deutschen Kunst 1871,* a statue of the royal founder of the Museum, Prussia was laying conspicuous claim to the role of supreme guardian of the arts in the young German Empire. These Berlin museums of the Second Empire could not be mistaken for museums of the first, Holy Roman Empire. For Prussia adorned Berlin, the new capital of the Empire, with its royal Prussian museums at its own expense. Even today the Staatliche Museen zu Berlin (State museums in Berlin) are not, as is often thought, the state museums of the German nation, that is of the Federal Republic of Germany. Instead, as part of the Stiftung Preußischer Kulturbesitz (Prussian cultural heritage foundation), they continue to be the state museums of the state of Prussia – which has meanwhile ceased to exist. Since they therefore now really belong to nobody, the Staatliche Museen zu Berlin belong today to all. They are in fact jointly funded by the Federal Republic and by each and all of the Federal states as a flagship of German cultural unity.

The glorification of the ruling Hohenzollern dynasty and the hegemony of Prussia in the new German Empire was continued in the exterior and interior decoration of the Nationalgalerie. Works from

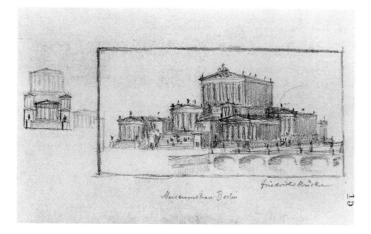

Fig. 4
Sketch design for the buildings of the Museumsinsel, c. 1841
Pencil drawing
Stiftung Schlosser und Gärten Berlin-Brandenburg

the bourgeois Wagener collection were displayed in side rooms, and in the two main rooms only the cartoons of Peter Cornelius were hung (fig. 5). These cartoons were preparatory drawings in the artist's own hand for the mythological and biblical wall-paintings which he had executed for the Alte Pinakothek and the Glyptothek in Munich and projected for the Campo Santo in Berlin, the Hohenzollern burial ground, which was never completed. In these rooms at the heart of the Nationalgalerie, significantly decorated with a larger-than-life bust of the artist in the apse, Cornelius and his idealising linear style, his belated Neoclassicism of a Nazarene stamp, were celebrated as the solemn climax of German art in the new Empire (see further the essay by Claude Keisch in this volume).

THE RETURN TO ART

It is clear that the Berlin Nationalgalerie, the first museum for ccontemporary art, was, at the time of its inauguration, on the Emperor's birthday, 21 March 1876, five years after the declaration of a united Empire, a highly self-contradictory institution. Solemnly installed in the sacred precinct of the Museumsinsel, this classicist temple, splendidly elevated above the banks of the Spree, presented the appearance of a shrine to the finest German hopes for art. However, neither in the real life of the dynamic modern industrial nation nor in the interior of the magnificent building was there much that corresponded to those hopes.[8]

It was the art historians who, as curators and directors of the Museum, transformed the Nationalgalerie and its collections into a

true temple, if not of German art, at any rate of the arts in Germany. They did so often working with their supreme overlords and often working against them, whether they were, until 1918, the King of Prussia and German Emperor, or subsequently the changing governments of the Weimar Republic, or Adolf Hitler and his anti-modernist dictatorship, or, after 1945, the rulers of the two Germanies, East and West, or, since 1992, of a reunited Germany.

The first art-historian Director of the Nationalgalerie was Max Jordan. He had ensured that Adolph Menzel's *Iron-rolling Mill* (cat. 45), finished in 1875, was acquired in good time for the opening, when it was the most modern picture in the Nationalgalerie. Going beyond Wagener's collection, he also succeeded in purchasing important works by the 'German Romans' Arnold Böcklin and Anselm Feuerbach (see cat. 49–52), who were still little appreciated at the time. This was also true of Menzel and Carl Blechen: Jordan was able to buy many of their paintings, and 1200 drawings by Menzel. Jordan even bought works by Fritz von Uhde and Max Liebermann (cat. 69–71), regarded with suspicion as representatives of the socialist trend to paint victims of poverty. However, Jordan's major achievement was the transfer to the Nationalgalerie of the frescos from the Casa Bartholdy, which took place in 1887. Painted in Rome by the Nazarenes Cornelius, Overbeck, Veit and Schadow between 1816 and 1818 for the Prussian Consul General Jakob Salomon Bartholdy in the Palazzo Zuccari, these frescos (see fig. 28, p. 40) inspired by both Raphael and Dürer were the first communal work by a confederation of German artists, and so in a sense the first suggestion of a national gallery. With this priceless original document of the Nazarene renewal of European mural painting, a dramatic bridge reaching across to the late art of Cornelius was suddenly created.

Max Jordan resigned from his office as Director of the Nationalgalerie in 1896, exhausted by unending disputes with the artists in the Prussian Academies of Art (those of Berlin, Düsseldorf and Königsberg). As they held the majority, they voted most of the funds provided by the state for the Nationalgalerie's purchases to commissions for themselves and their colleagues. Since Emperor William II expressly endorsed this acquisition policy, the inner sanctum of the Nationalgalerie, the two Cornelius rooms, was quickly transformed into a storehouse of patriotic pictures. The latest works of Prussian history painting, such as the bombastic *Entrance of the victorious Emperor William I through the Brandenburg Gate* (*Einzug Kaiser Wilhelm I. des Siegreichen durch das Brandenburger Tor*), were simply set up in front of the Cornelius's cartoons.

Hugo von Tschudi (fig. 6), appointed the second Director of the Nationalgalerie in February 1896, put an immediate stop to this

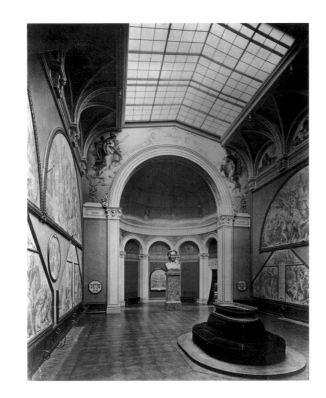

development, which had been vehemently criticised in the Berlin press. Tschudi resolutely implemented his predecessor's argument that the Nationalgalerie, like the Wagener collection at its basis, had to be much more open to what was happening internationally in art. Just a few weeks after taking office Tschudi travelled to Paris and, with the advice of Max Liebermann, bought from Durand-Ruel for the Nationalgalerie Eduard Manet's masterpiece *In the Conservatory* (*Au jardin d'hiver*, 1879; fig. 51, p. 167). That same year Tschudi bought further works by modern French artists – Monet, Degas, Rodin and Cézanne (cat. 68). Tschudi financed the acquisition of all these pictures without recourse to state funds, through donations from Berlin art lovers. These men, who were often members of the Jewish upper classes, had similar collecting interests and energetically supported Tschudi's expansion of the Nationalgalerie into a truly European collection.[9]

In December 1896, at the end of his first year in office, Tschudi presented his purchases in the second Cornelius room. A scandal was inevitable. The permanent exhibition of French art – the art of Germany's enemy, defeated in the 1870–1 Franco-Prussian War – in the German Nationalgalerie gave rise to heated controversy in the press and finally led to a debate in the Prussian Landtag (Parliament). Since the discussion was not going to die down, on 11 April 1899 Emperor William II visited the Museum in his capacity as its supreme overlord. He ordained that all Tschudi's re-hangings should be reversed. However, he did concede that the new purchases might be put on permanent display on the upper floor. He further decreed that in future all works acquired for the Nationalgalerie, including donations from private individuals, had to be approved by him personally.

Imperial censorship seriously impeded Tschudi's purchasing efforts, but did not cripple them. And, although Tschudi saw French painting as the standard by which contemporary art should develop, he was able to combine this aesthetic conviction undogmatically with a broad view of art history. The outcome of such perspicacity was the celebrated German Centenary Exhibition (*Deutsche Jahrhundert-Ausstellung*), which Tschudi organised in conjunction with Alfred Lichtwark and Julius Meier-Graefe in the Berlin Nationalgalerie, which was completely emptied for the purpose (see the essay in this volume by Angelika Wesenberg). Before eyes trained to look at Impressionism, nineteenth-century German art was suddenly transformed from a mere vehicle for imparting information into a series of painterly experiences. Seen afresh, forgotten artists like Caspar David Friedrich or Carl Blechen proved to be important representatives of European *plein-air* painting. The young Menzel was admired for his striking anticipation of Impressionism. But Tschudi also appreciated, for the first time, the painterly qualities of Böcklin and the other 'German Romans'. The canon of nineteenth-century German art was established for once and for all at the Centenary Exhibition; all major acquisitions for the great

German collections elsewhere were guided by it. Henceforward the Berlin Nationalgalerie operated as a kind of artistic evaluation machine. Everything that Tschudi showed there claimed in the first place to be art, and therefore to be appropriate for the first museum of modern art in Germany.

Tschudi's successor, Ludwig Justi, was no less bold in carrying on the transformation of the Nationalgalerie from a national shrine into an international museum. Throughout the ground floor Justi had small display rooms built in a series of styles ranging from Neoclassicism to Art Nouveau, and as a result a huge increase in exhibition space was achieved. The Cornelius rooms ceased to be sacrosanct. Justi purposefully expanded the collection in the field of German art, being extremely diplomatic in his dealings with the Kaiser.

Justi's finest hour came in 1919; after the abdication of the Hohenzollerns and the fall of the Wilhelmine Empire he was able to acquire the Kronprinzenpalais (Crown prince's palace), close to the Museumsinsel on Unter den Linden, as an annexe for the modern section of the Nationalgalerie. Here Justi installed on the ground floor the French works Tschudi had acquired, and on the floor above the most modern section of the Nationalgalerie, with masterpieces of German Impressionism. With its alternation between galleries devoted to a single artist and major special exhibitions of the very latest artistic phenomena the Kronprinzenpalais attracted the admiration of the young Alfred Barr: the Museum of Modern Art founded by him in New York in 1929 directly reflected Barr's experiences in Berlin.

When the National Socialists came to power in 1933 Justi was dismissed as Director of the Nationalgalerie. No museum collection was so affected by the Nazi iconoclastic onslaught on so-called 'degenerate art' as the modern section of the Berlin Nationalgalerie. Almost its entire stock was seized in 1937 and subsequently alienated. In the same year the Kronprinzenpalais was closed. Once again modern art in the Nationalgalerie was regulated, censored and this time even got rid of by the political authorities in Germany. It was, significantly, at the Nationalgalerie that the National Socialists closed off the art of the twentieth century. All 'rescue attempts' by Justi's former assistant Alois Schardt, who tried to construct a 'Nordic' tradition running from Caspar David Friedrich down to Franz Marc, failed. Once again art was appropriated for the presentation of what was 'German', this time with unbending strictness. Once again the Nationalgalerie was the platform chosen for the birth of Germanness from the spirit of correct German art. When the Nationalgalerie did not conform, it was closed down.[10]

EPILOGUE: THE BERLIN NATIONALGALERIE TODAY

Hardly surprisingly, the division of Germany after the Second World War also led to a division of the Nationalgalerie. The Nationalgalerie on the Museumsinsel was in the eastern sector of Berlin, and became the National Gallery of the German Democratic Republic. Since the collection of modernist art had been extensively plundered by the National Socialists, the works to be seen there were mostly nineteenth-century. Stored in anti-aircraft towers, many had survived the war, but there had also been considerable losses. The collection was appropriated by the Soviet Union, but returned to Communist Germany in 1958 as a gift. The large-format paintings and sculptures had remained in the badly damaged Nationalgalerie.

In the final weeks of the war the outstanding transportable nineteenth-century works, including those acquired by Tschudi, were evacuated to mines in the Harz and the Werra district, and from there reached West Germany. From 1968 these, along with the first important acquisitions for a new collection of twentieth-century art, were housed in a new building, designed by Mies van der Rohe, in the Tiergarten in west Berlin (fig. 7). A highly allusive paraphrase of the Alte (old) Nationalgalerie, the Neue (new) Nationalgalerie is one of the outstanding museum buildings of the twentieth century. Meanwhile a gallery of the Romantic movement (Galerie der Romantik) was created at Schloss Charlottenburg for the work of Friedrich, Schinkel and Blechen.

Following the reunification of Germany in 1990, in 1992 the state museums (Staatliche Museen zu Berlin) in the eastern and western sectors were also reunited. The Alte Nationalgalerie now contains the entire 'national' collection of nineteenth-century art; the works in the Galerie der Romantik will return there when it re-opens after restoration. The Neue Nationalgalerie houses twentieth-century art, beginning with Munch and German Expressionism.

The role of annexe for contemporary art that the Kronprinzenpalais once served has been continued since 1996 at the Hamburger Bahnhof (Hamburg station), converted for the purpose by Josef Kleihues. It houses all the state collections of the arts after 1980. The Alte Nationalgalerie has another annexe in the nearby Friedrichswerder church, built by Schinkel, where the Nationalgalerie's collections of sculpture from Schadow onwards will be displayed.

Thus in 2001, exactly 125 years after its opening in 1876, the Alte Nationalgalerie, restored to its original splendour, will re-emerge as the most important collection in Germany of nineteenth-century art. The restoration of the other museums on the Museumsinsel is also in hand: as the government of reunited Germany returns to its old capital city, on the Museumsinsel a cultural gesture will again be made that is symbolic for the political history of Germany. The former museums of the

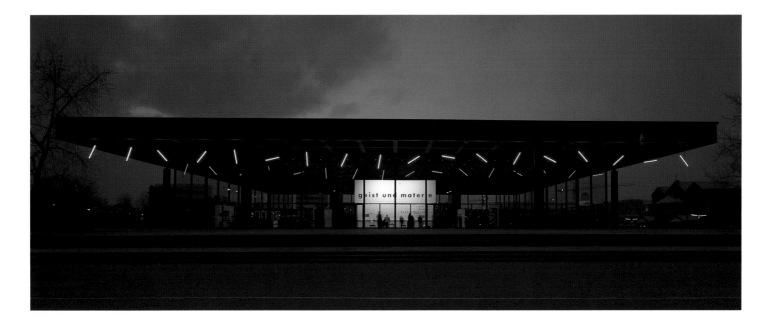

Fig. 7
The Neue Nationalgalerie
Architect Mies van der Rohe; opened 1968. Photograph, 1999

state of Prussia, now belonging to all the federal states, provide a model for German federalism. What has always been proudly self-evident for the London or Washington or other national galleries over the world now applies, for the first time, to the Berlin Nationalgalerie: it is the collection of a nation, in this case of the nation's nineteenth-century art.

A further important reintegration of the Nationalgalerie has been the acquisition, after unparallelled efforts by both the federal government and the state of Berlin, of the Heinz Berggruen collection of twentieth-century art, which is housed under the aegis of the Nationalgalerie in the Stülerbau opposite Schloss Charlottenburg. What was lost to the Nationalgalerie as a consequence of National Socialist iconoclasm has been brilliantly regained thanks to this settlement.

Today the inscription *Der Deutschen Kunst 1871* on the Alte Nationalgalerie has regained the embracing interpretation given it by Tschudi: whatever may be helpful in advancing German art, whatever has developed internationally through artistic exchange, whatever acquisitions cosmopolitan-minded benefactors make possible, are collected in the Berlin Nationalgalerie and its various buildings for the pleasure and instruction of all. The task of collecting art from all over the world in the Berlin museums, once taken up by Prussia in dire need, has now unquestionably, at the start of the twenty-first century, been fulfilled. Thanks to generous benefactors, from the start 'national' was expanded into 'European', and the Nationalgalerie has finally now been opened up to modern world art in all its varied manifestations. In this

the Nationalgalerie also reflects the different mentality of a reunified modern Germany, which is more familiar with cultural federalism than with the idea of cultural domination.

NOTES

1 On the problem of German art, cf. Belting 1998; Hans Belting, 'Moderne und deutsche Identität im Widerstreit. Ein Rückblick in der deutschen Nationalgalerie', in Belting 1999, pp. 117ff.; Hofmann 1999. On the Berlin Nationalgalerie, cf. Rave 1968; Honisch 1979; Forster-Hahn 1996a; Françoise Forster-Hahn, 'Weihestätte der Kunst oder Wahrzeichen einer neuen Nation? Die Nationalgalerie(n) in Berlin 1848–1968', in *Berliner Museen, Geschichte und Zukunft*, ed. Zentralinstitut für Kunstgeschichte, Munich 1994, pp. 155ff..

2 Cf. Claude Keisch, *Die Sammlung Wagener. Aus der Vorgeschichte der Nationalgalerie*, exhib. cat., Nationalgalerie, Berlin (East), 1976.

3 Peter Burian, 'Das Germanische Nationalmuseum und die deutsche Nation', in Bernward Dencke und Rainer Kahsnitz, *Das Germanische Nationalmuseum Nürnberg 1852–1977*, Munich 1978, pp. 127ff.

4 Gaehtgens 1992; Thomas W. Gaehtgens, 'The Museum Island in Berlin', in Wright 1996, pp. 53ff.

5 Wolf Lepenies, *The End of 'German Culture'* (The Tanner Lectures on Human Values, 1999), Cambridge MA 1999.

6 Cf. Dorgerloh 1999; Maaz 1999.

7 Bernhard Maaz, 'Alexander Calandrellis Reiterstandbild Friedrich Wilhelms IV. an der Nationalgalerie', *Jahrbuch der Berliner Museen*, N.F. XXXVI, 1994, pp. 199ff.

8 Peter-Klaus Schuster, 'National-International: Zu einer historischen Kontroverse um die Berliner Nationalgalerie', in Plessen 1992, pp. 210ff.

9 See Berlin–Munich 1996.

10 Cf. *Das Schicksal einer Sammlung. Die neue Abteilung der Nationalgalerie im ehemaligen Kronprinzen-Palais*, exhib. cat., Nationalgalerie, Berlin (East) 1986.

Art without a National Centre
German Painting in the Nineteenth Century

'Close your bodily eye so that you may first see your picture with your mind's eye. Then bring to the light of day what you have seen in the dark, so that it may reflect back on others from outside to inside' Caspar David Friedrich[1]

FRANÇOISE FORSTER-HAHN

BETWEEN NATIONALISM AND COSMOPOLITANISM

When the French critic Edmond Duranty reviewed the German art exhibition at the Paris World Fair of 1878, he keenly recognised as one of the special features of the 'German School' its diversity, a diversity consequent upon the political and cultural decentralisation of Germany. 'The Germans do not have – as we do – one single great forum for the arts, one single artistic world; they have separate and therefore diminished centres: Munich, Berlin, Düsseldorf, Weimar and Karlsruhe …'.[2] Looking at German art from the outside, the French critic articulated what one of Germany's most effective museum directors, Alfred Lichtwark of the Hamburger Kunsthalle, twenty years later would voice from the inside, on the occasion of the 1900 World Fair: while France and England, he argued, had 'a centre of national life' – and thus of cultural production and aesthetic discourse – there was 'no such rallying point' for the visual arts in Germany.[3] The competitive arena of world fairs, which provided a unique opportunity for critics to compare the visual arts of different countries, must have put into sharp focus the special 'conditions' at the roots of German art in the nineteenth century. Both Duranty and Lichtwark concluded that the lack of a political and cultural centre was linked to the diversity, but also to the fragmentation, of artistic production.

Indeed the attempt to analyse what constituted the 'Germanness' of German art had a long history, itself intricately connected with the course of German politics, with the struggle for national unity and identity. Once the German nation state had been established, however, German art became to some extent at least the pawn of political nationalism, and nationalist expectation would collide, towards the end of the nineteenth century, with the cosmopolitan aspirations of the modern movement. Most recently, in the wake of German reunification in 1990, German art and art history have again been subject to new interpretation,[4] and the issue will no doubt be raised again as a consequence of the exhibition this catalogue accompanies.

Like no other similar institution, the role of Berlin's Nationalgalerie, ever since its foundation in 1861 and opening in 1876, has been intimately interwoven with the discourse of contemporary cultural politics. The Museum is itself a microcosm of the multiple and shifting interpretations of nineteenth- and twentieth-century German art.[5] The national mission of the Museum was not only written in golden letters on the pediment of the building's façade, *DER DEUTSCHEN KUNST MDCCCLXXI* (For German art 1871 – 1871 being the date of the founding of the German Empire), but, as its visual and textual narratives, its exhibitions and catalogues, disclose, was inscribed into its very conception. In the 1877 edition of the Museum's catalogue, Max Jordan, its first director, explained to his readers that the biographies of artists of foreign nationality would be limited to

Fig. 8
PHILIPP OTTO RUNGE
Morning (Der große Morgen), 1809
Oil on canvas, overall dimensions 152 × 113 cm
Hamburger Kunsthalle, Hamburg

architecture and, most of all, its acquisition policies and display strategies not only mirror the course of modern German history, including the conflict between conservative and progressive forces, but also construct a visual narrative at the very centre of the capital city.

'GERMANNESS' AND THE GOTHIC REVIVAL

Present-day discussion of the German essence of German culture can be traced back over more than two hundred years to a series of political debates and aesthetic theories in which international openness was opposed to patriotic tradition. The conflict between cosmopolitanism and patriotism, which the historian Friedrich Meinecke and other German intellectuals and artists (such as Harry Graf Kessler – see further below) perceived as crucial in the first decade of the twentieth century, echoes the tension between notions of universality and German national awareness, or *Deutschheit* (Germanness), which first emerged in the latter part of the eighteenth century. Following the rediscovery of Gothic architecture, the reciprocal relationship between aesthetic discourse and an emerging political awareness is revealed in theories about the nature of Gothic art and its position vis-à-vis French and Italian culture. Goethe's classic essay on Strasbourg Cathedral (fig. 9), written when he was a young student and first published anonymously in 1772,[9] immediately caught the imagination of a wide audience. As the title, 'Of German Architecture', provocatively announces, the text sets out to identify the historical style of a particular monument, then in France, with *Deutschheit*. In the second section, the author declared: 'This is German architecture! Our architecture!'[10]

Forty years later, in 1812, with the distance of age and at the height of the anti-Napoleonic Wars, Goethe remarked upon his youthful essay: 'Since I saw that this building had its foundation on former German soil and had progressed so far at a genuinely German time, and that the name of the master builder on the modest gravestone had an equally native German sound and origin, I took it upon myself … to change the old, infamous designation "Gothic" architecture, and to claim it as our nation's "German" architecture. Nor did I fail … to make my [patriotic] sentiments public ….'[11] Clearly, the intensification of the national movement around 1812 also affected Goethe, who is usually seen as francophile and cosmopolitan, and opposed to the creation of a German political nation-state.

The age of Goethe was a period of violent turmoil, of revolution and wars, which engulfed almost all of the entire European continent, leaving no sphere of life untouched. As the ideas and political actions of the French Revolution swept over the continent, dynamic processes of transformation were set in motion: political structure, social organisation and aesthetic traditions would be changed forever. The French

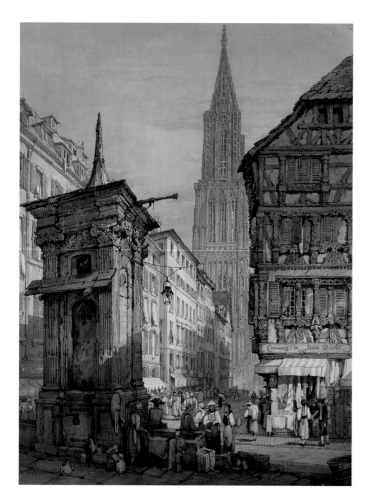

Fig. 9
SAMUEL PROUT
A View in Strasbourg, c. 1822
Watercolour and pen and ink, 62 × 47.7 cm
Ashmolean Museum, Oxford

their most essential facts, because of the 'character' of the Nationalgalerie.[6] After the defeat of the German Empire in the First World War, Ludwig Justi, director since 1909, made it clear in the 1920 catalogue how deeply he felt that 'these expressions of the German spirit' (the art displayed) would help to ensure that 'undamaged by the external collapse, the empire of the German spirit would remain strong and always grow.'[7] Shortly afterwards, Justi emphasised a national reading of the newly acquired *High Mountains* by Caspar David Friedrich (*Hochgebirge*; lost in 1945): '… here is personal feeling, German feeling. All the inexhaustible and yet clear, the rare and yet immediate richness of life of this painting is not accessible to the art lovers of other nations – just like the innermost core in the music of Beethoven.'[8] By ascribing to the German art displayed within it such an outright national meaning, Justi also reasserted the Museum's national role. Its urban site,

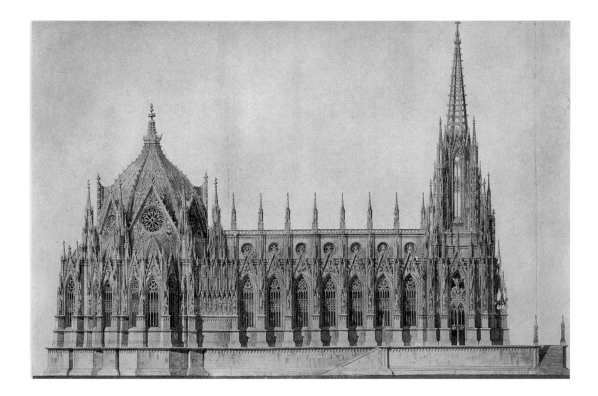

Revolution, 'an almost universal earthquake,' to use the words of Friedrich Schlegel,[12] produced such a volatile environment for artistic production that all sense of stability was lost. Whether artists in their search for a new visual language turned for inspiration to classical antiquity or the Middle Ages, or formulated a complex symbolic language – as Runge and Friedrich did – they all were keenly aware of living in a period of transition and participating in something new. As the young Adolph Menzel declared in a letter to a friend in 1836, 'Art has and always will follow the ways and by-ways of general human progress, because the artist, like all humanity, is only part of this development'.[13] The revival of Gothic architecture and of medieval themes and settings was imbued with patriotic sentiment. Karl Friedrich Schinkel's many visions of the Gothic cathedral, such as his paintings *Gothic Church on a Rock by the Sea* (cat. 3) and *Medieval City on a River* (cat. 1), are clearly an allusion to the newly articulated *Deutschheit*. Schinkel also drew up plans for the construction of a 'German' cathedral on the spot near Leipzig where the Allies defeated Napoleon's army in the decisive Battle of the Nations in 1813 (fig. 10). Schinkel's project was planned not only as a memorial to the Wars of Liberation, but also as a symbol of future German unity.[14] As such it prefigures the role that Cologne Cathedral, and the task of its completion, would soon assume in the public's imagination. However, as Cologne Cathedral moved to its completion from 1842 to 1880, patriotism began to shift toward nationalism.

The idea of a 'cathedral of German freedom' (*Dom der deutschen Freiheit*) and the vision of the Christian Gothic cathedral as an embodiment of national hopes were widespread during the anti-Napoleonic Wars and the early phase of the following Restoration period,[15] when Schinkel painted *Medieval City on a River* and *Gothic Church on a Rock by the Sea* (both 1815). Schinkel's towering Gothic cathedrals set in an idealised northern landscape, populated by small figures in medieval costume and immersed in dramatically lit skies, evoke a Gothic Middle Ages both as an act of poetic imagination and as a suggestive signal of political hope.

Unlike Schinkel, whose experience of Italy was as intensive as Goethe's, Runge and Friedrich never went to Italy. Rooted in North German Protestantism, each developed a very personal visual language of complex symbolism that opened their images to multiple interpretation. Both artists had connections to the patriotic movement and its ideologies – Runge designing the title page 'The Fall of the Fatherland' (*Der Fall des Vaterlandes*) for the magazine *Vaterländisches Museum*,[16] Friedrich painting the northern, German landscape with discreet references to the contemporary political situation.

Like many philosophers, artists, poets and political reformers, Runge was intensely aware of living in a period of profound change and thus of the necessity to produce a new art. His large canvas of *Morning* (fig. 8),[17] part of the cycle *The Times of the Day*, was inspired in its

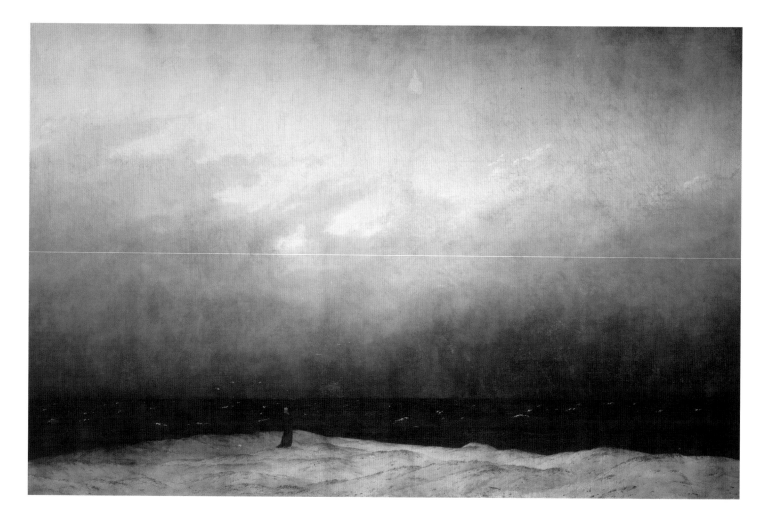

Fig. 11
CASPAR DAVID FRIEDRICH
Monk by the Sea (Monch am Meer), 1808–10
Oil on canvas, 110 x 171.5 cm, Nationalgalerie, Staatliche Museen zu Berlin

complicated allegorical system by the philosophy of Jakob Böhme. The painter associated the times of day with the seasons, the Ages of Man and ultimately with Christian and cosmological ideas. Although the cycle was never completed, Runge envisaged the paintings displayed in a Gothic architectural setting while poetry was read and music played. This conception of an entirely syncretic art form, transgressing all conventional boundaries, was as radical as contemporary ideas of a fundamental political renewal.

While Runge developed his theories about the visual arts and his innovative hieroglyphic pictorial language, Friedrich blended a spiritual and a political symbolism in his images of the northern landscape. His art has been subjected to contradictory readings, as either Christian and spiritual or political and patriotic.[18] But just as Gothic architecture could signal both Christian and patriotic renewal, so Friedrich's paintings embody multiple meanings, often ambiguous and shifting in time.

Friedrich first gained wide recognition during the period of French occupation, when he showed *Monk by the Sea* (fig. 11) and *Abbey in the Oak Forest* (fig. 12) at the Berlin Academy in 1810.[19] Both paintings elicited intense critical response and were bought by Prussian King Frederick William III on the suggestion of the Crown Prince. Not long afterwards, *The Solitary Tree* (cat. 6) and *Moonrise over the Sea* (cat. 7) were commissioned as pendants by the Berlin banker Konsul Wagener, as a morning and an evening landscape. The shepherd in the morning landscape, leaning in a reflective mood against the tree, and the three figures in the evening scene, sitting immobile on the rocks on the beach, contemplate the changing phases of the day, the rising light of sun and moon, and thus the changes of nature. Read as complementary images, they represent Friedrich's conception of nature not as a fixed state but

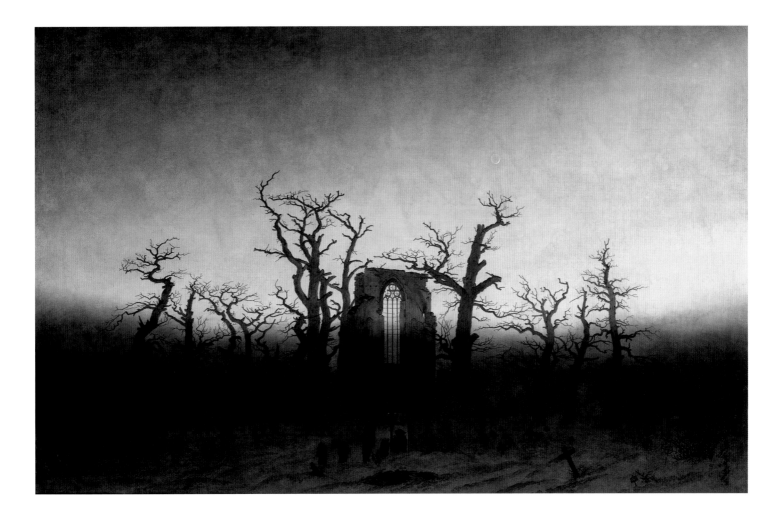

Fig. 12
CASPAR DAVID FRIEDRICH
Abbey in the Oak Forest (Abtei im Eichwald), 1809–10
Oil on canvas, 110.4 × 171 cm, Nationalgalerie, Staatliche Museen zu Berlin

a fluid process, changing at every moment, just as historical time is continuously flowing. While today both images may primarily invite a reading focusing on the spiritual symbolism, and reflection upon the passing of time and the mortality of human life, they also contain motifs that a contemporary audience would have decoded as signifiers of a patriotic spirit: the solitary tree is a splintered oak – a symbol of Germany – and in *Moonrise over the Sea* the man closest to the viewer is conspicuously wearing the Old German (*altdeutsch*) costume, a long coat and biretta. It was the costume associated with 'demagogues,' a term originating in police vocabulary and referring to those who pursued liberal to radical politics. In 1819, when the great reform movement had come to an end, 'Old German' costume was prohibited by decree, and it continued to signify political opposition. In *Man and Woman contemplating the Moon* (cat. 9) the couple (also identified as the painter and

his wife) are standing still in a dark forest between a fir and an uprooted old oak tree, the branches of which weave a tight net across the moonlit sky. The man is wearing *altdeutsch* costume. As in so many other landscapes of Friedrich's, the human figures are frozen in their positions, passive observers, turning their back to the viewer and contemplating the changes of nature, but also of history. Associating the man with the 'patriotic' opposition to the reactionary politics of restoration, Friedrich introduced into a timeless scene a concrete contemporary element.

Wedded to the vocabulary of Romantic rhetoric are ciphers of *Deutschheit* that are elusive for the present-day viewer, but were easily decoded by Friedrich's contemporaries. His landscapes of old heroes' graves, of Gothic ruins, of the high mountains and of oak trees fuse the spiritual experience of nature with the new awareness of *Deutschheit*. At a time when political and geographic unity were a vision of the future,

Fig. 13
PETER CORNELIUS
After Church (Nach dem Kirchgang), from *Illustrations to Goethe's Faust*, 1816
Engraved by F. Ruscheweyh
Goethe-Museum, Düsseldorf

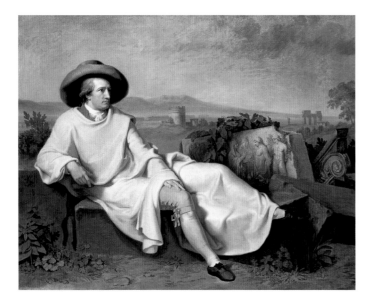

Fig. 14
JOHANN H.W. TISCHBEIN
Wolfgang von Goethe in the Campagna (Goethe im Campagna), 1786–7
Oil on canvas, 164 x 206 cm
Städelsches Kunstinstitut, Frankfurt

Friedrich pictured in his 'German' landscapes a national and cultural identity that was both highly emotive and patriotic. When Justi in 1920 described Friedrich's *Churchyard in the Snow (Klosterfriedhof im Schnee, 1810; lost in 1945)*,[20] a winter scene similar to *Abbey in the Oak Forest*, his reading blended German experience of 1920 with that of the artist's own time a century earlier: 'White snow covers like a shroud the German plane …'.[21]

As Friedrich painted the northern region as a German landscape and Goethe identified the Gothic as German, 'not foreign, but patriotic',[22] the young Peter Cornelius, a central figure in the Nazarene group in Rome, represented Goethe's tragedy *Faust I* as a typically German narrative with a youthful, energetic Faust in an idyllic northern neo-medieval setting (fig. 13).[23] Cornelius's drawings linked Goethe's text for the first time with the emerging national consciousness of the anti-Napoleonic Wars and the reform movement, and themselves came to be regarded as a typically German, an *altdeutsch* narrative. It is within this same context that we should read the creative projects of the young German artists known as the Nazarenes.

THE FASHION FOR DÜRER AND YEARNING FOR ITALY
The German fascination with Italy was poignantly captured by Johann H.W. Tischbein in his portrayal of *Goethe in the Roman Campagna* (fig. 14), 'how he is sitting on the ruins contemplating the fate of human works'.[24] The heroic figure of the German poet is set in an idealised Roman landscape filled with historical allusions and allegorical references. Tischbein not only created an emblematic image of German *Italiensehnsucht* (longing for Italy) and a programmatic aesthetic statement, but the image of a national icon. Goethe's life and work could serve as inspiration both for visions of the 'Gothic as German' and of the Italian heritage as classic and universal. In his youthful hymn to Strasbourg Cathedral, Goethe had already included the 'virile Albrecht Dürer' in his celebration of a German past. Much later, in his autobiography, he referred to Dürer's time as 'the *Deutschheit* of the sixteenth century'.[25] In choosing Dürer as their guiding model and imitating the dress and hairstyle of his time, the young artists later known as Nazarenes both propagated an aesthetic ideal and made a political – that is, patriotic – statement. Indeed they were known not only as 'Nazarenes' but also as '*Düreristen*'.

The first artists' 'secession' crystallised at the Academy in Vienna when two students, Franz Pforr and Friedrich Overbeck, met in 1808 and discovered not only their shared discontent with the mechanical teaching programme, but also their common vision of a future art. Stirred by the spirit of national and religious revival they founded the Brotherhood of Saint Luke in 1809. Vienna was then occupied by the

French, and the Academy had to close in May 1809. When it reopened in early 1810, the school could admit only a limited number of students, and thereby found a welcome pretext to exclude the 'rebels', that is foreigners and those who had joined the Brotherhood or had declared their solidarity with its goals. Immediately upon their rejection, these students decided to move to Rome. Three months afterwards they received permission, thanks to the intervention of the director of the French Academy, to settle in the monastery of Sant'Isidoro.

The Brotherhood's adoption of an almost monastic life-style was perhaps shaped not only by the ideal of medieval life and art, but also by the chaos and instability the artists had experienced in their own time. Pforr, called the 'Master', and Overbeck, the 'Priest', formed the nucleus of the group and played the dominant roles. Communal life was regulated by fixed hours of daily chores and quiet creative work. Each member inhabited a cell; in the evening there were gatherings in the refectory for readings and drawing after the model. In fact, drawing almost assumed the role of a spiritual ritual, replacing the prayer of the monks. This very regulated rhythm of daily life and work was interrupted by excursions into the surrounding countryside, of which numerous drawings trace the group's creative explorations.

Their close bonding and their common ideals had a profound impact upon their work. Rejecting the narrow ideas of the academic programme, they wanted instead to develop a visual language that would convey their inner feelings, which they regarded as 'the artist's greatest treasures'.[26] Almost in contrast to the ideal of a new collective spirit that was to mould their lives and pervade their work, they insisted upon art as an expression of the subjective self. The tension between a new awareness of the individual and the longing for a collective identity can be read in their mutual portraits and self-portraits. Overbeck painted *The Painter Franz Pforr* (cat. 13) soon after their arrival in Rome, in 1810. According to his explanation in a letter, Overbeck depicted Pforr in *altdeutsch* costume in an idealised environment, an open Gothic loggia overlooking a medieval town towards the sea, 'in the situation in which he would perhaps feel happiest'.[27]

Pforr's own vision of the peaceful solitude of medieval life is perhaps most intensely articulated in his complex painting *Sulamith and Maria* (fig. 15),[28] executed two years before he died of tuberculosis at the age of twenty-four in 1812. The panel, in its original frame, imitates the medieval diptych. On the left, the imaginary figure of the Raphaelesque Sulamith, in the pose of a Madonna and Child, is surrounded by symbols of purity and happiness and placed in an Italian landscape. On the right, Maria sits in a closed chamber with bull-eyed windows, a medieval interior immediately bringing to mind Dürer's famous engraving of *St Jerome in his Cell* (1514). Pforr explained that

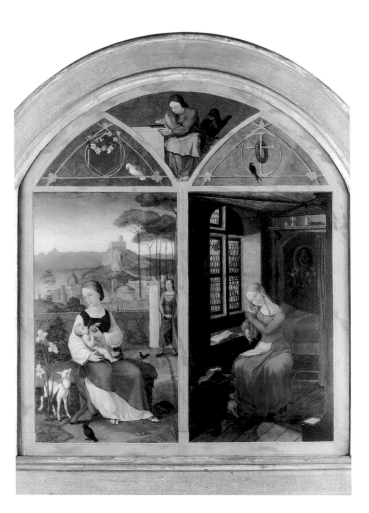

Fig. 15
FRANZ PFORR
Sulamith and Maria (Sulamith und Maria), 1811
Oil on panel, 34.5 × 32 cm
Sammlung Georg Schäfer, Schweinfurt

he wanted to recapture the atmosphere of the portrait that his friend Overbeck had painted of him two years earlier. While still in Vienna, Pforr had composed, in written and pictorial form, an allegorical legend to celebrate his friendship with Overbeck and to express their common ideals. It had been Overbeck's idea '... that each should paint for the other a picture in which the essential beauty and character of their sentiments and the manner of their painting were represented; these could be interpreted through two female figures'.[29] From the Song of Solomon and Friedrich Gottlieb Klopstock's *Odes*, Pforr developed the figure of *Sulamith*, Overbeck's bride and image of noble southern art, and *Maria*, Pforr's own imaginary woman, cast in the northern medieval mode. Pforr developed the image in his cell in Sant'Isidoro, when he was already mortally ill. The allegorical figures of the two women represent both

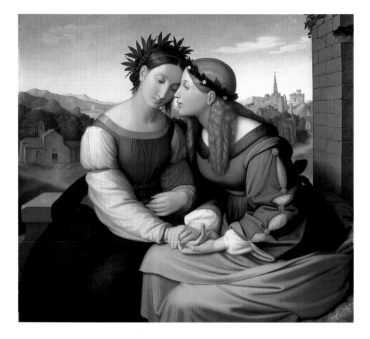

Fig. 16
FRIEDRICH OVERBECK
Italia and Germania (Italia und Germania), 1811–28
Oil on canvas, 94.4 × 104.7 cm
Neue Pinakothek, Bayerische Staatsgemäldesammlungen, Munich

ideal bride and aesthetic programme, the art of Raphael and Dürer, south and north united in harmony. The biographical layer of meaning, the commemoration of an emotionally charged moment of their friendship, would resonate far into the future: Overbeck remembered his friend's painting, that also was a testament, almost sixty years later on his deathbed.

Overbeck responded to *Sulamith and Maria* with *Italia and Germania*, begun in 1811, when Pforr was still alive, and completed in 1828 (fig. 16).[30] In contrast to Pforr's very private enterprise, this project was commissioned by the art dealer and publisher Wenner and as such is more 'public' in conception. Its symbolism at first sight has to do with aesthetic concerns: *Sulamith and Maria* have been transformed into *Italia and Germania*, fusing the southern Italian with the northern Gothic ideal. This vision of harmony belied the concrete reality of a very conflicted present: when the Nazarenes settled in Rome, the French occupied Italy, the Papal States had been dissolved, Pope Pius VII was a prisoner of Napoleon. In fact, it was Napoleon's confiscation of Church property that had provided them with a home, since the monks had been forced to leave their monastery of Sant'Isidoro. The Nazarenes lived in exile: a group of German artists forming a community in Rome. They were separated by culture and language from their Italian environment, emphasising their 'otherness' in life-style, dress and creative

work. Does the pictured union between north and south not also articulate the longing for a union between their homeland and their land of exile? The unity that did not exist in their concrete historical present was visualised in the idealised state of the work of art. Thus the reconciliation of opposites which *Sulamith and Maria* and *Italia and Germania* so poetically configure conveys a harmony that was entirely imaginary.

When Overbeck explicated his painting to his patron in a letter from Rome in 1829, many years after its conception, he reflected upon the melding of two foreign elements in the harmony brought by art, upon the intertwining of memory and present time, and the endurance of friendship: 'My choosing the idea of a Germania and Italia is explained by my particular standpoint as a *German* in *Italy*. These are, as it were, two elements, which indeed face each other on the one side [sic] as foreign, but to blend them, at least in the external shape of my work, is and should henceforth remain my task …. On the one hand the remembrance of *Heimath* (homeland) unforgettably imprinted on the soul, and on the other hand the charm of everything magnificent and beautiful which I gratefully enjoy in the present; both conceived as separate and mutually exclusive, but imagined as being in harmony and as mutually appreciative. What is meant finally is the yearning which constantly draws the north towards the south, towards its art, its nature, its poetry; and [they are] in bridal dress, [because] both [represent] the yearning as well as the object of their desire, because both are ideas that constantly rejuvenate … one may thus simply name the picture "Friendship".'[31] No-one has written more perceptively of the dislocation the German artist experienced in Italy – producing work in the south for an audience in the north, the '*Heimath*'; consciously mediating between two 'foreign' and exclusive elements by imagining their unity in a work of art.

In 1815, the Nazarenes received their first joint commission, a fresco decoration in the Palazzo Zuccari, the Roman residence of the Prussian Consul General, Jacob Salomon Bartholdy. Depicting scenes from the biblical story of Joseph in an archaising style, their murals were removed in 1886–7 and are now in the Nationalgalerie in Berlin (fig. 28, p. 40). This commission not only gave the artists their first opportunity to translate their vision of community into a major collaborative project, it also marks the beginning of the revival of fresco decoration for private and public buildings. Such major enterprises as the decoration of the royal residence in Munich, and of churches and public museums in Munich and Berlin, were inspired by this Roman example.

The Nazarenes' search for a collective identity and for a common aesthetic, both patterned after the past, seems like a last attempt to hold on to a world that was breaking apart around them. By contrast,

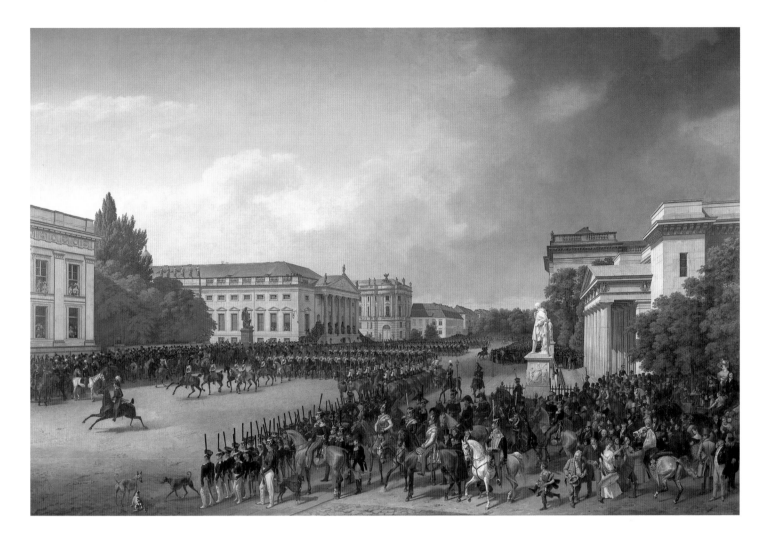

Fig. 17
FRANZ KRÜGER
Parade in the Opernplatz in 1822 (Parade auf dem Opernplatz), 1824–30
Oil on canvas, 249 × 374 cm, Nationalgalerie, Staatliche Museen zu Berlin

Runge had proclaimed at the beginning of the century, 'Art of all periods teaches us that humanity changes, and that a period, once past, never returns. Whatever gave us the disastrous idea of trying to bring back the art of the past? …What is the use of reviving old art?'[32] Similarly, Friedrich, who firmly believed that 'art is the language of our sentiment [*Empfindung*]', and that the artist should first see his picture with the mind's eye, scathingly criticised the eclecticism and reactionary tendencies of the Nazarenes, and their 'slavish aping' of an earlier period.[33]

'THE SPIRIT OF BERLIN': THE CITY AND ITS PEOPLE
The diversity of art in Germany that Duranty emphasised towards the end of the century came keenly into focus at its beginning, when, in 1801, Goethe criticised Berlin art as 'prosaic' and the sculptor Johann

Gottfried Schadow defended 'the prosaic spirit' of his city by stressing that 'here [in Berlin] every work of art is treated as a portrait or counterfeit'; only this approach 'will enable us to produce works of art in which we Germans will be seen as ourselves.'[34] While the Nazarenes strove to rejuvenate German art by inventing a utopian ideal modelled on the past and Runge and Friedrich explored renewal of *Deutschheit* in images of nature, Schadow proclaimed that Germans could be seen as German only in works of art that portrayed concrete reality. In 1822, in his 'Letters from Berlin', the poet Heinrich Heine wrote: 'Berlin is less a city than a place where a lot of people congregate, many fine minds among them, but for whom this place is negligible, for they themselves represent the spirit of Berlin'.[35] In the three decades between the end of the Wars of Liberation and the revolution of 1848 the polarity

between innovation and tradition, between cosmopolitan openness and an increasing drive towards nationhood, sharpened. The paintings of Berlin and its inhabitants, the cityscapes of Eduard Gaertner, Johann Erdmann Hummel and Franz Krüger, and the 'character studies' of Carl Blechen and Adolph Menzel, all give form to a growing self-awareness in Prussia's capital, to which Karl Friedrich Schinkel's comprehensive scheme of monumental buildings was giving definitive shape. It is the people – the enterprising burghers, the intellectuals, architects, poets, artists, musicians – who shape and occupy the spaces which the painters record in their images. In his monumental canvas *The Parade in the Opernplatz in 1822* (fig. 17)[36] Krüger did not merely commemorate the visit of Grand Duke Nicholas of Russia, son-in-law of the Prussian King, but proudly displayed in the right foreground people who should 're-present the spirit of Berlin': Schinkel, whose first civic building, the Neue Wache (New guardhouse; see also cat. 34), frames the picture on the right, the sculptors Schadow and Christian Daniel Rauch, the singer Henriette Sontag, the violinist Niccolò Paganini and ordinary citizens. Krüger, breaking with convention, pushes the tiny royal figures – the Grand Duke riding towards the King, who is positioned on the far left – out of the picture's centre. Most prominent is the lively crowd, which seems to be moving towards the very edge of the picture as if to invite the viewer to participate. Together with the architecture – the official buildings lining the main boulevard Unter den Linden – the citizens themselves, celebrities and otherwise, dominate Krüger's scene, and transform a traditional subject of history into an image of the modern urban crowd.

A few years later, in 1831, Hummel painted with equal topographical precision *The Granite Bowl in the Berlin Lustgarten* (cat. 37), an image that symbolises the industrial age: raw nature transformed through a sophisticated technical process into a central monument of the city. The bowl was slowly and carefully carved from a giant boulder of 'erratic' granite and placed by Schinkel in the central public square (the Lustgarten) framed by his museum (now called the Altes Museum), the old cathedral, the royal palace and the Zeughaus (Armoury). The highly polished surface of the granite bowl reflects the citizens passing by and their surroundings – upside down and slightly distorted – blurring the boundaries between reality and its mirror image.

When the painter Carl Blechen died in 1840, he was praised in an obituary notice as the 'ingenious inventor of a novel category of "character studies" in landscape painting',[37] well typified by his *View over Roofs and Gardens* (cat. 26). The term may easily be extended to other Berlin artists and their works, as it echoes Goethe's and Schadow's earlier definitions and captures the essence of much of the art produced in the Prussian capital during the first half of the century. Gaertner,

Hummel, Krüger, Blechen and the young Menzel all depicted scenes of their immediate local environment, urban sites and domestic interiors. In sharply focused pictures of public and private life they represented the bourgeoisie of the 'restoration period' in spaces which appear to be contained and safe. Even the urban sites appear as enveloping 'containers' of civic activities. If national unity and a more liberal form of government remained elusive goals, withdrawal into familiar spaces, public and private, offered an alternative sense of identity.

Many of the domestic interiors, often the living room or study-library, present the women of the house as still lifes, completely immersed in their activities – doing needlework, reading, playing music or merely gazing out of the window – almost always oblivious of the observer. Friedrich's *Woman at the Window* (his wife Caroline; cat. 8) is fixed into a strict pictorial structure of verticals and horizontals, motionless like the austere room itself, the sombre colour of her dress harmoniously blending into those of her surroundings. Her contemplation of nature, the Elbe landscape beyond, mediates between the bare dark interior and the brightly lit exterior. If Friedrich speaks in the Romantic vocabulary of solitude and yearning for the beyond – literally and symbolically – he also pictures the woman's rigid domestic boundaries.

In Menzel's painting of *The Balcony Room* (cat. 28) all sense of a safely ordered life is ruptured. Menzel pictured the modest living room of his family's Berlin apartment not as the tightly ordered interior of a well-organised life, but as an uncannily empty and disorganised space.[38] The pieces of furniture are haphazardly positioned, the sofa cut off by the picture's frame but reflected in the mirror, which extends the virtual space of the room beyond the edge of the canvas. The traces of time show in the peeling colours on the wall, and the picture's centre is completely empty. A gentle breeze blows through the white curtains, filtering the sunshine streaming through the open French windows and illuminating the emptiness of the room. While Menzel depicted '… in the interior the weather of the outside … ',[39] giving light and breeze an almost material quality, he also represented his living room bare of all sense of bourgeois stability and permanence. No Biedermeier *Gemütlichkeit* (cosiness) alleviates the signs of emptiness and disturbance.

PICTURING THE COURSE OF GERMAN HISTORY

The same sense of fleeting time and disturbance also marks Menzel's painting of contemporary history, *The Funeral of the Fallen March Revolutionaries* of 1848 (fig. 45, p. 129).[40] He adapted the Berlin tradition of cityscapes, in which the urban crowd has its part, for his image of the most explosive event that his generation experienced, the insurrection of 1848 in which liberals and radicals briefly forced the

Crown to relinquish control of the city. Unlike Delacroix and Meissonier in France, Menzel did not depict the fighting on the barricades, but the aftermath, the funeral of those who had fallen there: their coffins – draped in black – are piled up in a dark pyramid on the stairs of the Neue Kirche in the Gendarmenmarkt facing the disorganised crowd in the foreground. Menzel did not even picture the actual ceremony, the formal ritual of the day-long funeral, but the chaotic hour beforehand, a marginal moment when the citizens of Berlin were still gathering. Menzel captures the dynamic energy of the historic day, which for a short moment seemed to signal the victory of the revolution, in the fluctuating movement of the urban crowd, the most prominent part of his composition. The painting remained unfinished – as if the artist was unable to complete it – after the turn in the political events outpaced him, and government troops retook the city. He kept the canvas in the private sphere of his studio. After his death, however, when *The Fallen Revolutionaries,* together with his other canvases of the 1840s, was publicly shown, the picture was inscribed into the new narratives of aesthetic modernism. The only significant German painting of the 1848 revolution was thus given an aesthetic, rather than a political reading.

Menzel's *Flute Concert of Frederick the Great at Sanssouci* (cat. 32), however, finished four years later, became a centrepiece in the fashioning of a new national history, even though it, too, was anchored in the liberal-bourgeois ideology of the years leading up to the revolution of 1848. Like his earlier illustrations of Franz Kugler's *Geschichte Friedrich's des Grossen* (History of Frederick the Great), which was one of the numerous publications celebrating the centenary of Frederick's coronation in 1840, *The Flute Concert* and Menzel's other paintings of the life of Frederick II are not heroic images of great moments of world history. Rather they represent the king with psychological intuition and in 'daguerrotypical reality' as 'a father to his people'.[41] Like most liberals in the 1840s, Menzel saw Frederick as a philosopher-king and as a precursor of reform. While the ruling king, Frederick William IV, was giving the most important public commissions, a series of monumental mural decorations, to Peter Cornelius and Wilhelm von Kaulbach, Menzel pursued his own Frederick project in easel-paintings mostly executed for private collectors or without any commission at all (see further cat. 32).

Cornelius, invited to Berlin in 1841, was commissioned to decorate the Campo Santo, the projected burial chapel for the ruling Hohenzollern dynasty, a grandiose project that was never completed. Wilhelm von Kaulbach designed the murals for the stairwell of the Neues Museum, a new building behind Schinkel's (Altes) Museum. This equally monumental enterprise, on which he laboured from 1847 to 1863, consisted of six scenes of world history, from *The Construction of*

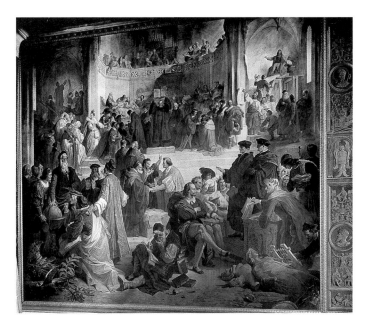

Fig. 18
WILHELM VON KAULBACH
The Age of the Reformation (*Zeitalter der Reformation*), 1847–63
Fresco
Formerly Neues Museum, Berlin; destroyed in 1945

the Tower of Babel to *The Age of Reformation* (fig. 18). These abstract and idealised images in strictly hierarchical compositions dominated the public's notion of what constituted German art well beyond the country's borders. When the cartoon for *The Age of Reformation* was exhibited at the Paris World Fair of 1867,[42] it earned Kaulbach a Medal of Honour, but also elicited sarcastic French criticism: it was a painting 'where the gymnastics of the mind play such a great role … a *School of Athens* revised and corrected by a German ….'[43] It is against the rhetoric of these monumental murals displayed in public buildings in the centre of Berlin that one has to see Menzel's history paintings. Executed during the 1850s, they demonstrate the image of Frederick the Great 'as father to his people' at a time when the role of this king was beginning to take on a new national function.

Long before the historical event of national unification actually took place, the drive for political unity had been transferred to the cultural sphere. The first 'German Universal and Historical Art Exhibition,' organised in Munich in 1858 (see further the essay by Claude Keisch), was also the first large exhibition that linked the move toward national unity with the visual arts. Many critics explicitly emphasised the political meaning of the event by stressing the 'pan-German' character of the exhibition, which 'hurries on ahead of politics … because the Academy has adopted the idea of a universal historical exhibition, the celebration [of

the fiftieth anniversary of the Academy] has achieved, so to speak, the breadth of the whole of German art.'[44] This 'epoch-making' exhibition, as another critic put it, would also assist 'the strengthening of the national consciousness' and would help to effect a 'powerful revival of the national spirit.'[45] Menzel's dramatic representation of the surprise nocturnal raid on the Prussians by the Austrians during the Seven Years War, *Night Attack at Hochkirch 1758* (fig. 30, p. 44), became the rallying point for a new German history painting. Although the Prussian King relegated 'this gigantic painting of a defeat'[46] to a room where 'during court balls the lackeys washed the tea-cups',[47] Menzel's picture eventually decorated the wall above the desk of the Emperor William II, after it had been celebrated as a 'national work of art' that anticipated the 'days of Sedan,'[48] the decisive German victory over the French in 1870. The powerful 'national upswing' of the Empire cast Menzel's paintings of Frederick in the role of national signpost.

While Menzel painted his very private gouaches of the French prisoners of war who passed through the railway stations in Berlin in 1870, Anton von Werner was commissioned to celebrate the victory of the German Armies in panels that were to line the processional route through Berlin in June 1871, and later to produce the designs for the mosaic decoration of the Siegessäule (Victory column). This colossal monument, and new accent in the urban lay-out of the city, marked Berlin's rapid ascent from provincial capital of Prussia to new metropolis of the Empire. It was Werner, director of the Academy and influential advisor to Emperor William II, not Menzel, who became the official chronicler of the Empire. His painting *A Billet outside Paris* (cat. 48) casts the events of the Franco-Prussian War into an anecdotal scene that entirely excludes violence. Werner was the only artist officially invited to follow the German armies, and to witness the proclamation of the German Empire at Versailles on 18 January 1871 so that he could commemorate the event on canvas. His several versions of *The Proclamation of the Empire* (fig. 19) shaped collective memory.[49] By manipulating the arrangement of the participants representing the individual German states the artist was able to convey the idea of national unity.[50] Menzel, in contrast, in his *Departure of King William I for the Front, 31 July 1870* (cat. 44), depicted the beginning of the war, not its battles or its final victory. In Menzel's painting the King and Queen are positioned in the middle ground, off-centre – small figures immersed in the crowd of Berlin citizens, who fill most of the picture's space. Once in the Nationalgalerie, however, Menzel's paintings were seen together with the monumental battle scenes commissioned for the Museum, and as part of these installations could be conveniently integrated into the Empire's invention of a new national narrative.

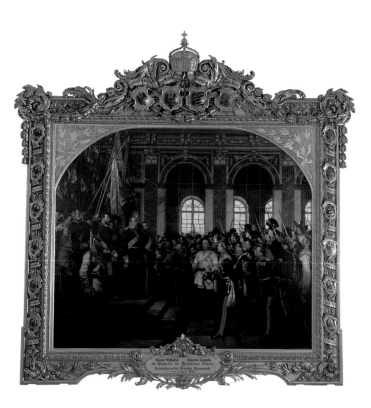

Fig. 19
ANTON VON WERNER
The Proclamation of the German Empire at Versailles, 1871
(Die Kaiserproklamation im Spiegelsaal von Versailles, 18. Januar 1871), 1877
Oil on canvas, 167 × 202 cm
Bismarck-Museum, Friedrichsruh

IMPERIAL NATIONALISM AND ESCAPE TO ITALY

After unification in 1871, the individual states retained their cultural autonomy, a series of dynamic fields of energy across the map of the Empire. No German city played such an exclusive role as Paris did for French or London for English art. The lack of 'one single great forum for the arts' and the tension between the periphery and Berlin as the aspiring new centre were also discouraging. Nowhere else was the experience of discontent, the disillusioned withdrawal of the artist from the political and social system, so marked as in Germany; it was art's 'imperfect connection to the life of the all-important social class, the bourgeoisie,' as Lichtwark explained.[51] Anselm Feuerbach, Hans von Marées and Arnold Böcklin spent most of their lives in Italy; Wilhelm Leibl moved out of Munich to live in remote Bavarian villages, and even Menzel, the painter *par excellence* of modern urban life, felt ambivalent about contemporary conditions and, after the completion of his *Iron-rolling Mill* (cat. 45) in 1875, withdrew more and more into the private medium of drawing, producing his most subjective and innovative images in black and white. Such withdrawal from the frustrating materialism of

life had a long tradition in German art, being an essential part of the history and philosophy of German idealism. The growing feeling of alienation both strengthened an intense belief in individualism and found relief in the idea of belonging to a global humanity.

As Conrad Fiedler, close friend and generous patron of Hans von Marées, interpreted the role of the artist and his natural right to creative individualism in 1876, 'Artistic consciousness in its totality does not go beyond the limits of the individual; and it never finds a complete outward expression …. Although the ideation of the artist can never fully express itself in the form of a work of art, it continuously strives toward expression and in the work of art it reaches for a moment its highest pitch. A work of art is the expression of artistic consciousness raised to a relative height.'[52] Just as the Nazarenes had insisted upon art as an expression of the subjective self and retreated to Italy, where as foreigners they did not have to engage themselves in the political situation, so a new generation of artists chose Italy and separation from their home country. In their case it was not only, in Overbeck's words, 'the yearning that constantly draws the north towards the south', it was also escape.

In 1870, the year of the outbreak of the Franco-Prussian War, Hans von Marées had returned to Germany, working together with the sculptor Adolf von Hildebrand in Berlin. But the stifling atmosphere of the capital paralysed his creativity, and he moved to Dresden, where Fiedler had built a studio for his friend. While in a state of anxiety and frustration over the situation in Germany, Marées met the young zoologist Anton Dohrn, who was about to realise his utopian dream of founding an international marine biology research institute in the Bay of Naples. Dohrn envisaged an international 'republic' of scientists, who would work at the Naples institute in scholarly and spiritual harmony. An assembly room at the centre of the building was to serve not only for scientific meetings but also for contemplation and spiritual elevation. Marées immediately recognised the artistic potential the function of such a room possessed, and proposed its decoration with frescos by himself and sculpture by his friend Hildebrand. Throughout the summer of 1873 he worked feverishly on this project, completing the cycle in November. *The Oarsmen* (cat. 54) on the north wall is faced by the *Work in the Orange Grove* on the south wall, contrasting two scenes of local work, activity at sea and cultivation of the land. Other scenes include *Fishermen readying their Boat for Departure* on the east wall and the *Pergola*, an open-air tavern where Marées and his friends spent the evening after a long working day – a group portrait immortalising those engaged in the artistic and scientific creativity of the institute – and two *Women Friends* sitting in the orange grove. Except for the athletic fishermen and rowers, the statuesque immobility of the figures in the stillness

Fig. 20
HANS VON MARÉES
The Ages of Man (Die Lebensalter), 1877–8
Oil on canvas, 98 × 78 cm, Nationalgalerie, Staatliche Museen zu Berlin

of each scene evokes longing for a non-existent world. In the tradition of the scholar Johann Joachim Winckelmann, who had associated the strong, youthful, half-naked boatmen of South Italy with the powerful Titans of mythology, Marées's heroic rowers and fishermen are rooted more in the artist's vision of the past than in his observation of the working conditions of the present. *The Orange Grove*, an image that became central to Marées's later work, is not about the hardships of farmwork in modern Italy, but the artist's vision of the Golden Age, as he imagined it again in *The Ages of Man* of 1873 (fig. 20) and in *The Hesperides Triptych* of 1884–5.[53]

According to Marées, the artist had to remain aloof from the social reality of his own time, as he explained in a letter of 1882 to Fiedler: 'The meaning of what I recently said (for example, the artist "born" and endowed with an ideal "by nature") is, that whoever devotes himself to the practice of the arts must attempt to achieve and maintain an

Fig. 21
ANSELM FEUERBACH
Iphigeneia (Iphigenie), 1871
Oil on canvas, 192.5 x 126.5 cm
Staatsgalerie, Stuttgart

beyond the painting's frame, as if his pictured persona were displaying the same strong will that had controlled the creative enterprise in Naples and informed his unambivalent formulations of the independence of the work of art from the political and social conditions of his time.

What Marées called 'the indestructible freshness of youth' was indeed an essential part of his and Feuerbach's enterprise. If in Marées's paintings the motif of men picking oranges merges with the myth of the Hesperides guarding golden apples, and so becomes a garden of the gods, Feuerbach's image of Iphigeneia symbolises the painter's longing both for his homeland and for the ideal of classical Greece. He produced several versions, both painted and drawn, of Iphigeneia, the second one in 1871 (fig. 21).[56] Feuerbach had painted his first version in Rome in 1862, a year before he executed the portrait of *Nanna* (cat. 49), who also posed as the Greek princess.

The motif of the lonely priestess sitting by the seashore lost in thought and longing for her homeland had developed into an archetype at the end of the eighteenth century, when Goethe wrote his *Iphigenia auf Tauris* (Iphigeneia in Tauris), introducing the theme of yearning in Iphigeneia's monologue:

> 'For, ah! the sea divides me from my loved ones,
> And by the shore I stand whole long days through
> With my soul searching for the Grecian land,
> And only muted tones amid its roaring
> Does the wave bring in answer to my sighs.'[57]

In 1870, while at work on the second *Iphigeneia*, Feuerbach wrote to his mother: 'I have intended the *Iphigeneia* for our house, and I believe that if someone wants a personification of yearning, he has it in this painting.'[58] The artist so intensely identified with Iphigeneia that he wanted to evoke in the viewer those emotions which had inspired its creation. In February 1872, when the finished second version was shipped to Germany, he explained: 'Iphigeneia … by the silence of the sea is a painting in front of which one can sit for hours, mellow, clear and soulful. The fluttering butterfly symbolises the soul.'[59]

These monumental, remote and motionless women seem suspended between their memory of the past and their existence in the present. As the object of their longing is excluded by the picture's frame, the viewer can easily identify with both intense yearning and the experience of deep dislocation. As in Oberbeck's *Italia and Germania*, remembrance of the *Heimath*, here 'the Grecian land', is interlaced with the experience of alienation, biographical and aesthetic layers coalescing in an image of idealised classical antiquity.

unprejudiced relationship to nature. This is possible only if the artist remains as much as possible untouched by incidental social conditions, by bourgeois narrow-mindedness; the external mark of such a state would be the indestructible freshness of youth.'[54] His belief in the elevated status of the artist and his work convinced Marées that '… time and the tendencies within that time can have only a very minor influence on an artist.'[55] Shortly after completing the intensive work on the Naples frescos, Marées portrayed himself seated not in, but placed before a landscape in Tuscany (cat. 55). The stark frontality and the rigidity of his body's pose, complemented by the stern gaze of his eyes, seems to dominate the world

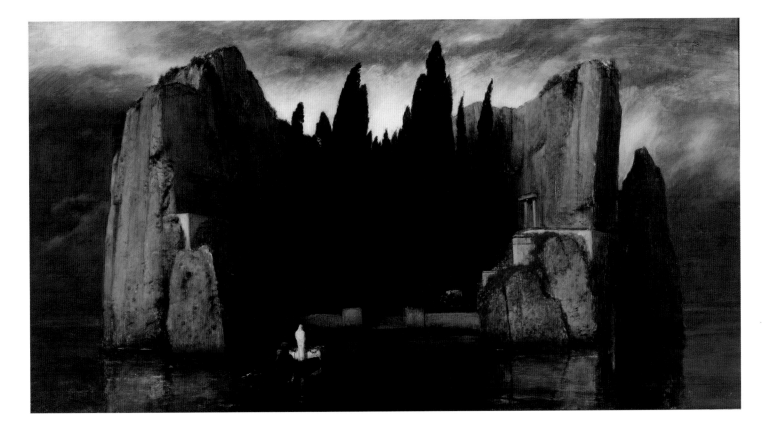

Fig. 22
ARNOLD BÖCKLIN
The Island of the Dead (Die Toteninsel), 1883
Oil on panel, 80 x 150 cm, Nationalgalerie, Staatliche Museen zu Berlin

The Island of the Dead (fig. 22) is as central to the work of Arnold Böcklin as the *Orange Grove* is to Marées and *Iphigeneia* to Feuerbach. Böcklin painted several versions, the one in the Nationalgalerie being the third of five.[60] The picture's title, a perfect match for the public's indulgence in mystifying romanticism, was not the artist's, but the idea of his shrewd Berlin dealer, Fritz Gurlitt. The massive island composed of steep rocks emerges from the dark, motionless surface of the water, which blends into the blue-violet of the cloudy night sky. A small boat carrying a tiny erect figure shrouded in white and a white coffin approaches from the left, disturbing the strict symmetry of horizontals and verticals that determines the picture's structure. Probably inspired at least partly by the cemetery on the island of San Michele in Venice, Böcklin kept the subject vague and ambiguous enough as to open the image – with its awe-evoking title – to many readings. The vocabulary of Romantic rhetoric – the silence of the sea, the desolate island, cypress trees, the coffin, a night sky, the tiny mysterious human figure turning his back to the viewer – not merely evokes a melancholic mood but also transposes the viewer to a timeless sphere. Divorcing the audience

from concrete historical time, Böcklin indeed produced a 'painting to dream upon'.[61] The picture achieved unprecedented popularity: 'Between 1885 and 1900 reproductions of Böcklin's paintings *Island of the Dead, Castle on the Sea, Spring Day* … were not supposed to be missing from any good bourgeois home.'[62] At a moment of history profoundly marked by political and economic stress Feuerbach produced an image that was 'the personification of yearning', Böcklin 'a painting to dream upon', and Marées visual metaphors of a Golden Age.

The same phenomenon of withdrawal marks the art of Wilhelm Leibl, who left Munich in 1873 at the age of twenty-nine. He sought to escape the decadence and jealousies of the art world there by moving to the remote Bavarian countryside, where he executed iconic images of the local peasantry, silent, motionless figures compressed into narrow interiors. Leibl himself identified so fully with the local way of life that he felt it to be necessary to his creative work: as he wrote in 1879, 'Here, in the open country and among those who live close to nature, one can paint naturally. My stay in Munich served to confirm my belief that painting in that town is simply a habit ….'[63] In *Three Women in Church*

(fig. 23), on which he laboured for four years, he effectively captured the transience of time and its effect upon human life.[64] Each representing a different stage of life, the women seem frozen into their poses and, for all their minute verisimilitude, appear as far removed from their local daily life as the fishermen in Marées's frescos at Naples. If Courbet, in his great *Burial at Ornans*, had secularised the funeral by transforming a religious event into a social one, then Leibl divorced the ritual of praying, echoing medieval images of kneeling donors, from its sacred context. And yet, by integrating into his painting the allusion to the stages of life, Leibl introduced a metaphorical meaning going beyond the faithful recording of nature.

During the 1870s, the *Gründerjahre*, the founding years of the Empire, while Werner celebrated the unified German nation in monumental official commissions, while Feuerbach, Marées and Böcklin in Italy and Leibl in Bavaria invented their idealised visions, Adolph Menzel in his Berlin studio painted two of the crucial images of the decade, *Studio Wall* (fig. 24)[65] and *The Iron-rolling Mill* (cat. 45), one a private contemplation of creative work, eros and death, the other a public statement of the dangerous conditions of modern industrial production.[66]

The Iron-rolling Mill, a monumental scene of modern industry, was begun in 1872, one year after the proclamation of the Empire, and completed after three years of intensive work in 1875. As Menzel himself emphasised, the picture, composed like a triptych, shows together three different shifts in an iron-rolling mill where rails for track were produced. In 1872 Menzel had visited Königshütte in Upper Silesia to immerse himself in studies of the manufacturing process, during a time of explosive unrest there, not only in labour disputes but also in violent confrontations between the Protestant, Prussian hegemony and the Polish, Catholic minority. Far more than demonstrating the so-called 'Rembrandt effect' in an orchestration of light and shade, or painting a modern version of the classical theme of 'cyclops' at their forge, Menzel chose a subject in shift work – the pace of the machines controlling the rhythm of the workers' everyday lives. Only eight months after its completion, *The Iron-rolling Mill* moved from a private collection into the public arena, the Nationalgalerie, Berlin's newly founded museum for modern art. While the *Studio Wall*, first exhibited in 1885, only gradually elicited critical attention, *The Iron-rolling Mill*, in contrast, prompted loud debate from the day Menzel first unveiled the canvas in his studio in a private showing. The painting was exhibited numerous times, travelled widely and was subjected to a multiplicity of readings – from the Cyclops of mythology to a socialist manifesto. Neither subject was commissioned; the artist was entirely free in his choice of topic and its configuration.

In the *Studio Wall* Menzel depicted a segment of his studio wall at night, positioning himself in the darkness below in such a way that the

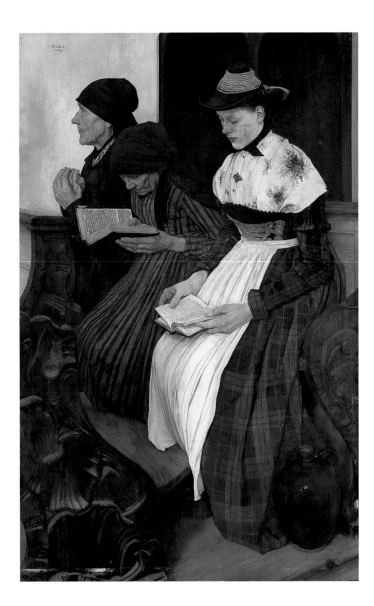

Fig. 23
WILHELM LEIBL
Three Women in Church (Drei Frauen in der Kirche), 1878–82
Oil on canvas, 113 x 77 cm
Hamburger Kunsthalle, Hamburg

viewer looks up at the three rows of plaster casts, which are dramatically lit by artificial light. The casts, death masks, a female and a male torso and the artist's tools are hanging from dark boards on a wall of Pompeian red. Whether identified as the *Venus de Milo*, Praxiteles' *Cnidian Venus* or merely the cast of female model, the torso, hollow and sharply illuminated, is the most prominently displayed. While the precise identification of the casts remains uncertain, their intense presence in their severely fragmented forms, in a picture that unlike most of his other larger canvases lacks preparatory studies, seems to convey the

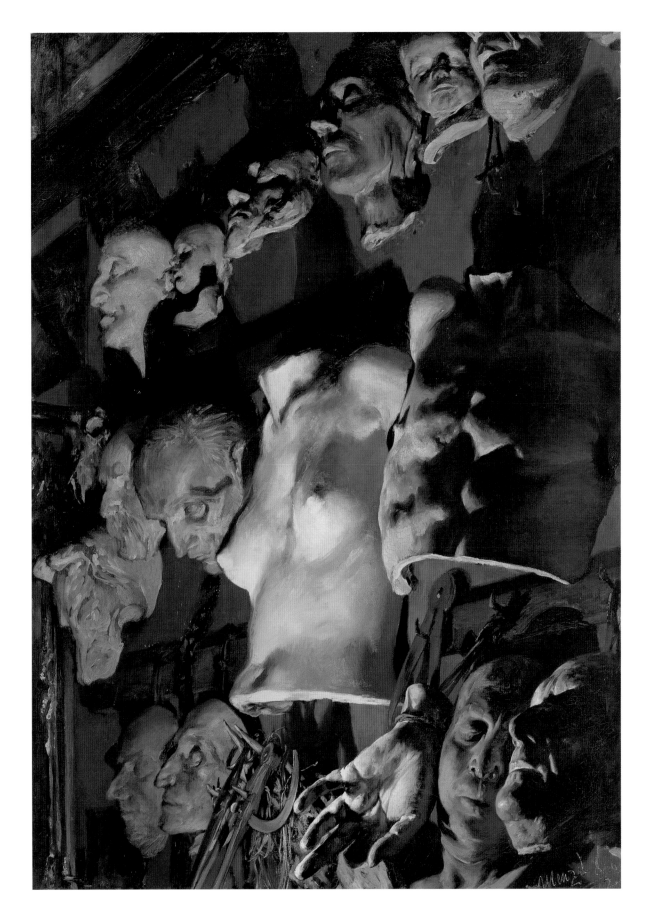

Fig. 24
ADOLPH MENZEL
The Studio Wall
(Atelierwand), 1872
Oil on canvas,
111 × 79.3 cm
Hamburger Kunsthalle,
Hamburg

35

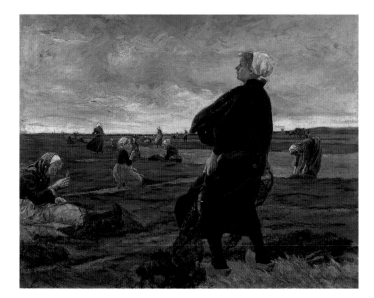

Fig. 25
MAX LIEBERMANN
The Netmenders (*Die Netzflickerinnen*), 1887–9
Oil on canvas, 180.5 × 226 cm
Hamburger Kunsthalle, Hamburg

artist's urgency. In his earlier *Studio Wall* of 1852 (cat. 31), the plaster casts of human limbs are arranged in the configuration of a human body almost as if floating in the hermetic enclosure of the studio. No intellectual or allegorical association, as in the casts of 1872, relieves the claustrophobic mood. In the earlier image the tension between the physical human body – even in its extreme segmentation – and its presence as an object of study in the artist's studio conveys a disturbing, almost shocking effect; the broken bones, the skinned hand, the shut window, all speak the language of negation and loss. In the 1872 version, the dramatic effect of light 'before our eyes transforms … the illuminated plaster casts to a phantom-like state of wakefulness'[67] – transforms particularly the female nude. The intricate arrangement of the objects and their carefully staged lighting are certainly not casual, but are an intense solitary reflection on sexuality, art and death. In his will Menzel, dwarf-like and a self-proclaimed bachelor, noted: '… I have also renounced, all my life, any relationship to the other sex as such. In short, there is no self-produced glue between myself and the external world.'[68]

Read together as two interrelated images, the *Studio Wall* and the *Iron-rolling Mill* not only indicate the dichotomy between an artist's private and public existence, they also serve as a metaphor for the state of the arts in Germany at the time. If one painting melds the deeply hidden anxieties of private existence and creative work with the experience of the fugacity of human life, the other articulates a keen

awareness of 'the social question', despite the ambiguity of Menzel's own position. However, he surely knew, when he chose the subject of heavy industry for a monumental canvas, that he would make a visible intervention in the political debates of the day. Both images, the multi-layered private contemplation and the rhetorical gesture for the public realm, illustrate the disjunction of the artist's private existence and public life.

INTO THE NEW CENTURY: MODERNITY IN THE EMPIRE
When, in 1889, at the invitation of the French, Max Liebermann organised an independent exhibition of German art for the Paris World Fair, he acted in open resistance to Bismarck's government, which had refused to participate. Having travelled widely and studied Dutch and French art, he brought a truly cosmopolitan approach to his professional career. He firmly believed in the *confraternité* of the arts beyond national boundaries, in stark contradiction to the increasingly chauvinistic attitude of the Empire.[69] In the exhibition, besides Liebermann's own large canvases, there were works by Leibl, Kuehl, Trübner, Uhde and others: it was the first coherent show of German modern art, staged not within, but outside, the Empire, so to speak in the capital of the enemy. Werner, hostile to Liebermann, immediately recognised its pivotal role. The exhibition signalled 'the date of the official proclamation of the new gospel …', producing the effect, 'at least in Germany, of trumpet blasts advertising its glory ….'[70]

Among his large *plein-air* canvases of the 1880s that Liebermann showed in Paris was *The Netmenders* (fig. 25), which Lichtwark subsequently acquired for the Hamburger Kunsthalle. Liebermann places the Dutch women mending nets in the wide, flat landscape in such a way as to lead the eye from the almost life-size woman in the foreground to the diminutive figures along the horizon. A strong sea-wind seizes their dark dresses. Although Liebermann chose a scene of collective work, he isolates each woman from the others. No anecdotal motif alleviates the picture's grave mood. The melancholic tone is intensified by the monumental woman in the foreground pulling a heavy net, who has arrested her work for a moment. Her eyes wander across the wide expanse of flat land towards the horizon as if she were reflecting upon her fate. The intertwining of human figure and nature, of co-operation and solitude, led contemporary critics to see in the picture a new form of naturalistic landscape painting, and even to elevate it to the status of a history painting.[71] In his creative work as well as in his entrepreneurial activities as organiser of exhibitions, as President of the Berlin Secession and an eloquent critic, Liebermann embodied the conflicting traits of the German avant-garde, who promoted modernism in the widest sense of the term, but ultimately strove for its integration both internationally and in the cultural fabric of the Empire.

Figs. 26 and 27
ERNST LUDWIG KIRCHNER
The Brücke (Bridge) *Manifesto, 1906:* frontispiece *(Künstler-Gruppe Brücke)* and titlepage
Woodcuts, images 13.2 × 5.6 cm and 15.2 × 7.5 cm
Kupferstichkabinett, Staatlichen Kunstsammlungen, Dresden

The question of whether and how to mediate between a national ideology and a cosmopolitan vision was critical in contemporary political and intellectual discussion. On one side stood Meinecke, whose position in his classic work of 1908, *Weltbürgertum und Nationalstaat* (Cosmopolitanism and the national state) was criticised by the Princeton historian Felix Gilbert in 1970 as a 'dangerous and even repulsive' glorification of nationalism.[72] However, shortly before the publication of Meinecke's book, in an essay for the progressive journal *Die Zukunft* (The future), Harry Graf Kessler, recently dismissed as director of the art museum in Weimar, had drawn very different conclusions.[73] 'There is no contrast,' Kessler declared, 'between being a good German and a good European; a conflict between national and international does not exist.'[74] But in the aggressive political climate before World War I, the government of William II propagated an exclusive nationalism in which the term 'cosmopolitan' was turned into an insult. For example, a reviewer sharply criticising Max Liebermann's 'unpatriotic' role as the organiser of the German art exhibition at the Paris World Fair singled out for blame the 'cosmopolitan artists and bankers' who had supported it.[75]

During the 1890s, the complex relationships between official and modernist art made for considerable ambiguity: not all government sponsored art was as rigidly conservative as William II's own position, nor were all modernist statements purely radical. Liebermann, Lovis Corinth, Julius Meier-Graefe and others often conceal under the rhetoric of their modernism a patronising attitude, just as the eclectic nature of most Secession exhibitions in Munich and Berlin blurred the

polarity between conservative and avant-garde art.[76] The language of modernism was not readily separable from nationalist discourse.

Perhaps typically for his generation, Kessler had discovered the power which the dream of a united Europe could invoke when, as a young man, he had read Nietzsche's *Jenseits von Gut und Böse* (*Beyond Good and Evil*; 1886). In his autobiography, published when he was living in exile, he quotes at length the passionate passage from Nietzsche that had 'opened his eyes', because Nietzsche's vision of 'the encompassing European nation' and 'the European of the future' had offered a paradigm for his own life. By identifying with Nietzsche's 'European of the future', he would finally be able to negotiate between the competing forces of his existence: the 'struggle between my English and my German blood, my English, German and French cultural heritage'.[77] Nietzsche's text inspired in the young Kessler a cosmopolitan conception of both his professional career and his private life beyond its application to the general state of the German nation. While Liebermann upheld the utopian ideal of '*confraternité* in the arts … outside all political consideration', Kessler believed that 'the engagement with Europe did not also mean a renunciation of the national, only its curbing'.[78] A restless wanderer between different European countries and their cultures, Kessler sought to mediate between a national ideal and a cosmopolitan vision by defining nationality as a fluid element: 'After all, nationality is nothing rigid, dead, there for once and for all – no more than is race, for instance. Every nationality metamorphoses continuously.'[79]

Like a conjunction of past and present, the year 1906, when Kessler published his essay 'Nationalität', also marks the date of the Centenary Exhibition at the Nationalgalerie, a retrospective of German art of the past century, and of the Brücke manifesto (figs. 26 and 27), pointing the way into the future. Nietzsche's writing, so influential on Kessler's early conception of culture and modern society, seemed also to confirm the Brücke artists' insistence upon a radical break with the moral and cultural values of the past. Although Die Brücke was a collective enterprise, it was mainly Ernst Ludwig Kirchner who prepared the text of the manifesto and produced its woodcut frontispiece of a bridge (*Brücke*) spanning a stream of water framed by trees. Inspired by Nietzsche's *Also Sprach Zarathustra* (*Thus Spake Zarathustra*),[80] the young artists took as the emblem of their ideal of radical renewal a bridge leading from the past to the future through creative work.

The Centenary Exhibition in the Nationalgalerie provided a unique opportunity to reconcile national tradition with international modernism.[81] It seemed to impose upon the diversity of 'regional schools' a more coherent history of nineteenth-century German art. However, no matter how fiercely Berlin competed to become the cultural capital of the nation, the historical tradition of cultural decentralisation

continued to shape artistic production and its critical discourses. As Duranty had recognised in 1878, 'the Germans do not have … one single great forum for the arts'; Berlin, despite political unification, would assume that role only in the 1920s. More successful was the exhibition's strategy of merging national tradition with international modernity. Friedrich was recovered for the history of modern art as a German Romantic, and Menzel's paintings of the 1840s, exhibited for the first time as a coherent group within an historical narrative, were read as precursors of Impressionism. If even 'the painter of Frederick the Great' offered this dimension, then modernism could be anchored in the German tradition, and the exhibition organisers could not merely deflect the current 'Francophobia' but merge their international conception with the prevailing patriotism. The way in which the exhibition was staged is significant: the designer responsible, Peter Behrens, masked the walls of the museum – and much of its patriotic décor – with neutral hangings. The device of masking, not eliminating, the décor of national history was perhaps a strategy congenial to those operating in the public sphere at that moment. *Überkleidungskunst* (the art of masking)[82] also poignantly envisages the layering of different aesthetic conceptions and political ideologies – a tangible metaphor for the precarious co-existence of multiple national identities.

NOTES

I am grateful for the expertise and assistance of my colleagues in Berlin, Annegret Janda and Claude Keisch, for the bibliographical searches of my research assistant Jovana Stokic, and for the clerical help of Barbara Wotherspoon. Unless otherwise stated, translations are my own. My previous publications, referred to in the footnotes, contain archival materials and a more comprehensive bibliography, particularly of the older German literature.

1 Quoted in Hinz 1974, p. 92.

2 Edmond Duranty, 'Exposition Universelle. Les Écoles Etrangères de Peinture. I. Allemagne', *Gazette des Beaux-Arts*, XVIII, 1878, p. 148.

3 Alfred Lichtwark, 'Deutsche Kunst', Weltausstellung in Paris 1900. Amtlicher Katalog des Deutschen Reichs, Berlin [1900], p. 122.

4 See Belting 1999; Hofmann 1999.

5 See Forster-Hahn 1996a and 1998, pp. 30–43.

6 Max Jordan, *Beschreibendes Verzeichnis der Kunstwerke in der königlichen National-Galerie zu Berlin,* 3rd edn, Berlin 1877, p. vi.

7 Justi 1920, p. 427.

8 Ludwig Justi, *Kaspar David Friedrich*, Berlin 1921, p. 32. Justi's booklet on Friedrich is a reprint of the passages from his 1920 catalogue with few changes and additions. The painting is Börsch-Supan and Jähnig 1973, no. 317, pp. 391–2.

9 J.W. von Goethe, 'Von deutscher Baukunst', in *Schriften zur Kunst. Schriften zur Literatur. Maximen und Reflexionen* (Goethes Werke, XII, Hamburger Ausgabe, 4th edn), Hamburg 1960, pp. 7–15, 560–6, commentary by Herbert von Einem. (This edition is preferred because my discussion relies on Einem's commentary.) After its first, anonymous publication, the essay was reprinted in Herder's collection *Von deutscher Art und Kunst*, Hamburg 1773, again in 1789 and later in Goethe's own *Kunst und Altertum*, 1824.

10 Ibid., p. 12; English translation from *Essays on Art and Literature*, ed. John Gearey, trans. E. and E.H. von Nardorff (*Goethe's Collected Works* III), New York 1986, p. 8.

11 Goethe, *Dichtung und Wahrheit, Zweiter Teil, 9. Buch* (Hamburger Ausgabe, cited note 9, IX), p. 386. English translation from Johann Wolfgang von Goethe, *The Collected Works*, ed. Thomas P. Saine and Jeffrey L. Sammons, IV, Princeton 1994, p. 286.

12 Friedrich Schlegel, *Philosophical Fragments*, trans. Peter Firchow, foreword Rodolphe Gasché, Minneapolis and Oxford 1991, p. 86, no. 424.

13 Menzel 1914, p. 13.

14 Hermann Beenken, *Das neunzehnte Jahrhundert in der deutschen Kunst*, Munich 1944, pp. 57–66, 'Die Kathedrale der deutschen Romantik'.

15 Berthold Hinz et al., *Bürgerliche Revolution und Romantik. Natur und Gesellschaft bei Caspar David Friedrich*, Giessen 1976.

16 Hamburg 1977, p. 130, no. 80; Traeger 1975, p. 467.

17 Hamburg 1977, p. 218, no. 200; see pp. 188–219; Traeger 1975, no. 497.

18 The basic catalogue raisonné of Friedrich's oeuvre is Börsch-Supan and Jähnig 1973; a shorter English version is Börsch-Supan 1974. For a contextual reading see Peter Märker, 'Caspar David Friedrich zur Zeit der Restauration. Zum Verhältnis von Naturbegriff und geschichtlicher Stellung', in Hinz et al. 1976 (cited note 15), pp. 43–72 (this essay is based on the author's dissertation, Kiel 1974); Koerner 1990; William Vaughan, 'Correcting Friderich (Friedrich): Nature and Society in post-Napoleonic Germany', in Hemingway and Vaughan 1998, pp. 208–28.

19 Börsch-Supan and Jähnig 1973, nos. 168 and 169.

20 Börsch-Supan and Jähnig 1973, no. 254, pp. 351–3.

21 Justi 1920, p. 339.

22 Goethe, *Dichtung und Wahrheit, Dritter Teil, 12. Buch*, as cited note 11, p. 507.

23 See F. Forster-Hahn, 'Romantic Tragedy or National Symbol? The Interpretation of Goethe's *Faust* in Nineteenth-Century Art', in *Our Faust? Roots and Ramifications of a Modern German Myth*, ed. R. Grimm and Jost Hermand (*Monatshefte*, no. 5), Madison 1987, pp. 82–121; and F. Forster-Hahn, 'A Hero for all Seasons? Illustrations for Goethe's *Faust* and the Course of Modern German History', *Zeitschrift für Kunstgeschichte*, LVI, 1990, pp. 511–35.

24 Tischbein in a letter to Johann Kaspar Lavater, quoted in Einem 1978, p. 35.

25 Goethe, *Dichtung und Wahrheit, Dritter Teil, 11. Buch*, as cited note 11, p. 480.

26 Overbeck in a letter to Prince Metternich, quoted Andrews 1964, p. 7.

27 Anton Merk, 'Zur Bildnismalerei der Nazarener', in Frankfurt 1977, p. 149.

28 Hans-Joachim Ziemke, 'Die Anfänge in Wien und in Rom', ibid., pp. 45–6; Andrews 1964, pp. 27–8.

29 Quoted (with slight modification) from Andrews 1964, p. 27.

30 *Neue Pinakothek München*, Munich 1981, pp. 249–50.

31 Overbeck in a letter to F. Wenner, January 1829, now in the Zentralarchiv, Staatliche Museen-Preussischer Kulturbesitz, Berlin. I owe the reference and the transcription of the letter to Dr. Annegret Janda and Dr. Jörn Grabowski.

32 Runge, letter of February 1802, quoted from Eitner 1989, p. 145.

33 Hinz 1974, pp. 124, 111.

34 Ed. Julius Friedlaender, *Gottfried Schadow, Aufsätze und Briefe nebst einem Verzeichnis seiner Werke*, 2nd edn, Stuttgart 1890, p. 6. For quotations of literature and sources, see Forster-Hahn 1982; F. Forster-Hahn and Kurt W. Forster, 'Art and the Course of Empire in Nineteenth-Century Berlin', in Atlanta 1989, pp. 41–60.

35 Heinrich Heine, *Sämtliche Werke*, ed. Hans Kaufmann, Munich 1964, VI, p. 194.

36 See Renate Franke, *Berlin vom König bis zum Schusterjungen. Franz Krügers Paraden Bilder preußischen Selbstverständnisses*, Frankfurt, Berne, New York and Nancy 1984.

37 The phrase is that of Ernst Heinrich Toelken in an obituary notice, quoted in *Kunst in Berlin 1648–1987*, exhib. cat., Altes Museum, Berlin (East), 1987, p. 222. For Blechen and the early work of Menzel see Werner Busch, *Die notwendige Arabeske. Wirklichkeitsaneignung und Stilisierung in der deutschen Kunst des 19. Jahrhunderts*, Berlin 1985, pp. 261–98. Busch's discussion of 'privat und öffentlich' follows Jürgen Habermas's definition.

38 On this picture and the Berlin tradition of *Zimmermalerei*, see Forster-Hahn 1993; the best English text on Menzel as a whole is Washington 1996.

39 Karl Scheffler, *Die Nationalgalerie zu Berlin. Ein kritischer Führer*, Berlin 1912, p. 121.

40 The German title is *Die Aufbahrung der Märzgefallenen*, of which a literal translation would be 'The Laying-in-State of the Fallen March-[Revolutionaries]'; see F. Forster-Hahn, 'The German Experience of 1848: Imaging the *Vörmärz*, the Revolution and its aftermath', in Hemingway and Vaughan 1998, pp. 268–88.

41 Despite recent revisionist readings, I would still argue that Menzel's illustrations and paintings have a liberal-bourgeois underpinning. My reading is based on historiographical discourses of the 1840s and the theoretical debates about the nature of history painting: see Forster-Hahn 1977 and Françoise Forster-Hahn, 'Die "formende Kraft" historischer Bilder: Adolph Menzels und Anton von Werners Darstellungen deutscher Geschichte', in Berlin 1993, pp. 80–90. Hubert Kohle gives a thorough discussion of Menzel's history paintings in a forthcoming book.

42 The cartoon was for Kaulbach's murals in the Neues Museum, Berlin, since destroyed. For a social-historical account of the period, see Grossmann 1994.

43. Paul Mantz, 'Les beaux-arts à l'exposition universelle', *Gazette des Beaux-Arts*, Paris 1867, XXIII, p. 137.

44 Julius Große, *Die deutsche allgemeine und historische Kunst-Ausstellung zu München im Jahre 1858*, Munich 1859, p. V.

45 Friedrich Pecht, *Aus meiner Zeit*, 2 vols., Munich 1894, II, p. 99.

46 Albert Hertel, 'Erinnerungen an Menzel', *Süddeutsche Monatshefte*, no. 9, 1912, 1, p. 787.

47 Menzel's own version of the history of his painting as recounted ibid., p. 787.

48 Friedrich Pecht, *Deutsche Künstler des 19. Jahrhunderts. Studien und Erinnerungen*, 2 vols., Nördlingen 1877–81, p. 348.

49 Berlin 1993, pp. 332–53, 366–9. The version illustrated is the only one surviving.

50 Thomas W. Gaehtgens, *Anton von Werner, Die Proklamierung des Deutschen Kaiserreiches. Ein Historienbild im Wandel preußischer Politik*, Frankfurt 1990.

51 Lichtwark 1900 (cited note 3), p. 124.

52 Fiedler 1957, pp. 54–6 (slightly modified).

53 Gerlach-Laxner 1980, p. 145f., no. 123. Fiedler gave *The Ages of Man* as a wedding present to his wife. In *Verzeichnis der Gemälde und Skulpturen des 19. Jahrhunderts*, Staatliche Museen Preußischer Kulturbesitz, Berlin (West) 1976, pp. 247–9, the painting is seen as a link between the frescos at Naples and the *Hesperides Triptych* in the Neue Pinakothek, Munich.

54 Hans von Marées, *Briefe*, ed. Anne-S. Domm, Munich and Zurich 1987, p. 241: letter 05.02.1882 to Konrad Fiedler, written in Rome; English trans. from Nochlin 1966, p. 158.

55 Letter of 29 January 1882, ibid. p. 156.

56 The first version of 1862 is in the Hessisches Landesmuseum, Darmstadt. See Karlsruhe 1976, pp. 169–72, 185–6; Ecker 1991, pp. 312–16, 225–6, nos. 470, 370.

57 English translation Charles E. Page, *Goethe's Plays*, London 1980, p. 415. The translation in *Collected Works* (cited note 11) was not available to me.

58 Karlsruhe 1976, p. 186; Julius Allgeyer, *Anselm Feuerbach*, 2nd edn, Berlin and Stuttgart 1904, p. 150.

59 Karlsruhe 1976, p. 192.

60 Andree 1998, p. 421, no. 345; Franz Zelger, *Arnold Böckl in. Die Toteninsel. Selbstheroisierung und Abgesang der abendländischen Kultur* (Kunststück), Frankfurt 1991. The fact that Hitler owned the painting (destined for his Linz museum) has certainly influenced the recent critical discourse on Böcklin's work.

61 Quoted from *Arnold Böcklin*, exhib. cat., Kunstmuseum, Düsseldorf, 1974, p. 46; see also Rolf Andree, *Arnold Böcklin*, Düsseldorf 1962, pp. 44–6, 57.

62 Quoted from Jürgen Wißmann, 'Zum Nachleben der Malerei Arnold Böcklins', in Düsseldorf 1974 (cited in previous note), p. 28. Only Meier-Graefe's severe and polemic criticism in his 1905 book *Der Fall Böcklin* began to dismantle the pedestal on which Böcklin had been placed.

63 Letter to his mother, dated 18.03.1879, quoted from *Künstlerbriefe aus dem neunzehnten Jahrhundert*, ed. Else Cassirer, Berlin 1919, p. 360; English translation, Nochlin 1966, p. 161; see now Röhrl 1996, pp. 157–8. On Leibl and his circle see Ruhmer 1984.

64 Munich–Cologne 1994, p. 343f., no. 97.

65 A recent exhibition focused on this painting: *Menzels Atelierwand*, exhib. cat., ed. Jenns Howoldt and Stephanie Hauschild, Hamburger Kunsthalle, Hamburg, 1999.

66 For a critical analysis of both paintings F. Forster-Hahn, 'Ethos und Eros: Menzels *Eisenwalzwerk* und *Atelierwand*', in *Im Labyrinth der Wahrnehmung*, ed. Thomas Gaehtgens, Claude Keisch, Peter-Klaus Schuster, *Jahrbuch der Berliner Museen*, Neue Folge, in press. This volume will publish the papers of the Menzel symposium organised by the Nationalgalerie in 1997 and refer to recent literature on the artist.

67 Franz Dülberg, 'Die deutsche Jahrhundertausstellung Berlin 1906', *Zeitschrift für bildende Kunst*, no. 17, 1906, p. 233.

68 Kirstein 1919, pp. 92–8, esp. p. 97.

69 In a letter of May 1889 to Antonin Proust, Liebermann asserted '… le sentiment de la confraternité de l'art existe aussi bien à Paris que chez nous en dehors de toute considération politique'; Zentralarchiv, Staatliche Museen zu Berlin. On Liebermann's 1889 exhibition, see Françoise Forster-Hahn, 'La Confraternité de l'art': Deutsch-franzözische Ausstellungspolitik von 1871 bis 1914', *Zeitschrift für Kunstgeschichte*, no. 4, 1985, pp. 506–37.

70 Ibid.

71 Eberle 1995–6, pp. 333–7; Holly Richardson, 'Landschaftsmalerei ist die schwerste Kunst', in Hamburg 1997, pp. 21–31; and on the *Netmenders*, pp. 151–3.

72 Friedrich Meinecke, *Weltbürgertum und Nationalstaat. Studien zur Genesis des deutschen Nationalstaates*, Munich and Berlin 1908; translated as *Cosmopolitanism and the National State*, trans. Robert B. Kimber, intro. Felix Gilbert, Princeton 1970; p. IX.

73 Harry Graf Kessler, 'Nationalität', in *Künstler und Nationen. Aufsätze und Reden, 1899–1933* (*Gesammelte Schriften in drei Bänden*, ed. Cornelia Blasberg and Gerhard Schuster, III), Frankfurt 1988, pp. 117–30; first published in *Die Zukunft*, Berlin, 7 April 1906, pp. 17–27. Both Meinecke and Kessler (though briefly) discuss Johann Gottlieb Fichte's addresses to the German nation (*Reden an die Deutsche Nation*, 1807–8).

74 Ibid., p. 128.

75 *Berliner Politische Nachrichten*, no. 112, 15 May 1889.

76 Paret 1980; Makela 1990; Forster-Hahn 1996b, where all authors analyse the multi-faceted cultural life of the 1890s.

77 Harry Graf Kessler, *Gesichter und Zeiten, Erinnerungen*, pp. 210, 213–15; first published by S. Fischer, Frankfurt (?) 1935; French edn 1936.

78 Kessler 1988 (cited note 73), p. 215.

79 Ibid., p. 129.

80 Georg Reinhardt, *Die frühe 'Brücke': Beiträge zur Geschichte und zum Werk der Dresdner Künstlergruppe 'Brücke' der Jahre 1905 bis 1908* (Brücke-Archiv Heft 9/10), Berlin 1977–8: on Nietzsche's influence, pp. 28–31; on the different editions of the Brücke manifesto, pp. 82–92. For an English translation and summary of the literature, see Washton Long 1993.

81 Sabine Beneke, *Im Blick der Moderne. Die 'Jahrhundertausstellung deutscher Kunst (1775–1875)' in der Berliner Nationalgalerie 1906*, Berlin 1999; F. Forster-Hahn, 'The Politics of Display or the Display of Politics?' *Art Bulletin*, LXXVII, no. 2, June 1995, pp. 174–9.

82 Franz Dülberg, *Die deutsche Jahrhundert-Ausstellung*, Leipzig 1906, p. 35.

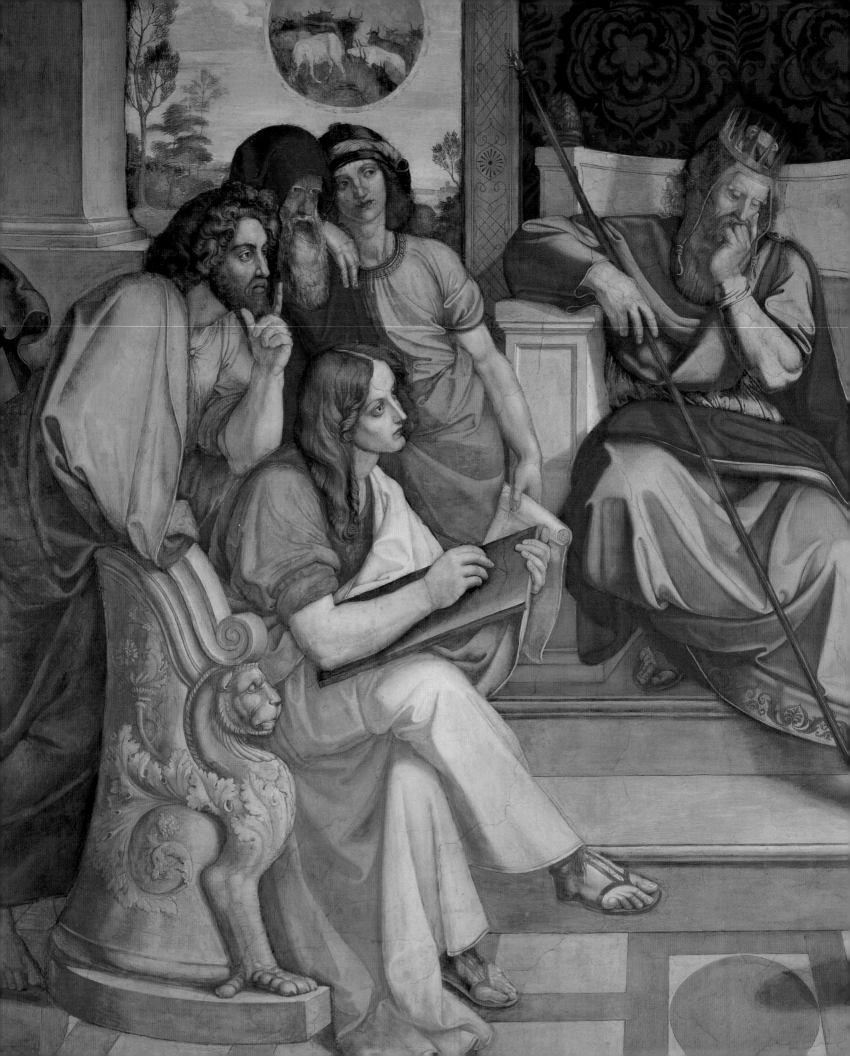

The Making of the History of Contemporary Art
From an Exhibition in Munich to a Museum in Berlin

CLAUDE KEISCH

'In every present there is an unrecoverable image of the past, which is liable to vanish should that present not recognise itself in it as intended.'[1] Public museums do not merely enshrine the past within their temple-like exteriors: they attempt to keep up the connection between the past and the present. The fact is that their classifications and evaluations are no more than temporary and provisional, and the new light constantly being cast on old pictures itself soon fades away into the past. Museums keep up to date by making additions to their collections, by hiving off parts of them and by changing their installation. In the case of the Berlin Nationalgalerie, in 1906, thirty years after opening in 1876, it had on display little more than a quarter of its original holdings, the picture collection bequeathed by Konsul Wagener's picture collection – which, by the terms of his will, was to be kept 'undivided'[2] – and only half the cartoons of Peter Cornelius, originally occupying pride of place in the two grandest rooms. Even before the First World War drastic alterations had muffled the rhetoric of the original interior decoration, achieving a more functional effect, and the weighting between sculpture and painting had swayed towards the latter. At that time the prevailing sensibility was that of the Secession, and no longer of the Academy.

The desire to keep the past in line with the present was matched by a need to anchor contemporary art in history, and this, in turn, reflected a crisis in the cultural status of art and the social position of artists. Princely patronage had largely disappeared after the Napoleonic Wars. The gap had been met to some extent by numerous local art associations (*Kunstvereine*), which raised money for exhibitions and so forth among their 'shareholders' and set aside funds to support artists in distress. Commissions also came from the state, for example the monumental frescos being painted very prominently in Munich and elsewhere. But this did not solve the problem of a general sense of artistic anaemia. The 'end of the Romanic era' (in Hegel's view of world history) was evident, at every art exhibition, in the conflict between two mutually irreconcilable approaches, realism based on observation and idealism. The title of a novel of 1836 by Karl Immermann, who was sympathetic to the ambitions of the group of genre painters working in Düsseldorf (the 'Düsseldorf School'), summed up the situation: *Die Epigonen*, the Epigoni, or 'successors' – the name given in Greek mythology to the (lesser) sons of the Seven Heroes of Thebes. Tradition weighed heavily, and could be counterbalanced only by providing its own history for living art. This task was taken up by the critics, who were frequently both journalists and early practitioners of the new discipline of art-history.

Indeed the year 1837 saw the publication both of the first comprehensive handbook of European art history, by Franz Kugler,[3] and of the first of a three-volume history of modern German art (*Geschichte der neueren deutschen Kunst*), which was published in Paris and Berlin, in French and in German.[4] Its author, Athanasius Graf Raczynski, a Polish aristocrat in the Prussian diplomatic service, had been collecting works by German contemporaries as well as Italian Renaissance masters since 1820. The work is organised by local school (specifically Düsseldorf, Munich and

Fig. 28
PETER CORNELIUS
Joseph interprets the Dreams of Pharaoh (Joseph deutet die Träume des Pharao), fresco from the Casa Bartholdy in Rome, 1816–17 (detail)
Fresco overpainted with tempera, 246 × 331 cm
Nationalgalerie, Staatliche Museen zu Berlin

Berlin), these in turn are arranged by genre, and the genres of art are ordered alphabetically by artist. The book was more a situation report than a history, but the choice of title had some significance. Kugler for his part had ended his account essentially with the eighteenth century, then appended a very brief 'review of the art tendencies of the present', although elsewhere he wrote a great deal about contemporary art. Just twenty years later it was all very different. August Hagen and Anton Springer, the former in Königsberg (Kaliningrad) in East Prussia, the latter in Bonn, wrote comprehensive histories of art in their century at virtually the same time;[5] likewise Ernst Förster, who had begun his career as a Nazarene painter before turning wholly to scholarship,[6] devoted two of the five volumes of his history of German art (*Geschichte der deutschen Kunst*), published in 1860, entirely to the period after the eighteenth century – the 'period of art's revival', which began with Johann Joachim Winckelmann's fresh approach to classical art and the academic reforms of Anton Raphael Mengs.[7] This very partisan work, which allots Friedrich and Menzel a succinct, highly critical page each but dilates in several long sections over Peter Cornelius, is governed by the 'unshakeable conviction that every attempt on the part of German artists to move in the direction of French Mannerism, or of Franco-Belgian Naturalism … emperils the ground conquered by our great geniuses and will lead inevitably to the rapid downfall of art.'[8] *A propos*, Förster underlined the merits of an exhibition organised in Munich two years previously, lauding its 'high, almost solemn earnestness',[9] its patriotic enthusiasm, its strengthening of the communal bond.

THE 1858 MUNICH EXHIBITION

The exhibition held in Munich in 1858 was indeed a clarion call.[10] Although there were many links between the local art associations, which passed on exhibitions to one another and were all members of an association 'for historical art', the initiative came not from them but from a 'first pan-German conference for artists' which had met at the end of September 1856 in the spa town of Bingen on the Rhine; it was followed one year later by a second conference in Stuttgart. The Düsseldorf 'Malkasten' (Paint box), which unlike the art associations, set up by art consumers, was a society representing the interests of painters, was the inspiration of both events. Not without good reason, it was announced at the Stuttgart conference that 'until further notice we will dispense with the advice and help of associates', in other words non-artists.[11] Matters for discussion included not only the improvement of artists' material situation and the protection of intellectual property, but first and foremost the founding of an exhibition of German art, which would be held regularly and which would concentrate less on selling

than on rendering an account of contemporary art. The intention was to prove 'how Germany can measure up to neighbouring states and outdo them, if it brings together the fruits of its creative endeavours'. The prospectus for the exhibition clearly followed the lines of the Great Exhibition in London in 1851 and the Exposition Universelle in Paris in 1855: as there, both patrons and artists were to contribute to an overview that would promote 'the love of art, the fame of the Fatherland, the heightening of the national spirit'.[12] The difficulty of finding a suitable venue was resolved when the Munich Academy deferred a retrospective exhibition planned for the fiftieth anniversary of its foundation in favour of the national enterprise. As a result the Munich Glaspalast (Crystal palace) was now available – a building based on the London model, erected in 1854 by Karl von Voit, the architect of the Neue Pinakothek, for an exhibition of art and industry. When, in its inaugural year, the building hosted a 'general', or pan-German, exhibition, the painter and journalist Anton Teichlen had suggested the exhibition should also be historical.

While its setting in a building of iron and glass might seem to indicate modernity, the art exhibition of 1858 took place, nevertheless, under the auspices of the Munich Academy, whose ideas had been dominated for decades by the monumental art of Peter Cornelius; it was now run by Wilhelm von Kaulbach, and his ambition had always been 'to paint God's spirit in history', but with naturalistic detail (see fig. 18, p. 29). As the Munich Academy and the Munich artists' union each had its own representative on the subcommittee in charge of preparations alongside the '*centralcomité*' elected by the general artists' assembly (and later on also delegates from the individual artists' associations),[13] from the outset they were assured of the determining influence. The two chairmen of the subcommittee were Kaulbach and Feodor Dietz; Dietz, a military artist with the title of court painter at Baden, represented the Munich artists, but was also an honorary member of the Academy. The subcommittee's secretary was the aesthetic philosopher Moritz Carrière, the Secretary of the Munich Academy. All the other committee members lived in Munich.

According to the published programme, 'only works by German artists, that is, artists whose artistic training has been at German schools of art, or who otherwise effectively belong to such schools' were to be accepted. But what did 'German' mean, in a conglomerate of large and small kingdoms and principalities that had failed to unify as a state in 1848 and were still suspended between a 'greater Germany' (including Austria) and a 'lesser' one (under the hegemony of Prussia)? Without any reference to it being made in the programme, Austrian painters were eventually included. On the other hand, despite the desire to integrate, it was planned from the beginning that the exhibition should

be divided according to local schools and within them according to genre, making it impossible to impose any historical system. Just how far the historical approach was from being accepted as the norm was shown by the comment of one of the participants after the exhibition on the drawbacks of a 'purely historical view', which would have to 'take into consideration in every period all the activity in the most diverse categories ... of artistic creativity', thus restricting 'the clarity of an overview of the individual genres'.[14]

A first step had nevertheless been taken, in this retrospective of the development of German art 'since Carstens, Schick, Overbeck and Cornelius' – in other words, of Neoclassicism and the kind of Romanticism that had been officially honoured in Düsseldorf and above all in Munich . 'Surely no greater service can be done to the present-day muddle and uncertainty in artistic direction than to discover once more the points of departure for German art ….'[15] The political dimension is clear: it was all about proclaiming 'the German essence, inspired and informed by the spirit of Christianity and ancient Hellas'[16] – in that order.

Fig. 29
ASMUS JAKOB CARSTENS
The Greek Princes in the Tent of Achilles (*Die Helden im Zelte des Achill*), 1794
Watercolour and gouache on paper, 45.2 × 66.1 cm
Akademie der Künste, Berlin, formerly on loan to the Staatliche Museen zu Berlin

RECEPTION OF THE 1858 EXHIBITION

In the end over two thousand works were brought together in the Glaspalast. Painting, sculpture, graphic art and architecture were represented. 'They have all come, the living and the dead,' Dietz declared in his opening address on 22 July. 'Those who have fought out the battle of life, for whom the riddle of the ideal has been solved, who are sleeping in their graves, they are here, they are among us! … Space and time have been conquered, and the remarkable picture of a spiritual family is revealed before our eyes.'[17] Dietz went on ever more emphatically, 'And we know that when our eyes fail, when the work we are doing falls from our dying hand, it will be taken up and carried on by a related hand to expand the spiritual power of the nation! No, we are not mistaken in clinging warmly to the idea that our art is a national art!' The reference to the nation, the acknowledgement of the prevailing 'world peace' as a favourable precondition for the flowering of art, did not prevent the speaker from wallowing in strikingly warlike metaphors or from narrowing his view exclusively to Bavaria immediately he became more specific, as Carrière, the previous speaker, had also done: the art promoted by Ludwig I and Maximilian II of Bavaria 'reveals what German art is!'

That was rather an overstatement. The state of German art was revealed more tellingly in the arrangement of the first room,[18] perhaps not quite voluntarily. Organisation according to school (in alphabetical order: Berlin, Düsseldorf, Dresden, Munich, Prague, Stuttgart, Vienna) entailed the hanging of Menzel's large battle scene *Night Attack at*

Hochkirch 1758 (fig. 30) opposite a work by Cornelius of only a few years earlier, *The Riders of the Apocalypse* (fig. 31), commissioned for Berlin. The polarity between realism and idealism could not have been given clearer definition, even if some viewers were ready to accord the same status to Menzel as to Cornelius.[19] In the same room Kaulbach's cartoon for his fresco in the Neues Museum in Berlin, *The Construction of the Tower of Babel* (*Turmbau zu Babel*; destroyed in 1945; cartoon in the Nationalgalerie; see also fig. 18, p. 29) and work by Carstens (see fig. 29) dating back more than sixty years could be seen together.

Dietz's attempt to show German art as culminating in the monumental classicism of Munich had yet another context. While local committees had been active in many places in Germany and Austria, Berlin held back. The Berlin Academy refused to participate right to the last.[20] Only individual artists – such as Menzel, Eduard Magnus or Gustav Richter – submitted contributions, and cartoons by Cornelius owned by the King of Prussia were also sent. Following a request from Munich the Prussian royal contribution was considerably reinforced after the exhibition had opened, and the Ministry of Culture took steps that important works were added so as to compensate for the weakness of the Berlin presence.[21] 'Hammering and banging could be heard' still in September, and 'removals of the pictures were being undertaken' to provide places for worthier new arrivals.[22] (In spite of this the absence of sculpture by Gottfried Schadow meant that one of the undisputed early peaks of German art was missing.)

Fig. 30

ADOLPH MENZEL

Night Attack at Hochkirch 1758 (Friedrich und die Seinen bei Hochkirch, 1758), 1856

Oil on canvas, 295 × 378 cm

Formerly Nationalgalerie, Staatliche Museen zu Berlin; missing since 1945

Fig. 31
PETER CORNELIUS
The Riders of the Apocalypse (Apokalyptische Reiter), 1846
Cartoon for a fresco, never executed, in the Camposanto at Berlin Cathedral
Charcoal on paper; 472 × 588 cm
Formerly Nationalgalerie, Staatliche Museen zu Berlin; lost in 1945

Fig. 32
UNKNOWN
PHOTOGRAPHER
Adolph Menzel, 1861
Photograph

Although it remained tacit, Berlin's non-cooperation reflected an enduring, and only incidentally cultural, rivalry between the two most powerful German states, Bavaria and Prussia. The influential conservative Berlin newspaper *Vossische Zeitung* could not bring itself to include more than a three-line report of the opening of the exhibition.[23] However, the *Deutsches Kunstblatt*, edited in Berlin by Friedrich Eggers, praised the exhibition and printed the opening speeches, as did Max Schasler's rival Berlin journal *Die Dioskuren*. Very comprehensive reviews followed in both papers; but only the *Deutsches Kunstblatt* attempted an historical analysis. Another leading Berlin newspaper, the *Spenersche Zeitung*, published a review in several instalments.[24] By far the broadest coverage was the review in thirteen instalments in the *Allgemeine Zeitung*, published in Augsburg, but distributed widely throughout Germany and even in the United States.[25] The critics in both the *Spenersche Zeitung* and the *Allgemeine Zeitung* made an attempt to follow the historical thread, overstepping the predominant classification into genres and schools. The writer in the *Allgemeine Zeitung* was very critical of the remoteness of the late Romantics from contemporary reality, and in the *Spenersche Zeitung,* too, there are some strikingly percipient and sensitive passages: for instance, in Friedrich, whose work was always haunted by sinister and disquieting interpretations, the anonymous writer saw 'something of that unerring earnestness of a child's gaze'. Surprisingly, he adds: 'Perhaps this stress on the religious element … is ascribed to the pictures more on the basis of the climate of the period when they were painted, and is not intrinsic to them. The present three examples, in our view, are the most simple echoes of nature, as pure and uncontrived as innocence itself.'[26] This approach to Friedrich would not become widespread until decades later.

The critic of the *Allgemeine Zeitung* looked for the beginnings of new German art expressly not in 'Chevalier von Mengs, whose artistic genius had been stuffed and crammed with all the narrow-minded stricture, with all the dogmatic pedantry of his day', nor in the academies. 'It was to develop organically and not artificially, like everything that has true life-force. It had to fight a battle of death-defying courage to justify its existence – and has its heroes and martyrs.'[27] By 'heroes and martyrs' only Asmus Jacob Carstens was meant. Carstens had travelled from Schleswig by way of Berlin to Rome, where he died of consumption while still young. His art, predominantly in black and white, but conceived on a monumental scale, had something utopian about it, as did his break with the Berlin Academy in the name of pure dedication to art. Possibly this great gesture of emancipation was more famous than his work, in the way that at a later date Van Gogh's letters would for a period become better known than his pictures. Carstens's role as a 're-awakener' of German art is quite frequently extolled in metaphors with Christian connotations.[28] His contribution was generally taken to have been a break with the 'mannerism' of the eighteenth century, a return to both naturalism and idealism. If the 'Roman German' Carstens could be seen as a parallel to John Flaxman in England, and his Stuttgart contemporary Gottlieb Schick a parallel to Jacques-Louis David in France,[29] an international network of relationships might be constructed for German art.

As was usual at the time, a review of the exhibition was published in book form.[30] Just as the Centenary Exhibition of 1906 afforded Richard Hamann the opportunity to position German painting for the first time between sensibility and naturalism, so in his 1858 review Julius Grosse, a respected dramatist and poet and the editor at the time of the *Neue Münchner Zeitung*, produced a comprehensive account of the history of the art of his century, one that both was scholarly and theoretical and acknowledged the crisis to which idealism had now come (even though he favoured it). His discussion of landscape painting includes page-long quotations from Ralph Emerson.

On 20 September five hundred participants met at the third artists' congress in three years.[31] The financial success of their speculative exhibition, for which a Munich banker had advanced funds, was already clear. In the speech by Dietz justifying the artists' having forming their organisation there was a new catchphrase: 'My friends! Without the association there would be no German school!'[32] Immediately on the heels of the search for an historically based national identity there came

an exhortation to national unity, parallelling the political struggle which would shortly, at the cost of three wars, in 1864, 1866 and 1870–1, bring into being the powerful, but ultimately brittle, German Empire.

The next general exhibition of German art was planned for 1860, but did not take place until 1861, in Cologne. The splendid public celebrations which accompanied it could not endow it with the symbolic impact of the first one, which was possible only once. 'Here,' it was declared, 'the question whether Germany has a national art and, if so, what its distinctive characteristics are can be resolved.'[33] In the reviews the emergence of a patriotic vocabulary is striking, for instance in discussing Cornelius: 'It is the powerful, unbending German spirit that emanates from his figures, without a trace of blind faith or unthinking submission, as his faith, on the contrary, is the outcome of his own thought and life, it is ... more philosophical than theological in nature, and unshakeably firm just because of that selfsame manly, free character.'[34] Similar words were written many times up until 1945 regarding Dürer's *Knight, Death and the Devil*. The tone can be less militant, however, when there is discussion of other genres: 'The German empathises more intimately with the life of Nature than any other people. He is a heartfelt friend of the beauty of landscape and therefore of landscape painting, too.'[35]

Obviously the desired conclusion was quite generally drawn, 'that in fact the concept and drawing are the main thing for our painting, that idealism is the red thread linking masterpiece to masterpiece, that the portrayal of history, i.e. of human life in events and situations of general significance and intellectual interest, represents the culmination and centre of fine art.'[36] A sign of the international percolation of this outlook is a clerical error made by the Goncourt brothers in a note of their travels through Germany in their diary for 10 September 1860: comparing the stares of the natives to the spectacles of the novelist E.T.A. Hoffmann's character Dr Coppelius, they wrote instead 'Cornelius'. Even twenty years later, the Berlin critic Ludwig Pietsch, an advocate of Realism, would grumble: 'To those who keep telling the German people the semi-legendary story of the birth of a new, great German art after a long night, brought about by the Romantics, neo-Catholics, contour-draughtsmen and fresco painters in Rome and Munich, the completely separate course of development of art in Berlin seems to have remained largely unknown.'[37]

THE BERLIN NATIONALGALERIE

In the meantime the Nationalgalerie had been founded (1861), built (1865 onwards) and opened (1876) in Berlin. Within a few years after 1858 the subtle play of art politics had carried the initiative for attaching a history to contemporary art a little further forward. Working the other way round, that is, extending the collection of Old Masters in Schinkel's

Fig. 33
FRANZ HANFSTAENGL
Peter Cornelius, c. 1855
Photograph

Museum to include the present, had been considered earlier, for instance by the scholarly Baron von Rumohr, but a self-sufficient department for living artists was inevitably preferable to the artists' lobby and to state patrons. The desire for a national collection of contemporary art had been in and out of view since the mid 1830s, always returning under a slightly different aspect, but always tied in to the 'Fatherland', meaning Prussia or Germany. The final push towards making this a reality was the legacy of the banker J.H.W. Wagener, a collection of 262 pictures bequeathed to the King of Prussia in 1861.[38]

Wagener's collection reflected almost half a century of German art and German taste. He had bought almost everything straight from the studio, and his changing preferences had always chimed with the prevailing standards of taste and fashion. The collection was layered like geological strata – theatrical history painting of the 1850s and its Belgian models had overlaid the genre of the Düsseldorf School of the 1830s; below that were the South German realist minor masters; finally, in the earliest layer, the Romanticism of Friedrich and Schinkel. There could be no doubt that, apart from the very recent works, it was all outside the current debate and so had become history. But the Parisian model

Fig. 34
The Nationalgalerie, Berlin, exhibition gallery on the first floor, 1879
Photograph
Zentralarchiv, Staatliche Museen zu Berlin

Düsseldorf painter Karl Friedrich Lessing taking as their subject the religious wars of the late Middle Ages were purchased; when the Museum opened one of them hung in the entrance hall together with Eduard Bendemann's *Jeremiah at the Fall of Jerusalem* (*Jeremias beim Fall Jerusalems*). More important still was the addition of monumental black-and-white cartoons for frescos, among which there took pride of place seventy-three compositions by Cornelius for three picture cycles, in particular the religious subjects for a 'Campo Santo' or mausoleum complex for the Hohenzollern dynasty, which was no longer expected to be built. Two years before the painter's death the Ministry of Culture and the King had decided, despite their outsize dimensions, to exhibit these permanently as 'masterpieces … which have a European renown and the importance of which will be subsequently recognised in even greater measure',[39] and his earlier cartoons were purchased immediately after his death. They were admired, not despite their austerity but rather because of it, as the highest manifestation of idealist art, and were regarded as a genre apart. The two central rooms of the main floor of the new building, of double height, were built especially for them. The programme was set. In 1868 Alfred Rethel's cartoons for his frescos in Aachen on the history of Charlemagne, which again had been admired in Munich, were also purchased.

Thus, when the gallery was opened in 1876 (fig. 34), fifteen years after its institution, it had on display 389 paintings – the Wagener collection and 127 others – eighty-five cartoons and a few sculptures; there was also a collection of drawings. When two late eighteenth-century portraits, by Anton Graff and Heinrich Tischbein, were accepted as a gift in 1867, and the next year the first example of work by Carstens (the 're-awakener') followed, a start, though a hesitant one, had been made towards extending back to the period before the Napoleonic Wars, before Neoclassicism and Romanticism. It was, however, only after the purchase of three major works by Menzel between 1873 and 1875 that the challenge to idealism of modern Realism of a Berlin stamp was issued, that the antithesis as it were scrabbling in the basement of the Munich exhibition was at last acknowledged.

of the Musée du Luxembourg was not considered. Since 1818, the Luxembourg had accepted works provisionally, and then, soon after the artist's death, they were transferred to the Louvre or other museums. The Nationalgalerie was different – like the Neue Pinakothek in Munich, opened in 1853, it exhibited the works of the living against the backdrop of art history, into which they were gradually absorbed.

In that backdrop, however, an imbalance in the collection was soon revealed – the complete absence of the Nazarene movement. In the light of the 1858 exhibition this lack seems to have struck Wagener himself as no longer tolerable, for in the same year as he determined in his will that his collection was destined for a museum he added a late work by Cornelius, *Hagen sinking the Nibelungs' Treasure* (*Hagen versenkt den Nibelungenhort*), so initiating a correction that would continue in following years.

All in all the Nationalgalerie at the time of its opening bears the stamp of 1858. What had triumphed in Munich then, or at least similar work, was displayed there. Thus in 1864 and 1876 two large pictures by the

NOTES

1 Walter Benjamin, *Geschichtsphilosophische Thesen*, in *Schriften*, Frankfurt 1955, I, p. 496.

2 Ludwig Justi, *Die Zukunft der Nationalgalerie*, Berlin 1910, p. 14.

3 Franz Kugler, *Handbuch der Geschichte der Malerei von Konstantin dem Großen bis auf die neuere Zeit*, 2 vols., Berlin 1837; *Handbuch der Kunstgeschichte*, Stuttgart 1842; an English translation was published in 1842.

4 Athanasius Graf Raczynski, *Geschichte der neueren deutschen Kunst*, 3 vols., Berlin 1836–41; *Histoire de l'art moderne en Allemagne*, Paris 1836–41.

5 August Hagen, *Die deutsche Kunst in unserem Jahrhundert. Eine Reihe von Vorelesungen mit erläuternden Beischriften*, 2 vols., Berlin 1857; Anton Springer, *Geschichte der bildenden Künste im neunzehnten Jahrhundert*, Leipzig 1858 (as a continuation of his *Handbuch der Kunstgeschichte*, published in 1855).

6 Ernst Förster, *Geschichte der deutschen Kunst*, 5 vols., Leipzig 1860.

7 Ibid., IV, p. I.

8 Ibid. IV, p. X.

9 Ibid., IV, p. XVI.

10 The exhibition was open from 22 July to 15(?) October 1858. The following is based on a survey of the press of the time undertaken at my request by Stefan Körner, whom I thank very sincerely. The search was extended by Jan Werquet, to whom my thanks are also due.

11 Admittedly, this lasted only for the first day: *Deutsches Kunstblatt*, no. 8, 1847, p. 372.

12 Programme and invitation to the 'general German and historical art exhibition' in Munich in *Die Dioskuren*, no. 3, 1858, p. 34.

13 Articles 9–11 of the programme, ibid.

14 Ibid., p. 177.

15 This comment, which surely comes from the *Düsseldorfer Zeitung*, was quoted repeatedly, e.g. *Allgemeine Zeitung*, 29.12.1857, p. 5790, and *Die Dioskuren*, no. 5, 1858, p. 15.

16 Moritz Carrière in his speech at the opening, printed in *Deutsches Kunstblatt*, no. 9, 1858, p. 206, and in *Die Dioskuren*, no. 3, 1858, p. 141.

17 Quoted from *Deutsches Kunstblatt*, no. 9, 1858, p. 207; also *Die Dioskuren*, no. 3, 1858, p. 141. As if this thought were destined to be illustrated, a few years later one of the last survivors of the Romantic Classicist generation, Buonaventura Genelli, who was born in Berlin, imagined the ideal 'fellowship in the world beyond, which would unite him with his kindred spirits – right back to Carstens. (It is the last sheet in the suite *Aus dem Leben eines Künstlers*, executed mainly between 1857 and 1861, and published in 1868 in copper engravings. The pencil drawings are now in the Museum der bildenden Künste, Leipzig.)

18 The painter E. Seibertz was in charge of the exhibition. An unnamed Munich correspondent give a vivid description of it in 'Die allgemeine deutsche und historische Ausstellung in München', *Die Dioskuren*, no. 3, 1858, p. 139–42 (and several further instalments).

19 *Allgemeine Zeitung*, 21.09.1858, p. 4275. Later Theodor Fontane, who had made the same comparison in 1866, still had to soothe irritated readers in an explanatory note.

20 *Allgemeine Zeitung*, 08.07.1858, p. 3061; *Die Dioskuren*, no. 3, 1858, p. 126; *Die Dioskuren*, no. 3, 1858, p. 147f. (with an exhaustive 'Explanation by the business committee for the general and historical exhibition in Munich'); *Die Dioskuren*, no. 3, 1858, p. 162, with a reference to the Academy's evasive stance in the foreword to its catalogue of that year's exhibition.

21 *Allgemeine Zeitung*, 01.08.1858, p. 3449f.

22 *Illustrirte Zeitung* (Leipzig), 18.09.1858.

23 On 25 July.

24 On 27, 29, 31 August, 3, 5 September.

25 Unsigned, 'Briefe über die culturgeschichtliche Bedeutung der deutschen Kunstausstellung in München', thirteen instalments from 27.07. to 14.11.1858.

26 *Dolmen in the Snow* (*Hünengrab im Schnee, c.* 1807; Galerie Neuer Meister, Dresden), *Morning in the Mountains* (*Morgen im Gebirge, c.* 1830–4; destroyed), and a lost variant (1821–2) of *The Polar Sea* (*Das Eismeer*, Hamburger Kunsthalle, Hamburg).

27 *Allgemeine Zeitung*, 21.07.1858, p. 3273.

28 For example, ibid.

29 *Ibid.*, 18.08.1858, p. 3729.

30 Julius Große, *Die deutsche allgemeine und historische Kunst-Ausstellung zu München im Jahre 1858. Studien zur Kunstgeschichte des XIX. Jahrhunderts*, Munich 1859.

31 Friedrich Eggers, 'Die deutsche allgemeine Künstler-Versammlung in München', *Deutsches Kunstblatt*, no. 9, 1858, pp. 253ff. Cf. also the letters from Munich in *Die Dioskuren*, no. 3, 1858, p. 172f.

32 *Deutsches Kunstblatt*, no 9, 1858, p. 254.

33 'Die deutsche allgemeine und historische Kunstausstellung in München', *Illustrirte Zeitung* (Leipzig), no. 790, 21.08.1858, p. 119.

34 *Allgemeine Zeitung*, 19.08.1858, p. 3745.

35 *Spenersche Zeitung*, 03.09.1858.

36 *Allgemeine Zeitung*, 06.09.1858, p. 4026. Here a different writer, not the writer responsible for the discussion of the exhibition in several instalments, is expressing his views, and clearly taking a different position.

37 Ludwig Pietsch, 'Adolf Menzel', *Nord und Süd*, XI, 1879, pp. 439–79; this quotation is at p. 441.

38 For the historical background of the Nationalgalerie see Dorgerloh 1999, pp. 35–47; also Forster-Hahn 1996b, pp. 78–99; Françoise Forster-Hahn, 'Museum moderner Kunst oder Symbol einer neuen Nation? Zur Gründungsgeschichte der Berliner Nationalgalerie', in '*Der deutschen Kunst …*' 1998.

39 Report of the Commission for the Audit of the State Budget … for 1865, quoted in Dorgerloh 1999, p. 161. For the incorporation of the Cornelius cartoons, see ibid., pp. 159–65.

Fig. 35
ERICH HECKEL
Spring (Frühling), 1918
Oil on canvas, 91 x 92.5 cm
Nationalgalerie, Staatliche Museen zu Berlin

Constructing and Reconstructing a Tradition
Twentieth-century Interpretations of the Development of Nineteenth-century German Art

ANGELIKA WESENBERG

ANGELIKA WESENBERG

A 'NATIONAL PICTURE ARCHIVE'

In 1895, when Max Jordan resigned the Directorship of the Nationalgalerie, the serried ranks of pictures on the walls contained few works that were more than mediocre. A few important masterpieces, by such as Schinkel, Friedrich or Menzel, could be found, but they hardly stood out from the throng. For more than two decades the acquisition of paintings for the Museum had been decided on the merit of their subjects – genre, history or portraiture. Its holdings constituted above all a kind of 'national picture archive'. But both the collection and its installation represented a notion of national identity that had been outgrown; and the approach of the new century underlined the fact that a collection originally of contemporary art was now a historical one, reaching back nearly a hundred years. Future directors would have to mediate between the past and the present, they would be compelled to re-order and re-organise the collection constantly, and to re-articulate the criteria governing it. As if driven by the dialectic that Nietzsche had expounded in 'The Uses and Disadvantages of History for the Living' (*Vom Nutzen und Nachteil der Historie für das Leben*), they were forced time and again to reconstruct history in order to serve present needs.

During the first decades of the twentieth century the succession of shifting contemporary attitudes to art is reflected with amazing directness in the Nationalgalerie's treatment of its nineteenth-century holdings. Around 1900, the climax of the cult of genius in the focus on autonomous masterpieces; from around 1906, the construction of a developmental history of European modern art on the platform of Impressionism; during the 1920s and into the 1930s, a focus on Expressionism as a characteristically German strain of art and its tracing back far into the past. At the beginning of the twentieth century theme or message of any kind in works of art was completely devalued; a few decades later art was nothing without 'content', spirit or meaning. The positivism of nineteenth-century German *Kunstwissenschaft* was abruptly rejected in the twentieth century, and then was taken up again in a form of scrupulous, humanist scholarship in conscious opposition to ideological blinkering. Throughout, to a greater or lesser extent, in blatant or latent form, the Germanness of German art was always an issue. Throughout, no less strikingly, the debate centred around the same selection of artists, though over time they were subjected to highly divergent interpretations: Caspar David Friedrich, Philipp Otto Runge, Carl Blechen, Hans von Marées, Hans Thoma.

THE AUTONOMOUS MASTERPIECE

The first director of the Nationalgalerie in the new century, appointed in 1896, was Hugo von Tschudi, who had previously been an assistant to Wilhelm von Bode at the neighbouring

Gemäldegalerie, dedicated to art of the Old Masters. From the beginning Tschudi took a strikingly radical approach, energetically confronting the 'national archive'. He could not, without coming into conflict with the Emperor or the Academy, rid the collection altogether of history paintings and portraits of dignitaries, but he crammed these together in a few areas, freeing the remainder of the galleries for pictures which he valued as works of art, and hanging these much more spaciously than had been the rule hitherto.

Tschudi's museum was a museum of masterpieces, and not of German masterpieces alone. He became notorious for his acquisition (through donations to the Museum that he arranged) of important works by the French Impressionists, including the first painting by Cézanne (cat. 68) to enter a public museum anywhere. However, he also lobbied the Minister of Culture so as to acquire quite different works, too, including paintings by Böcklin, Feuerbach, Schwind, Thoma, Leibl and Klinger,[1] and, for example, the important *Palm House* (cat. 23) by Carl Blechen, who was then still little known.

Justifications for admitting a work of art into the display collection were its aesthetic value, its originality, its conviction, but not its subject or its style. Essential to this approach was the idea of the autonomy of the work of art, a principle that had been espoused by Tschudi during the time he had earlier spent in Rome in the circle of Hans von Marées and Adolf von Hildebrand, and later also of the patron and critic Conrad Fiedler (see cat. 53–56). Hildebrand had argued that art must be judged on its own terms in his essay *Das Problem der Form in der bildenden Kunst* (The problem of form in the visual arts), and so had Fiedler in his *Schriften über Kunst* (Writings on art), published in 1896, the year Tschudi took office. The idea was new, however, in the history of the Nationalgalerie, and was found almost as disturbing as Tschudi's disregard of the artist's nationality, above all in his interest in modern French art.

According to Tschudi, to quote from a speech he gave at the Academy in the presence of Emperor William II in 1899, 'the value of a painting' was 'not determined by what it represented, but by the measure of creative power it contained within it'.[2] Tschudi regarded 'force of character' as the origin of a true masterpiece,[3] and believed that only 'the few who are capable of perceiving the best' would be able to appreciate it.[4] In a way that is highly specific to the period he saw the task of both the artist and his audience as the development of a response to colour: 'the ultimate goal of painterly creativity will always lie in reproducing the infinite richness of the phenomena of light'.[5]

The Emperor would certainly have defined 'the ultimate goal of painterly creativity' in very different terms: he abhorred the kind of painting that blurred contour in order to represent the fall of light.

Furthermore, whether the art concerned was old or new, he believed its content should be clear and comprehensible, it should reinforce moral values, it should represent good examples to follow, and it should reflect and confirm national identity. In the speech he gave in 1901 at the official opening of the Siegesallee (the continuation of Unter den Linden from the Brandenburg Gate to the Siegessäule or Victory column), he remarked: 'Art should help to have an educational influence on people, it should give the lower classes, too, after their hard work and toil, the opportunity to be guided once again by ideals'.[6]

The shift from the Emperor's perspective to the new Director's involved the collapse of the normal understanding of the purpose of art in the nineteenth century. Attention to the subject, story or content was required to give way to formal appreciation alone; academic standards should be abandoned in favour of free, subjectively determined composition; subjects suitable for the state and found appropriate by its ruler would be replaced by genre and banality. A further consequence, however, was that it became necessary to find a new definition of the 'national' in art, for this had been determined in recent decades by the picture's subject-matter. To forestall criticism and for the ears of the Emperor, Tschudi had stated in 1899: 'Every artist is national, in so far as he gives expression to the characteristics of the race from which he derives, unadulterated by foreign adjuncts'.[7] His two successors at the Nationalgalerie, Ludwig Justi and Alois Schardt, would accept this idea without question when they assembled a canon of specifically Germanic expression in art, and in so doing they returned to debates of what constituted 'Germanness' that had raged in the early nineteenth century.

Indeed Tschudi's attitudes have notable parallels with the approach of Wilhelm Bode, formerly his superior and now his rival: both embodied the new type of brilliant connoisseur who could both appreciate great works from different stylistic periods and pursue personal preferences. For Bode the Italian Renaissance was the ideal, because it inaugurated the self-discovery of modern man. Tschudi pursued this notion of individual autonomy into modern times and applied it specifically to the painting of the Impressionists. In 1904 the Kaiser-Friedrich-Museum was opened for the display of Renaissance art, which had by now long been accepted into the canon; meanwhile the Nationalgalerie was preparing an exhibition on the history of painterly vision that would prove much more controversial.

ART HISTORY EVALUATED IN IMPRESSIONIST TERMS
In 1906, after long years of preparation, the 'German Centenary Exhibition' (*Deutsche Jahrhundert-Ausstellung 1906*), an exhibition of German art from 1775 to 1875, opened at the Nationalgalerie. It was organised by Tschudi in collaboration with the critic Julius Meier-Graefe

and the director of the Hamburger Kunsthalle, Alfred Lichtwark, also a dedicated modernist. By contrast to the Centennale held in 1900 in centralist France, in which the material displayed came mostly from Paris collections and was well known, for the exhibition in Berlin the history of national art in the German Empire, which had not been established until 1871, first had to be written. This had involved protracted research. What had emerged from the exhibition held in Munich in 1858 was very out of date. The organisers enlisted the help of regional collaborators and instituted preliminary local exhibitions in order to discover 'forgotten' masters and to obtain a comprehensive overview.

The German Centenary Exhibition of 1906 was not only the first retrospective exhibition of nineteenth-century German art; it also formulated the history of that period in ways that are still broadly accepted today.[8] It did not simply bring together whatever could be found that was of importance, but it constructed a path of formal and aesthetic development, from the linear to the painterly, leading from the Neoclassicists and Nazarenes to the early work of Max Liebermann. 'At one pole stands the break with Rococo, which took place under the influence of Antiquity through the adoption of a simplified formal language. The other boundary is formed by the emergence of the Impressionist approach to art.'[9] This emphasis on the progress of the *malerisch* (painterly) in art conditioned both the selection of the works exhibited and their interpretation. In the cases of Friedrich and Runge, for example, both of them 'rediscoveries' of the exhibition, the restriction on reading this overview imposed led to misinterpretation.

With reference to Friedrich, Tschudi explicitly admitted the one-sidedness and anachronism of his approach: 'All this Romanticism, which was perhaps the main thing for the artist himself, becomes secondary for us in view of the novelty opened up to the seeing eye as far as the beauty of landscape is concerned … the wet meadows striped by the shadows of clouds, the sparsely animated hills with the silver haze of a pale spring day lying over them, the shallow undulations of the Bohemian mountains with the morning mists swirling between them, that is the content of Friedrich's pictures in which we recognise the beginnings of a development that has continued right up to our own day.'[10] What was essential in Friedrich's work, for Tschudi, was the appropriation of reality by the individual, a strand that could be followed in landscape painting through the entire nineteenth century and be seen to reach its culmination in French Impressionist painting. Lichtwark, on the other hand, was disturbed by the readings of his colleagues. Taking once again the example of Friedrich, he remarked, 'The impression Friedrich makes on advocates of Art for Art's sake of the stamp of Meier-Graefe is interesting. They hate reverie and mysticism. They enjoy only what is real in the picture.'[11]

After the Centenary Exhibition, the Nationalgalerie was rearranged according to the criteria the exhibition had established. Important works that had been in the exhibition (such as cat. 8 and 57) were acquired for the Museum and were assigned an undisputed place in it. There was as yet no occasion for dispute, since neither the Emperor nor the purchasing committee had necessarily to concur with the particular way in which the exhibition organisers viewed painting before Impressionism; there were other possible interpretations of the same pictures.

Tschudi ran into serious difficulties, however, when in 1908 he tried to acquire some works by Delacroix and Corot using government money. The Kaiser in no uncertain terms deplored their 'painterly vision' and the absence of clear contours. After consent had initially been given by the Kaiser for the purchase, but then shortly afterwards had been not remembered, and so effectively withdrawn, Tschudi's position as Director of the Nationalgalerie became untenable.

ART HISTORY IN TERMS OF FUNDAMENTAL PRINCIPLES

From around 1911, the idea that the painterly vision had developed towards Impressionism along a straight path was recognised to require modification and qualification. A variety of reciprocal influences across time and space began to be recognised. Writing a foreword to the catalogue of an exhibition of the Nemes painting collection at the Neue Pinakothek in Munich in 1911, the year of his death, Tschudi himself observed: 'Then suddenly, from the standpoint of Impressionism, unexpected perspectives on earlier art open up. Manet has caused Velázquez and Goya to be seen in a new light. Together with our admiration for Cézanne an appreciation of El Greco has been aroused.'[12] Referring to the tasks of 'a twentieth-century museum director', he expected that 'the material in the collection would interest him first and foremost where it is tied to the present by living threads'.[13] Tschudi knew that by now such a 'living' relationship to the past was understood by younger artists to mean more than simply formal similarities: they sought inner relationships that had more to do with a psychology of style. *Der Blaue Reiter* (The blue rider), a manifesto full of illustrations exploring precisely this kind of connection, was published by the group of artists that soon took this name in 1911, dedicated to Tschudi's memory. Juxtaposing Gothic sculptures, pictures by El Greco and by Robert Delaunay and 'naïve' works of art, their 'almanac' presented these as examples of related expressive intention. In Berlin Bode reacted angrily to Tschudi's Nemes foreword, to its advocacy of purely contemporary, ahistorical criteria of appreciation. 'From which of these trends in ultra-modern art is the young art historian supposed to try to achieve a correct understanding of the Old Masters? Is he supposed to ally himself with the Neo-Impressionists, or with the Cubists, or the

Fig. 36
The Kronprinzenpalais (Crown Prince's palace), former annexe to the Nationalgalerie, as hung by the Director Alois Schardt, with Friedrich's *Winter (Churchyard in the Snow)*, 1810, hanging on the right, 1933
Photograph, Zentralarchiv, Staatliche Museen zu Berlin

Futurists, or even the "Blue Riders" on their wild gallop and other Stormers?'[14]

The Swiss scholar Heinrich Wölfflin, who had been Professor of Art History at the University of Berlin from 1901 and from 1911 a member of the purchasing committee of the Nationalgalerie, to some extent shared this ahistorical approach, but his five antithetical pairs of 'principles' (*Grundbegriffe*) were inherent absolutes, dependant on the nature of vision and painting itself. In his presentation of the history of art the evolution from two-dimensional to three-dimensional, from closed to open forms, from the linear to the painterly, was a progression repeated periodically. Wölfflin had also applied these ideas, originally developed from the study of Renaissance and Baroque art, to the immediate past, giving a series of lectures on the history of art of the nineteenth century at Berlin University in 1911. He opened his observations with slides of Cornelius's frescos from the Casa Bartholdy in Rome (see fig. 28, p. 40): these were highly 'linear'. He appreciated the Romantic landscapes of Friedrich and Blechen for the progress they had made on the way towards the 'painterly'; Marées, however, did not fit into this scheme of things, and Wölfflin put him down as a special case, a 'genius', an oddity in what should be 'a history of form without names'. In Symbolist art around 1900 he noted a renewed return to the linear. He concluded his introduction with an imaginary tour of the National-galerie, exhorting his students to comprehend its diversity as an organic entity, 'so that we may become accustomed to associating the alpha and the omega, the beginning and the end, as closely as possible'.[15]

Ludwig Justi, a pupil of Wölfflin, became Director of the National-galerie in 1909. From January to June 1919, an unsettled period following

the overthrow of the monarchy, he wrote a new guide to the Museum, *Deutsche Malkunst im neunzehnten Jahrhundert* (German painting in the nineteenth century). Instead of arranging the pictures chronologically or regionally, he ordered them according to his own *Grundbegriffe* (principles). His crucial distinction was between 'making for external reasons' and the more important 'making from inner compulsion'. The latter he further divided according to artistic aims: realism, rhythm, painterliness, expression. He grouped and discussed the important pictures in the Museum under these headings, but made it clear: 'The other values always had a part to play as well: in Cornelius's composition there is also expression, in Krüger's realism painterliness, in Manet's painterliness realism, in Feuerbach's rhythm expression, in Friedrich's expression painterliness, and so on, richly intertwined.'[16] Further on, he justifies this open system in which formal criteria such as 'rhythm' or 'painterliness' are ranged beside categories more related to subject-matter, such as 'expression': 'If this rich material does not fit exactly into the structure we have provided, divisions of another kind seem to us less appropriate. At any rate, if one takes as one's guiding principle a single viewpoint, for instance that of Impressionism, everything is greatly simplified, both for the writer and for the reader, but the lines are distorted.'[17]

Although Justi became notorious as a consequence of his purchase of important Expressionist work, he later noted that he 'was much more intensely involved personally in many cases where acquisitions of earlier works were concerned, of Caspar David Friedrich and Runge, Schnorr and Ramboux, or Thoma'.[18] Generally, both Justi's purchases and his writings reveal an emphatic new orientation towards German art – an approach also apparent in his very language, in which he prefers Germanic compounds to Latin ones, thus *Aufbau* to *Komposition* and *Sachlichkeit* to *Realismus*.[19]

The abolition of the monarchy in 1918 had roused once more the question of what was meant by national or German art, or what was the basis of the cultural unity that had played so important a role when the Nationalgalerie had been founded. Again, as at the beginning of the nineteenth century, it was affirmed that the people and the culture constituted the identity of the German nation state. Since, however, the people and the culture were not bound by fixed political frontiers, the notion became widespread of an underlying Nordic or Germanic nature, which could be recognised unproblematically, so it was believed, in the ecstatic works of the Dutch Van Gogh or the Norwegian Munch. Under the heading 'expression', which had come to serve as the unifying factor of Wölfflin's organic entity, Justi brought together Friedrich's *Winter (Churchyard in the Snow)* (*Winter (Klosterfriedhof im Schnee)*, 1810; lost in 1945; see fig. 36) and *Spring* by the Brücke artist Erich Heckel (fig. 35).

In 1919 Justi secured the Kronprinzenpalais (Crown Prince's palace), which had now lost its purpose, as an outhouse of the Nationalgalerie for contemporary art. Until its closure by the National Socialists in 1937 the works shown there were predominantly German Expressionist, representing modern 'expression'.

ART HISTORY IN TERMS OF EXPRESSIONISM

Some ten years later the same reproach was levelled at Justi that he had once made of Tschudi, that he had adopted 'a single viewpoint as his guiding principle'. In early January 1933, a few days before Adolf Hitler became Chancellor, Justi was attacked in his absence, as he himself reports, in the left-wing journal *Kunstklub* (Art club) for his 'Teutonism, or "Germanic" line in the formation of the modern collection'.[20] The attack was occasioned by the return of the French and German Impressionist paintings to the Nationalgalerie from the Kronprinzenpalais, where they had opened the installation in 1919. Modern art at the Kronprinzenpalais now began with Munch and Van Gogh. The *Kunstklub* also took issue with the newly revised edition of *Deutsche Malkunst im neunzehnten Jahrhundert*.[21] Justi responded with an article in which he traced his 'Germanic' line back to its origins: 'Instead of the line of good *peinture* there is a quite different, self-sufficient line, to Thoma and further back to Caspar Friedrich, to the Nazarenes and Carl Philipp Fohr and finally to the masters of High and Late Gothic, to Grünewald'.[22] The referent of the 'line of good *peinture*' was Tschudi and the Centenary Exhibition. According to Justi, '*peinture*' satisfied no more than the eye. He was convinced, rather, that 'art is the generous, sumptuous figuration of spiritual value',[23] a 'capacity of the human soul to enter into the form and weave of Nature, a reverent experience of the earth, sea and sky, sun and clouds, a soft, magical music in the taut construction of a picture that only we Germans understand, a sound that haunts the paintings of Friedrich and Thoma, Goethe's poetry and Schumann's *Lieder*'.[24] To *peinture* and the emphasis of Romance or Latin art on the formal and aesthetic he opposed the 'Nordic yearning for expression'. The history of art was not a history of seeing but a history of feeling.

Justi was suspended from his post by the National Socialists in July 1933, which obviated the party-political takeover of his ideas. These were widely shared by his contemporaries, and indeed perilously close to the Nazi aesthetic at many points. Alois Schardt, a former assistant of Justi's, was appointed Acting Director. As such he planned and initiated the rearrangement both of the Kronprinzenpalais and of the Nationalgalerie.

Schardt's notions were not very different from Justi's, and in the Kronprinzenpalais, with which he began, he collected works showing a Romantic 'conception of the world and of art … with the emphasis being placed on the inner impulse which creates an outer form for

itself'.[25] On the ground floor he opened his hang with Runge, Blechen and Friedrich, also Fohr and Wasmann; on the first floor Hans von Marées was flanked by landscapes by Feuerbach and Thoma, and on the top floor there were Expressionist pictures. However, the point of placing the works by Marées where they were escaped even those colleagues who supported Schardt; they were unable to see any path from Marées's hermetic art to Expressionism. By contrast, the affinity of German Romanticism and Expressionism was a concept by now familiar and acceptable.

It was Schardt's intention to present in the Nationalgalerie's own building, in a second phase, the two other tendencies which he identified in German art, one towards naturalism, based on the idea that 'matter is the only certainty in the world', and the other represented by the Neoclassicists, Nazarenes and academic artists, who looked neither to the soul nor to the world, but to 'an idea transcending everything'.[26] But his display at the Kronprinzenpalais never opened. Schardt was not confirmed in his post, and his tenure ended in November 1933. The attempt by a number of art historians and by several functionaries of the new regime to establish Expressionism as a specifically German style and as the National Socialist style went, fortunately, no further. Schardt emigrated to the United States in 1939.

THE ALTERNATIVE WORLD OF HUMANISM

During the few months he spent in office Schardt, regarded as 'too strongly set in his views',[27] had an intellectual opposite in his colleague Paul Ortwin Rave. Rather than following through a 'line' Rave undertook research in a field, working with scholarly devotion on Schinkel and Blechen, writing articles and papers above all on art and architecture in Berlin, with learned application and minute attention to detail.

In 1931 Rave had installed in the Prinzessenpalais a Schinkel museum, which Schardt removed in 1933 for reasons of space. Schardt, however, in Rave's opinion, regarded 'all Neoclassical art, even of the age of Goethe, as virtually degenerate'.[28] For Rave, by all appearances, the opposite was the case, and the implicit goal of his busy occupation with Schinkel, Blechen and Goethe was cultural preservation. In their different spheres the artist Max Liebermann, the director of the Jewish Museum in Berlin Franz Landsberger and others felt similarly. It was no accident that in 1932 Rave reviewed Landsberger's *Kunst der Goethezeit* (Art in the age of Goethe),[29] and in 1949 himself published a similar work for post-war Germany, *Das geistige Deutschland im Bildnis. Das Jahrhundert Goethes* (Cultural Germany portrayed: Goethe's century).

For this work Rave used, somewhat extraordinarily, several plates from the catalogue of the exhibition *Grosse Deutsche in Bildnissen ihrer Zeit* (Great Germans in portraits of their own time), which he had

helped organise to accompany the 1936 Olympic Games in Berlin, and placed at the front of both volumes the same quotation from Goethe.[30] It would seem that Rave re-used these illustrations rather as one might write over a palimpsest, substituting for the idea of 'greatness' that of spirit. He had, indeed, done something similar before, having written and seen published in 1945 *Die Malerei des XIX. Jahrhunderts. 240 Bilder nach Gemälden der National-Galerie* (Painting in the nineteenth century: 240 reproductions of pictures in the Nationalgalerie), the Nationalgalerie's copy of which bears a swastika stamp, indicating its receipt there before the end of the war. After the Nazi capitulation, as the English words 'Printed in Germany' in the imprint prove, but still in the year 1945, Rave published *Deutsche Malerei des 19. Jahrhunderts* (German painting in the nineteenth century), a book so similar that it could be mistaken for the first, although there is a slightly different number of plates and they are in a slightly different order. Liebermann, whose works had been taken from the walls shortly before the Museum was closed because of the war in 1939, was absent from the former volume but is lavishly re-presented with seven works in the second, and Corinth is represented by *Ecce Homo,* a picture that had been impounded in 1937. The introductory text is longer and more outspoken in the second version. His general conclusion is: 'A multitude of possibilities became available – and this is in fact the style of our time, which this book sets out to recognise, appreciate and affirm. There is no longer and there no longer can be a single truth (as the philosophers never tire of telling us), and there is not only one art.'[31]

In the winter of 1949–50 Rave gave a series of lectures at Humboldt University in Berlin on the writing of history in the nineteenth century.[32] He traced the relationship of art to the history that was written of it from the middle of the century on, moving into the twentieth century and considering 'The Centenary Exhibition and its Consequences' in his thirteenth lecture; in the eighteenth lecture he considered the 1930s, with the title 'Ideas current in Europe' (referring to Pauli, Waldmann, Einstein and Scheffler), and in the final session 'Phenomenology and Existentialism in the History of Art?'. His question mark should no doubt be understood as a warning against renewed closure of thought.

NOTES

1 Cf. Tschudi to Bosse, the Minister for Culture, 23.04.1896: draft letter in the Central Archives, Gen. 10, Bd. IV, at 626/96.

2 Hugo von Tschudi, 'Kunst und Publikum' (1899), in Hugo von Tschudi, *Gesammelte Schriften zur neueren deutschen Kunst*, ed. E. Schwedeler-Meyer, Munich 1912, p. 73.

3 Ibid. 4 Ibid., p. 75. 5 Ibid., p. 69.

6 Emperor William II, 'Die wahre Kunst', 18.12.1901, quoted Ute Lehnert, *Der Kaiser und die Siegesallee*, Berlin 1998, p. 249.

7 Tschudi 1899 (cited note 2), p. 66.

8 Angelika Wesenberg, 'Impressionismus und "Deutsche Jahrhundert-Ausstellung 1906"', in Munich 1996, pp. 364–70.

9 Hugo von Tschudi, 'Ausstellung deutscher Kunst aus der Zeit von 1775–1875 in der Königlichen Nationalgalerie Berlin 1906', in Tschudi 1912 (cited 2), p. 173.

10 Ibid., p. 204.

11 Alfred Lichtwark, *Briefe an die Kommission für die Verwaltung der Kunsthalle*, 20 vols., Hamburg 1896–1920, XIV, p. 11 (03.01.1906).

12 Hugo von Tschudi, Foreword to the catalogue of the collection of Kgl. Rat Marczell von Nemes, Budapest, exhibited Alte Pinakothek, Munich, 1911, in Tschudi 1912 (cited note 2), p. 227.

13 Ibid., p. 229.

14 Peter-Klaus Schuster, 'Hugo von Tschudi und der Kampf um die Moderne', in Munich 1996, p. 35f.

15 Heinrich Wölfflin, *Kunstgeschichte des 19. Jahrhunderts, Akademische Vorlesung aus dem Archiv des Kunsthistorischen Instituts der Universität Wien*, ed. with commentary Norbert M. Schmitz, Alfter 1994, p.129.

16 Ludwig Justi, *Deutsche Malkunst im neunzehnten Jahrhundert. Ein Führer durch die Nationalgalerie*, Berlin 1920, p. 404.

17 Ibid., p. 406f.

18 Ludwig Justi, *Werden, Wirken, Wissen, Lebenserinnerungen aus fünf Jahrzehnten*, ed. Thomas W. Gaehtgens and Kurt Winkler, Berlin 2000, I, p. 443.

19 Ibid., p. 512.

20 Ibid., I, p. 413f., II, p. 247.

21 Ludwig Justi, *Deutsche Malkunst im 19. und 20. Jahrhundert*, I, *Von Runge bis Thoma*, Berlin 1932.; II, *Von Corinth bis Klee*, Berlin 1931.

22 Ludwig Justi, 'Volkstum und öffentliche Kunstsammlung', quoted Kurt Winkler, 'Ludwig Justis Konzept des Gegenwartsmuseums zwischen Avantgarde und nationaler Repräsentation', in 'Die deutsche Kunst ...' 1998, p. 74.

23 Justi 2000 (cited note 18), p. 442.

24 Ibid., p. 462.

25 Alois Schardt to Rust, the Minister for Culture, 09.11.1933, typescript (photocopy), Central Archives, Staatliche Museen zu Berlin, Schardt documents. See also Andreas Hüneke, 'Alois Schardt und die Neuordnung der Nationalgalerie nach völkischen Gesichtspunkten 1933', in 'Die Deutsche Kunst ...' 1998, pp. 82–96.

26 Ibid.

27 Paul Ortwin Rave, *Kunstdiktatur im Dritten Reich*, Hamburg 1949, p. 34.

28 Ibid., p. 34.

29 Paul Ortwin Rave, 'Franz Landsberger, *Die Kunst der Goethezeit*', in *Deutsche Allgemeine Zeitung* (Berlin), 22.03.1932.

30 See Paul Ortwin Rave, *Kunst in Berlin. Mit einem Lebensbericht des Verfassers von Alfred Hentzen*, Berlin 1965, p. 199.

31 Paul Ortwin Rave, *Deutsche Malerei des 19. Jahrhunderts*, Berlin 1945, pp. 13, 37.

32 Handwritten lecture plan, Central Archives, Staatliche Museen zu Berlin, Rave estate.

Romantic Landscape

Is it not strange that the very period that, more than previous ages, develops the imagination also wants to find in the fantastic and marvellous more meaning, sense and connection, both inner and outer, than had been demanded earlier from those works of art that had, one might say, been formed completely by the operation of reason? But one sees again how in each generation One Spirit manifests itself in many areas and feelings. People who do not even know or understand Novalis are nonetheless related to him.

Ludwig Tieck, *Eine Sommerreise* (A summer journey), 1834

Close your bodily eye so that you may first see your picture with your mind's eye. Then bring to the light of day what you have seen in the dark, so that it may reflect back on others from outside to inside.

Caspar David Friedrich, 1830

Gothic architecture has a meaning, and the very highest meaning; and, while painting generally has to be satisfied with no more than weak, indeterminate, misleading, distant intimations of the divine, by contrast architecture, so conceived and applied, can depict and embody the infinite almost directly, merely by the imitation of the wealth of nature, even without reference to the ideas and mysteries of Christianity, although these have had no little influence on the genesis and development of church architecture.

Friedrich Schlegel, *Ansichten und Ideen von der christlichen Kunst*

(Aspects and ideas of Christian art), 1823

Like music, landscape painting can express only general feelings, it cannot express thoughts plainly. The reason for this is that we have lost the key to the language of nature, and stepped outside the great natural harmony, and therefore, too, most of the feelings that the observation of nature arouses in us are of a sorrowful, yearning kind.

Ludwig Richter, *Lebenserinnerungen eines deutschen Malers*

(Memoirs of a German painter), 1879

Caspar David Friedrich stands at the heart of the German Romantic landscape tradition. His landscapes derive from minute observation of nature and are often based on drawings he made on walking expeditions in the German countryside. The transcription of nature was never the sole aim of his meticulous, highly finished paintings. Rather, he held that the artist must look through the mind's eye, and that what he saw there allowed him to invest his works with poetic feeling and transcendent significance.

Friedrich's Tetschen Altarpiece of 1808 (fig. 37), the first of his crucifix landscapes, stands as a manifesto. The painting was conceived as an altarpiece for a private chapel (though never installed there). It is primarily a mountain landscape, however, the religious dimension indicated only by a slender carved and gilded crucifix rising above the trees to catch the rays of the setting sun, not unlike a shrine a wanderer might come upon in his travels. For Friedrich, landscape revealed the spirituality inherent in nature and was entirely commensurate with Christian belief. (The symbol-laden frame was carved to the artist's own design.) Rejecting centuries of traditional Christian iconography, Friedrich here opened up new vistas in German painting.

Friedrich was also concerned with German yearning for liberation, especially as the nation struggled against Napoleonic occupation. He often employed such landscape motifs as massive oak trees to signify the aspirations of the German people (see cat. 10). His slightly younger contemporary, and one of the artistic geniuses of the age, the architect and painter Karl Friedrich Schinkel, also explored such themes in his panoramas and landscape paintings, often dominated by vast Gothic cathedrals (see cat. 1, 3). For him, Gothic architecture was German architecture and a potent symbol of the German people. During these same years Philipp Otto Runge (1777–1810) was developing a highly personal symbolic language charged with psychological tension, especially when, as in his *Hülsenbeck Children* (fig. 38), he explored the complex and tentative emotional landscape of young peoples' lives.

Friedrich's paintings were acquired by King Frederick William III as early as 1810. His reputation faded after his death, however, and the exalted position he now holds in nineteenth-century German art derives from a reappraisal of his achievement carried out by early twentieth-century critics. In recent decades that reputation has travelled abroad, as his central role in the European landscape tradition has been acknowledged. Moreover, German Romantic painting as a whole has come to be seen as a central component of the wider European Romantic movement. CR

Fig. 37
CASPAR DAVID FRIEDRICH
The Tetschen Altarpiece (*Das Kreuz im Gebirge*), 1808
Oil on canvas, 115 x 110 cm
Sächsische Landesbibliothek, Staats- und Universitäts-bibliothek, Dresden

Fig. 38
PHILIPP OTTO RUNGE
The Hülsenbeck Children (*Die Hülsenbeckschen Kinder*), 1805–6
Oil on canvas, 131.5 x 143.5 cm
Hamburger Kunsthalle, Hamburg

Karl Friedrich Schinkel

1781–1841

1 Medieval City on a River (Mittelalterliche Stadt an einem Fluß), 1815

Oil on canvas, 94 × 140 cm

Inv. no. Schinkel-Museum A 2

PROVENANCE On deposit with the Nationalgalerie since 1914

REFERENCES Waagen 1844/ 1980, p. 335f.; Berlin 1981a, pp. 56f. and 247; Berlin 1981b, p. 50f.; Galerie der Romantik 1986, p. 74f.; London 1991, no. 22

NOTES

1 Waagen 1844/ 1980, p. 330.

2 Ibid., p. 333.

3 Karl Friedrich Schinkel, 'Gedanken und Bemerkungen über Kunst im Allgemeinen', Wolzogen, no. 3, 1868, p. 367.

4 Waagen 1844/ 1980, p. 335f.

5 Ibidem.

6 Quoted in Berlin 1981b, p. 84.

7 Cf. Helmut Börsch-Supan in Berlin 1981a, p. 247.

Karl Friedrich Schinkel's impressive life's work comprised not only architecture, town-planning and 'heritage management' but also designs for stage sets and for the applied arts, and painting. He had drawn since his youth, and discovered landscape painting at an early stage. According to his friend and biographer Gustav Friedrich Waagen, he developed his talent for 'pure' landscape painting with a virtuosity 'otherwise unparalleled in the history of art'. Waagen was convinced that if Schinkel had devoted all his powers to it he would have been 'the greatest landscape painter of all time'.[1] Schinkel had, furthermore, done very important work in the field of 'historical' landscape, in which he would both faithfully depict nature and visualise art and life in other regions and eras.[2] Schinkel himself formulated his propensity to 'historical' landscape most succinctly while working on his masterpiece, A View of Greece in the Golden Age (Blick in Griechenlands Blüte, 1825; formerly Nationalgalerie, Berlin, lost in 1945): 'Landscape views have particular interest if traces of human existence appear in them.'[3]

In his youth Schinkel, the architect of classicist Berlin, was, 'in keeping with the patriotic enthusiasm of that period, enthralled with the grandeur and magnificence of the Middle Ages'.[4] Waagen described Medieval City on a River as 'the ceremonial entry of a German emperor into his palace, which is dominated by a huge Gothic cathedral of the most beautiful form, resplendent with the richest ornament'; it provided a 'superb idea of altdeutsch (Old German) art and splendour'.[5]

Schinkel painted this picture at the climax of the Wars of Liberation. Prussia had risen up in 1813 in an attempt to shake off French dominion. The hope that this would lead to the formation of an enlightened German nation had also arisen. The Romantics used the German Middle Ages to inform their ideal of renewal, and transfigured the Gothic style, which they regarded as German, into a symbol of the national unity and strength for which they yearned. As well as paintings featuring Gothic architectural motifs (see further cat. 3), Schinkel also made designs for a Gothic cathedral memorialising the Wars of Liberation, commissioned by King Frederick William III of Prussia (fig. 10, p. 21). Schinkel conceived this building as a religious, historical and 'living' monument, for 'through the style of its decoration' it was to be 'founded for the people which lives on and flourishes'.[6]

In the painting Schinkel shows the sunlit west façade of a Gothic cathedral against a dark stormy sky heavy with rain. The top of the north tower on the west front is still unfinished, but a white flag on which the imperial eagle can be discerned is fluttering on the scaffolding. The bad weather seems to be passing over; there are glimpses of the blue of the sky through the first breaks in the clouds. A rainbow arches from the palace on the left above and beyond the cathedral towards the medieval town set further back on the right. The High Gothic architecture of the church is articulated with exceptional detail and recalls the cathedrals of Strasbourg and Rheims, but associations with Cologne cathedral above all are suggested by the uncompleted north tower on the west front and the design of its upper storeys. Prominent figures in public life, such as Goethe, Sulpiz Boisserée, Crown Prince Frederick William, Johann Joseph von Görres and Freiherr vom Stein, had advocated that Cologne Cathedral, left uncompleted in the Middle Ages, should now be finished to mark the rebirth of the German nation. Schinkel, too, was involved in discussions of its restoration and made designs for its continuation. After the original design for the façade had resurfaced in 1814, the completion of the Cathedral finally got underway in 1842.

Schinkel combined the idea of an architectural project still to be completed with the ceremonial entry of a ruler into his residence. Passing members of the populace greet the prince gladly, with only a hermit remaining in his place of retirement on the right under the oak trees. The scene can surely be interpreted as a simile for the victorious return of Frederick William III from the Napoleonic Wars.[7]

The Medieval City was intended by Schinkel to be a pendant to his Greek City by the Sea (Griechische Stadt am Meer; formerly Nationalgalerie, Berlin, lost in 1945), painted in the same year. By grouping the two works together he emphasised that for him the cultural ideal of the northern Middle Ages was insufficient, and needed to be counterbalanced by Mediterranean antiquity. He came back to this view and again expressed his faith in classical antiquity ten years later, in his major work already mentioned, A View of Greece in the Golden Age. BV

2

Karl Friedrich Schinkel
2 *Morning (Der Morgen)*, 1813

Oil on canvas, 76 × 102 cm

Inv. no. A I 1135

PROVENANCE Given in 1911 by Bruno Cassirer,
Berlin; formerly in the possession of General Field-
Marshal Neidhardt von Gneisenau, Berlin, and his
descendants

REFERENCES Waagen 1844/ 1980, p. 351; Berlin
1981a, p. 245; *Galerie der Romantik* 1986, p. 68

Schinkel's *Morning* originally accompanied a pen-
dant *Evening* (*Abend*; formerly Nationalgalerie,
Berlin, lost in 1945), both commissioned by the
Prussian general August Wilhelm Anton Graf
Neidhardt von Gneisenau, 'to whom this matter
was so important that in the midst of the tumult
of war he still took time to exchange letters
with Schinkel regarding the details of the land-
scapes'.[1] Two years earlier, in 1811, Schinkel had
already attempted the subject of the times of
day in two large pen-and-ink drawings (lost in
1945). Many Romantic artists, notably Friedrich
(see cat. 6, 7) and Philipp Otto Runge besides
Schinkel, repeatedly took up this theme of tem-
poral cycles as a means of reflecting on the
social upheavals of the early nineteenth century.

In *Morning* two women dressed festively in

Renaissance costume walk with their children
towards a clump of beech trees. Warm, sum-
mery, morning light floods through the lush
tree-tops, and behind them the sun is already
up. Children play contentedly in the grass under-
neath the trees, while on the right-hand edge
of the grove two riders appear. Like the walkers
they, too, are dressed in Renaissance attire.
One's gaze travels past the antique remains
overgrown by vegetation in the left foreground
into the distance. There the sea extends to the
horizon, and on the coast there is a town fea-
turing magnificent Italian Renaissance domes.

This landscape scene is indisputably an 'his-
torical' one (see cat. 1). By referring back to
golden ages of the past, in this case the
Renaissance, Schinkel suggests a vision of social

3

renewal in Germany. Painted in 1813 during the Wars of Liberation, *Morning* is full of patriotic tumult and fervour. Its programmatic intentions become even clearer when it is visualised beside its pendant *Evening*. In this picture two eagles symbolising the struggle against Napoleon hovered in a storm over a rock surrounded by oak trees, while from it mighty waterfalls tumbled down into the deep. No doubt completely in line with the wishes of Schinkel's patron, the two pictures were conceived as heralding the dawn of a new age after a dark and stormy night. BV

1 Karl Friedrich Schinkel, 'Gedanken und Bemerkungen über Kunst im Allgemeinen', *Wolzogen*, no. 3, 1868, p. 351.

Karl Friedrich Schinkel

3 *Gothic Church on a Rock by the Sea (Gotische Kirche auf einem Felsen am Meer)*, 1815

Oil on canvas, 72 × 98 cm

Signed bottom centre: *Schinkel. inv. 1815*

Inv. no. W.S. 200

PROVENANCE Bequeathed by Konsul Wagener in 1861

REFERENCES Berlin 1981a, p. 249f.; *Galerie der Romantik* 1986, p. 73f.

During his first trip to Italy, in 1803, Schinkel stayed in Istria, where he visited the coastal town of Pirano. Its cathedral by the sea made a lasting impression on him. 'On a rock that extends out from the town into the sea stands the main church of the city, which, with its tall tower that seems to have been built after the pattern of the campanile of St Mark's in Venice, produces a magnificent effect.'[1]

Schinkel worked the experiences gained on that Italian journey into his 'historical' landscapes envisaging the Middle Ages. In 1813, with *Gothic Cathedral by a River (Gotischer Dom am Wasser*; Nationalgalerie, Berlin), he initiated a series of pictures featuring cathedrals; he painted *Gothic Church on a Rock by the Sea* two years later. A group of elegantly dressed gentlemen are

depicted riding towards a harbour during the hours of darkness. The stormy wind blowing in from the sea plucks at the riders' plumed hats and cloaks and violently shakes the bushes and trees. They pass a Gothic wayside shrine on the right, which Schinkel based on one at Halle an der Saale dating from 1455. On the left, near the sea, a cathedral rises majestically as if it had grown out of the rocks. The low-lying sun remains hidden behind the pinnacles of the church, illuminating the house of God auspiciously.

Schinkel's cathedral pictures reflect the political and spiritual situation in Germany after the collapse of the Holy Roman Empire. Patriotism, roused by feeling against Napoleon between 1813 and 1815, prompted the Romantics to idealise the German Middle Ages as a period of national unity and strength, which they should take as a model for their own time. In these years, under the influence of Romantic writers whom he knew such as Clemens Brentano and Achim von Arnim, Schinkel's preferred subjects became the stories and materials of history, *altdeutsch* (Old German) themes and Gothic architecture (which they assumed to be of German origin). In his essay on his Gothic design of the Prussian Queen Luise's Mausoleum in the park of Schloss Charlottenburg, Schinkel claimed Gothic to be the expression of a collective spirit, as a 'will to form arising from the original aspiration of the race combined with the ideas of Christianity. In this the spirit achieved full victory over mass or matter.'[2]

Schinkel's picture was probably commissioned by the Berlin banker Konsul Wagener, who began his collecting activity with its purchase in 1815, the year it was painted. Almost half a century later, in 1861, the Wagener collection was donated to the king of Prussia to form the basis of the Nationalgalerie. BV

1 Karl Friedrich Schinkel, *Reisen nach Italien*, ed. Gottfried Riemann, Berlin 1979, p. 38

2 Quoted Berlin 1981a, p. 244.

4

Karl Friedrich Schinkel

4 *The Rugard on Rügen (Der Rugard auf Rügen)*, 1821

Oil on paper on canvas, 51 × 132 cm

Signed bottom right: *Schinkel 1821 Rugard auf Rügen*

Inv. no. NG 6/91 (Schinkel-Museum A 17)

PROVENANCE Transferred to the Nationalgalerie in Berlin in 1914

REFERENCES Berlin 1981a, p. 259f.; *Galerie der Romantik* 1986, p. 83f.

Schinkel painted three landscapes in 1821, following a journey to Stettin and the island of Rügen in the Baltic Sea: a view of the Stubbenkammer hill on Rügen, a view of the town of Stettin and, as a pendant to this, a view of the Rugard chain of hills on Rügen, which is the only one of the three to have survived.

Seen as if in bird's-eye view the hilly coastal landscape extends to the horizon in the evening light of an autumn day. The panoramic format conveys the impression of infinite expanse; it almost seems possible to discern the curve of the earth. The view was taken from the tower of the church of Bergen – the town nestling in the foreground – looking north-east over the Rugard hills to the bay of Prorer Wieck, with the steep slopes of the Schanzenberg in the centre.

In selecting this panoramic format Schinkel was reverting to his early practice as an artist. In 1805 he had returned from a journey to Italy full of impressions and ideas. While there was as yet no opportunity to fulfil his architectural ambitions, he exhibited dioramas and panoramas, in particular a panorama of Palermo in 1808, with great success. He remained interested in panoramas throughout his life, and just two days before the onset of the illness that killed him he was planning a panorama in which the main monuments of every city and country in the world were to be assembled together.

In the 1820s Schinkel as a painter turned away from the Romantic, patriotic, medieval material of his earlier work (see cat. 1–3) to the naturalistic representation of things that could

be seen. Painted a year before *The Rugard on Rügen, Castle by a River* (*Schloß am Strom*; Nationalgalerie, Berlin) is Schinkel's last picture with a Romantic inflection. A few years later he expressly distanced himself from his earlier passionate enthusiasm for the Gothic: in conversation with Goethe, whom he visited in Weimar on his return from Italy in 1825, Schinkel described his Romantic landscapes as 'sins of my youth'.

When Schinkel showed *The Rugard on Rügen* with its pendant, *View of Stettin* (*Blick auf Stettin*), at the Berlin Academy in 1824, his new interest in painting from nature was attentively noted by contemporary critics. 'Herr Schinkel has submitted for exhibition … two landscapes of places in his native country. Wheresoever this

master turns his hand, the Muse favours him, and indeed these landscapes again reveal his universal genius, although they are a complete departure from the landscape style with which we have been familiar in his work hitherto.'[1] Schinkel's movement towards naturalistic landscape was continued and developed fully by Eduard Gaertner (cat. 34, 35) in his town views, in particular his famous panorama of Berlin seen from the roof of the Friedrichswerder church (Schinkel Pavilion, Schloss Charlottenburg, Berlin). BV

1 *Königliche privilegierte Berlinische Zeitung*, Berlin 1824, no. 263.

Caspar David Friedrich

1774–1840

5 *Greifswald Harbour (Der Greifswalder Hafen)*, c. 1818–20

Oil on canvas, 90 x 70 cm

Inv. no. A II 536

PROVENANCE Acquired in 1919 from the collection of Rear-Admiral Kirchhoff, Warnemünde

REFERENCES Justi 1920, p. 315f.; Sumowski 1970, p. 75f.; Börsch-Supan and Jähnig 1973, p. 484, no. 1; Schmied 1975, p. 76; *Galerie der Romantik* 1986, p. 40f.

NOTES

1 Quoted in Hinz 1974, p. 204f.

2 Ibid., p. 94.

3 Justi 1920, p. 315f.

'If one goes back five or six decades in the history of landscape painting, particularly in Germany, one encounters a branch of art in a pretty bleak condition', wrote Carl Gustav Carus, a friend and pupil of Caspar David Friedrich, in 1840. In landscape painting, Friedrich had 'intervened with a thoroughly deep-thinking and energetic mind and in an absolutely original way in the desert of the prosaic, stale and commonplace, and, while he struck out only with an austere melancholy, from its midst an individual, new, luminous, poetic direction emerged.' Carus appreciated the pictures of the greatest landscape painter of the German Romantic movement as the expression of a 'new, profoundly spiritual (*urgeistig*)' tendency in art. In this he acknowledged the insight of his fellow artist the Frenchman David d'Angers, who had recognised Friedrich as the 'discoverer of the tragedy of landscape'.[1]

In Friedrich's conception, art could only come into being through visionary seeing and imagination: 'Close your bodily eye so that you may first see your picture with your mind's eye. Then bring to the light of day what you have seen in the dark, so that it may reflect back on others from outside to inside.'[2] Friedrich freed the representation of landscape from traditional categories – the *veduta* or topographical view, or the composite or ideal landscape – seeking instead to introduce feeling in his pictures and to convey the meditative experience of devotion to nature. Using motifs such as ships at sea, moonlight, dry oak trees, Gothic ruins or lonely mountain peaks, he created for himself a vocabulary of 'divine symbols' in which a spiritual content was encoded.

Friedrich's early fame rested on three paintings: *The Cross in the Mountains* or *Tetschen Altarpiece* (fig. 37, p. 59), which caused a critical storm in 1809, and the two works purchased by the King of Prussia in 1810, *Monk by the Sea* and *Abbey in the Oakwood* (figs. 11 and 12, pp. 22–3). His work after that date, however, was soon overlooked, as Realism became dominant. Only following a reappraisal by the Norwegian critic Andreas Aubert in the very early twentieth century was public interest in Friedrich's work reawakened. Then in 1906, on the occasion of the Centenary Exhibition at the Berlin Nationalgalerie devoted to German art between 1775 and 1875, Friedrich's work was finally given full recognition.

Friedrich probably painted *Greifswald Harbour* between 1818 and 1820. The university and port of Greifswald on the Baltic Sea had been Friedrich's birthplace and home, and he remained closely associated with it throughout his life. He returned there regularly, whether to visit relations or to walk through the surrounding countryside and sketch. Greifswald was also the site of early traumatic experiences. Friedrich's childhood was shattered by deaths in his family, which deepened his propensity to melancholy. His mother died when he was seven years old, his sister died one year later, and when he was thirteen his brother was drowned before his eyes while ice-skating.

In *Greifswald Harbour* ships and boats returning to port or already lying at anchor are a simile for the voyage of life, indicative of the dangers, uncertainties and finite nature of its course. Significantly, Friedrich has placed in the centre of his composition a particularly magnificent sailing ship, which in contrast to the fishermen's boats is destined to travel across the wide expanse of the oceans. Against the silhouette of the town, and the outlines of the churches of St Mary, St Nicholas and St James, described with topographical accuracy, the ship's masts stand out bereft of their sails. An immense evening sky of shimmering gold overarches the terrestrial comings and goings of the fishermen and sailors.

An infrared photograph of the painting made in 1974 revealed that the figures of the fishermen in the foreground and the boat they are unloading were added subsequently. Since the style of the figures is manifestly untypical of Friedrich it is clear that the composition of the foreground is not the artist's own.

The Nationalgalerie acquired the picture in 1919 and the next year Ludwig Justi, Director at that time, paid tribute to it in his survey of German nineteenth-century painting in the Museum: 'The secret music of this picture is revealed to us only if we imagine the inner animation of the ship. Ardour and longing and dreaming live in these forms apparently reproduced so matter-of-factly.'[3] BV

5

6

Caspar David Friedrich

6 *The Solitary Tree* (*Der einsame Baum*), 1822

Oil on canvas, 55 × 71 cm

Inv. no. W.S. 52

PROVENANCE Bequeathed by Konsul Wagener in 1861

REFERENCES Justi 1920, p. 312f.; Wolfradt 1924, p. 159f.; Börsch-Supan and Jähnig 1973, no. 298; Schmied 1975, p. 96; *Galerie der Romantik* 1986, p. 44f.; Hoch 1987, p. 145f.

In 1822 the Berlin banker Konsul Johann Heinrich Wagener, whose collection of art would later form the nucleus of the Berlin Nationalgalerie, commissioned from Friedrich two pendant pictures representing the times of day, a morning and an evening landscape. By November of the same year Friedrich reported in a letter to his patron that both paintings were finished. *The Solitary Tree* was the picture of morning, though it has been catalogued under various titles: in Wagener's own collection it was known as *A Green Plain* (*Eine grüne Ebene*), the first Nationalgalerie catalogues called it *Landscape in Harz* (*Harzlandschaft*) and it was first given its generally accepted title *The Solitary*

Tree in the early twentieth century by the Nationalgalerie curator Ludwig Thormaehlen.

Friedrich has depicted the broad expanse of a meadow landscape with ponds, groups of trees and villages extending as far as a range of mountains; just in front of the mountains rise the towers of a distant Gothic town. In the distance the softly rounded peaks of the Jeschken (Ješted) range in northern Bohemia (modern Czech Republic) can be discerned; Friedrich had observed these and recorded them in a drawing while walking through the Isergebirge in the summer of 1810. Indeed, during this walking tour Friedrich had recorded his impressions in a great many sketches and drawings, which

7

he used as models for numerous pictures over later years (see further cat. 11).

A mighty oak rises like a monument in the middle of the composition. Standing by a marshy pond which reflects the sky, it provides shelter for a shepherd whose scattered sheep are grazing the water meadows. Its powerful trunk has withstood wind and weather, but at the top of the giant tree there are already dead branches. Clouds have formed in an arc above the oak and its uppermost branches seem to reach up into them. For the oak, Friedrich referred to studies of such trees he had made between 1806 and 1808 around Neubrandenburg and later in the Riesengebirge.

The oak in this picture is a symbol of the life force and strength of nature, while at the same time its dead branches are a reference to spheres beyond life. Firmly rooted in the ground yet reaching towards the sky, the oak becomes an intermediary between earth and heaven – as if 'the universe pivoted round this tree'.[1] BV

1 Wolfradt 1924, p. 159f.

Caspar David Friedrich

7 *Moonrise over the Sea* (*Mondaufgang am Meer*), 1822

Oil on canvas, 55 × 71 cm

Inv. no. W.S. 53

PROVENANCE Bequeathed by Konsul Wagener in 1861

REFERENCES Justi 1920, p. 318f.; Wolfradt 1924, p. 24f.; Börsch-Supan and Jähnig 1973, no. 299; Schmied 1975, p. 98; *Galerie der Romantik* 1986, p. 46f.

For Friedrich, as for many Romantic artists and writers, cycles of the times of day and the

seasons had a special value. Like others, Friedrich linked his own experiences of the course of life between birth and death with the theme of changes in time. This was a way of perceiving the greater rhythm which carries and forms human beings as well as natural phenomena and the events of the cosmos.

This moonlit landscape – a favourite theme (see also cat. 9) – was the picture of evening pendant to the picture of morning (cat. 6) in Friedrich's pair of paintings of the times of the day for Konsul Wagener. The surface of the sea is lit up with silvery highlights by the reflection of the rising full moon, which is half hidden behind the banks of clouds above the horizon, with its light seeming to break forth as if through a gateway. Complementary colours of blue, purple and a yellow that ranges from golden to whitish bond the composition and lend it tension. Fascinated by this phenomenon of nature, three people have sat down on the mighty rocks on the shore and are looking intently into the distance, towards the moon and the two sailing ships: their dark silhouettes impart rhythm to the illuminated surfaces of sea and sky. As Willi Wolfradt wrote in his monograph on Friedrich:

'They sense the ebb and flow of the lapping water, the strange transience of appearances, the mystery of where they come from and whither they are going. The weight of the elemental penetrates their pious hearts and fills them with the muteness of stone. Yet the more militantly their minds look into the wonderful light, yearning carries them towards the distance. And as they lose themselves in the prodigious journey and yet, at the same time, an unspoken awareness of being earthbound ties them to the old, deep existence of the rocks, the heartbeat of all contemplation takes form.'[1]

A reassuring mood emanates from the painting, imparted by the security of the three figures in friendly communion and the ships returning to harbour. But the immensity of the universe is also felt. If the predominant theme in *The Solitary Tree* is concentration on this life, in this picture of evening nature is revealed in transcendent beauty, while the moon is a symbol of hope, leading our thoughts to premonitions of the world beyond. BV

1 Wolfradt 1924, p. 24f.

Caspar David Friedrich

8 *Woman at the Window (Frau am Fenster)*, 1822

Oil on canvas, 44 × 37 cm

Inv. no. A 1918

PROVENANCE Acquired in 1906 from the painter's family in Greifswald

REFERENCE Börsch-Supan and Jähnig 1973, no. 293

Friedrich was virtually rediscovered in the preparations for the Centenary Exhibition at the Nationalgalerie in 1906, when he was represented to the public at large with over thirty pictures, and his work was the sensation of the show.

This small, private, almost intimate picture of his wife Caroline, née Bommer, whom he had married in 1818, was on view in 1906 for the first time since it had first been exhibited at the Dresden Academy in 1822. It shows Caroline standing in Friedrich's sparsely furnished studio in the house on the Elbe where they had lived since 1820. The picture remained in the possession of the painter's family in Greifswald until the Nationalgalerie acquired it shortly after the exhibition.

In the catalogue of the exhibition Julius Meier-Graefe described this picture (and all the others) from an Impressionist point of view. He appreciated it in purely painterly terms, and in doing so heightens our own sensibility to qualities of this kind that the picture indeed possesses, for instance the marvellous changing greens of Caroline's dress, but also some incidentals easy to overlook: '… the ochre at the corners of the window makes all the difference … the trees in light greenish yellow, and beneath them a delicate streak of yellow.'[1] Though this is a comparatively simple work by Friedrich, close study in formal terms – of the motif of the statuesque figure viewed from the rear, of the picture-plane constructed in balanced verticals and horizontals, of the harmonious, muted tones of blue, green and ochre – compels our appreciation of the extremely subtle colouring and the exquisite gradations of light.

'Window pictures' had been popular particularly in Dutch painting, and became so again in the nineteenth century. It was predominantly women who were depicted, women

in their domestic environment. The juxtaposition of inside and outside, of internal and external worlds, was essential to such pictures. Generally the outside comes in, as light and movement, as life. Friedrich's *Woman at the Window* is characterised by a particularly stark opposition between the austere room and the open air. The window permits the entry of a slanting top light. Caroline looks through the open middle area of the lower window across the Elbe to the far bank lined with poplar trees. There is traffic on the river, and we can discern the rigging of two sailing boats.

Only three pictures of interiors by Friedrich are known: this one, *Woman with a Candlestick (Frau mit Leuchter*, 1825; lost) and *Woman on the Stairs (Frau auf der Treppe, c.* 1825; private collection, Hamburg). The other two also featured his wife Caroline and significantly they, too, remained in the family. But for all the domesticity of their subject-matter, like Friedrich's landscapes these three pictures also have a deeper meaning and symbolism. In common with nearly all window pictures from the Romantic period, for instance those by Georg Friedrich Kersting or by Moritz von Schwind (see cat. 19, 20), this work, too, was intended to convey a sense of yearning. Over and above the opposition between dark and light and limit and expanse, Friedrich's *Woman at the Window* expresses the soul's (Romantic) longing to escape from earthly confinement into the infinity of Nature – in a particularly impressive way. The river, the ship and the bank on the far side, for all their objective reality, are at the same time symbols, with an existential and religious content. AW

1 *Die deutsche Jahrhundertausstellung Berlin 1906*, II, Munich 1906, no. 516, p. 162.

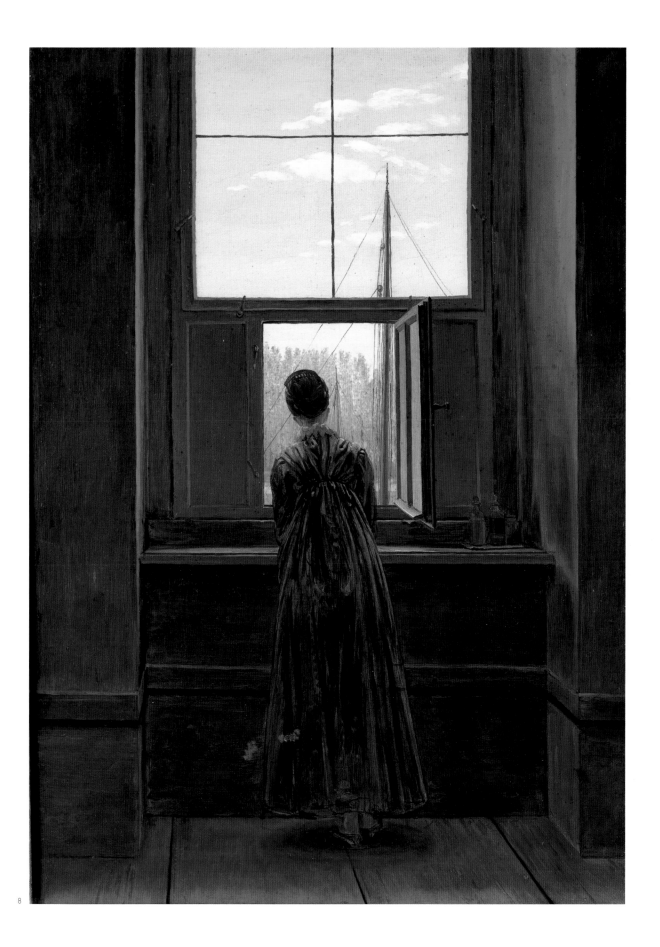

8

Caspar David Friedrich

9 *Man and Woman contemplating the Moon (Mann und Frau in Betrachtung des Mondes)*, c. 1818–25

Oil on canvas, 34 × 44 cm

Inv. no. A II 887

PROVENANCE Acquired in 1935 from the Galerie Nathan, St. Gallen, in exchange for five paintings, including works by Camille Pissarro, Alfred Sisley and Max Liebermann

REFERENCES Hanfstaengel 1937, p. 217; Sumowski 1970, pp. 131, 179; Börsch-Supan and Jähnig 1973, no. 404; Schmied 1975, p. 82f.; *Galerie der Romantik* 1986, p. 50f.

NOTES

1 *Handwörterbuch des Deutschen Aberglaubens,* Berlin 1934, IV, col. 481.

2 Clemens Brentano, *Werke,* ed. F. Kemp, Darmstadt 1963, II, p. 155.

3 Ludwig Tieck, *Schriften,* I, Berlin 1828, p. 33.

4 Joseph von Eichendorff, *Sämtliche Werke. Kritische Ausgabe,* Stuttgart, Berlin, Cologne 1993, I, p. 327.

5 Quoted Schmied 1975, p. 82.

6 Börsch-Supan and Jähnig 1973, no. 366.

7 Quoted ibid., p. 356.

8 Quoted Kaspar Monrad, *Caspar David Friedrich und Dänemark,* Copenhagen 1991, p. 77f.

'Night and the moon have always been associated with a feeling for the strange, the secret, the hidden', according to a dictionary of German superstitions.[1] In the work not only of Friedrich but of most of the philosophers, writers and painters of the Romantic period moonlight was a metaphor of exceptional significance. Moonlight had magical powers that stimulated artists' imaginations. The moon embodied the world of feeling, the dimly intuited, the feminine; it was a zodiacal sign for the soul. A moonlit night could serve to convey the Romantics' poetic sensibility and intellectual recognition of the 'dark side', developed in opposition to the Enlightenment. In the moonlit landscape the eternal divine was to be encountered and could have effect on one's own existence. Far from being a mere landscape motif, the moon became the object of a personal relationship, something trusted and familiar, its bright orb in the inky black sky heralding a more beautiful existence and auspiciously casting a light from the past into the darkness of the present. 'When the moon's quietly soothing tears/ Wash away the hidden sorrow of the nights/ Peace is in the air', Brentano says in one of his poems.[2] Ludwig Tieck adjured the 'magic moonlit night/ Which grips the senses,'[3] and Joseph von Eichendorff's poem '*Mondnacht*' (Moonlit night) contains the lines 'And my soul stretched/ Its wings out wide,/ Flew through the quiet lands,/ As if flying home.'[4]

Moonlight and twilight especially attracted Friedrich: 'Twilight was his element,' his friend Carus recalled: 'a solitary walk early in the first morning light and then a second in the evening at sunset or after, though then he was happy for the company of a friend: those were his only distractions.'[5] Friedrich himself commented ironically on his fondness for moonlight, saying that no doubt he would go to the moon after he died, as he painted nothing but moonshine.

In *Man and Woman contemplating the Moon* a woman pauses on a hillock near a dramatically contorted uprooted oak during a nighttime walk through the mountain forest. Enveloped in darkness, the couple direct their eyes towards the moon with its promise of solace, its light filling the air like a veil, solemn and still. Already in 1840, in a letter written to the Dresden Gallery, the painter Johan Christian Clausen Dahl conjectured that Friedrich had depicted himself in this picture with his young wife Caroline. She has placed her arm trustingly on the shoulder of her companion as they contemplate the moon together. The depth of the moonlit night endows the trees and rocks with a strange, almost uncanny stature and significance, but also the very power of nature serves to draw the two people closer. Facing together the realisation of their own transience, they are united by their experience of the mystery of the unfathomable.

Friedrich painted a first version of this composition, *Two Men contemplating the Moon* (*Zwei Männer in Betrachtung des Mondes*; Galerie Neue Meister, Dresden) in 1819. Another version was recently acquired by the Metropolitan Museum of Art, New York.[6] Karl Förster, a critic who, along with the painter Peter Cornelius, spent some time in Friedrich's studio in 1820, reported: 'Two young men swathed in cloaks look out enchanted at a moonlit landscape, their arms round one another's shoulders. "They're plotting some demagogic intrigues," Friedrich said ironically, as if by way of explanation.'[7] Friedrich was referring to the climate of repression and censorship during the restoration period that had followed the Wars of Liberation. He did not conceal his democratic views, and in many pictures, including this, depicted male figures wearing the *altdeutsch* (Old German) garb of the 'patriots', even during the time of their persecution and while the wearing of such clothing was banned. One who in 1814 had advocated wearing the medievalising costume as a badge and uniform of freedom and democracy was the patriot writer Ernst Moritz Arndt, a native, like Friedrich, of Greifswald.

There is some dispute over the date when this picture was painted. Various periods between 1818 and 1825 have been put forward with different justifications. One possibility is that Friedrich was inspired to paint this picture by his Danish guest Peder Hjort, who visited the artist in Dresden in 1817 and told him about an exceptional apparition of the moon which he had witnessed together with his fiancée near Copenhagen. Impressed by his description, Friedrich supposedly exclaimed: 'I'll paint it for you! Give me the lady's address, and you'll find the painting on her wall when you get back home from your travels.'[8] BV

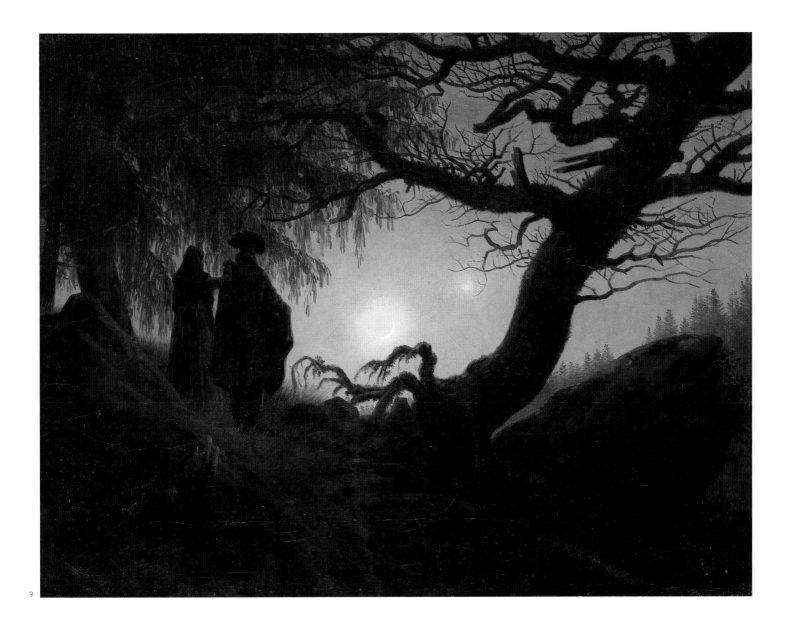

9

Caspar David Friedrich

10 *Oak Tree in the Snow* (*Eichbaum im Schnee*), 1829

Oil on canvas, 71 x 48 cm

Inv. no. A II 338

PROVENANCE Acquired in 1921 from the dealer F. Axt, Dresden

REFERENCES Sumowski 1970, pp. 117, 226, 238; Börsch-Supan and Jähnig 1973, no. 365; *Galerie der Romantik* 1986, p. 56f.

NOTES

1 Quoted Friedrich Möbius, 'Die Eichen in Caspar David Friedrichs Gemälde "Abtei im Eichwald"' in *Caspar David Friedrich. Leben. Werk. Diskussion*, ed. Hannelore Gärtner, Berlin 1977, p. 165.

2 Gotthard Ludwig Kosegarten, *Gedichte*, Leipzig 1788, II, p. 44f.

3 Friedrich Gottlieb Klopstock, *Herrmanns Schlacht*, in *Klopstocks Werke. Teil 4*, ed. R. Hamel, Berlin and Stuttgart [n.d.], p. 204.

4 Gotthard Ludwig Kosegarten, *Vaterländische Gesänge*, Greifswald 1813, p. 72.

5 Theodor Körner, *Werke. Teil 1*, ed. A. Stern, Stuttgart [n.d.], p. 73.

6 Quoted Möbius, as cited note 1, p. 168.

7 In an essay written in 1828 the Greifswald collector Carl Schilderer described Friedrich's painting *Dolmen in the Snow* (*Hünengrab im Schnee*; Staatliche Kunstsammlungen, Dresden) as an 'Old Fatherland scene'. Cf. Börsch-Supan and Jähnig 1973, p. 112.

8 Quoted Schmied 1975, p. 54.

The German Romantic movement discovered enormous expressive potential in the oak tree. Symbolically linked already with the mighty heroes of pre-history, the oak features in the poems of 'Ossian', published 'in translation' but actually written by James Macpherson in 1762–3 and well known in Germany by 1774, thanks to their prominence in Goethe's *Werther*. In Ossian the heroes often fall near oak trees, in combat they stand near the trunks of oak trees, after victory in battle they foregather round oak trees and 'consecrate the night to the songs of prehistory'.[1] In Ossian-influenced poems by the Rügen theologian and poet Gotthard Ludwig Kosegarten, whose ideas on nature and religion had a lasting impression on the young Friedrich, there are descriptions of oak trees as hoary giants which look down on the pygmy race of people of the present; they stand around the graves of the heroes of pre-history. 'They also planted offshoots of the sacred oak … these grew into trees climbing to the sky, and have now rustled on the hill for a thousand years.'[2] Ossian's heroes' oaks were given a national, patriotic interpretation by Friedrich Gottlieb Klopstock in his play *Hermanns Schlacht* (Hermann's battle, 1769), where the subject was no longer mythical giants fighting for their possessions and honour, but Germans opposing the occupying Romans: 'Oh, Fatherland, you are like the sturdiest, most shady oak in the innermost grove!'[3] The old oak that no storm had been able to break became a symbol of a national and social order that supposedly had existed since time immemorial. During the Wars of Liberation, the thousand-year-old storm-battered oak with the trunk that could not be bent became 'freshly verdant, high-topped, wide-spreading and shady',[4] as Kosegarten put it in the epilogue to his *Vaterländische Gesänge* (Songs of the Fatherland), published in 1813. Ernst Moritz Arndt (see also cat. 9) and Theodor Körner in particular linked their patriotic writings with the oak-tree motif: 'German nation, most magnificent of all, your oak trees are standing, you have fallen.'[5] In 1814, after the defeat of Napoleon, Friedrich Tieck wrote: 'Freedom, roars the oak wood.'[6]

Friedrich was preoccupied with the oak as with no other tree. Certain trees of impressive stature that he had drawn from nature he reproduced several times in different pictures with a patriotic context – his 'altvaterländisch' (Old Fatherland)[7] pictures. Generally the oaks are standing round cemeteries or dolmens, and it is often late autumn or winter. The oaks have a long history behind them, they have withstood wind and weather, they have been scarred by storms or struck by lightning. Friedrich selected trees full of character with obvious respect for their individuality.

In this painting, depicting a lonely oak lost in a wintry expanse of snow, the half-dead tree becomes a huge monument to transience. At its foot lie the mysteriously petrified remains of a toppled trunk, frozen into shapes reminiscent of fabulous creatures. The oddly twisting branches of the tree produce an extraordinary interlace decoration against the cool, brilliant blue of the sky.

This is not the only painting of an oak tree in which Friedrich opted for a winter scene. For him snow was 'the great white cloth, the embodiment of the utmost purity, under which nature prepared for new life'.[8] As is often the case in Friedrich's pictures, the oak tree has lost its foliage, but it is not dead, and will bear leaves and turn green again. The day is not oppressively overcast, on the contrary the light blue sky is a sign of hope. *Oak Tree in the Snow* is the most distilled, and the most mature in composition, of Friedrich's variations on the motif of the oak tree in a winter landscape, such as *Dolmen in the Snow* (*Hünengrab im Schnee*, 1807; Staatliche Kunstsammlungen, Dresden), *Winter* (1808; formerly Bayerische Staatsgemäldesammlung, Munich, destroyed by fire in 1931), *Churchyard in the Snow* (*Klosterfriedhof im Schnee*, 1810; formerly Nationalgalerie, Berlin, lost in 1945) and another painting entitled *Oak Tree in the Snow* (1827; Wallraf-Richartz Museum, Cologne). BV

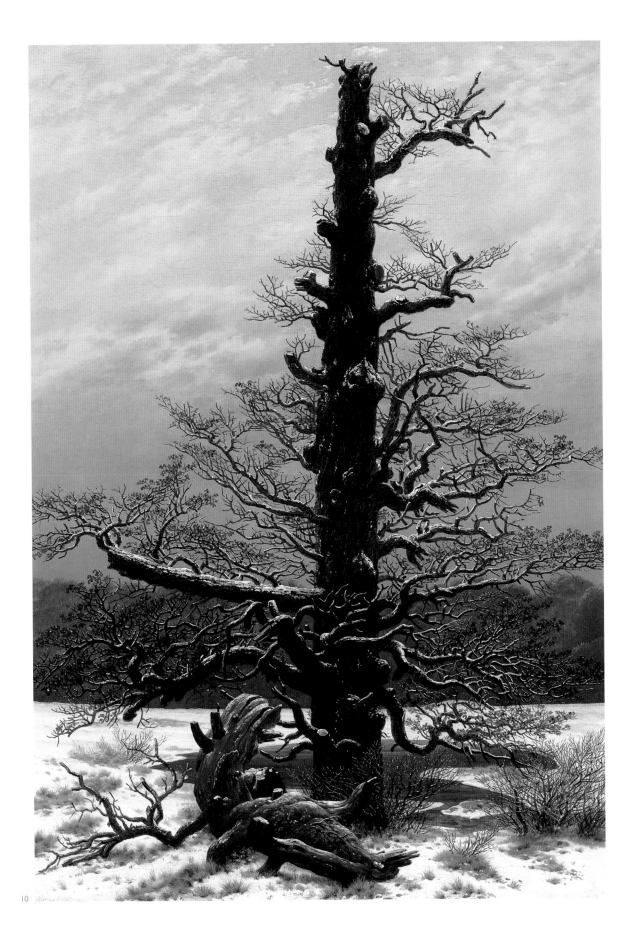

Caspar David Friedrich

11 The Riesengebirge
(Das Riesengebirge), c. 1830–5

Oil on canvas, 72 × 102 cm

Inv. no. A I 1079

PROVENANCE Acquired in 1909 from Fräulein Elsa von Corswandt, Berlin; previously in Crummin bei Bannemin, near Wolgast

REFERENCES Börsch-Supan and Jähnig 1973, no. 414; Galerie der Romantik 1986, pp. 60ff.

NOTES

1 Heinrich von Kleist, reworking a text by Clemens Brentano, 'Empfindungen vor Friedrichs Seelandschaft', Berliner Abendblätter, 1810, p. 47f., quoted Börsch-Supan and Jähnig 1973, p. 76.

2 Carl Gustav Carus, 'Andeutungen zu einer Physiognomie der Gebirge', in Briefe und Aufsätze über Landschaftsmalerei, ed. Gertud Heider, Leipzig and Weimar 1982, p. 99.

3 Börsch-Supan and Jähnig 1973, no. 300.

4 Ibid., no. 513.

From the appearance of his first masterpiece Monk by the Sea (1808–10; fig. 11, p. 22), which was taken to be the signal of a new age, viewers were provoked again and again by the monotony of Friedrich's painting. 'But there's nothing to see,' Marie Helene von Kügelgen exclaimed before the Monk, and a year before he committed suicide the poet Heinrich von Kleist described it as 'a boundless waste of water'; 'the picture sits there like the Apocalypse with its two or three mysterious objects, as if it were thinking Young's Night Thoughts' (the gloomy prognostications, 1742–5, of the English poet Edward Young); the small figure of the Capuchin on the shore was 'the lonely centre of the lonely circle'. Kleist was struck not least by the absence of a real foreground.[1] In rather milder form the same thing applies to Friedrich's late work Riesengebirge.

As was the general practice at that time, when composing his pictures Friedrich referred to nature studies made possibly decades earlier, which he would combine freely with one another (see also cat. 6). In this case he used a drawing made on 11 July 1810. He had undertaken arduous mountain walks from Dresden up the river Elbe at least from 1799, first of all in the Elbsandsteingebirge and from 1803 into northern Bohemia, too, returning there several times over the decades. On the other hand he made just one journey through the Riesengebirge, in July 1810, with his friend Kersting. On that journey he first got to know these western foothills of the Sudeten from the Silesian side – the northern part belonged to Silesia, but the southern part to Bohemia. The first and most impressive of the many results of these walks was Morning in the Riesengebirge (Morgen im Riesengebirge; Nationalgalerie, Berlin), a picture which he started immediately after his return home.

Characteristic of these mountains is the way the peaks rise in broad rows of crests – compared by Friedrich's friend Carus to 'the gently raised back of a peacefully rolling ... breaker'.[2] In Morning in the Riesengebirge their boundlessness is set off by a backdrop of steep rock with a crucifix soaring up from it. In this work, painted twenty years later, the lack of any such strong accent may be missed initially. Once it has traversed the distinct and tangible foreground, the eye has to travel a whole series of overlapping hills into the distance, across mist-shrouded slopes which seem to become ever flatter and less sharply defined as they recede, in order eventually to find the highest elevation deep in the background. The picture actually shows the view across the undulating heights of the Riesengebirge over the Ziegenrücken to Jeschken (Ještěd), the highest peak in northern Bohemia. At first glance the dominant impression is of solitude. The place seems barely habitable. However, in the near distance the tiny figure of a walker resting on a rock can be discerned. An evening mist is rising from the valleys, and the subtle alternation between more translucent and duller strips of colour – greenish, purple, brownish red – changes with increasing distance more and more into a light, insubstantial grey in which the materiality of the distant peak is dissolved. Its summit rises into a very pure sky traversed by just a few reddish-purple wisps of cloud. At the horizon the transparent layers give way to an orange glow.

Towards the corners of the picture the luminosity of the sky diminishes almost to white, recalling the termination of the arch of an altarpiece. Friedrich, who, following suggestions from the theological writer and poet Kosegarten, was the first artist, in his Tetschen Altarpiece (fig. 37, p. 59), to denote a landscape painting as a devotional picture,[6] endowed every composition with a solemnity which prompts symbolic interpretations. But it is not necessary to read The Riesengebirge as a Protestant sermon to perceive the tension between the terrestrial weight of the close at hand and the sublime perfection of the far away, or to experience the slow progression towards the soft illumination of the distance as redemptive.

A large picture dated 1822–3 in the State Hermitage Museum in St Petersburg shows the same view, but enhanced by a much more lively foreground.[3] There is also a sepia drawing, probably executed later, almost identical to the Berlin picture except that a rather higher viewpoint is assumed.[4] CK

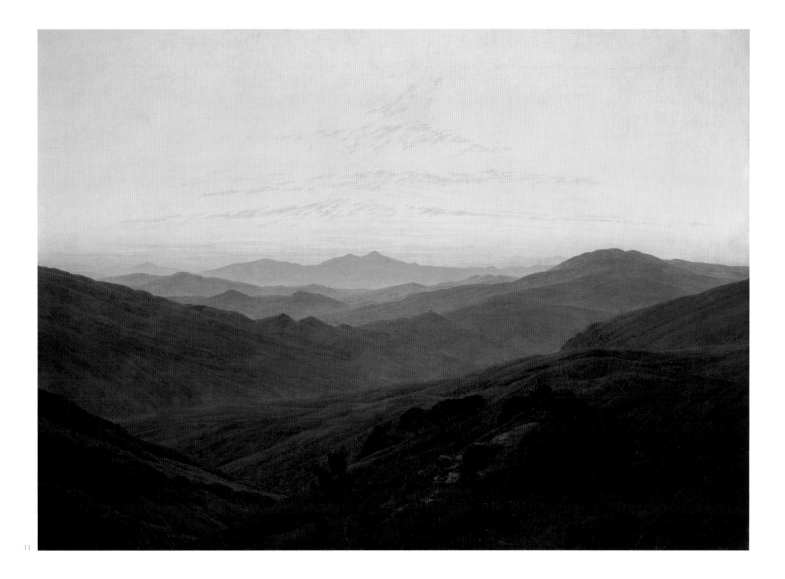

11

Nazarenes and Late Romantics

Now at last I come to what, according to my innermost conviction, I regard as the most powerful and, I would say, unfailing means of giving German art the foundations for a new direction appropriate to this great age and the spirit of the nation: this would be nothing other than *the reintroduction of fresco painting* as it was in Italy in the days of the great Giotto and down to the divine Raphael If the spirit of God is not with art, then all other means are of no avail, and the greatest endeavours and encouragement are no more than trumpery. So, providing there is this spirit, fresco painting is ideally suited to incorporating all the elements of art in the freest, greatest manner, and, instead of trying to combine completely incompatible superficialities following the path of empty eclecticism, it draws together as to a focal point the rays of life emitted by God, forming a glowing fire that illuminates and warms the world beneficently.

<div align="center">Peter Cornelius to Johann Joseph von Görres, 1814</div>

Therefore all in all we see the proper recognition of Christian art and painting and of its practical principles adequately safeguarded The true painter must now convey everything he sees in this divine light of inner spirituality, and even his inner visions and ideas must assume this nature and form. This mysterious light of the soul must shine forth complete and plain from all his works in beautiful clarity, like a word that has been spoken; and it is in this that the real essence of Christian beauty lies, and this is what distinguishes it from Antique art.

<div align="center">Friedrich Schlegel, Über die deutsche Kunstausstellung zu Rome im Fruhjahr 1819</div>

<div align="center">(On the exhibition of German art in Rome in the spring of 1819), 1819</div>

Italy is certainly the country where nature has been preserved at its most unspoilt and to the greatest extent in its original beauty. The Italian going about his business has a much more natural and healthy appearance than I have found among the inhabitants of other countries I have seen, even if in culture he is backward and spiritually has sunk almost to the lowest level Almost all Germans who stay here for only a short time form a tender attachment to Rome and seldom leave it without some pain, all the more because it is only here that one really enters into the German essence, not to mention emerges out of it, if that is what one wants. For where else can one find so many outstanding Germans in one place as right here? And where does one feel more drawn towards one's fellow countryman than in a foreign land? If one considers the inner bond between things, I almost think Rome must be considered part of Germany

<div align="center">Julius Schnorr von Carolsfeld to Johann Gottlob von Quandt, 1818</div>

In 1809 six art students in Vienna, including Friedrich Overbeck and Franz Pforr, banded together to form the Lukasbrüder, or Brotherhood of Saint Luke, honouring the patron saint of painting. Their lofty aim was to invest modern painting with the purity of form and spiritual values that they admired in the art of High Renaissance Italy and Northern Europe. In its melding of sources from both traditions, Overbeck's archaising portrait of Pforr (cat. 13) exemplifies the synthesis of Raphael and Dürer they hoped to achieve, while his later *Triumph of Religion in the Arts* (fig. 39) demonstrates the group's commitment to a revival of religious painting. In 1810, four of the artists travelled to Rome, Peter Cornelius (1783–1867) joining them soon after. There, they lived a devout, communal life in the unused Franciscan Monastery of Sant'Isidoro and dressed in biblical garb. The name by which the group is traditionally known, the Nazarenes, began as a term

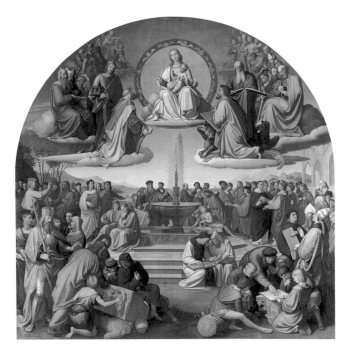

Fig. 39
FRIEDRICH OVERBECK
The Triumph of Religion in the Arts (Triumph der Religion in den Künsten), 1832–40
Oil on canvas, 389 × 390 cm
Städelsches Kunstinstitut, Frankfurt

of derision for this affectation in dress and demeanour but has since come to refer more generally to the many German-speaking artists who gravitated to Rome over the next several years and shared the artistic and religious values of the original Lukasbrüder.

The group had the opportunity to put its ideals into practice when the Prussian Consul in Rome, Jakob Salomon Bartholdy, commissioned the decoration of a room of his Roman palace with large-scale frescos telling the story of Joseph. Overbeck and Cornelius carried them out in 1816–17 (see fig. 28, p. 40). In 1817 a Roman aristocrat commissioned them to decorate the Casino Massimo with frescos illustrating the great medieval and Renaissance Italian poets. This project carried on for ten years. The latter frescos remain in situ in Rome while the Palazzo Bartholdy frescos were later detached and in 1887 brought to the Nationalgalerie in Berlin.

Cornelius returned to Germany in 1819 where he received important commissions for murals in Berlin and Munich. Julius Schnorr von Carolsfeld, who spent ten years in Italy, returned north in 1828, to paint monumental decorative schemes and to complete an ambitious project called the *Bilderbibel* (The Bible in pictures), comprising 240 engravings. Over the years, he turned some of the elegant, linear drawings for the project into delicately coloured paintings such as *Ruth in Boaz's Field* of 1828 (fig. 40). Overbeck, for his part, remained in Rome.

On their return to Germany, some Nazarenes became influential teachers. A later generation of Romantic painters, including Ludwig Richter and Moritz von Schwind, came under their influence. Only in later years did they evolve their distinctive approaches, involving in Richter's case dramatic German landscape scenes and in Schwind's the illustration of folk tales and fairy-tale and medieval legends. CR

Fig. 40
JULIUS SCHNORR VON CAROLSFELD
Ruth in Boaz's Field (Ruth auf dem Acker von Boas), 1828
Oil on canvas, 59 × 70 cm, National Gallery, London

Joseph Anton Koch

1768–1839

12 *Waterfalls at Subiaco*
(*Wasserfälle bei Subiaco*), 1812–13

Oil on canvas, 58 × 68 cm

Signed bottom left on small panel: *G. Koch fece 1813*

Inv. no. A 1 407

PROVENANCE Commissioned by the painter
Robert von Langer as a gift for the name day of his
father Johann Peter von Langer, director of the Munich
Academy. Both father and son were loyal to Koch for
many years and championed him in Munich. Later
the picture passed into the possession of Max Jordan,
Director of the Nationalgalerie; bequeathed by him
in 1887

REFERENCES Lutterotti 1985, no. G 25; *Galerie der
Romantik* 1986, pp. 18ff.; Stuttgart 1989, no. 98

NOTES

1 Letter to Robert von Langer, no. 15 of 20.10.1812.

2 Quoted from Koch's 'Gedanken eines in Rom
lebenden Künstlers …' (1810) in Lutterotti 1985, p. 40.

3 This group is repeated almost exactly in *Landscape
near Ronciglione* (*Landschaft bei Ronciglione*; 1815;
Hamburger Kunsthalle, Hamburg); Lutterotti 1985,
G 31.

4 Lutterotti 1985, G 18; quotation from the *Allgemeine
Zeitung*, Munich, in Lutterotti 1985, p. 287.

'This district is quite in the taste of Caspar Poussin, but more lively in colouring.'[1] Nicolas Poussin, the creator of the 'heroic landscape' in the seventeenth century, was one of Koch's guiding lights, but in this case he was referring to Poussin's contemporary Gaspard Dughet, also known as Poussin, whose compositions Koch found more cheerful and natural, though they had less 'majesty'.[2]

The river Anio lies blue and smooth as a calm lake round a small island with trees growing on it, and in the background people can be seen bathing. Before the two arms of the river rejoin at a lower level they form two small waterfalls. The shady foreground starts only at some distance from the viewer, being bounded at the front by a fallen tree. Koch often sought out a slightly raised vantage point, which would afford an open view into the unfolding distance and obviate as far as possible motifs cutting across one another. The view opens out in a leisurely way across the river valley and its populated outcrops, until finally closed off by the unwelcoming, uninhabitable peaks of the Sabine Mountains under an ultramarine sky. There is no aerial perspective to veil the clarity of the unfolding terrain, and one can almost sense the dimensions of the expanse aurally, for on the small plateau on the left a shepherd is playing the bagpipes. The sound of his instrument may carry one across the water, beyond the island, diagonally through the picture from front to back, and in an exact continuation of this diagonal the shepherd family and their donkey emerge from the shadow. There are similar groups walking through other landscapes by Koch,[3] and even if the woman carries a basket of fruit on her lap instead of a child the biblical resonance is perfectly clear: a secularised Holy Family is travelling through the landscape of the Campagna on its way to Egypt.

Koch, a former supporter of the Jacobins and by this time critical of all authority, especially Napoleonic, mistrusted priests, but not Christianity. Just as there are echoes of the New Testament in his shepherd's family, so one can recognise in the varied landscape, leading stage by stage from the idylls and travails of human life to the timeless sublimity of the mountains, a summary of divine creation. In this way of seeing, the uprooted oak in the foreground refers symbolically to the perils of this world – and of the present, which encroaches into the picture in the form of utilitarian buildings, work done to stabilise the river banks, and smoking chimneys, though these do not disrupt the idealisation of the whole. Koch repeatedly expressed the view that only by such a systematic inclusion of the animate and inanimate, transcending the conventional categorisation of art into genres – history painting, landscape painting, genre – could the artist move beyond the 'mere copying of nature'.

The picture was painted during a three-year period Koch spent in Vienna, where, during the late years of the Napoleonic Wars, he thought he had better chances of finding patrons than in Rome, which had become unsafe and inaccessible for rich travellers. This hope was not fully realised, but he did join a flourishing circle of Romantic writers, centred on the philosopher Friedrich Schlegel. Schlegel's conception of ideal 'historical' landscape painting was close to Koch's own and confirmed him on his path.

Koch had painted the same waterfalls from a different angle and in a larger format two years earlier, in *Near Subiaco* (*Gegend bei Subiaco*; 1811; formerly Museum der bildenden Künste, Leipzig, missing since 1945): the picture was lauded when shown in Munich in 1811 as 'indisputably the crowning glory of the exhibition in the landscape sector, a work in an individual, but genuinely German style'.[4] CK

12

Friedrich Overbeck

1789–1869

13 The Painter Franz Pforr (Porträt des Malers Franz Pforr), c. 1810 (reworked 1865?)

Oil on canvas, 62 × 47 cm

Inscribed: *F. Pforr*

Inv. no. A II 381

PROVENANCE In the artist's possession until 1869. Acquired by the painter Carl Hoffmann the Younger, son of the sculptor Carl Hoffmann, in Rome in 1887. When Overbeck was widowed in 1853 Hoffmann's wife Caroline took him in and cared for him. He adopted her in 1855 and from then on called himself Hoffmann-Overbeck. From 1878 the Nationalgalerie purchased several works from Overbeck's estate, which had passed to her

REFERENCES Howitt 1886, I, p. 161, II, pp. 276, 401; *Galerie der Romantik* 1986, p. 98f.; Lübeck 1989, cat. 11

NOTES

1 The Dresden version, long considered to be a copy, has recently been 'rehabilitated'.

2 This report, however, is open to doubt, for in October 1810 (see following note) Overbeck wrote of his intention not to interrupt the work until it was completed.

3 Letter to Joseph Sutter, 10 October 1810, in Howitt 1886, I, p. 161.

4 Published in Fritz Herbert Lehr, *Die Blütezeit romantischer Bildkunst. Franz Pforr der Meister des Lukasbundes*, Marburg 1924, p. 293f.

Art as a religion, religion as a way of life and friendship as a sacrament – that was essentially the programme behind the network of 'friendship pictures' and reciprocal portraits by the young German Romantics in Rome in the last years of Napoleonic rule and the first years of the restoration period. Overbeck was seventeen and Pforr eighteen when they sealed their friendship at the Vienna Academy in 1806, a friendship that became the driving force behind the Lukasbund (Brotherhood of Saint Luke), formed with four other young artists in 1808. Franz Pforr of Frankfurt (1788–1812), the strongest character in the association, died soon after its members had taken up residence in a secularised monastery in Rome, but his figure remained central to the reputation of the Nazarene movement, an essential element of the 'foundation myth' to which it owed much of its authority.

Pforr and Overbeck's artistic brotherhood-in-arms was elevated beyond the personal by the way they interrelated their ideas not only through writing but in pictures. They invented themselves as two ideal painters, who had two ideal brides: the fair and gentle, 'German' Maria and the proud and haughty, 'Italian' Sulamith. Pforr's small Gothicising diptych *Sulamith and Maria* (fig. 15, p. 25) is a confessional summation of all the ideals of their life and art grounded in religion. It is one of the few works that Pforr's illness permitted him to paint. Overbeck's contributions took longer to come to fruition: *Italia and Germania* (fig. 16, p. 26; Neue Pinakothek, Munich; a second version in the Gemäldegalerie Neue Meister, Dresden)[1] was completed only in 1828, and he may even have reworked this portrait of his friend (slightly) in 1865, after more than half a century,[2] before it was hung in the painter's drawing-room in the Palazzo Bagni in Rome.

In September 1810 the group had moved into the former monastery of Sant'Isidoro on Monte Pincio to live 'in devout harmony as befits brothers in a monastery, occupied quite exclusively with our art'. The portrait of Pforr was painted mainly there, for in October Overbeck was 'in the process of completing the underpainting'.[3] According to his own description, in which he mentioned all the elements he regarded as important, his friend 'stands in *altdeutsch* (Old German) costume' at the Gothic window surrounded by the tendrils of a vine.

The death's head with cross in the centre of the balustrade had been Pforr's emblem since his time in Vienna. In the background 'a young woman (perhaps his woman)' is sitting, 'busy knitting and at the same time reading a holy book'. Piety and domesticity thus characterise the artist's chosen companion, and the white lilies beside her – otherwise attributes of the Virgin Mary – indicate the religious model of their lives. 'The whole thing is intended to present him in the situation in which he would perhaps feel happiest.' Many details correspond to notes made by Pforr headed 'A Dream of the Future'.[4] The background illustrates the Nazarenes' practice of historicist composition, syncretising periods and geographical areas: a Gothic town, meaning a German one (in a deliberately incorrect, downward-leading perspective), and behind it an Italian coastline. (Schinkel, too, liked to link townscape and water: see cat. 1, 3). Although the attributes of Art are absent, the whole structure of the picture, from the arched frame to the view on to the sea, is a variation on the device for the Lukasbund 'seal' etched by Overbeck the previous year in Vienna.

With just the same unbounded confidence as his artistic contemporaries showed in emulating Antique sculpture, Overbeck based himself on *altdeutsch* (Old German) and early Italian art, which he saw embodied in Dürer and in Raphael respectively. Many of his pictures so closely resemble Raphael in both subject and style as to be virtually exchangeable with them. The portrait of Pforr, on the other hand, with its deeply serious expression, its awkward pose (look at the hands!), its abstention from lighting and modelling and its cold, austere linearity – as a result of which everything appears to be there for a reason and pregnant with meaning – is based on *altdeutsch* paintings of around 1500. Such paintings had been collected at that time notably by the Boisserée brothers in Heidelberg, and were indeed the very paintings that had been in Pforr's mind when he was forming his own style and figuration. A panel by Hans Suess von Kulmbach in the Metropolitan Museum of Art in New York might well have provided a direct model for Overbeck's portrait: the front is a head-and-shoulders portrait of a young man, while the back has a bride making a garland at a window, with a cat beside her. CK

13

Friedrich Overbeck

14 *Christ in the House of Mary and Martha (Christus bei Maria und Martha)*, 1812–16

Oil on canvas, 103 × 85.5 cm

Signed bottom left on the small plaque on the stool, between crossed palms: *FO 1815*; the wall tablet top right reads: *Martha! Martha! Sollicita es & turbaris erga plurima porro unum est necessarium! Maria optimam partem elegit quae non auferetur ab ea lucX: 41–42*

Inv. no. A II 453

PROVENANCE Acquired in 1925 from the David Vogel collection through the Galerie Neupert, Zurich

REFERENCES Howitt 1886; *Galerie der Romantik* 1986, p. 96f.; Lübeck 1989, p. 124f.

That the Zurich master baker David Vogel should commission a devotional religious picture from Friedrich Overbeck in 1812 was entirely in keeping with the ideas of the Lukasbund (see cat. 13), formed four years earlier. David Vogel's son Ludwig was one of the founder members of the group. Overbeck had originally considered painting the meeting between the risen Christ and Mary Magdalene (Noli Me Tangere) for David Vogel. At the end of 1813, however, he decided on the present subject, one which was very popular with the Nazarenes: Cornelius and Wilhelm Schadow, for example, made a number of drawings of it.

Adhering closely to the Gospel according to Luke (10: 38–42), the text of which can be read in part on a tablet on the wall, Overbeck depicted Christ's visit to Lazarus' sisters Mary and Martha after Lazarus had been raised from the dead. In reply to Martha's reproach that she had to wait on the guests while Mary sat idly listening to him, Christ said: 'Martha, Martha, thou art careful and troubled about many things: But one thing is needful: and Mary hath chosen that good part, which shall not be taken away from her.' Overbeck, who had converted to Catholicism in 1813, had often discussed questions of belief with Ludwig Vogel, who was inclined to Protestantism, among others that of the relative importance of faith or of deed in achieving salvation. Mary and Martha, wrote Overbeck in 1814, would be a fine subject for art, as 'in them the opposition between the active and contemplative life seems almost

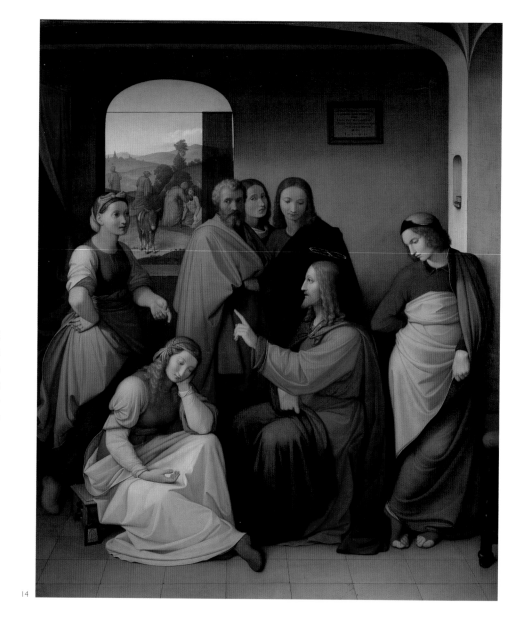

14

personified'.[1] Overbeck's painting professes the choice of religious contemplation and 'research into the most holy truths'.[2] At the same time, by depicting the Good Samaritan outside the window, it acknowledges the role of charity and good works. This combination of parables from the Bible was a novel approach to Christian iconography, typical of the Nazarenes.

The composition, the colour and the statuesque forms of the formulaic figures are clearly modelled on Italian Renaissance example, and first and foremost on Raphael. The portrait of James, looking sideways on in the centre, resembles Raphael's supposed self-portrait in the *School of Athens*; on James's left the Apostle

Peter resembles a Michelangelo. The model for the Apostle John on his right was a young man called Saverio, whom the Nazarenes often painted. In recognition of his patron Overbeck gave the figure of Lazarus, leaning on the right, the features of Ludwig Vogel, who, on receiving the finished picture, exclaimed: 'Oh, that is really and truly my Overbeck! … so strongly did your full heart and your spirit immediately speak to me from the work.'[3] BV

1 Howitt 1886, I, p. 325.

2 Letter from Overbeck to Ludwig Vogel, 15.05.1816, quoted ibidem, p. 357.

3 Ibidem, p. 358.

Julius Schnorr von Carolsfeld
1794–1872

15 *The Annunciation*
(*Die Verkündigung*), 1820

Oil on canvas, 120 x 92 cm

Signed bottom right: *18 JS 20*

Inv. no. A I 895

PROVENANCE Acquired at the Grosse Ausstellung (Great Art Exhibition) in Dresden in 1905, in preparation for the 1906 Centenary Exhibition

REFERENCES Justi 1923, p. 9f.; Frankfurt 1977, no. C 38; New York, 1981, no. 77, p. 198f.; *Galerie der Romantik* 1986, p.102f.; Leipzig 1994

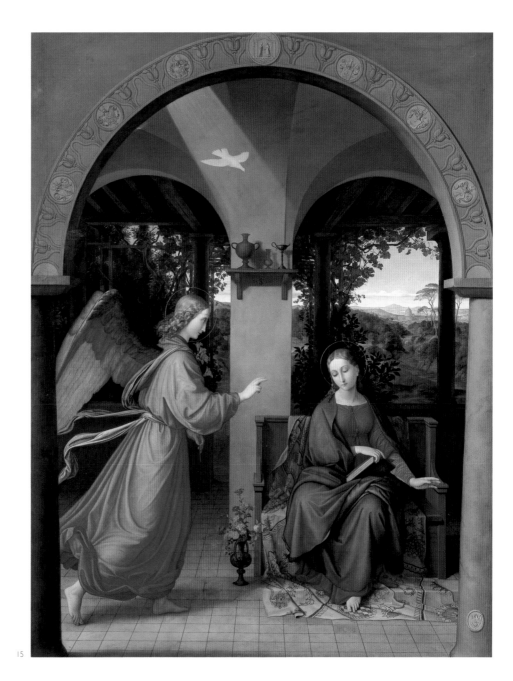

15

In 1819 Christian Leberecht von Ampach, canon (Domherr) of Naumburg, commissioned a number of pictures in Rome from various Nazarene painters, including *The Annunciation* from Julius Schnorr von Carolsfeld. Julius, the son of the Leipzig history painter Veit Hans Schnorr von Carolsfeld, had gone to Rome a year earlier, where he joined the Brotherhood of Saint Luke at the invitation of Cornelius and Overbeck (see cat. 13, 14). 'You have judged me worthy,' wrote Schnorr to them, 'to become another brother in your splendid group. So take me into your arms! My existence is now part of yours.'[1] Schnorr shared their Spartan communal life at Sant'Isidoro until in 1820 the brothers disbanded to live and work separately, but still associated artistically.

The *Annunciation* is one of the rare devotional pictures in Schnorr's oeuvre. The Archangel Gabriel bearing a lily (a symbol of virginity), the ray of divine light with the Dove of the Holy Ghost, and Mary sitting on a bench with a book in her hand are derived from traditional Christian iconography, but Mary's soulfulness demonstrates Schnorr's engagement with the Italian Quattrocento, especially with Fra Angelico. For this work Schnorr drew constant inspiration from Fra Angelico's 1449 fresco of the Annunciation in San Marco in Florence, which he had visited in December 1817. He wrote to his father that he was 'enchanted, elevated and possessed' by Fra Angelico's works, which seemed the 'purest outpourings of a holy man' and 'like the revelation of another world'.[2]

Behind the framing arch, the interior opens to an idealised landscape, in which, in reference no doubt to the founding of the Church, the dome of St Peter's can be seen in the far distance; also the outlines of Mount Soracte, while the Tiber runs through the middle ground. Stylised lilies and coats of arms in roundels decorate the framing arch, the middle medallion representing the Annunciation a second time with the positions of angel and Virgin reversed. Framing the picture internally in such a way was a favourite device of the Nazarenes (see cat. 13). For Schnorr, 'depicting a moment which is the quintessence itself of all tenderness and holiness was the greatest difficulty'. But he was grateful 'that this particular subject was allocated to me. Thanks to this commission, I have achieved great and important enlightenment with regard to sacred art and my attitude to it, for me it has been a door that has given me access to the only real and true art.'[3] BV

1 Quoted Leipzig 1994, p. 17f.

2 Schnorr von Carolsfeld 1886, p. 98.

3 Ibid, pp. 234 and 236f.

Carl Philipp Fohr
1795–1818

16 *The Knight before the Charcoal-burner's Hut (Ritter vor der Köhlerhütte)*, 1816

Oil on canvas, 54 × 66 cm

Inv. no. A II 742

PROVENANCE Acquired in 1931 from the Reichart Regierungsrat, Innsbruck

REFERENCES Justi 1932, p. 59f.; Munich 1985, p. 264f.; *Galerie der Romantik* 1986, p. 106f.; Munich 1998, p. 340f.

NOTES

1 Clemens Brentano, *Gesammelte Schriften*, Frankfurt am Main 1852–5, VIII (Letters), p. 170.

2 E.T.A. Hoffmann, *Briefwechsel*, ed. Friedrich Schnapp, Munich 1967, I, p. 348.

3 *Morgenblatt für gebildete Stände*, supplement no. 259, 1813, p. 46f.

4 Friedrich de la Motte Fouqué, *Der Zauberring. Ein Ritterroman*, ed. Gerhard Schulz, Munich 1984, p. 360f.

5 Justi 1932, p. 59f.

Carl Philipp Fohr showed a lively interest in the medieval world from an early age, influenced by the teacher and historian Philipp Dieffenbach, who would subsequently write Fohr's biography. In his native town of Heidelberg the Boisserée brothers' collection of late medieval German and Netherlandish paintings and contact with the group of Romantics around Clemens Brentano, Achim von Arnim and Johann Joseph von Görres also greatly influenced Fohr to revive medieval legends and fairy tales in paint. In 1816 he travelled to Rome, where he shared a studio with Koch (see cat. 12) and was in close contact with the Nazarenes. Two years later, at the age of only 22, he drowned while swimming in the Tiber.

Though he also made landscape watercolours and drawings Fohr left just seven oil-paintings, of which the Nationalgalerie in Berlin owns two: *The Lost Knight (Der verirrte Ritter)*, painted on a gold ground in medieval fashion, and *The Knight before the Charcoal-burner's Hut*, both inspired by Friedrich de la Motte Fouqué's chivalric romance novel *Der Zauberring (The magic ring)*, published in 1813. In his own lifetime the German Romantic writer and dramatist de la Motte Fouqué (descended from a French Huguenot family) enjoyed a greater reputation than he does today, and this book was one of the major successes of its period. Friedrich Schlegel called it the finest novel 'since *Don Quixote*',[1] E.T.A. Hoffmann found it 'marvellous beyond all measure and enthralling'[2] and Heinrich Voß, reviewing it, wrote that his 'whole soul was set aglow'[3] when reading it.

The novel takes place at the time of the Third Crusade. A magic ring gives rise to many and various chivalric battles and adventures. Christianity and paganism clash, but Christian faith overcomes all evil magic, and chivalric honour and virtue triumph over all human weaknesses. The protagonists are Otto von Trautwangen and his cousin Bertha von Lichtenried, who grow up together in their father's castle. Their bond is sorely tested when Otto rides off on a quest for the lady Gabriele von Portamour to obtain the magic ring from Sir Montfaucon.

Fohr's painting depicts an episode from the twelfth chapter of the novel. Otto believes, as a result of a magic potion, that he has forfeited his honour. He retires into solitude, from which he is brought back by Sir Arinbjörn to fight once again against the heathen. In the far north Otto finds his mother Hildiridur, with whom he sets out home again. Fohr shows the scene in which Otto and his mother, accompanied by Arinbjörn and Heerdegen von Lichtenried, seek shelter for the night in a charcoal-burner's hut.

'Night had already fallen, and its deep gentle darkness contrasted strangely with the white snow-covered peaks and the overhanging forests. The full moon shone bright in the sky, but black clouds would rapidly streak over it, like raven's wings. It was clear that the travellers had lost their way ….The tracks and prints of hooves on the snow led them towards a hut, which loomed before them under the tall, snow-laden pines on an almost terrifying slope at the head of the valley. Someone, at the sound of their approach, had lit a light at a small window, and its shaft fell across the path down to the frozen mirror of the valley stream.'[4]

Faithful to the text of the novel, Fohr creates a painterly nocturne. The moonlight picks up silvery and gold reflections on the knights' armour. The soft light merges with the rhythm of the rugged wooded landscape to form an atmosphere of solitude and tranquillity. The figure of the knight with his golden armour was doubtless inspired by Altdorfer's *Saint George* (1510; Alte Pinakothek, Munich). The Boisserée brothers had just acquired this work in 1816, the year Fohr's picture was painted, and the artist would have been able to see it in their collection.

Ludwig Justi bought Fohr's picture for the Nationalgalerie in 1931. 'The form, lighting and feeling for nature are close to Caspar Friedrich's masterpieces,' he wrote. 'Against their dark surroundings the soft colours of the moonlit riders and horses, heightened by a few stronger passages and shimmering gold, are beautifully done.'[5] BV

Ludwig Richter

1803–1884

17 *Fountain in the Woods near Ariccia* (*Waldbrunnen bei Ariccia*), 1831

Oil on canvas, 47 × 61 cm

Signed bottom left: *L. Richter 1831* and on the rim of the fountain: *LR*

Inv. no. NG 1355

PROVENANCE Bequest of Dr. Georg August Freund, Berlin, 1916

REFERENCES Friedrich 1937, pp. 19, 46f., no. 37; Neidhardt 1991, no. 94

17

'On the way to Ariccia there is a hermit's hut in the woods, with a fountain below it. I sat there, too, for several days, drawing beneath the shady trees, and the passers-by in their colourful attire kept me wonderfully amused. It would have been possible to fill whole sketchbooks with the most delightful groups and figures.'[1] Richter's memoirs are full of such vivid passages, describing both the time he spent in Italy between 1823 and 1826, which meant so much to him, and the following seven rather depressing years he spent as a teacher of drawing at the Meissen porcelain factory.

Richter held on nostalgically to his memories of the country where he had experienced his artistic awakening; using the sketches he had made there, he painted this fountain near Ariccia, on the Via Appia Nuova leading from Albano to Ariccia, in 1828 and again in 1831. In the figures, who pass by on the sunlit road beside the fountain as if on a stage, he shows contemporary stereotypes of Italian country people: the huntsman, the young woman beating a tambourine, the mother with her babe in arms, the little child piping, the mendicant monk.

In 1834 a serious illness suffered by his wife consumed the money Richter had put aside for a second journey to Italy. He used what was left of it that September to travel up the valley of the Elbe to Teplice in Bohemia (now Czech Republic). The trip opened his eyes to nature in his own country (see cat. 18) and freed him of his 'pathological' longing for Italy – as Richter himself characterised it, enthusiastically but no doubt also with resignation.[2]

One product of that journey was *The Pilgrims' Rest* (*Die Rast der Pilger*; Kunsthalle, Bremen), painted in 1839, a not dissimilar picture in which he substituted for Italian folk the equally colourful inhabitants of Bohemia. Many years later, in 1861, he returned to the composition once again and combined motifs of both pictures in the pen-and-ink drawing *Pilgrims at a Fountain* (*Pilger an einem Brunnen*; Kupferstichkabinett, Staatliche Museen zu Berlin). The repetition of the motifs of fountain and rest indicates their personal significance for Richter, but these Romantic metaphors of travel and rest, peril and safety, the far and the near were important generally for his time. AW

1 Ludwig Richter, *Lebenserinnerungen eines deutschen Malers*, ed. Karl Wagner, Berlin 1982, p. 94f.

2 Ibid., p. 179.

Ludwig Richter

18 *Lake in the Riesengebirge* (*Teich im Riesengebirge*), 1839

Oil on canvas, 63 × 88 cm

Signed bottom right: *L. Richter 1839*

Inv. no. A I 269

PROVENANCE Bought the year it was painted for the Sächsischer Kunstverein (Saxon art association), which frequently purchased pictures by Richter; won in a lottery by the Oelsnitz businessman Carl Meynert; to the dealer Emil Geller, Dresden; acquired in 1978

REFERENCES Friedrich 1937, p. 22 and no. 58; *Galerie der Romantik* 1986, p. 112

It was not only for Friedrich (see cat. 11) that Dresden was the starting point for an exploration of the Riesengebirge and the mountains of Bohemia. Richter, thirty-six when he painted *Lake in the Riesengebirge*, had not yet embarked on the long series of woodcut illustrations for books of fairy tales and idyllic portrayals of country life which were to make him the most widely popular German artist of his century. But the pictures he painted from his records and memories of the two and a half years he

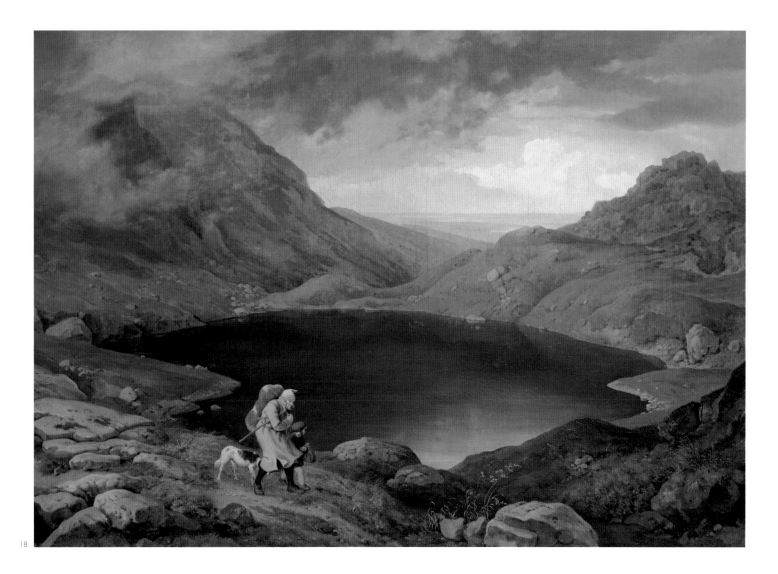

18

had spent in Italy were behind him; they had come to an end with his first walking tour in Bohemia in 1834. In Bohemia at last he had been able to treat native landscapes 'poetically' as he had done Italian, and to exorcise his mourning for the loss of Italy, Italy meaning for him artistic freedom and unfailing inspiration.[1]

Four years later, in August 1838, on commission from the Leipzig publisher Georg Wigand, he set out from Breslau (Wroclaw) to walk through Silesia and northern Bohemia. He had agreed to undertake the section entitled 'Walks through the Riesengebirge and the Glatz county', among others, for Wigand's folio volume of steel engravings, *Das malerisch romantische Deutschland* (Pictures of romantic Germany).[2] On 14 August, after walking across the hills from the Spindlerbaude to the Hirschberg, he happened upon and drew the

quaint figure of a laden-down pedlar and his companions,[3] which he inserted into the painting unaltered a year later. The view itself of what was known as the Kleiner Teich (Small lake) corresponds to another drawing Richter made, which was also used for a steel engraving by A.H. Payne for Wigand's *Wanderungen* (Ramblings),[4] as well as for a small picture again dating from 1838, which one might call an oil sketch were it not far too detailed.[5] Only some foreground details have been altered from the drawing in the present larger picture.

Comparison with paintings of mountains by Friedrich, who would die in Dresden one year later, reveals the younger artist more concerned with everyday realism. He avoids introducing elements that might have symbolic resonance, for example symmetry; far from bearing any ulterior significance, the impending storm that

darkens all the colours means no more than still greater discomfort for the travellers. Empathising with this group, the viewer will feel not deeply affected and elevated, but better off. Romanticism yields to the Biedermeier era. CK

1 Claude Keisch, 'Ludwig Richters lebenslanger Abschied von Italien', in Dresden 1994, pp. 46 ff.

2 Karl Josef Friedrich, *Ludwig Richter wandert ins Riesengebirge. Zwei neu entdeckte Tagebücher Richters von 1838 und 1865*, Dresden 1938.

3 Pencil drawing, Kupferstichkabinett, Staatliche Kunstsammlungen, Dresden.

4 Including the same figure group. Cf. C. W. Schmidt, *Ludwig Richter. Deutsche Landschaften. 49 Stahlstiche*, Berlin 1941, fig. 47.

5 Location unknown; Friedrich 1937, no. 57; colour illustration in Eugen Kalkschmidt, *Ludwig Richter. Leben, Werk und Wirkung*, Munich 1940, pl. IV.

Moritz von Schwind

1804–1871

19 *The Rose, or The Artist's Journey*
(*Die Rose oder Die Künstler-
wanderung*), 1846–7

Oil on canvas, 216 × 134 cm

Inv. no. A 1110

PROVENANCE First exhibited at the Munich
Kunstverein, then in Leipzig, where its purchase for the
newly founded museum was heatedly discussed but
rejected: 'the burlesque, almost repulsive figures in the
foreground completely spoilt the picture for me',
related one member of the committee. Ideas of selling
it to Weimar and Prague also came to nothing. The
picture passed into private hands. Acquired in 1874
from an Erlangen spinning-mill owner called Schwartz

REFERENCE Karlsruhe and Leipzig 1996, no. 268

NOTES

1 Schwind to Ernst Julius Hähnel, 05.08.1846: Stoessl
1924, p. 201.

2 Schwind to Bonaventura Genelli, 27.08.1846: ibid.,
p. 203. The expression 'wasted genius' is repeated at
least three times in Schwind's letters.

Schwind spent a formative early period in Vienna in the circle of Franz Schubert, then began his 'journeyman' years, the conclusion of which was signalled by *The Rose*. When he finally settled down in 1847 at the age of forty-three as a professor at the Academy in Munich, he had worked on many sorts of projects: medievalising frescos, popular woodcut broadsheets and illustrations for fairy tales. *The Rose* was still not finished when he moved to Munich, although he had been working on it in the summer of 1846 'with all the strength of his body'.[1]

The Rose is a dream of the age of chivalry and a landscape, a ballad and a lyric to nature, rolled into one. In the cool morning air the trumpets ring out from the castle tower. A bride and her bridesmaids are awaiting the bridegroom, who appears in the distance with his train. From the opposite side the musicians are toiling up a steep, narrow path from right to left, against the comfortable direction for the viewer's 'reading'. They bring their instruments with them: a bassettel (a kind of small cello), a bagpipes, a fiddle, and the tárogató (a kind of clarinet). They are uncouth, like the 'mechanicals' in *A Midsummer Night's Dream*, and like Shakespeare's play this picture is a saga of woodland poetry. Just as the fairies rule there, here gnomes may pop out of every bush, as in fact they do in a very similar composition painted only a few years earlier, *The Ride of Kuno von Falkenstein* (*Der Falkensteiner Ritt*; Museum der bildenden Künste, Leipzig).

The foreground is bounded by a steep, precipitous slope. The exaggeratedly tall format, the narrowness of the path round the balcony, the restricted view into the distance and the powerful foreshortening draw the viewer into depth with unsettling effect. As in a stage set, the group of damsels in the tower emerges from the very darkness into which the figures behind them abruptly disappear.

Two worlds meet one another, the ideal world of fairy-tale chivalry and maidenly beauty and sad, grotesque, ill-fitting reality. 'The hero,' Schwind explained, 'is the last of the musicians, a man of high ideas and great imagination, but he has advanced no further in the world than to blow his little piece in the company of a common, idle mob for their delight, perhaps to the derision of the genteel world – in short a wasted genius. A figure appropriate to modern times, perhaps.'[2] In a moment he will be able to press to his heart a rose which one of the damsels has dropped (accidentally or deliberately), yet it is only a matter of time before he is pitifully disillusioned. Schwind's opinion of himself as a young man suits his antiheroes: 'I think I dream too much in the daytime.'

The painter Theodor Rehbenitz, a member of the Brotherhood of Saint Luke (a Nazarene), who was eking out a living in far-off Kiel as a university drawing master, is thought to have been the original model for the 'last of the musicians'. At any rate this musician is a typical misfit of the Biedermeier period – one of many such outsiders, dreamers, 'good-for-nothings'. Franz Grillparzer's novella *Der arme Spielmann* (The poor player) was published the same year *The Rose* was painted: its subject is a fiddler whose dreams of art and love fail lamentably. As a street musician he hangs on delightedly to a single note, played again and again. The artist as an oddity, an outsider, was again the theme of the 'black Romanticism' of E.T.A. Hoffmann for instance, whose hero is always ready to mistake appearance for reality.

Schwind's group of musicians had their origin in a group of figures in the background of *Sir Kurt's Journey for his Bride* (*Ritter Kurts Brautfahrt*; formerly Kunsthalle, Karlsruhe, destroyed by fire in 1931), painted between 1835 and 1840. The motif of the dropped rose, on the other hand, as can be seen from the preparatory drawings, was invented only at the last minute. Previously the tárogató player had his hands clasped behind his back. The episode of the rose is by no means the nucleus of the picture, even it forms the punch-line.

Schwind's colouring is strictly local, defined within sharp contour lines and separate from object to object: the colours do not reverberate with one another, nor, thinly and smoothly applied, are they the least expressive. They serve only to characterise and aid the narration. Schwind's line, on the other hand, has a great deal of variety, from the broad curves of the architecture to the detail of the foliage. In the group of damsels there predominates a sliding, gracefully swinging curve recalling Hogarth's 'line of beauty'. In the part of the picture where the musicians appear, the contours are broken in a spiky, angular, arhythmic way. The ideal poetry and the dysfunctional prose are also differentiated formally. Idealising art absorbs reality most readily through caricature. CK

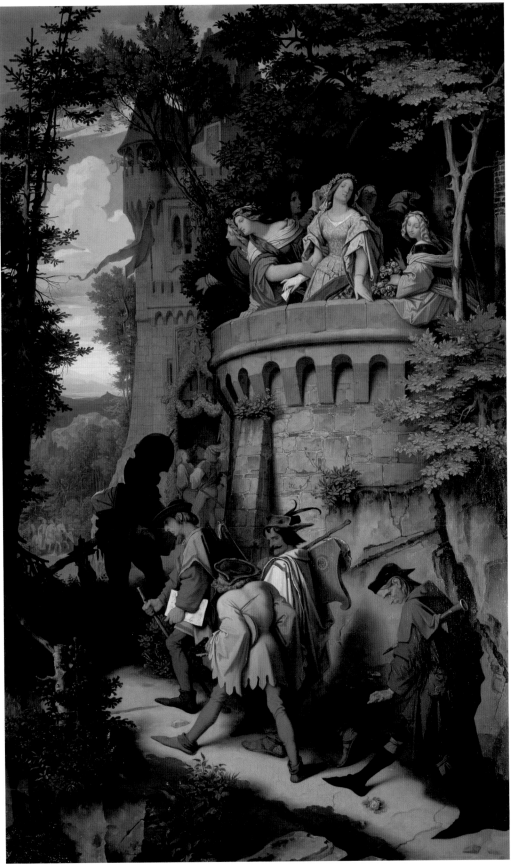

Moritz von Schwind

20 *The Adventure of the Painter Joseph Binder (Abenteuer des Malers Joseph Binder), c. 1860*

Oil on canvas, 65 × 37 cm

Inv. no. A 1 676

PROVENANCE Purchased in 1900 from the artist's son, Hermann von Schwind

REFERENCE *Galerie der Romantik* 1986, p. 111f.

NOTES

1 To Bonaventura Genelli, 27.08.1846: Stoessl 1924, p. 203.

2 Schwind to Peter von Cornelius, 20.09.1862: ibid., p. 404.

3 Ibidem.

4 Schwind to Julius Thaeter, 09.12.1848: ibid., p. 236.

5 Schwind to Josef Kerner, 09.02.1836: ibid., p. 123.

6 Schwind to Julius Thaeter, June 1848: ibid., p. 229f.

7 Schwind to Franz von Schober, 27.11.1830: ibid., p. 66.

8 Schwind to Franz von Schober, undated (Spring 1833): ibid., p. 84.

9 Schwind to Franz von Schober, 10.07.1833: ibid., p. 86.

10 Schwind to Ludwig Schaller, 01.10.1835 and 24.07.1836: ibid., pp. 111, 118.

11 Schwind to Frau von Frech, 29.07.1842: ibid., p. 148.

Following the painting of *The Rose* (cat. 19) Schwind's art branched out in a new direction. 'But I would really again like to do something where beauty is the main thing, and not for ever and a day contend with things in costume,'[1] he complained. He counted *The Rose* and the commissions for frescos he received as 'things in costume'. He began now, alongside the commissioned works, seriously to put in hand a 'collection of lyrical pictures' which had 'been accumulating since my earliest youth … in good times'. Although these were generally sold singly, they were intended as 'a coherent whole'.[2] The concept of a cycle dispersed in many places, its coherence maintained in the mind of its creator and perceptible only in the context of his complete oeuvre, would have been impossible before the nineteenth century; another instance, however, is Menzel's 'cycle of historical pictures' centred on Frederick the Great (see cat. 32).

In 1862 Schwind's 'travel pictures', as he called them, had become 'around forty in number'.[3] For all the variety of their subject-matter they had in common the private character of 'fancy pictures', and so stand in sharp contrast to Schwind's public art, both the frescos and the woodcut illustrations. He himself called them 'curiosities, which are not suitable for public view'.[4] 'But just imagine,' he had lamented very early on to a poet friend, 'if you had to write poems about things that were not even good enough for the cat and, on top of that, subject to the whim of a prince as regards metre, form of expression and, worst of all, whole idea ….'[5]

Schwind's alienation from his public was of a piece with his avoidance of politics. The revolutionary movements, the 'dreadful perplexities of the time', unsettled him. 'Only the innermost core now acts as a counterbalance against the frenzy that has taken hold of all heads ….I cannot stand the political chatter. So we mean to try and let the unruly army pass right over us ….'[6]

Whether their subject-matter is mythological, like the fairy dance (the *Elfenreigen*), which had not then been trivialised, medieval, or 'modern' (like *The Adventure of the Painter Binder*), all the 'travel pictures' are full of Romantic poetry, almost all embed the figures in the landscape, and almost all do no more than hint at a story. The majority refer back to ideas, or even sketches, from Schwind's early

years. Only nostalgia for his youth and systematic retrospection can explain why Schwind should have chosen the painter Joseph Binder (1805–1863), of all people, as the protagonist of the picture. He had been Schwind's travelling companion in 1830,[7] but soon his friend's moods had become 'intolerable' to him:[8] 'I have completely cut myself off from Binder. Instances of impertinence over many years have convinced me that I have been dealing with a self-seeking, arrogant person.'[9] There was also a dispute about money which hung about for some time.[10] The estrangement continued during the three years Schwind spent in Frankfurt, where Binder also lived.[11] However, it did not darken Schwind's memory of the youthful episode of a woman arriving unexpectedly and fleetingly on the scene while the painter was sketching — a kind of Biedermeier version of Baudelaire's poem *'Passante'* (The passer-by). About 1848–50 Schwind painted a first version of the composition (on panel; Nationalgalerie, Berlin), which was not completed; but its essential idea was used in the central panel of his polyptych *The Symphony* (*Die Symphonie*, 1848–52; Neue Pinakothek, Munich). This new, modified version dates to about ten years later. The young woman appears literally like 'a ray of sunshine' in the middle of one of those woods full of mysterious, labyrinthine, rampant vegetation that Schwind could depict like no other artist.

The contrast of illusion and frustration, an inexhaustible theme of Romantic literature, occurs in Schwind's works in many variations, but the painting closest to *Binder's Adventure* is *Apparition in the Forest* (*Erscheinung im Walde*, c. 1823; Ratjen Foundation, Vaduz), a sepia composition of a knight in pursuit of a fairy, which Schwind converted into an oil painting no less than thirty-five years later. The vision always evades capture, and the dreamer remains behind alone. CK

Colour, Light and Air

In this connection we would like to assign the paintings of *Professor Blechen* to their proper place. Some of them prove that even landscape – though one might least credit it – is capable of humour, indeed of a black humour. This *Afternoon on Capri* [*Nachmittag auf Capri*], which is difficult to make out owing to the pure brightness of the sun, which for all the simplicity of its masses is fragmented, which despite being monochromatic is strident … this is no soulful view of nature, nor does it set out to be: its features relate to such a view like those of a madman to the sane human face. Craziness has its truth, too, and is in no way excluded from art. If the whole thing looks to someone who has never been on Capri, in the morning or the afternoon, more like a lye run through with muddy red and bluish ingredients than a picture, yet it can be really and truly enjoyable, though hardly in any other context except juxtaposed with and surrounded by completely different pictures. For to delight in this way in a nature oppressive even to itself presupposes a certain surfeit of strength both in the painter's genius and in the viewer's understanding.

Gustav Adolf Schöll, *Über das Leben der Kunst in der Zeit* (On the life of art in its time),
commenting on the autumn 1832 Berlin Academy exhibition, 1833

On my frequent journeys to Italy I quite often heard: 'This or that artist from Prussia is in Rome to make studies, he has been commissioned to paint a large work'. What kind of studies can these be, that a German has to make in Italy? Nothing else than drawing isolated motifs from little known works, then fitting together the same comfortably back in his native land – what is quite correctly called 'composing'. The fact is that such composite works, even if they still have a so-called classical appearance, leave us completely cold, and must leave us cold, because the painter himself had no other feeling in painting them than that of a carefully calculated assembly, with no feeling, truth or reality.

Ferdinand Georg Waldmüller (from papers in his estate)

I very much praise the fact that you are using pastel, but I advise you in applying it to landscape to accustom your eye and taste to a whole that may admittedly be very harmonious, but *matt* in all the individual colours. Everything in it that has to do with air must be ruled out in advance. Fluid colour is more indispensable in that than for anything else. Rocks and individual parts of plants in foregrounds tend to work better. But architecture can be drawn with it best of all, such as the Orangerie for instance, with the weather-worn statue railings in the foreground. But in general I advise you to use it only as a stopgap when time and place do not allow for oil studies: like that time in the Wildkammer, and especially in the evening.

Adolph Menzel to Carl Johann Arnold, 1 June 1848

By the early decades of the nineteenth century, the oil sketch was a vital part of a landscape painter's training across Europe. Whether travelling in Italy or working at home, artists made these simple, direct studies in the open air. They were rarely intended for public exhibition but were tests of skill in the rapid transcription of natural phenomena, ways of training the hand and eye to observe and record fleeting effects of light and atmosphere. In Germany, Friedrich's friend Johann Christian Dahl (1788–1857) was a leading exponent of the landscape oil sketch, and his commitment to working from nature influenced countless artists, including Carl Blechen, both in Berlin and when he embarked on a visit to Italy.

Blechen spent eighteen months in Italy, from late 1828, making drawings and oil sketches as he travelled as far south as the coast below Naples. Camille Corot (1796–1875), perhaps the most innovative master of the landscape oil sketch, had just left Italy and they did not meet. Yet he and Blechen

Fig. 41 CARL BLECHEN
Storm in the Campagna (Unwetter in der römischen Campagna), 1829
Oil on cardboard, 27.5 × 44.5 cm, Nationalgalerie, Staatliche Museen zu Berlin

painted remarkably similar Italian motifs in not dissimilar manners, as a comparison of Blechen's *Campagna Landscape* (fig. 41) and Corot's *Roman Campagna with the Claudian Aqueduct* of about 1826 (fig. 42) makes clear. However, both painters drew a sharp distinction between the sketch and the larger, 'finished' painting, where questions of compositional arrangement and stylisation came into play. Blechen's *Park of the Villa d'Este in Tivoli* (cat. 24) may well have had its origins in his observations of the picturesque site, but the large size of the canvas, its artful manipulations of scale, and the addition of colourful figures in sixteenth-century costume reveal it as just such a 'finished' work.

Fig. 42 JEAN-BAPTISTE COROT
The Roman Campagna, with the Claudian Aqueduct, c. 1826
Oil on paper, 21.6 × 33 cm, National Gallery, London

Back in Berlin, in the mid-1840s Adolph Menzel also painted oil sketches, most often in the privacy of his studio or the family apartment. There, he sometimes experimented with effects achieved through artificial illumination. He also brought to bear an appreciation of the innovative skills in naturalistic representation that English landscape painters, notably Constable and Turner, had made. Though they are now regarded as among his finest accomplishments, Menzel himself did not consider such sketches highly. He did not exhibit them and they only became known towards the end of his long life. For many visitors seeing them for the first time, they were among the revelations of the Nationalgalerie's great 1906 Centenary Exhibition, surveying German art from 1775 to 1875. Such informal sketches of the 1840s suddenly seemed like precocious German anticipations of French Impressionism dating from some thirty years later. CR

Carl Blechen

1798–1840

21 Gorge near Amalfi (Schlucht bei Amalfi), 1831

Oil on canvas, 110.3 x 77.5 cm

Inscribed bottom right: 1831

Inv. no. A 1319

PROVENANCE Acquired in 1881 with six other works by the artist from the collection of Kammergerichtsreferendar Frick

REFERENCES Rave 1940, no. 1117; Galerie der Romantik 1986, p. 131f.; Berlin–Munich 1990, no. 47

NOTES

1 Karl Friedrich Schinkel, Reisen nach Italien, ed. Gottfried Riemann, Berlin 1979, p. 190f.

2 Max Liebermann, Preface to the catalogue of the Blechen exhibition at the Akademie der Künste, 1921, reprinted in Die Phantasie in der Malerei. Schriften and Reden, Berlin 1983, p. 148f.

3 Quoted from Rave 1940, p. 15.

'Immediately you reach the Gulf of Amalfi, the scenery becomes more and more romantic,' Schinkel wrote in the journal of his second visit to Italy. 'As you round the projecting angle that carries the fort, you see Amalfi in the fold of the hills, built up in the strangest way ….All the buildings appear just as little dots, with only the town itself forming a larger mass, behind which you can follow the gorge, overgrown with foliage and richly configured higher up with caves and jutting rocks, right up into the high mountains …. From the church we went back down to the square and followed the main road, which leads up towards the gorge. It soon takes on the strangest character; it closes in, you go under arches and vaults, across which paths lead from one side of the valley to the other …. At the last turn the valley seems closed off by a manufactory building many storeys high, where paper is made.'[1]

Blechen, who had been dreaming of a journey to Italy since the early 1820s, was unable to realise his desire until 1828, after the sale of his much admired painting Encampment of the Semnon Tribe (Das Semnonenlager; formerly Nationalgalerie, Berlin, lost in 1945). Intended as a study trip, the journey soon turned into an intensive stint of unparalleled creativity. In Italy Blechen experienced the glittering sun and almost tropical heat of the southern summer. He represented the colour-saturated landscape, steeped in light, in hundreds of studies and sketches. 'It was only after his Italian journey that [Blechen] became a master,' remarked the painter Max Liebermann about a century later; 'it was only in Italy that he finally achieved freedom. In the studies he brought back from there he gives the best that a painter can give, which is to give back what he, Blechen, saw: the simplest and therefore the hardest thing to do.'[2]

In May 1829, together with the writer and painter August Kopisch and probably also the painter Leopold Schlösser, Blechen proceeded from Naples to Sorrento and thence to Amalfi. There the artists walked through the Valle dei Molini, or valley of the mills, with its many bridges crossing the mountain torrent, its buildings, its manufactories driven by water power, and surrounding hills: 'We travelled to Amalfi on donkeys,' Blechen wrote in his recollections of the journey, 'arriving about nine o'clock in the evening. We stayed there for a week, sketching various things in the valley, and went on foot

over the hills to Ravello, where we again did some drawing, then we went back again to Amalfi.'[3] During this trip Blechen tirelessly recorded his impressions of Amalfi's rugged environs. His Amalfi sketchbook is one of the finest achievements of Blechen's 'Grand Tour' and his most important contribution as a draughtsman to nineteenth-century art.

Among the 66 sheets in this sketchbook there is a wash drawing of the Valle dei Molini (Rave no. 1157), which the artist used as the basis for his painting executed two years later. Back from Italy, Blechen ennobled and at the same time enraptured the reality prosaically recorded in his drawing: brightly shimmering and darkly shaded rocks rear up with sublime force from the luxuriant vegetation in the deep gorge. Light sneaks into the valley, bathing the walls of the mill in sunbeams and turning silver the transparent veil of smoke issuing from the manufactory chimney. Reflections of light sparkle on the tree-tops swayed by the wind and on the tumbling waters of the mountain torrent. A group of woodcutters are felling trees for firewood. Emphasising the verticals and stressing the contrasts of light and shade, Blechen introduced expression and drama in this extremely painterly work. Poetically transfigured though it is, the presence of the manufactory amidst this sublime mountain scenery shows Blechen's interest in early industrialisation, as again in his Iron-rolling Mill, Neustadt-Eberswalde (Walzwerk bei Neustadt-Eberswalde; Nationalgalerie, Berlin), painted at about the same time. Blechen painted another version of the Gorge (private collection), and a similar composition with variations in the architecture is in the Museum der bildenden Künste in Leipzig. BV

21

22

Carl Blechen

22 *Three Fishermen on the Gulf of Naples (Drei Fischer am Golf von Neapel)*, c. 1830–5

Oil on canvas, 20 x 34 cm

Inv. no. NG 870k (F561)

PROVENANCE Acquired in 1891 from the estate of the Berlin banker H.W.F. Brose. As early as 1855 Brose owned 26 fairly large pictures, some unfinished, and 18 oil sketches by Blechen, as well as works by Dutch, Italian and German Old Masters. He began his collection of Blechen's works with the acquisition of a few copies in 1838; works in Blechen's own hand were added from 1839 on

REFERENCES Rave 1940, no. 1637; *Galerie der Romantik* 1986, p. 125; Berlin–Munich 1990, no. 82

Blechen's view of Italy was completely focused on its present, its immediate appearance. Just as he neither studied Antique form nor re-created its spirit, but noted it down in the ruinous condition it had when he saw it, in the same way, with people, he was less interested in the type than in the activity. Where others would represent ideal figures of young Italian women in their picturesque costumes, Blechen, more frequently, drew and painted groups of *pifferari* (bagpipe players) and Neapolitan fishermen. With the white of their clothes and the red of their caps they stand out almost like signals in the wide expanse.

On his return from Italy Blechen transposed a number of his studies into compositions, as he did in this small picture. Two pencil drawings that he brought back from Naples of the fisherman sitting on the right playing the mandolin served as a starting point. But the elegantly elongated, dreamy figures are above all individual notes in a fanfare of blue, white and red. Since the brilliant ultramarine expanse of the sky is uninterrupted by any cloud, and the sea's darker blue is unfathomable, colour in the picture becomes an 'elemental', almost magic phenomenon (comparable to the experience of entering the light-filled Blue Grotto on Capri, which was rediscovered by two German painters in 1826 to much excitement). Smaller lights answer one another across the distance: the white streaks of light from the rising sun on the shoulders of the young fishermen are echoed on the other side of the water, at the the edges of the picture, by the pinkish light on the heights of Capri and Sorrento. It must have been at about the same period that Blechen similarly depicted an old dray-horse against such a cloudless blue sky (*Alter Karrengaul in Landschaft*, Stiftung Schlösser und Gärten Berlin-Brandenburg). CK

Carl Blechen

23 The Interior of the Palm House (Das Innere des Palmenhauses), 1832–3

Oil on paper on canvas, 64 × 56 cm

Inv. no. A 1617

PROVENANCE Acquired in 1898 at the auction of the collection of Karl Ludwig Kuhtz

REFERENCES Rave 1940, no. 1735; *Galerie der Romantik* 1986, p. 134f.; Berlin–Munich 1990, no. 64

23

In 1830, on the recommendation of the great Prussian natural scientist Alexander von Humboldt, King Frederick William III bought the Foulchiron palm collection from Paris, and to accommodate it had a palm house erected on the Pfaueninsel (Peacock island) near Potsdam to designs by Schinkel; parts of an Indian pagoda acquired the previous year were incorporated into it. The building was completed in 1831 and destroyed by fire in 1880.

In 1832 the king commissioned Carl Blechen to paint two pendant pictures of the Palm House, intending to give them to his daughter Charlotte, wife of the Tsar of Russia. Blechen made careful preparations for the commission. As well as making numerous detailed drawings in order to ensure accuracy, he produced this preparatory study of the glass-enclosed, sun-filled space. In it odalisques are lying amidst the lush green of tropical plants, reinforcing the magic of the Orient that emanates from the filigree-like Indian architectural elements.

Blechen did not complete the somewhat larger and slightly altered final version of the two views of the Palm House (Stiftung Schlösser und Gärten, Berlin-Brandenburg) until 1834. In the autumn of the same year he showed the paintings at the Berlin Academy, where they were widely acclaimed. 'What particularly impresses me,' the reviewer in *Museum* of 6 October 1834 wrote, 'is the harmonious, warm humidity of the whole thing. I believe I can feel the faint spicy moisture, the mild fragrance of the hothouse …. The innocent plenitude and tenderness and the dreamlike charm of oriental vegetation come over me. The artist has rounded off the effect with gentle, poetic staffage …. I have seen the Palm House several times; I see it here exactly as it is, but at the same time translated from speech into music.'[1]

As payment Blechen asked for the relatively high sum of 100 *Friedrichsdor* (1000 gold *Talers*) for each painting. Initially the king refused the artist's demand. He accepted it only after Schinkel had written an expert opinion. 'The concept of the subject is extremely original, and it has been executed with immense understanding, considerable study of nature and outstanding tastefulness. The world of tropical plants in its plenitude as it is shown here is foreign to us in northern countries, and an artist has to struggle and make real efforts to reproduce it freely in this region. The great pains involved cannot be detected in the pictures, and that is in fact their most excellent aspect.'[2] BV

1 Review of the Berlin art exhibition in *Museum. Blätter für bildende Kunst*, ed. Franz Kugler, Berlin, 6 October 1834, p. 323.

2 Karl Friedrich Schinkel to Hofmarschall von Maltzahn (the Lord Chamberlain), 27 June 1834, quoted in Rave 1940, p. 33f.

Carl Blechen

24 Park of the Villa d'Este in Tivoli (Park der Villa d'Este in Tivoli), c. 1831–2

Oil on canvas, 127.5 x 94 cm

Inv. no. A III 463

PROVENANCE Acquired in 1958

REFERENCES Rave 1940, no. 869; Berlin–Munich 1990, no. 53

NOTES

1 Elisa von der Recke, *Tagebuch einer Reise durch einen Theil Deutschlands und durch Italien in den Jahren 1804 bis 1806*, IV, Berlin 1817, p. 154f.

2 Karl Friedrich Schinkel, *Reisen nach Italien*, ed. Gottfried Riemann, Berlin 1979, p. 219.

3 *Museum. Blätter für bildende Kunst*, ed. Franz Kugler, Berlin, 11 February 1833, pp. 41ff.

4 *Vossische Zeitung*, Berlin, 13 November 1832.

'This villa lies almost at the centre of an immense and sublime picture gallery of Nature,' Elisa von der Recke wrote on 14 May 1806 in the diary of her Italian journey. 'One's gaze seems to hover round a magic image out of Ariosto: indeed it is possible to believe one is wandering around in a luxuriant fairyland, walking through this garden which is still delightful in its neglected state. It abounds in pleasure groves, full of wildness and delicacy, and in grottos overhung with curtains of rampant greenery.'[1]

The Villa d'Este had been built and laid out in the mid sixteenth century to designs prepared by Pirro Ligorio for Cardinal Ippolito d'Este. One of the most famous sights in the vicinity of Rome, the villa attracted and inspired numerous travellers to Italy. When, in the spring of 1789, Goethe sent his completed *Torquato Tasso* to the Duchess of Weimar, who happened then to be staying in Rome, she asked another literary friend, Johann Gottfried Herder, to read the poet's most recent work aloud to her in the park of the villa.

Schinkel was also among the admirers of the Villa d'Este, visiting it on 15 October 1824 during an excursion to Tivoli, and recording it in drawings (Kupferstichkabinett, Staatliche Museen zu Berlin): 'After we had spent long enough delighting in this wonderful rocky valley, we climbed up and saw the grandiose estate of the Villa d'Este on the Tivoli slope. The terraced garden with its laurel hedges, cypresses and pines, fantastic rock and grotto arrangements, spurting fountains and pools is no less attractive for itself than it is for the view it offers over the far-spreading Roman Campagna.'[2]

Four years after the visit by Schinkel, his colleague and patron in Berlin, Blechen was able to realise his long-cherished wish of travelling to Italy. Although he at first spent time in Rome and in various places in the Campagna, the traditional cultural sites of Rome were of less interest to him than the landscape, villas and gardens outside the city. Like many other artists of his period he, too, lingered in the park of the Villa d'Este, and its delightful fountains and magnificent ancient cypresses made a lasting impression on him.

Blechen contrived to impart to this view of the villa and gardens, painted after his return from Italy, a startling monumentality, calling on his experience as a theatrical scene-painter. Light slants down sideways in tender, hazy veils between the majestically towering cypresses; indeed the stream of golden light seems to splinter on meeting the wall of dark treetops. The atmosphere of a summer day seems to be charged with solar energy. As if on a stage, figures in Spanish court dress stroll between sun-flooded areas and dark shadows on the avenue of cypresses leading to the villa. Like the tendrils of an arabesque they relax the severity of the axial composition, recapturing the Mannerist spirit of the original landscape.

Blechen showed his painting at the Berlin Academy in 1832, and it attracted attention. King Frederick William III bought it at the exhibition for 200 *Talers*, and would later buy five more works by Blechen. There were several mentions of the picture in the press, some laudatory and some disparaging. To the critic of *Museum* Blechen's abjuration of traditional composition, his reassessment of landscape as a means of making visible an individual experience of nature, seemed like a 'quirkily comical genre of landscape'. 'The eye is boxed-in-the-ears' by his painting, 'but after the initial shock recognises a tall avenue of trees and rising up from it in steep perspective terraces and the villa, with fountains spouting voluminously at its foot; on the avenue at the front slender figures in Spanish costumes walking across. The light shining in between the tips of the trees virtually scalps the tall trunks and slits the ground, dazzling stripes of light run across with slanting jagged shadows between them, and the knights bend and stretch amidst them; whoever they may be, in figure and gait they have something so exaggeratedly ceremonious and affected about them as a result of the eccentric lighting that they look like court fools. It is truly a genuine scenic joke.'[3] The review of 13 November 1832 in the *Vossische Zeitung* is completely different: 'Blechen strives with extraordinary power and veracity to bring Nature before our eyes He leads us through every part of his picture on the step-ladder of his colours and in this way, by virtue of the power of his composition, achieves wonderful effects. Certainly not a trace of pettiness can be discovered in his pictures; his woods and rocks, his gorges, his lighting, his shadows, everything is *frappant* and magnificent.'[4] BV

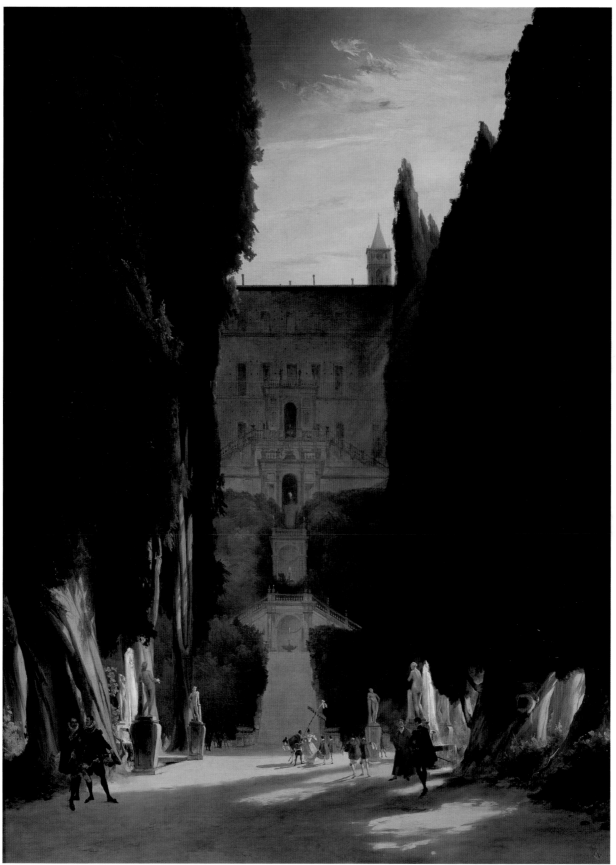

Carl Rottmann

1797–1850

25 The Battlefield of Marathon (*Schlachtfeld von Marathon*), c. 1849

Oil on canvas, 91 × 90.5 cm

Inv. no. A I 209

PROVENANCE Acquired through the dealer Miethke, Vienna, 1875

REFERENCES Bierhaus-Rödinger 1978, p. 416, no. 698; Munich 1998a, pp. 36ff., no. 187

NOTES

1 *Kunstblatt*, no. 12, March 1849, p. 48.

2 Bierhaus-Rödiger 1978, document 50 (Corinth, 15.11.1834).

This visionary depiction of the battlefield on which the Greeks under Miltiades won a decisive victory over the Persians in 490 BC is one of the painter's last works. In a more cursory and emblematic way it repeats his 1848 encaustic painting of *Marathon* for King Ludwig I of Bavaria now in the Neue Pinakothek in Munich. Shortly after it had been unveiled, Ernst Förster had perceptively appraised the dark mural of *Marathon* as a 'political' as well as an historical landscape, and knowledge of this later version would have reinforced him still further in that view.[1]

With memories of the widespread revolutionary uprisings of 1848 still fresh, Förster had recognised in Rottmann's scene of Marathon a dream of a new Hellas disappointed and the illusion shattered that a flourishing, just *polis* might be created in both Greece and Germany. Greece, until the first decades of the nineteenth century, had been under foreign, predominantly Turkish rule. In the early 1820s a long-drawn-out war of liberation started, during which it was dangerous to set foot in the land of classical antiquity of which Hölderlin and Goethe had sung. Only in Naples or Sicily could one still feel close to Greek landscape and culture, as Rottmann did while drawing and painting during his journey to Italy in 1826–7. The Greek uprising attracted enthusiastic supporters throughout western Europe. The Greek cause was espoused in France and Germany in particular, because in these countries it was closely bound up with their own domestic political struggles, their own demands for freedom and liberalism. After eleven years of bitter struggle the Greek state was founded, with the support of the Western powers, in 1832. Prince Otto of Bavaria, the younger son of Ludwig I, was chosen to be King of Greece, and a dream seemed to have come true.

After his trip to Italy Rottmann had created a cycle of Italian landscapes in fresco for the arcades of the Munich Hofgarten, and a cycle on Greek history was now planned. In 1834–5 Rottmann travelled through Greece, poverty-stricken for all its proud past, to prepare the project. As he reported to his wife in Munich, he was confronted there by a 'picture of destruction, it is horribly beautiful'.[2] Rottmann did not convert his studies of Marathon into the wall painting until 1848 or into this more abstract painting on canvas until 1849, by which

time the political situation had changed dramatically. Bavaria's Greek mission had virtually collapsed. After a popular uprising, in 1843 the constitution of Greece was altered to admit only Hellenic citizens to offices of state. Otto of Bavaria finally left the country in 1862. From the 1840s onwards Rottmann's pictures of Greece grow darker, and the Nationalgalerie's picture has an heroic pessimism.

Above the brown land, which extends to a stretch of blue water, hangs a sky heavy with clouds. Earth and sky are joined visually by means of several circular forms. The outer curve is answered by an oval in the centre of the picture, which is bounded in the sky by the overarching rain front and in the centre is traversed by an unfathomable dark stripe separating sea and sky. Interestingly enough Friedrich's painting *Monk by the Sea* (fig. 11, p. 22) has a similar dark horizon line. In Rottmann's painting only the ruined tower is a reminder of human activity, and significantly it is encircled by mounds.

In sketches of 1840–1 for the wall painting, one in charcoal on card and another in watercolour, Rottmann had already worked towards elevating the human struggle into a cosmic one, and now he carried it through in this painting. The field of human conflict becomes a battle of the elements. Rottmann had precedent in Altdorfer's *Battle of Arbela* (*Alexanderschlacht*), then as now in the Alte Pinakothek in Munich. There the tormented sky reflects and exalts the raging human combat below, which here is only remembered. In the absence of any physical evidence of an actual, dated event the impression is given of an everlasting struggle, of a ceaseless return to repetition to which both nature and history are subject. Marathon is henceforth no more than a name, a void. AW

25

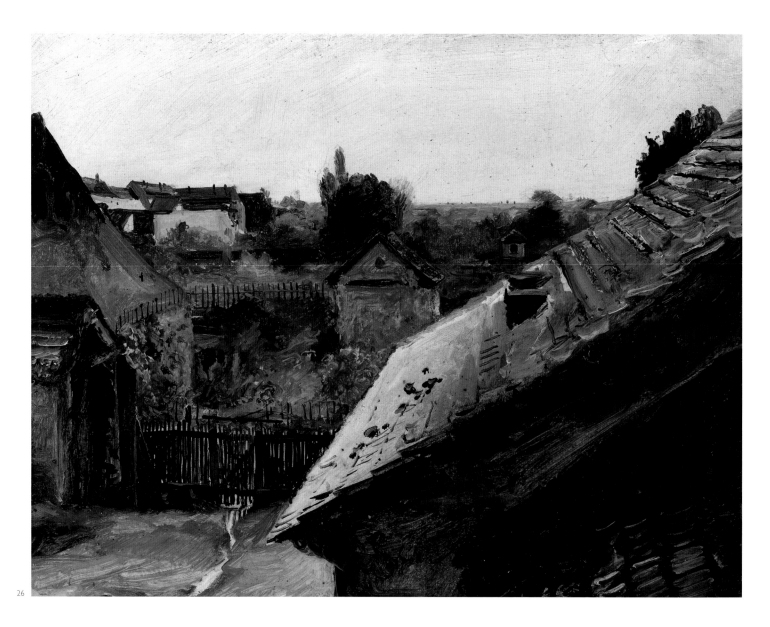

26

Carl Blechen

26 *View over Roofs and Gardens*
(*Blick auf Dächer und Gärten*),
c. 1835

Oil on paper on cardboard, 20 × 26 cm

Inv. no. A I 319

PROVENANCE Acquired in 1881 with six other
works by the artist from the collection of
Kammergerichtsreferendar Frick

REFERENCES Rave 1940, no. 1730; *Galerie der
Romantik* 1986, p. 139f.; Berlin–Munich 1990, no. 68

The view across roofs was first discovered as
a subject with the rise of painting in the open
air. The first successful attempt at photography,
by Nicéphore Niepce in 1826, also shows a
view over roofs. Blechen, in this picture from his
last period, recorded the view from his Berlin
apartment at no. 9, Kochstraße, which ran be-
tween Wilhelmstraße and Friedrichstraße. He
had moved to this artisan district in 1832.

In this apparently accidental, partial outlook
on to the ordinary, poor, unspectacular build-
ings of the vicinity Blechen boldly dispensed
with the conventions of landscape painting. He
leads the eye past the gradient of the roof wet
with rain towards nothing remarkable, the allot-
ments stretching out of sight to the horizon,

divided by wooden fences. But roofs and walls
are organised into a dynamic composition: on
the right the house roof juts out beyond the
centre of the picture, on the left the view is
open to the backyard and adjacent landscape
of 'sprawl'. It has just rained, and the puddles in
the yard reflect the sky. A soft light shimmers
in silvery reflections on the damp roof. The
painterly harmonies of green, ochre and umber
under a white-grey sky are conveyed with an
animated brush, spontaneously applied.

Blechen's partiality for the sketch-like, for
unusual details and unconventional subjects
heralding developments of the future, were
further developed by Adolph Menzel in the
1840s (see cat. 27). In a joint exhibition of the

27

two artists held in the Nationalgalerie in 1906 their closeness was recognised: Blechen was described as 'Menzel before Menzel'.[1] Ludwig Justi also praised this painting: 'How remote we are here from the views of buildings by the architectural painter Gaertner! A view is chosen which a professional painter of the time would have thought scarcely worth depicting. And how freely it is viewed …! A contingency of reality was regarded by this painter as subject enough – as Impressionist doctrine would proclaim to the world only much later: a corner of nature, seen through one man's temperament.'[2] BV

1 G.J. Kern, *Karl Blechen. Sein Leben and seine Werke,* Berlin 1911, p. 134.

2 Justi 1932, p. 122.

Adolph Menzel

1815–1905

27 *Tenement Backyard (Hinterhaus und Hof)*, 1844

Oil on canvas, 44.5 × 61.5 cm

Inv. no. A 1957

PROVENANCE Evidently sold in the artist's lifetime. Acquired in 1906 from the Salon Fritz Gurlitt, Berlin

REFERENCE Washington 1996, cat. 13

The youthful Menzel had already, in his 400 woodcuts for Franz Kugler's *Geschichte Friedrichs des Großen* (History of Frederick the Great,

1839–42), created one masterpiece of illustration, and a second one, *Oeuvres de Frédéric le Grand* (The works of Frederick the Great), was occupying his evenings. But during the day he turned his hand to oil painting, which up to then he had tried only in a few historical-genre pictures. 'My time is now filled with painting (after nature, which I have never previously done at all) …,' he wrote in a letter in spring 1844.[1] *Tenement Backyard*, one of his very first landscapes, belongs to that period, for the view depicted is from a window of the house at Zimmerstraße 4, where he lived only until early 1845, and while he was there in 1845 he could not have experienced such summery weather.

Clearly defined objects are visible only on the periphery: receding on the right the bare

outline of the back of a tenement building that must have been newly constructed, but has immediately become run down, and in front of this a small latrine block; on the left, similarly distant from the centre of the picture, a shed-like building. Between the two, a sturdily constructed and reinforced fence on an undefined, barren plot of land; the churned-up ochre-coloured earth of a small building site, overgrown with scrub; the wooden channel of an irrigation pumping system winding across the yard to a small excavation where bright sand has been freshly spread. There are no builders on the building site, but on the other side of the fence children are playing and, unexpectedly, become the focus of the picture, despite their tiny scale.

Behind them, distinct from the rest, is a kind of picture within a picture. The brown-tar colour with which the light ground was overlaid before colours were introduced here remains bare and takes on independent life.[2] The marks of vigorous scraping can be recognised – an unorthodox technique which Menzel also used quite often in his later work; it removes the substance of the paint layer, which was thin anyway, creating a visionary, unfixed image which hovers like a mirage and contrasts sharply with the detailed, practical concreteness of the tenement block beside it. As a consequence of this employment of two different painterly languages side by side, the aesthetic unity of the picture is compromised.

Was this the effect intended by the painter from the start? Probably not. But once it had occurred it was deliberately not obliterated by further working. In a work that could be categorised as a 'study' the artist had the freedom to experiment without worrying about the considerations imposed by sale or exhibition, and to enable a painting to become a dialogue with itself. The fact that Menzel himself released such works (see also cat. 28 and 33) into the public domain towards the end of his life indicates a fundamental change at the end of the century in what was expected of art. CK

1 To Carl Heinrich Arnold, 23.04.1844; Wolff 1914, p. 79.

2 Cf. Hans-Joachim Gronau, 'Maltechnische Beobachtungen am unvollendeten Gemälde *Ansprache Friedrichs des Großen an seine Generale vor der Schlacht bei Leuthen* von Adolph Menzel', *Forschungen und Berichte*, XXVI, 1987, pp. 283–90, at pp. 286–8.

Adolph Menzel

28 *The Balcony Room (Das Balkonzimmer)*, 1845

Oil on cardboard, 58 × 47 cm

Signed bottom right: *A. M. /45.*

Inv. no. A I 744

PROVENANCE Acquired in January 1903 from the R. Wagner gallery, Berlin; the proprietor, Hermann Pächter (died 1906), a dealer primarily in Oriental objects, from the early 1880s had increasingly enjoyed Menzel's confidence in matters commercial

REFERENCES Forster-Hahn 1993; Washington 1996, no. 18

For almost a hundred years *The Balcony Room* has been regarded as typifying the art of 'the young Menzel'. When the painting by the thirty-year-old artist was purchased for the National-galerie very belatedly, just two years before his death, there was a reassessment of his work. Nationalistic cultural policy had characterised him as 'the painter of Frederick the Great' (see cat. 30, 32), with Frederick as the harbinger of the glory of the Hohenzollern dynasty then ruling, but alongside that figure 'the young Menzel' now emerged as an Impressionist ahead of his time. Neither of these interpretations did justice to the complexity of his oeuvre; both limited attention to no more than a part of his work. In particular the ambiguity, the less obvious facets of his art, were to a large extent ignored.

In *The Balcony Room* the 'freshness' of both the view and the execution have always been emphasized, and justifiably so – the suggestion of atmosphere, the heart-warming poetry of an ordinary domestic scene. Less attention has been given to the problems implicit in the domestic scene, and in the process of painting it. The problem in both cases may be summed up as emptiness.

In all probability the room depicted is a room in the flat where the artist was then living, in the newly built Schöneberger Straße, on the extreme southern edge of Berlin as it then was. He lived there together with his mother (who died a year later) and younger brother and sister. Menzel may also have painted and drawn from this balcony. We do not know whether his studio was in the same house. At the time he was already recognised as an illustrator, and he

was working on the brilliant woodcut vignettes of his *Oeuvres de Frédéric le Grand*, but a large genre picture, *The Interruption (Die Störung, Staatliche Kunsthalle, Karlsruhe)*, had been standing on his easel unfinished since 1843. As yet there was very little trace of his later affluence; no doubt the family was living in straitened circumstances.

In the decades following 1800 there had been numerous paintings, especially water-colours, of interiors in which there were no people, but attention is always directed to the decoration, and the furniture and pictures attest to the affluence and culture of the occupants. Not only is Menzel's room devoid of people, but there are no noteworthy objects in it, either. Nothing to indicate that it is habitable and inhabited. The rug's dimensions are very modest. The chairs, turned away from one another, seem to have been moved from their usual positions, to have been deliberately displaced. The sofa and the picture hanging over it – an engraving, judging by the wide margin round the image – can be seen only as a reflection, deprived of all material weight. From Jan van Eyck's *Arnolfini* double portrait down to the subtle compositions of the Berlin artist Hummel (see cat. 36, 37) mirrored images had always only supplemented the concrete information; in *The Balcony Room* the mirrored image provides a more coherent idea of the room's appearance than what is shown of the room directly. If the objects brought into the picture by an optical sleight are excluded, the pictured space would be extremely unwelcoming and forlorn – but for the curtain moving in the wind and the light streaming in. The light shines through the curtain exactly on the central axis, is reflected on the wooden floor and brightens the mirror image.

The paint, however, has been released from servitude to contours and local colour, and thanks to the absence of objects acquires a thrilling life all its own. Hugo von Tschudi had despaired at the inability of the 'crude word' to do justice to the unostentatious 'marvels' of this painting.[1] The highlight on the empty wall is still puzzling – a reflection of the sun? Or did the decorator break off from his work at this point? Or did Menzel leave the picture 'unfinished'? A large part of the picture surface, in any case, remains undefined. The thin shaded area which represents the sofa on the left also relieves the

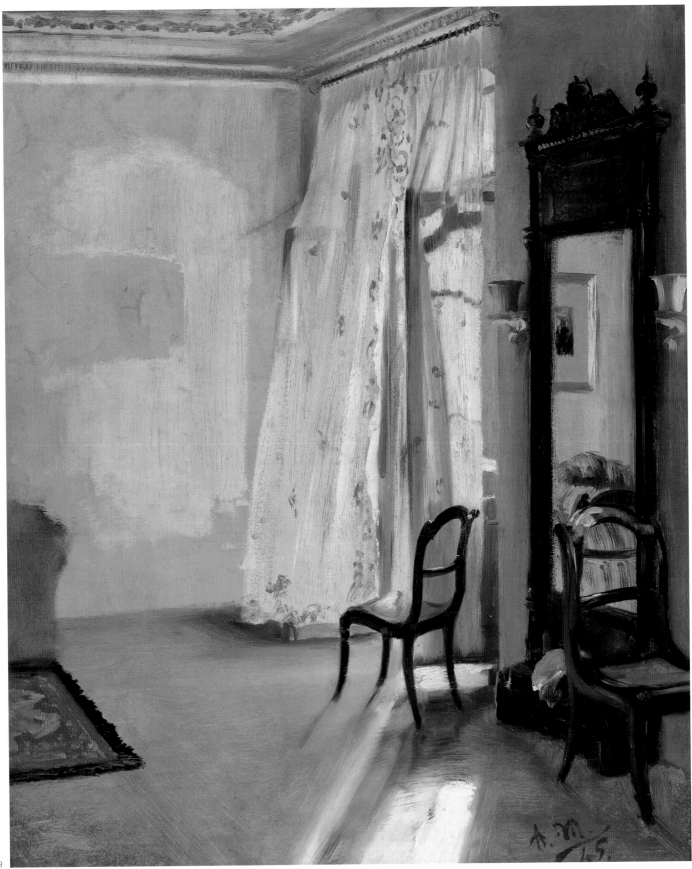

wall of its physical mass. The logic of the picture did not allow for plasticity here.

Contrary to traditional perspective construction the picture offers two different levels of view, and the floor seems to slide away under the viewer's feet.[2] Nor are there any lateral boundaries that might help to fix the foreground plane. In addition the clarity of depiction is not constant: here distinct and substantial, there cursorily dabbed on – corresponding to the eye's actual perception, which changes focus from one moment to the next. Even in Menzel's day theorists were considering simulating the 'different adaptation of the eye depending on the remoteness of the object to be perceived' and painting objects more indistinctly the greater distance they were from the main subject of the picture.[3] This had further consequences: breaking down the perception of an object into several stages also brought into question the pictorial fiction of time standing still – one of the fundamental conventions of picture-making since the Renaissance. The sense of unease concealed in the painterly beauty of *The Balcony Room* is an analogy for the deceptive peace of the Biedermeier period, in which revolution was hatching. CK

1 Hugo von Tschudi, 'Aus Menzels jungen Jahren', *Jahrbuch der königlichen Preuszischen Kunstsammlungen*, XXVI, Berlin 1905, pp. 215–314, at p. 227.

2 Werner Busch, *Die notwendige Arabeske. Wirklichkeitsaneignung und Stilisierung in der deutschen Kunst des 19. Jahrhunderts*, Berlin 1985, pp. 278ff.

3 R. Wiegmann, 'Die illusorische Wirkung bei Gemälden, mit besonderer Beziehung auf die Portraitmalerei', *Deutsches Kunstblatt*, VI, 1855, pp. 197ff.

Adolph Menzel

29 *The Berlin–Potsdam Railway* (*Die Berlin-Potsdamer Bahn*), 1847

Oil on canvas, 42 × 52 cm

Signed bottom right: *A.M. 1847*

Inv. no. A I 643

PROVENANCE Acquired in 1889 through the R. Wagner gallery (Hermann Pächter, see cat. 28). Formerly owned by Wilhelm Puhlmann of Potsdam, a military doctor and one of Menzel's oldest and most trusted friends, the owner of many of his drawings and graphic works. On his death in 1882 the drawings were purchased by the Nationalgalerie, but his heirs set aside *The Berlin–Potsdam Railway*, which was bought by Hermann Heinrich Meier of Bremen, a major collector of graphic work, who later exchanged the picture 'for a sheaf of Menzel's lithographs, artist's proofs from the work on the army' (for the *Berliner Kinderwochenblatt*, no. 41, of 7 October 1832)

REFERENCE Washington 1996, no. 35

Aged barely seventeen Menzel had made a lithograph copying English railway subjects.[1] Later he would constantly draw and paint travellers in carriages – a new kind of interior. This picture of 1847, however, based on a drawing done two years earlier,[2] was to be his only work depicting the new means of transport in a landscape context.

Just three years after the first German railway line, which, from December 1835, ran from Nuremberg to the neighbouring town of Fürth, the capital of Prussia followed Bavarian example and created a link with Potsdam, the old garrison town and royal residence. The locomotives came from Newcastle. The station for Berlin was built not far from the Schafgraben on the southern edge of the city, where Menzel drew, painted and etched repeatedly, and not far from his apartment. Throughout his life he was attracted by the new districts opening up on the margins of the city. The landscape in *The Berlin–Potsdam Railway* is mainly wasteland, abandoned fields or gardens awaiting development by the new construction companies that were springing up. Menzel was the first artist in Germany to acknowledge such spaces in suspension at the gates of the city, in effect registers of the dynamic industrial progress of the time.

That same year Menzel's friend Eduard Biermann painted the transport of two loco-

motives through the yard of the Borsig factory in Berlin.[2] This may have inspired Menzel to incorporate the puffing train into the composition, originally, as the 1845 drawing shows, a pure landscape. The train adds the dimension of time. But Berlin had also heard of Turner's *Rain, Steam and Speed* (National Gallery, London), painted just three years earlier, even if through the filter of a respectfully astonished review.[3] Where Turner, though, heightens nature into a cosmic force, Menzel affirms his own aesthetic of non-rhetoric.

Although the city may be silhouetted on the horizon – the two similar domed towers of the German and the French cathedrals on the Gendarmenmarkt can be made out – topographical accuracy was very far from being the point of the picture. Conformity to this genre of work, popular since the late eighteenth century, is laid out like a bait, arousing and at the same time disappointing conventional curiosity. The highly suggestive lights, darks and accents of colour turn out on closer examination to be rapid brushstrokes that provide fragmentary information at best. Where one thinks one can recognise a building, the colour sweeps over the crucial form, never breaking its momentum for the sake of the depiction of an object. The paint almost everywhere remains thin, and in large parts of the picture surface the dominant colour is the sepia brown used by Menzel to prime his canvases, bearing the rough traces of the bristles of a hard brush. Julius Meier-Graefe, who found praise for *The Balcony Room* (cat. 28), felt that this way of painting was 'quite coarse and over-hasty', 'more boorish than brilliant'. 'The whole thing is really too "poor" (*ärmlich*),' he felt.[4]

The Berlin–Potsdam Railway was the first work by 'the young Menzel' (see cat. 28) to enter the Nationalgalerie, though it already held some of his later, more narrative-like pictures. In his third year as Director Hugo von Tschudi opened his mind to an artist he had assessed very ambivalently just a short time before: in comparison with Arnold Böcklin's 'poetic' painting, Menzel's had appeared 'cerebral' to him.[5] *The Berlin–Potsdam Railway* also occasioned him to prompt Menzel to make his only, though momentous, comment on Constable, several of whose paintings he said he had 'looked at in detail' as a young man.[6] CK

29

1 Kupferstichkabinett, Staatliche Museen zu Berlin, SZ Menzel,
no. 1750

2 See Sabine Beneke and Sybille Gramlich, *Berlin Museum,
Märkisches Museum. Gemälde I, 1, 16.–19. Jahrhundert. Verzeichnis
der Bestände des künftigen Stadtmuseums Berlin,* Berlin 1994,
p. 90f., illus.

3 Ernst Förster, 'Die Kunstausstellung der königlichen Akademie
in London 1844', *Kunstblatt,* XXII, 1844, p. 324.

4 Meier-Graefe 1906, p. 89.

5 Hugo von Tschudi, 'Adolf Menzel', *Pan,* III, 1896, pp. 41ff.

6 Idem, 'Aus Menzels junge Jahren', *Jahrbuch der königlichen
Preuszischen Kunstsammlungen,* XXVI, 1905, footnote on p. 23.

Adolph Menzel

30 *Horse study: Head lying, in Harness (Pferdestudie. Kopf liegend, im Geschirr)*, 1848

Oil on paper, glued on to cardboard, 64.2 × 50 cm
Dated bottom left: *16 April 1848*
Inv. no. A III 510

PROVENANCE An old photograph shows the picture in a very visible position in Menzel's studio. In his lifetime it could have been exhibited only once, in 1861 (see cat. 33). Acquired in 1906 from the artist's estate
REFERENCE Washington 1996, no. 43

Rather than faltering in the intensely political year 1848 Menzel's output was stimulated and diversified, and he developed fresh approaches to both form and subject-matter. He produced his first sketches for the series of paintings he would undertake on the life of Frederick the Great, including that of the Battle of Hochkirch, *Night Attack at Hochkirch 1858* (lost in 1945; see fig. 30, p. 44), and it is in this connection that the twelve or so studies of horses which he painted in the course of a few months must have been made (three of them after heads which Menzel had brought to his studio from a slaughterhouse).[1] Among these, only this study of 16 April, showing the head tossed back, the mane tangled, the eye dimmed, the harness still in place, suggesting death in dramatic circumstances, measures up to the expressive pathos of Delacroix, for example – and also recalls the studies of the heads and limbs of executed criminals made by Géricault for *The Raft of the Medusa*. The twisted leather strap cuts sharply into the soft white hair, very subtly painted, and the metal has a really cold glint. The tacit symbolism of this elemental opposition between nature and bondage cannot be ignored. The atmosphere of Berlin's revolutionary spring and its street battles must have contributed to the experience here conveyed of fighting and death.

Years later, in 1865, Thomas Couture would paint a young artist sitting on a colossal antique head drawing the head of a dead pig (Van Gogh Museum, Amsterdam). For further study, instead of casts of antiquities hanging on the wall, he has an old shoe, vegetables and ordinary utensils. Menzel would have made a suitable butt for

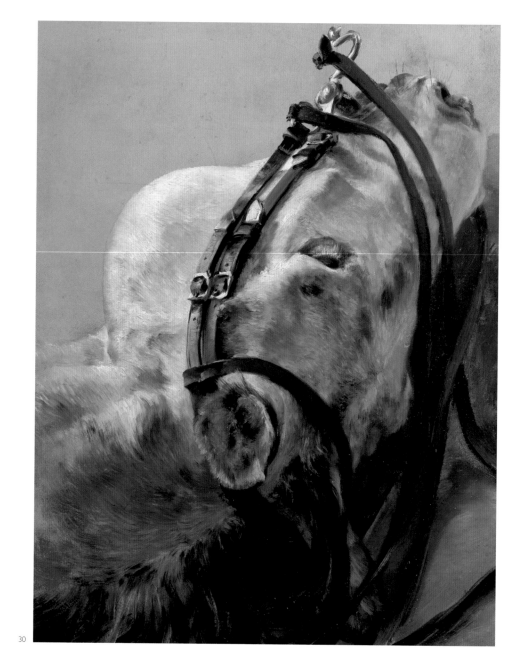

30

Couture's satire, which was entitled *A Realist* (*Un réaliste*). CK

1 Letter to Carl Heinrich Arnold, 03.05.1848; *Adolph Menzels Briefe*, ed. Hans Wolff, Berlin 1914, p. 134.

Adolph Menzel

31 *Studio Wall (Atelierwand)*, 1852

Oil on paper, mounted on wood, 61 × 44 cm

Signed top right: *A. M. 20. März 1852*

Inv. no. A I 904

PROVENANCE In the hands of the dealer R. Wagner, Berlin, in 1904; acquired in 1906

REFERENCE Washington 1996, cat. 65

31

As part of his preparation for *Night Attack at Hochkirch 1858* (see further cat. 30 and fig. 30, p. 44), Menzel is said to have 'built himself a dark glory-hole in his studio, in which he lit candles so that he could then study the effect, the colours, through a small hole'.[1] Likewise he apparently lit the plaster casts hanging on his studio wall from beneath and painted them to 'get my hand and my large, broad brush used to big, impasto painting, and to the peculiar light of the flames all around'.[2] We are familiar with these plaster casts from later photographs of Menzel's studio. They included 'only a few tried and trusted casts of Antique sculpture … casts from nature and particularly the most varied assortment of death masks take pride of place'.[3] In a later photograph the muscular hand hanging here next to the skull can be recognised.[4] It would therefore seem to have accompanied Menzel throughout his life.

At about the same time as this was painted Edgar Allan Poe was writing his macabre tales. The gaze directed at the torn-off stumps of arms, which seem to be searching for their lost parts so as to reassemble themselves into a whole, or at the flayed hand which hangs like genitalia between them – beside the skull and pointing significantly towards the palette – is comparable to Poe's gaze fixed on the impending death swinging ever closer with the pendulum. But the palette, only half included in the picture, offers an escape from the realm of death. It is instantly understood as a symbol of art. It must also be a man-made light that endows the plaster with a semblance of ghostly animation.

The Berlin *Studio Wall*, like the still larger, more elaborate version in Hamburg painted twenty years later (1872; fig. 24, p. 35), may be interpreted as 'a Realist's answer to the question of the use of the academically accepted canon of forms' – and at the same time as the triumph of an 'aesthetic of the fragment', which accords the dignity of art to the inconsequential and incomplete.[5] CK

1 Karl Scheffler, *Adolph Menzel*, Berlin 1922, p. 174, quoting the eyewitness report of Robert Warthmüller.

2 Albert Hertel, *Erinnerungen an Menzel* (1911–12), quoted from Lammel 1992, pp. 88–98, at p. 91.

3 Friedrich Eggers, 'Künstler und Werkstätten: Adolph Menzel', *Deutsches Kunstblatt*, vol. 5, 1854, pp. 2f., 10ff., 18ff.

4 Photograph by Zander & Labisch.

5 Cf. Werner Hofmann, 'Menzels verschlüsseltes Manifest', in *Beiträge zum Problem des Stilpluralismus*, Munich 1977, pp. 141–8.

Adolph Menzel

32 *The Flute Concert of Frederick the Great at Sanssouci (Flötenkonzert Friedrichs des Großen in Sanssouci)*, 1852

EXHIBITED IN LONDON ONLY

Oil on canvas, 142 × 205 cm

Signed bottom right: *Adolph Menzel Berlin 1852*

Inv. no. A I 206

PROVENANCE The composition, probably first conceived in 1848, was translated into a larger format in several phases of work. After two approaches (the first in the spring of 1849 and the second in spring or early summer 1850) the sugar manufacturer Ludwig von Jacobs reserved the picture in Potsdam in the spring of 1851. It was completed at the beginning of August 1852. The banker Magnus Herrmann of Berlin bought it about 1870 and sold it on to the Nationalgalerie in 1875. The frame with neo-Rococo mouldings designed by the artist himself went missing in 1945 and has been reconstructed from Menzel's drawings and archive photographs for the exhibition this catalogue accompanies

REFERENCES Hermand 1985; Dresden 1988, pp. 43ff.; Washington 1996, cat. 56

NOTES

1 Menzel to Carl Heinrich Arnold, 6 September 1840.

2 Cf. Hermand 1985, p. 38ff.

3 Axel Delmar, *Die kleine Exzellenz* (1905), quoted from Lammel 1992, pp. 99–126, at p. 107f. Menzel's remarks are translated rather differently in Washington 1996, p. 246. The German is as follows: 'Der König steht da wie ein Kommis, der Sonntags Muttern etwas verflötet …. Überhaupt habe ich's bloß gemalt des Kronleuchters wegen …. Manchmal reut's mich, daß ich's gemalt habe: enfin bestand die Hälfte meines Lebens aus Reue. So oder so.'

In order to illustrate Franz Kugler's *Geschichte Friedrichs des Großen* (History of Frederick the Great) and the king's own literary works Menzel had been engaged in comprehensive historical research since 1839, familiarising himself with every aspect of the later eighteenth century, its buildings, costumes and customs. At quite an early stage he planned one day to paint 'a cycle of large historical pictures' centred on the figure of the 'great king'.[1] The first sketches were made in 1848, the year of Revolutions, and by early 1849 the first of a loose series of ever larger pictures was finished; the last in the series was begun in 1859 and abandoned a few years later. From the start Menzel moved well away from late Romantic ideal history in order to get closer to a past that was still at hand and not yet transfigured by myth.

Only a few of the pictures of Frederick depict important, pivotal events; the remainder show his everyday life, portraying the king as a complex personality, sensible of his duty, susceptible to passion and above all cultured – a monarch devoted to Reason and the well-being of his subjects, and as such a model ruler in the minds of the discontented, liberal citizens of Prussia before and after the failed Berlin revolution of 1848. Frederick was well versed in all the arts and sciences, composed poems in French, wrote treatises on political philosophy and history (these Menzel would illustrate) and organised private concerts at which he performed flute solos, occasionally of music he had composed himself.

During the lengthy preparatory work for one of these large pictures, *Night Attack at Hochkirch 1858* (see further cat. 30), depicting a moment from a battle that the Prussians did not win, Menzel painted two peaks of Frederican culture, of which the *Flute Concert* was the second and the first *The Round Table at Sanssouci (Tafelrunde in Sanssouci,* 1850; formerly Nationalgalerie, Berlin, lost in 1945), in which the king is shown as an enlightened intellectual in conversation with Voltaire. The *Flute Concert* illustrates one of the evening concerts which the King organised for his sister, Markgräfin Wilhelmine von Baireuth, during her final visit (1750).[2] Wilhelmine, herself a cultivated woman and a composer, is the luminous figure in white on the bright red sofa listening dreamily with her head tilted, while Frederick's other sister, Princess Amalie, sits on her right.

The performance is taking place in the concert hall at Schloß Sanssouci, with its wall decorations by the court painter Antoine Pesne and the stuccoist Johann August Nahl, shimmering in the atmospheric light of the candles and chandelier. The idea for the picture had its origin in a woodcut for Franz Kugler's *Geschichte* made ten years earlier, which gives a much more spontaneous, concentrated view of the scene, set behind figures that block the foreground. By contrast the *Flute Concert* with its empty foreground has a theatrical aspect. Again by contrast to the woodcut, the thirty-eight-year-old king wearing the simple jacket of the Prussian army uniform is anachronistically given the pointy features for which the king in his old age – 'Old Fritz' – was to become legendary. Sitting among the orchestra, intent on the soloist as they wait to come in at the end of the cadenza, are Carl Philipp Emanuel Bach at the harpsichord, Franz Benda, Johann Joachim Quantz and Carl Heinrich Graun, all outstanding musicians of their age. In this ideal community of minds – also present are the mathematician and physicist Pierre de Maupertuis, Baron Jakob Friedrich von Bielfeldt and the opera director Gustav Adolf von Gotter – distinctions of rank are only marginally perceptible.[2] The psychology of the figures is echoed in the spatial atmosphere, the subtle play of the light. Thus the rhythmically spaced line of candles is grouped with the musicians, and the chandelier casts its light on the listeners; but both a candle and the reflected image of the chandelier blaze around the king.

As soon as it became known this picture established itself as Menzel's most popular work. Soon it was also pressed into service to support the official myth of Prussia, and reproduced thousands of times, though without the artist's involvement; in his old age he tended, on the contrary, to regard it with grumpy self-criticism: 'The king stands there like a shop assistant piping a tune to mothers on a Sunday …. In fact I only painted it for the sake of the chandelier …. Sometimes I regret having painted it; but, anyway, half my life is made up of regrets, one way or another.'[3] CK

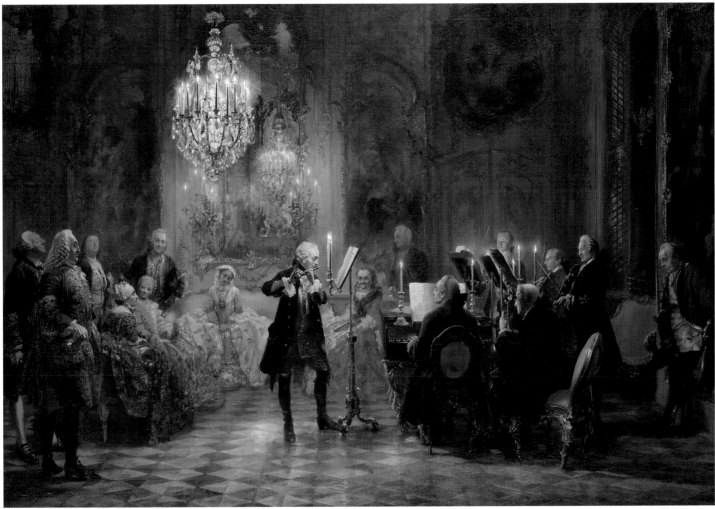

Adolph Menzel

33 The Théâtre du Gymnase (Das Théâtre du Gymnase), 1856

Oil on canvas, 46 × 62 cm

Signed bottom left: *Menzel. 1856*

Inv. no. A I 981

PROVENANCE Acquired in 1903 by Adolf Rothermund of Dresden-Blasewitz, by whom sold in 1906 to the Nationalgalerie

REFERENCE Washington 1996, cat. 80

NOTE

1 Kirstein 1919, p. 116.

In 1861 Menzel exhibited several of the small, 'private' pictures, including *The Théâtre du Gymnase,* which he had previously held back in favour of work with more pretentious subject-matter. The response was extremely disappointing, so that it was only in the last decade of his life that he once again released this side of his work, which was then 'rediscovered' in the light of Impressionism. The key position which *The Théâtre du Gymnase* acquired in the eyes of the turn-of-the-century admirers of the 'young Menzel' was justified by references to French painting; and comparisons can certainly be made to Daumier's *Drama (Le Drame, c.* 1860; Neue Pinakothek, Munich) and the theatre and concert pictures of Degas and Toulouse-Lautrec. Many of their innovations are anticipated here, notably the use of an oblique view and an un-balanced composition in which all the elements of the picture – stage, stalls and boxes – are moved off focus, leaving the centre empty.

The idea for the *Théâtre* came from the first of Menzel's three visits to Paris. During the World Exhibition of 1855, when his *Round Table at Sanssouci* (see further cat. 32) was shown at the Salon, he was able to spend two September weeks exploring the city, which seemed to him a 'Babylon'; and as he loved opera and the theatre a visit to the Théâtre du Gymnase was natural. The Gymnase, built by Auguste Rougevin in 1820, was the preferred venue for Eugène Scribe's contemporary comedies and for musical melodramas. The germ of Menzel's picture appears on a double page of the sketchbook he used in Paris. However, he extended his original sketch of the auditorium outwards, giving the scene not only more room but heightened tension. The stage, dominated by the flaming red of the nearby box, occupies almost two thirds of the width of the picture, and the actors have considerably more weight than in the sketch. The small figures of the audience, leaning forward from all the boxes, animate the scene, and the head of the conductor and the top of a cello link stalls and stage – a device later encountered several times in Degas's work.

Just four years after the *Flute Concert* (cat. 32) had been completed, its modern antithesis appears. Once more we have actors and an audience, and artificial light, but in the harder light of the *Théâtre* there is no psychological ripple, and there is no principal figure. The actors on the stage do not fulfil that role – their drawing-room exchanges have nothing of the highly charged impact of Daumier's *Drama –* and the audience is an excited, surging, drifting mass, a pack. Seeing here becomes greedy consumption, the opera glasses become weapons in some aimless hunt. As if we ourselves were provided with such glasses, we perceive the three figures on the stage in contrary perspective, as more colourful, clearer and nearer than the musicians in the orchestra pit or than the audience, although Menzel added details to the audience 'in the very last years before the picture left his studio'.[1]

The warm dark ground of the picture wells up from the stalls and the orchestra, among which individual heads, sheets of music and collars can only gradually be distinguished, with a reddish sheen adhering to them. Evidently outside the picture space, besides the footlights, which sharpen all the contrasts, there is a gentler source of light. The three primary colours, yellow, blue and red, parallel the three unequally proportioned rectangles that form most of the picture surface, the red rectangle dramatically intensified in a way that is justified only by the alienating effect of the lighting from below. As one studies this use of colour it is hard not to think of Delacroix. CK

Biedermeier Realism

Look, there goes Mr Biedermeier,
And his wife, son on arm;
He walks sedately as if on eggs,
His motto: neither hot nor cold!
He is a highly respected citizen,
His words are spiritual, his aspirations worldly;
He lives in that fine house,
And – lends out his money at extortionate rates.

He votes at elections as he should,
And finds all disputes distasteful;
Although not a friend of paying taxes,
He very much respects Authority.
Summoned to the town hall or officialdom
He doffs his hat while on the steps;
Then he goes proudly home,
And – lends out his money at extortionate rates.

Missing church on Sunday
Would be against his Christian duty;
There he gets absolution for his soul
And dozes when the parson speaks;
That takes him happily on to the blessing,
The doughty man accepts it piously,
Then full of elevation he goes home,
And – lends out his money at extortionate rates.

Oh noble house! Oh fine morals!
Where every poison is stifled in the bud.
Where only things gladly avoided and seemly
Are practised and tolerated.
Oh pious culture, flower of faith,
May possessions protect and shield you! –
There must be respect in State and home:
Else – money will not yield extortionate rates.

Ludwig Pfau, 1846

The years between the defeat of Napoleon in 1815 and the Revolutions of 1848 were a time of relative peace, prosperity and innovation in German-speaking Europe. The period acquired its name from a minor literary character of the day named Gottlieb Biedermeier, who embodied sober, solid, not to say philistine, middle-class values. Perceptions of the era have long been coloured by this hint of something pedestrian. In fact, a newly confident middle class was testing and enjoying its liberties and searching for its representative modes of expression. In the decorative arts – and it is now recognised as a great age for the arts of design – it tended to eschew monumental and ostentatiously classical statement in favour of a more modest, chaste style, ultimately derived from classical forms but simpler and more domestic in scale. Approaches varied from region to region, of course, but the essential characteristic of Biedermeier art was identified by Theodor Fontane as 'rigorous simplicity'.

In painting, emphasis was given to the objective recording of natural phenomena. Large-scale history painting was in decline. Landscape painting and the portrait, both genres that invite close observation and naturalistic depiction, increased in importance. Art patrons were anxious to acquire representations of landscapes they themselves recognised, indeed might have walked in, such as the Viennese Ferdinand Georg Waldmüller's minutely detailed *Prater Landscape* (also known as *Eine Auparthie*) of 1830 (fig. 44). (This painting, which disappeared in 1945, has only recently been restored to the Nationalgalerie.) The same artist recalled that the commission to paint a strictly realistic portrait of an old lady (cat. 38) marked a turning point in his career, when 'the blindfold fell from my eyes'. Nor did he turn those eyes away from unpleasant social realities of the age, as in *Evicted* (fig. 43). In technique, brushstrokes were masked in favour of an enamel-like finish.

Berlin was expanding rapidly, growing to fulfil its emerging role as a major European capital. Imposing new public buildings by Schinkel and his disciples were rising, giving the city an architectural grandeur it had previously lacked. Some, like the Neue Wache on Unter den Linden, painted by Eduard Gaertner, were meant to commemorate victory in the Wars of Liberation (cat. 34). He and fellow cityscape painters such as Johann Erdmann Hummel carefully depicted the new city as it filled with architectural and technological wonders like the granite bowl in the Lustgarten (see cat. 36, 37). They also turned their attention to the back alleys and unprepossessing side streets where old Berlin lived on – leaving an invaluable painted record of what, between them, prosperity and war would ultimately destroy. CR

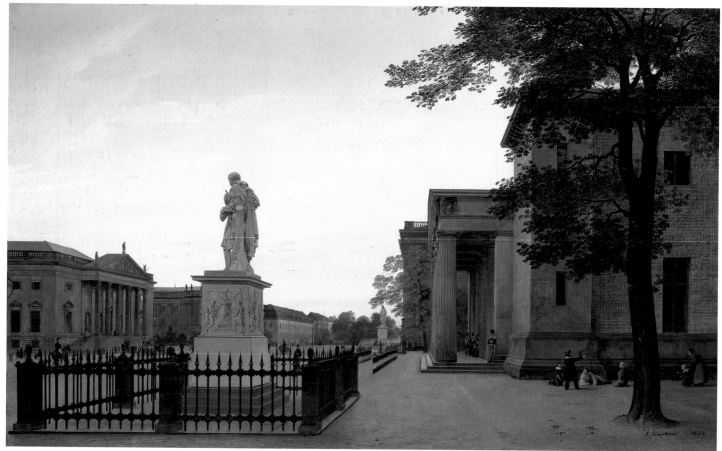

34

Eduard Gaertner

1801–1877

34 *The Neue Wache (Die Neue Wache)*, 1833

Oil on canvas, 44 × 77 cm

Signed bottom left: *E. Gaertner 1833*

Inv. no. A 1917

PROVENANCE Acquired on the occasion of the Centenary Exhibition of 1906 from the dealer E. Schulte, Berlin, 1906

REFERENCES Wirth 1979, p. 27f.; *Galerie der Romantik* 1986, p. 156f.; Berlin 1997, p. 142

Eduard Gaertner was the most brilliant of the architectural painters active in Berlin during the Biedermeier period. For four decades, from the late 1820s to the late 1860s, he dominated this field, and his was the image of the city that became established. His many views are charac-terised by accurate observation, finesse in light-ing and a strong feeling for narrative detail. Set within a music of light and shade, weather and landscape, his architectural scenes convey the breath of a living entity.

The Neue Wache (New guardhouse) had been built to a design by Schinkel for Frederick William III on Unter den Linden, Berlin's splen-did triumphal way, as a monument to Prussia's victorious struggle for liberation against Napoleon. On his return from a period of study in Paris, Gaertner tackled the subject for the first time in a watercolour of 1829 (Stadtmuseum, Berlin). In the painting of 1833 Gaertner notice-ably reduced the staffage, shifting the emphasis more on to the buildings. To the right there is a partial view of the east side of the Neue Wache, behind it the projecting façade of Prince Heinrich's palace, which subsequently became the University. Opposite these the Royal Opera House built by Knobelsdorff and the Baroque façade of the Royal Library can be seen.

Both in the strange emptiness of the fore-ground and in the dark outlines on the columns and walls of the Neue Wache of figures planned but not executed one can detect the rejected idea of a street scene that would have been more animated. But evidently Gaertner pre-ferred the spareness of the present scene, in which the statue of General Scharnhorst in front of the Neue Wache is dominant. Swathed in his cloak, the great campaigner who rebuilt the Prussian army has an attitude of concen-trated thought. On the central axis of the picture, as a pendant to the Scharnhorst monu-ment, the statue of Graf Bülow appears, very much diminished by the perspective; like Scharnhorst he had fought against Napoleon.

Gaertner here celebrates the architectural and sculptural programme of the Unter den Linden as a *via triumphalis* dedicated to the victorious national liberation movement. The time of day is the approaching evening. The dusk and the unusual quietness on Berlin's main thoroughfare impart a solemn mood to this highly programmatic picture. BV

35

Eduard Gaertner

35 *View of the Backs of the Houses on Schloßfreiheit (Ansicht der Rückfront der Häuser an der Schloßfreiheit)*, 1855

Oil on canvas, 57 × 96 cm

Signed bottom right: *E. Gaertner*

Inv. no. NG 7/93 and FNG 66/93

REFERENCES Wirth 1979, p. 51; Schuster 1993

'Schloßfreiheit … is the name given to the part of the esplanade on to which the narrow side of the Castle abuts in a westerly direction, formed by a row of tall, beautiful houses in which several prestigious, well-stocked gold- and silversmiths' shops and other retail outlets of the most varied description are located.'[1] Ever since, in 1678, the municipal authorities of the Friedrichswerder district of Berlin had demanded jurisdiction over these houses, even

though it was not conceded to them, this street had been named 'Schloßfreiheit' (Castle free-dom). In the Wilhelmine era it became subject to the aspirations to grandeur of the imperial house. At the end of the nineteenth century William II had the row of houses demolished to build the National-Denkmal (National monu-ment) to his grandfather Wilhelm I in 1896.

In this painting Eduard Gaertner not only re-produces an aspect of Berlin's architecture, he at the same time provides an insight into the lives of the street's inhabitants. Looking across the sluice channel of the Spree that forms the Museumsinsel, the painter shows the Schloß-freiheit from the rear, in a picturesque rather than a monumental view, with winter gardens, balconies full of flower pots and washing hung out to dry. Above the idyll of middle-class exist-ence the Castle rises grandly and impressively in the shape of the dome newly built by Friedrich August Stüler above the Eosander gate (since destroyed). The summer afternoon light illuminates the walls of the houses in warm, richly nuanced colours. In the foreground, the

elegantly dressed gentleman leaning on a rail-ing with a dog on the lead is perhaps the un-known patron who commissioned the work.

Gaertner framed the composition with two important buildings by Schinkel. At the left-hand edge appear the south piers of the Schloß-brücke (Castle bridge) and one of the marble statues commemorating the Wars of Liberation. The marble of this *Victory* is shiny white in Gaertner's light, and her wings appear to reach higher than the Castle dome. At the right-hand edge the east side of the Bauakademie (Academy of architecture; 1832–5) is just visible. Gaertner contrived to bring this building into his townscapes on several occasions; and it was the main subject of one of the most important paintings of his late period, *The Bauakademie* (1868; Nationalgalerie, Berlin). BV

1 Leopold Freiherr von Zedlitz-Neukirch, *Neuestes Conversations-Handbuch für Berlin und Potsdam*, Berlin 1834, reprinted 1981, p. 706f.

36

Johann Erdmann Hummel

1769–1852

36 *The Grinding of the Granite Bowl (Das Schleifen der Granit-schale)*, 1831

Oil on cardboard, 46 × 75 cm

Signed bottom right: [illegible]

Inv. no. A I 884

PROVENANCE Gift of the Berlin Kommerzienrat (Counsellor for Commerce) L. Bialon, 1905

REFERENCES Rave 1942; Rave 1959

Hummel, a professor of perspective and optics at the Berlin Academy of Arts, commemorated one of the great technical feats of his day in a series of three pictures, showing the grinding and turning of a great granite bowl, and finally (cat. 37) its installation in the Lustgarten

(pleasure garden) in front of the Berlin Museum (now the Altes Museum) on the Museumsinsel.

About 1820, exploiting the opportunity provided by new technical advances, craftsmen in Berlin had begun to make pedestals and bowls and such like from 'erratic' blocks of granite left behind in the region by the glaciers of the Ice Age. In *Kunst und Altertum* (*Art and Antiquity*) Goethe was very laudatory about these novel 'granite works in Berlin'. The British ambassador, the Duke of Devonshire, commissioned a particularly large granite bowl from the court mason, Christian Gottlieb Cantian. In response, the King of Prussia determined that a piece which would surpass the one being made for England should be made for Berlin: the largest of all such products must stay in the country. Cantian's response was an offer to make a bowl for Prussia that was still larger and more splendid than the antique porphyry bowl from Nero's Domus Aurea in the rotunda of the Vatican Museums.

A particularly large erratic from the Mark

Brandenburg was worked on the spot for two years. The roughly hewn block weighing 80 tonnes was then rolled down to the River Spree on tree trunks and transported to Berlin on a specially built barge. Cantian had borrowed from the building commission one of the modern steam engines, which he set up next to his temporary workshop close by the museum, in order to carry out the grinding and polishing, which took another two years. Hummel recorded this grinding process – which caused a public sensation, and was therefore eminently worth depicting – with great technical virtuosity and much relish in the many and varied reflections on the polished granite. The bowl has become a mirror of the new manufacturing forces and of a new age.

Berlin townscape painting was lastingly influenced by Hummel's theories of perspective and his publications on optics and geometry, which accompanied the rise of new kinds of pictures such as panoramas and dioramas. AW

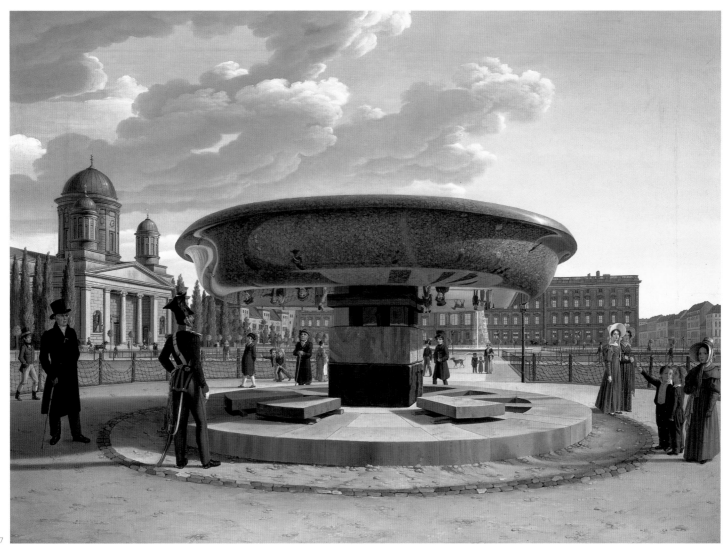

37

Johann Erdmann Hummel

37 *The Granite Bowl in the Berlin Lustgarten (Die Granitschale im Berliner Lustgarten)*, 1831

Oil on canvas, 66 x 89 cm

Inv. no. A I 843

PROVENANCE Gift of the Berlin Kommerzienrat (Counsellor of Commerce) L. Bialon, 1905

REFERENCES As cat. 36; also Hummel 1953, p. 43 f.; Hentzen 1973; *Galerie der Romantik* 1986, p. 149f.

Hummel exhibited his trio of paintings relating to Cantian's large granite bowl (see cat. 36), including this picture, at the Berlin Academy in 1832. The bowl is seen installed in the Lustgarten in front of the Berlin Museum (now the Altes Museum) still with its temporary mounting. The form of the substructure of the bowl had proved problematic. Designs by Schinkel and by Cantian were rejected. Eventually, when the bowl was dedicated in 1834, it was mounted on three simple blocks of granite. A 'Biedermeier wonder of the world',[1] the making and installation of the granite bowl had kept the whole of Berlin agog — engineers, architects and bystanders alike.

Hummel again demonstrates his great interest in optical phenomena in this painting. The polished exterior of the bowl collects the light of the sunny day in reflected images of its surroundings like a convex lens. The visitors to the Lustgarten standing nearby are reproduced upside down in a panorama-like curved image on the bottom of the bowl. In the foreground, next to a soldier, formally dressed in a frock coat and top hat, Cantian, a pupil of Hummel's, is proudly surveying his work. The two boys marvelling at the bowl are Hummel's sons, accompanied by their female cousin. The illusionism in the representation of the grain of the stone is brilliant. By making the bowl, which seems gigantic in the close-up view, apparently expand above the eaves of the buildings (the Cathedral and Castle) that surround the Lustgarten Hummel's perspective monumentalises it most effectively. BV

1 P.O. Rave, 'Die Große Granitschale im Lustgarten. Ein Biedermeierweltwunder', in Rave 1965, p. 106.

Franz Krüger

1797–1857

38 *Prince Augustus of Prussia (Porträt des Prinzen August von Preußen)*, c. 1817

Oil on canvas, 63 × 47 cm

Inv. no. A I 452

PROVENANCE Acquired in 1890 from the estate of M. Waldenburg, Berlin

REFERENCE *Galerie der Romantik* 1986, p. 140f.

Biedermeier painting in Berlin was able to build on a tradition of accurate observation and truth to nature that went back to the time of the painter and engraver Daniel Chodowiecki (1726–1801). In Berlin they give 'preference to those works of art which are a true and faithful reproduction after a model that is before the artist's eyes; in other words, here every work of art is treated as a portrait or counterfeit.'[1] Or so the sculptor Johann Gottfried Schadow described art in Berlin in 1801, after Goethe had criticised its 'naturalism'.

Franz Krüger was the outstanding portraitist among the Berlin painters of the Biedermeier period. To ensure authenticity for his numerous likenesses of worthies from both the nobility and the middle classes, he prepared with careful drawings and studies from the life. He was known also for his equestrian pictures, hunting scenes and depictions of ceremonies.

In this portrait Prince Augustus of Prussia (1779–1843), a nephew of Frederick the Great, stands in formal pose in the audience room of his palace in Wilhelmstraße; the renovation of its interior to designs by Schinkel had just been completed. Wearing the uniform of the Artillery Guards and with the insignia of the General Staff on his chest, the prince stands in the centre of the room, one hand on his sword, the other holding his plumed cocked hat between the tips of his fingers. His military cloak just happens to have been thrown down on a chair on the left. A drawing of fortifications lying on the table refers to the military experience he had gained fighting Napoleon.

On the wall in the background we see a picture within a picture: the famous portrait of the renowned Mme Julie Récamier painted by

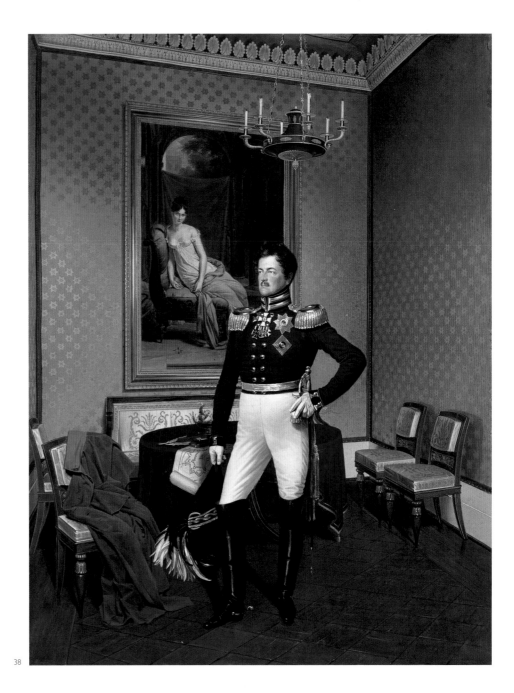

38

François Gérard in 1805 (Musée Carnavalet, Paris), a masterpiece of the French Empire period. Among the many admirers of Mme Récamier, the wife of a Paris banker, Prince Augustus, who had met her at the salon of Mme de Staël at Château Coppet on Lake Geneva, had pride of place. It was said that she had considered divorcing her husband in order to marry the prince. In fact she stayed with M. Récamier, even though his business had meanwhile failed. In 1808, however, she gave her celebrated portrait to the prince. As a token

of his own attachment, Prince Augustus in 1819 commissioned from Gérard a painting of *Corinne on Misenum* (*Corinne au cap de Misène*; Musée des Beaux-Arts, Lyons), depicting the heroine of the novel by Mme de Staël, and gave this to her. Mme Récamier's portrait was returned to her after the prince's death. BV

1 'Über einige in den Propyläen abgedruckte Sätze Goethes, die Ausübung der Kunst in Berlin betreffend', in Gottfried Schadow, *Aufsätze und Briefe*, ed. Julius Friedländer, Stuttgart 1890, p. 46.

Ferdinand von Rayski

1806–1890

39 *Haubold von Einsiedel*
(*Haubold von Einsiedel*), 1855

Oil on canvas, 73.3 x 61.9 cm

Signed bottom right: *FvR 1855* (also Rayski's pictogram, a dog's head)

Inv. no. A 1956

PROVENANCE Painted for the boy's parents in Reibersdorf and Milkel (Saxony). In the possession of the family until acquired in 1906. Like Waldmüller, Rayski was rediscovered at the Centenary Exhibition of 1906, which showed twenty of his pictures

REFERENCES Walter 1943, p. 28 and no. 791

This boy with a romantically medieval Christian name, the son of the Obermundschenk (chief cup-bearer) to the King of Saxony, was to be granted only a short life (1844–1868). He was eleven years old when the portrait was painted, but his boldness seems more youthful than childish. Although it is dreamily veiled, his bright gaze locks on to the viewer's eye. His very up-right figure appears in clear frontal view, while the arms jutting out in wide arcs virtually take over the canvas. One looks in vain for the hands. Rayski quite frequently holds a portrait sus-pended in this way between the grander three-quarter-length format and the more intimate head-and-shoulders. It is a format conducive to 'psychological realism',[1] which Rayski conveys subtly through painterly handling. Here, using a restrained palette between velvety grey and light ochre he gives character to the face, de-fines the body against the indeterminate, airy space, suggests with striking looseness of touch the floppiness of the white collar and the blond curls, and differentiates cast shadows in all their flatness and sharpness from the illuminated areas. Reference has justifiably been made to Manet, in particular to his *Piper* (*Le Fifre*, 1866; Musée d'Orsay, Paris).[2]

Rayski was able to measure himself against English portrait painting, for example Thomas Lawrence, on a trip to England in 1862, where he went at the invitation of Haubold's father, though the purpose of the visit was to buy horses. Rayski painted portraits of several mem-bers of the Einsiedel family, including Graf Kurt von Einsiedel, and another portrait of Haubold

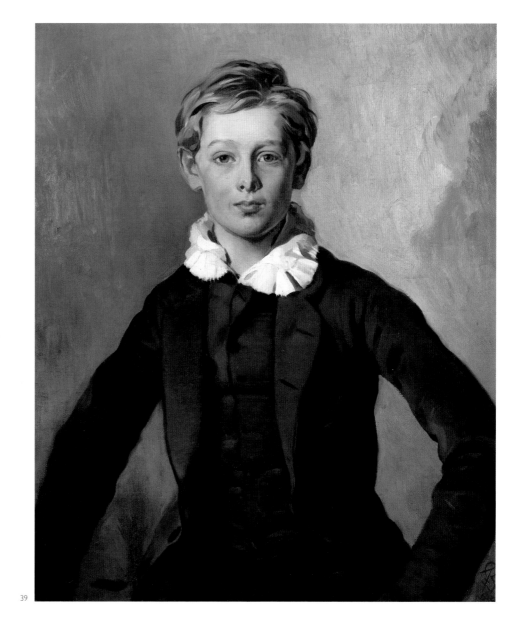

39

two years later, this time in profile and rather gloomily solemn (whereabouts unknown).

The Einsiedels were only one of the Saxon families with whom Rayski had connections over many years.[3] He had abandoned a career as an army officer in favour of painting, but he soon also gave up taking part in exhibitions and com-peting for public commissions. Specialising in hunting scenes and portraits, he was able to combine socialising with the practice of his pro-fession, often extending his visits to country estates belonging to friends or relations for months. As a result his work was often been perceived as being 'gentlemanly', which is in fact thoroughly misleading. Although his work was

generally paid for, albeit modestly, Rayski was able to keep his distance from the art business, and, while this entailed sacrifices, it gave him the freedom to follow his own path. With stub-born, if apparently casual, individuality he did not let his powers of expression succumb to the demands of convention. CK

1 See Mathias Goeritz, *Ferdinand von Rayski und die Kunst des neunzehnten Jahrhunderts*, Berlin 1942, p. 86.

2 See ibid., p. 157f.

3 Agatha Kobuch, 'Ferdinand von Rayski und seine adligen Auftraggeber in Sachsen', in Dresden–Munich 1990–1, pp. 15–22.

Ferdinand Georg Waldmüller

1793–1865

40 *The Mother of Captain von Stierle-Holzmeister* (Die Mutter des Hauptmanns von Stierle-Holzmeister), *c.* 1819

Oil on canvas, 54 × 41 cm

Inv. no. A I 1083

PROVENANCE The whereabouts of this celebrated picture was not known at the time of the Centenary Exhibition in 1906, which contributed decisively to the rediscovery of the artist. In 1909 it was unearthed in the possession of the sitter's descendants (along with cat. 41 and a third portrait) by the Viennese art historian Arthur Roessler, who wrote the first major monograph on Waldmüller. Purchased that same year through the Viennese art dealer Artaria

REFERENCES *Galerie der Romantik* 1986, p. 175; Munich–Vienna 1990, no. 2; Feuchtmüller 1996, p. 29 and no. 51

40

The ancient Councelloress (Hofrätin), her corpulence harshly compressed by an Empire dress of striped silk, sits patiently for her as yet obscure twenty-eight-year-old portraitist, who until then had worked mainly as a scenery painter and miniaturist. Her past career as Henriette Mirk, including her success playing second-string roles in the opera at the Hofburgtheater in Vienna, where she had appeared from 1777 onwards, is obviously a distant memory. She is as carefully turned out as all Waldmüller's later sitters would be, her plump face framed by corkscrew curls and lace trimmings; her watch hangs on an expensive watch charm. She is not striking a pose; her eyes do not seek the viewer's gaze but remain slightly lowered. But her figure so imposingly fills the space of the canvas that an almost disturbing impression of proximity is created.

This uncomfortable picture is beautiful in its colouring, in its unfailingly subtle transitions of modelling, particularly the flesh, and in its differentiated rendering of materials and their varying response to the light that falls on them. Things are observed in the most minute detail, but without pedantry.

Throughout his life, whenever it was a question of defending truth to nature against prescribed standards of style or academic conventions, Waldmüller was ready to join battle. He styled himself a copyist after nature. A polemic he wrote, advocating reform of the teaching at the Vienna Academy, where he held a post, occasioned interminable disputes and lasting discrimination against him. In the description of his artistic development he appended to this work, he linked his awakening to Realism from the imprisonment of convention to this commission in particular. 'Studies from nature,' he wrote, '– an idea which had hitherto remained completely foreign to me! … Captain von Stierle-Holzmeister commissioned me to paint a portrait of his mother. But, he said to me, paint her exactly as she is. In accordance with his commission I now tried to reproduce nature with the utmost fidelity – and it worked! All at once the blindfold fell from my eyes. The only right path, the inexhaustible fount of all art – looking, observation and understanding of nature – had been opened up to me; what had for so long resonated as an inkling in my soul woke to consciousness, and, although

41

Ferdinand Georg Waldmüller

41 *Captain von Stierle-Holzmeister (Porträt des Hauptmanns von Stierle-Holzmeister), c. 1819*

Oil on canvas, 54 × 40 cm

Inv. no. A I 1082

PROVENANCE As cat. 40

REFERENCES *Galerie der Romantik* 1986, p. 173f.;
Feuchtmüller 1996, p. 29 and no. 50

These portraits of mother (cat. 40) and son could never have been regarded as pendants, they are so differently conceived. The youthful retired captain presents himself romantically, with an extravagant twist of his head over his shoulder to regard the viewer face on, caught in the act of moving rather than holding a pose; his beret marks him as artistic. His cloak with its many folds gives him the air, it might be thought, of a *carbonaro* – a member of the libertarian Italian secret society that was in the news at the time – or even a brigand, were it not for the snow-white collar and the distinguished silk cravat.

Josef Stierle-Holzmeister (1781–1848) had retired from his post as a captain in the infantry as early as 1811. In Vienna until 1828, then in Preßburg (now Bratislava), and in Vienna again from 1840, he became known as the centre of a salon much frequented both by cultured officers and by a wider society, at which poets read and distinguished visitors to Vienna would put in an appearance. In 1844 he published his *Gesammelte humoristische Novellen, Erzählungen und Gedichte* (Collected humorous novelle, stories and poetry) in three volumes. He owned several other pictures by Waldmüller. CK

immediately after that realisation I could hardly conceal from myself how far I had previously strayed from the right path, I was now firmly resolved never to depart from it again ….'[1]

The late portraits of the French painter Jacques-Louis David, by this time in exile in Brussels, have a blunt objectivity very similar to Waldmüller's in his depiction of Frau von Stierle-Holzmeister. CK

1 Autobiographical preface to the second edition (1847) of Waldmüller's pamphlet *Das Bedürfnis eines zweckmäßigeren Unterrichts in der Malerei und plastischen Kunst* (1846), here quoted as reprinted in Feuchtmüller 1996, p. 339.

Carl Spitzweg

1808–1885

42 *English Tourists in the Campagna (Engländer in der Campagna)*, c. 1835

Oil on paper, glued on to card, 40 x 50 cm

Inv. no. A II 505

PROVENANCE Acquired from the Galerie Ernst Arnold, Dresden, in 1926

REFERENCES Roennefahrt 1960, no. 621; *Galerie der Romantik* 1986, p. 161f.

It was not only Moritz von Schwind (see cat. 19) who painted eccentric individuals on the fringes of society; Adolph Schrödter and Johann Peter Hasenclever in Düsseldorf and Theodor Hosemann in Berlin also devoted themselves to this type of picture, and its most striking exponent was Carl Spitzweg in Munich. For a century or more, through innumerable copies, his touchingly ludicrous *Poor Poet (Armer Poet)* starving in his garret, his town clerks sharpening their quills, his cactus-growing parsons enjoyed immense popularity among the German *petit bourgeois*, whom he mirrored in their veneer of harmlessness. People were happy to overlook the bitter undertone of such pictures, just as for a long time an emphasis on their anecdotal humour occasioned the neglect of their painterly qualities and their innovatory colourism, which was entirely abreast with the international current of *plein-airisme*.

Spitzweg can be relied upon to show the flip side of Romantic imagery: he depicts not solitary walkers (see cat. 9, 18) but short-sighted, inquisitive mineral hunters, commonplace families on an outing, or the loud, disturbing intrusion of a crowd of trippers on a stretch of countryside. On his first journey to Italy in 1832 – whence he wrote sarcastic letters home ('I made really good progress with my studies here … for example, when we entered the Temple of Venus, behind an old wall I stepped into an enormous heap of muck, and, because my boots stank quite revoltingly afterwards, I soon realised that it was a modern one'[1]) – he experienced modern tourism. The stream of middle-class visitors newly making their way there was regarded at the time as spoiling Italy.

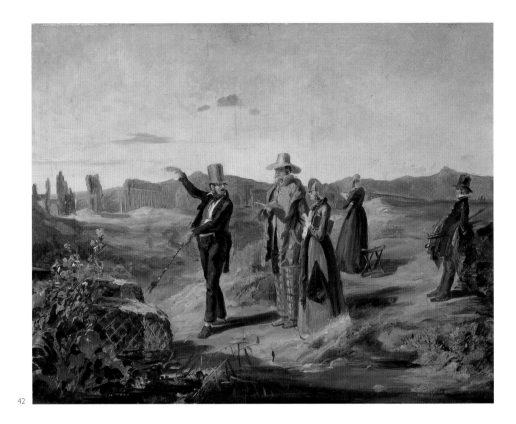

42

'The world is bearable, except in places where the English arrive with their money,' wrote the philosopher Friedrich Theodor Vischer in 1840.[2] In Joseph Anton Koch's pamphlet *Moderne Kunstchronik* (Modern art journal) of 1834 English art tourists fall prey with particularly guileless haste and undiscriminating naivety to the rogue artists or dealers who opportune them. There was a gulf between these visitors and the cultivated English gentlemen who had had their portraits painted on the Grand Tour in the previous century. Nor are Spitzweg's tourists capable of any Romantic feeling for the Roman landscape and its ruins; with their spyglasses, travel guides and every kind of practical accessory they bear the tokens of their foreign insensitivity with them. Spitzweg depicts them pointedly and sharply, briskly, sketchily and detachedly, not without a sideways glance at English and French caricatures, which were widespread at the time. CK

1 To his brother, 01.06.1832.

2 25.01.1840, in *Deutsche Briefe aus Italien. Von Winckelmann bis Gregorovius*, ed. Eberhard Haufe, Leipzig 1965, p. 316.

Ferdinand Georg Waldmüller

43 *Early Spring in the Vienna Woods (Vorfrühling im Wiener Wald)*, 1864

Oil on canvas, 42 x 54 cm

Signed bottom centre: *Waldmüller 1864*

Inv. no. A I 866

PROVENANCE Acquired in 1905 from the dealer Friedrich Schwarz in Vienna as part of the preparations for the 1906 Centenary Exhibition at the Nationalgalerie, which showed no fewer than 30 pictures by Waldmüller

REFERENCES *Galerie der Romantik* 1986, p. 184f.; Feuchtmüller 1996, pp. 282ff. and no. 1084

Once set upon his path of truth to nature (see cat. 40), Waldmüller never turned back. Portraiture, which was initially his main activity, receded in importance, as he turned to landscape, sometimes as a subject in its own right, sometimes as a backdrop to group portraits and pictures of everyday life. He observed the harsh contrasts of summer sunlight; eschewing impressionistic shimmer, he carefully studied the

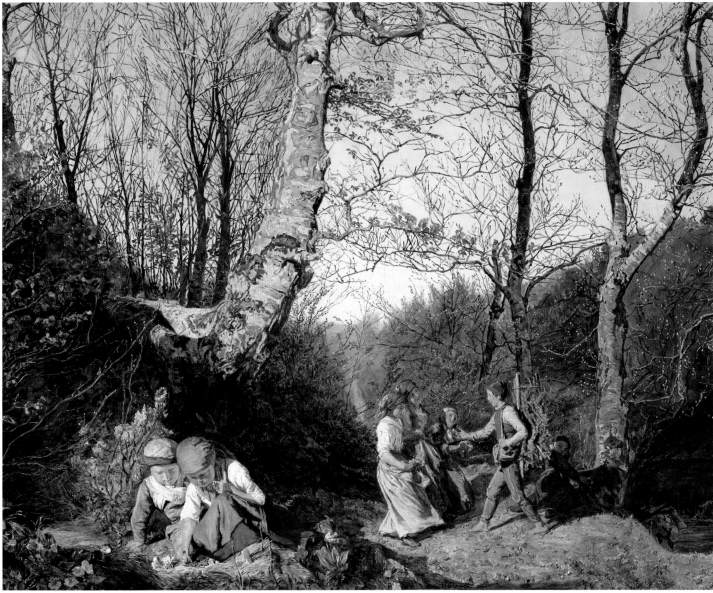

43

alterations of local colour by light. As a result he ceased to model forms plastically but abutted patches of bright colour, which were widely criticised for being too flat and abrupt. Teaching at the Vienna Academy, he advocated the primacy of direct study from nature over the copying of older models; in 1857 he even demanded that the academies should all be closed, and was suspended without pay, which caused him great hardship.

Waldmüller painted this *Early Spring in the Vienna Woods* in 1864, a year before his death. It was the third version of a composition dated 1862[1] which had itself been preceded by three variants, the first dating from 1858.[2] However, there are good grounds for supposing that each picture, or at least its landscape element, was painted afresh in the open air.[3] In the groups of children, the effect of a random moment is skilfully counterfeited. Both groups are busy with their own concerns, one with nature – picking violets and liverwort – the other with a lively game. Happy children are recurrent motifs in Waldmüller's genre painting, which is much more often light-hearted and idyllic than critical or finger-pointing. Often, surprisingly vigorous, highly contrasted movement not only enlivens the narrative but sets up spatial tensions: even in this version, in which the figures are smaller than in earlier ones, the relative scales of the foreground and middleground groups are disconcerting, and so again is the relationship between the middleground group and the great bent tree-trunk. CK

1 Private collection, New York; Feuchtmüller 1996, no. 1047; second version Feuchtmüller 1996, no. 1062.

2 *Girls picking Violets* (*Veilchenpflückerinnen*; Germanisches Nationalmuseum, Nuremberg), Feuchtmüller 1996, no. 960. The other two are ibid., nos. 1035 and 1036.

3 See ibid., no. 284.

The Kaiserzeit

Now to the third question: what or who was the reason that I did not paint '66 and '70? Everything was the reason. First of all personal causes: to be as short-sighted as I was, moreover not a rider, and knowing nothing about armour and weapons – that is fatal in the field. And if in art some study of reality and observation are essential preconditions to everything one undertakes, then hardly less so there [would have been] the naïve presumption with which I set about my 'Hochkirch'* some twenty years ago – without ever having seen a manoeuvre! – that I would certainly not repeat today. That picture, which you praise so highly! Today I am ashamed of it. Not altogether of the picture, but of the enterprise. Furthermore, no call was made upon me, though I would have declined it anyway. For patriotic requirements the need has been covered by other people; and above all – does the horror have to be painted?!?

Adolph Menzel to the critic Friedrich Pecht, 9 December 1878

The Pre-Raphaelite movement, Realism, Naturalism, Impressionism – all these to some extent feuding movements are agreed in so far that *all of them* – even those on the most extreme right and left wings – declare: the traditional Amor and Psyche, the traditional nursery, the traditional bowling alley or traditional pub serving *weiss* beer, the traditional Thuringian landscape, the traditional seascape, the traditional battle picture have not a jot of value, and take on a value only if, by virtue of some *new element* – which may be located externally or internally, it does not matter – something *new*, a new approach to the external or the internal, an expansion or deepening, can be indicated.

Theodor Fontane (from papers in his estate)

But more: art should help to have an educational influence on the people, it should give the lower classes, too, after their hard work and toil, the opportunity to be guided once again by ideals. To us, the German people, the great ideals have become lasting possessions, while they have been more or less lost to other peoples. If art now does nothing more, as is often the case at present, than represent misery as even more horrible than it is, then it is sinning against the German people. The nurture of ideals is after all the greatest work of culture.

Emperor William II, speech given on the completion

of the Siegesallee in Berlin, 18 December 1901

Night Attack at Hochkirch 1758 (fig. 30, p. 44)

The German Empire was declared at Versailles in January 1871, following the victory of combined German forces over the French in the Franco-Prussian War. Much of German-speaking Europe, long divided into independent kingdoms, principalities and dukedoms, came under central political control. The Prussian King William I became Kaiser, or Emperor. Otto von Bismarck, who had masterminded unification, became Chancellor. The Prussian capital, Berlin, was designated the imperial capital and also took on new importance as a cultural arbiter for Germany. Berlin, however, never assumed the absolute cultural pre-eminence that the imperial administration might have assumed in 1871 that it would. A half dozen other great cities, including Munich, Frankfurt and Cologne, boasted independent and influential cultural institutions and saw little reason to follow the lead of the old Prussian capital in such matters. Nonetheless, a stirring historic event like the declaration of Empire called for grand commemorations: monuments soon began to rise in Berlin, pictures to be painted and sculptures cast.

The Nationalgalerie, under construction on the Museumsinsel since 1865, received a gold inscription on its façade dedicating it to German art and dating it to the year of unification, 1871. When it opened in 1876, its walls were hung with patriotic history paintings, battle scenes and official portraits of the imperial family. If the Emperor and his successor, William II, had had their way it would have become a shrine to German imperial ambition and military might. (Successive directors thought otherwise, as the paintings in this exhibition show.) Berlin's Academy of Fine Arts was the chief training-ground for the artists needed to produce such works. At its head, and near the Emperor's ear, Anton von Werner wielded great power in imperial Berlin. He controlled many commissions and was the official painter of court life and the grand military and political events of the day. A sentimental scene of military life like *A Billet outside Paris* of 1894 (cat. 48), recalling for a later generation the 1871 victory over the French, exploited the startlingly vivid realism that was Werner's stock-in-trade and the Berlin academic ideal.

Adolph Menzel did not hold such august official positions but he also turned his hand to imperial subjects, celebrating the military parades on Unter den Linden and the fancy-dress balls that punctuated Berlin life. No emperor could command the respect Menzel gave to the eighteenth-century Prussian king Frederick the Great, while a pre-imperial picture like *The Funeral of the Fallen March Revolutionaries* of 1848 (fig. 45), sadly commemorating three hundred revolutionaries who died in the 1848 uprising, hint that he harboured more liberal political sentiments than the Emperor might have approved. In the end, his great subject was Berlin itself, endlessly expanding, constantly under construction, full of fascinating novelties like railroads and belching factories. For Menzel, Berlin was the site of a ceaseless spectacle, only one element of which was imperial bombast. CR

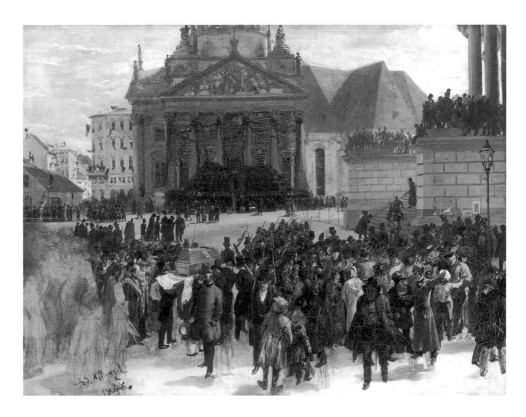

Fig. 45
ADOLPH MENZEL
The Funeral of the Fallen March Revolutionaries (*Die Aufbahnung der Märzgefallenen*), 1848
Oil on canvas, 45 × 63 cm, Hamburger Kunsthalle, Hamburg

Adolph Menzel

1815–1905

44 *The Departure of King William I for the Front, 31 July 1870 (Abreise König Wilhelms I. zur Armee am 31. Juli 1870)*, 1871

Oil on canvas, 63 x 78 cm

Signed bottom right: *Ad. Menzel Berlin 1871*

Inv. no. A I 323

PROVENANCE Commissioned by the banker Magnus Herrmann; a first attempt to acquire the work for the Nationalgalerie (before 1877) came to nothing because the price was too high. Acquired in December 1881 through Hermann Pächter of R. Wagner dealers, to whom Herrmann had sold the picture that same year

REFERENCE Washington 1996, cat. 134

NOTES

1 *An Afternoon in the Tuileries Gardens (Ein Nachmittag im Tuileriengarten)*, 1867, Gemäldegalerie Neue Meister, Dresden; *Paris on a Weekday (Pariser Wochentag)*, 1869, Kunstmuseum Düsseldorf.

2 Kirstein 1919, p. 78.

3 Max Ring, *Die deutsche Kaiserstadt Berlin und ihre Umgebung*, I, Leipzig 1883, p. 102.

As if two different painters were at work, in Menzel's townscapes from the 1840s people, if they are present at all, are seen only in the distance – tiny, subordinated to the atmospheric space; whereas in those painted in the 1860s people in all their excited bustle fill the picture space, indeed articulate it. Not the least important factor in this change were the novel experiences of modern city life being felt in the mid century: it is significant that of this new type Menzel's pictures of the greater city of Paris come first,[1] while one of Berlin does not appear until several years later.

At the same time this townscape is a representation of an event. On the outbreak of the Franco-Prussian War in 1870 the artist had interrupted his summer stay in the Elbsandsteingebirge in Saxony. On the day he returned to Berlin he saw and heard, from the window of a first-floor restaurant on Unter den Linden, the commotion surrounding the king's departure for Potsdamer station.[2] Before setting off to join the Army, William I had granted an amnesty for 'political crimes and misdemeanours'. Only when he was already on his way did he announce, from Mainz, that he had taken over supreme command of all the troops of the German Federation.

Unter den Linden, leading from Berlin Castle to the Brandenburg Gate, was Berlin's most elegant promenade; but it was also the route for royal cavalcades and for troops marching past on their return from the field. 'Here one sees the finest palaces, the most magnificent artistic monuments, the top-ranking hotels, the most expensive shops with their alluring window displays ….'[3] It must be assumed that the artist's viewpoint is between the Brandenburg Gate and Friedrichstraße; the grand neo-Baroque houses – or is the one at the front a hotel? – are fictive representations of a type becoming widespread just at this time. In the background the brick tower of the newly built Rathaus (Town hall) is clearly recognisable, while the less distant, imposing Castle appears only in a shadowy, veiled form. Just as the Rathaus, the symbol of the citizenry of Berlin, is given precedence over the king's residence, none of the many buildings connected to the state and court comes into view.

The city's bourgeoisie – among them the person who commissioned the painting, Menzel's friend the banker Magnus Herrmann,

Herrmann's son-in-law the painter Albert Hertel, and their wives – takes complete possession of the picture. Only one of its representatives appears submissive; the rest are curious and excited, busy, sometimes knowledgeably waiting it out, and even occasionally according a glance at the king's barouche, which has travelled almost to the edge of the picture. The old king's friendly wave and the sobbing queen's distress hardly suggest an historic moment. So many figures, so many droll characters, so many individuals of different situations, every one of them drawing attention to themselves. Physiognomies, gestures, fabrics, everything is material for virtuoso brushwork, not least the flags, which are generally meant to billow out freely in the wind, but here cling twisted and limp around their poles – in striking contrast to the freely fluttering *tricolores* in Monet's or Pissarro's townscapes. Not by chance has Menzel in his sceptical patriotism included the Red Cross among the flags.

The way the architecture is depicted, it is almost a satire on perspective. We look from a slightly raised viewpoint on the lines of the crowd, but obliquely up at the façade of the building on the right, which produces a grotesquely vertiginous foreshortening of the underneath of the foremost balcony. All the ornament is squashed together in a very small space, and the cornice is depicted fully vertical. This right-hand third of the picture, offering only disjointed fragments of perception, seems to be the key to the whole work. CK

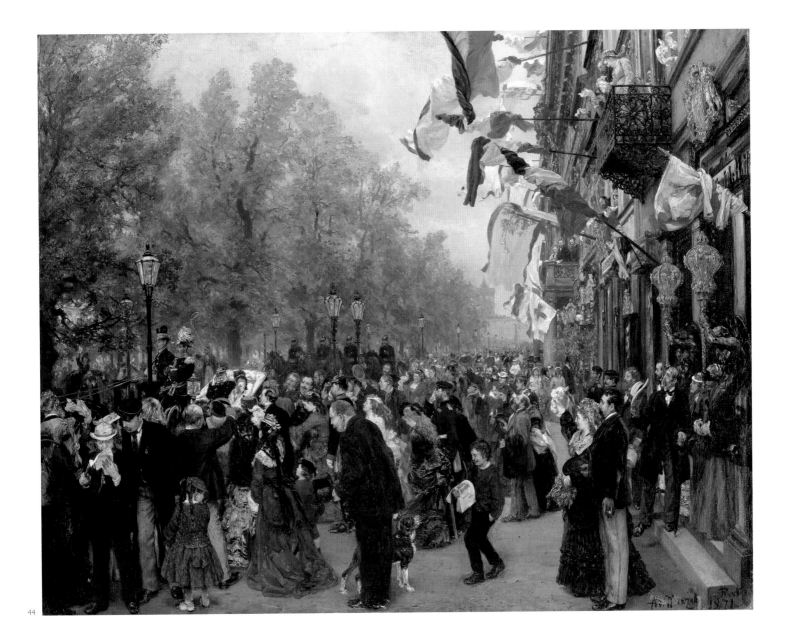

44

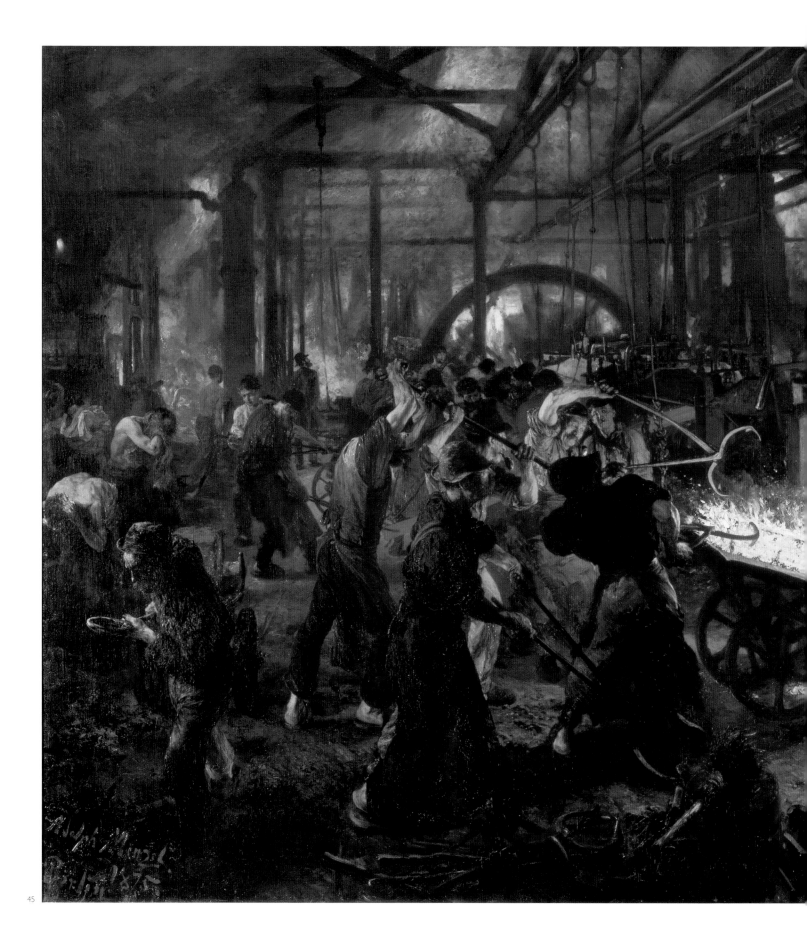

Adolph Menzel

45 *The Iron-rolling Mill (Modern Cyclops) (Eisenwalzwerk (Moderne Cyklopen)), 1875*

EXHIBITED IN LONDON ONLY

Oil on canvas, 158 × 254 cm

Signed bottom left: *Adolph Menzel. Berlin 1875*

Inv. no. A I 201

PROVENANCE The Berlin banker Adolph von Liebermann, the painter's uncle, purchased the work in staggered payments as it proceeded. When he received it at the beginning of 1875 Liebermann was already getting into financial difficulties, which the following year would force him to put his important art collection up for auction. In anticipation of this he sold the *Iron-rolling Mill* to the Nationalgalerie in October 1875 for 30,000 *Talers*, having paid 11,000 for it. The director of the Nationalgalerie, Max Jordan, gave it the title *Modern Cyclops*

REFERENCES Berlin 1976; Washington 1996, no. 160

At the age of fifty, having completed his enormous picture of the coronation of William I as King of Prussia, with its 132 portraits (1865, Stiftung Schlösser und Gärten, Potsdam) Menzel never repeated the attempt to capture the present using the means employed in traditional ceremonial pictures. Nonetheless capturing the present became increasingly an all-absorbing preoccupation. After abandoning his series of large pictures devoted to the life of Frederick the Great, he had pushed the representation of history to extremes of artificiality and waywardness, producing, until into the 1880s, splendidly painterly gouaches of historical anecdotes – bewildering, narcissistic manifestations of an art at a dead end. But at the same time he was exploring the chaotic bustle of modern life, and devoted a large oil-painting, of the kind that he had until recently reserved for history, to depicting industry. In European painting of the time this was unprecedented. Courbet's most technologically modern subject was still the fire engine,[1] and Ford Madox Brown's *Work* (1862, Manchester City Art Galleries) did not show work carried out with machines.

Menzel's choice of subject was not occasioned in any sense by a commission – from an industrialist, for example, who might have

wanted a 'portrait' of his factory, as the factory owner Albert Borsig had commissioned from Menzel's friend Paul Meyerheim a cycle of large paintings of *The History of a Locomotive* (*Geschichte einer Lokomotive*) for his country house. In Menzel's case the banker Adolph von Liebermann stepped in as a buyer only when the painting had already been conceived. Paradoxically enough, Menzel's introduction to the subject had come about through a commission of an extremely old-fashioned kind: a charter or diploma commemorating the jubilee of a Berlin metalworks (1865; Kupferstich-kabinett, Staatliche Museen zu Berlin), illuminated with allegorical figures and decoration – in which Menzel's fervid imagination could be given free rein. The initial inspiration for the *Iron-rolling Mill* may have come when he inserted into two fields of the architectural frame of the allegory a pair of scenes of factory life, lit up with the glow and clouded with the smoke of the foundry: the tripartite division of Menzel's picture, in which the manufacturing process is flanked by workmen washing after the end of their shift and at a meal break, is certainly still reminiscent of the scheme of the diploma.

In the interval, however, the material had become much more topical, for the industrialisation of Germany had picked up still greater pace as victory over France in 1870–1 was translated into huge reparation payments from that country. The period quickly became known in Germany as the *Gründerzeit* (Founders' age), and the international financial and economic crisis of 1873 as the *Gründerkrach* (Founders' crash). The crash came in the middle of Menzel's work on the *Iron-rolling Mill*. In the late summer of 1872 he had travelled expressly to Königshütte in Upper Silesia, where the Vereinigte Königs- und Laurahütte AG, co-financed by the great Berlin banker Gerson Bleichröder, was notable both for its highly advanced technology and for its acute social tensions. There he had studied this manifestation of the present with its implications for the future in just the same way as he had previously researched the factual evidence of history. He read engineering literature and drew machines and tools, but first and foremost, just as previously he had drawn soldiers in war, here he made studies of the movements of the workers in their dramatic partnership with machines. Few of the numerous drawings that have been

preserved suggest that they were made spontaneously, as they happened; the individual studies mostly reappear in the painting, translated into colour but otherwise identical, as if Menzel already had the complete composition worked out before he went to the site of the works to obtain accurate details. He seems never to have made a sketch of the whole picture, any more than he did for other works after 1865; in these years Menzel made a habit of 'montaging' very complex pictures with a large number of figures from a wide variety of individual notes. As he was also able to make other studies in nearby metalworks – at Borsig's factory in the Berlin suburb of Moabit for example – the *Iron-rolling Mill* would have evolved as he alternated between drawing and painting.

Menzel himself gave an exact and technical exegesis of the scene in the picture, the making of a length of rail.[2] The white-hot 'puddle ball', which has been removed from the puddling furnace to a wagon, begins to slide, as the shafts of the wagon are raised, under the first of a series of rollers. Three workers armed with tongs are directing it while three others, with a huge hoisting device towering behind them, are waiting for the puddle ball at the other side. Afterwards it will be ferried to and fro 'through all the processing stages, each shaping it to a different profile, on the whole line of rollers'. 'On the left a workman is taking away to cool a block of iron which has been shaped by a steam hammer.' In the distance behind him is the glow of the puddling furnace with the silhouette of a factory inspector outlined in front of it. In the background of the great hall the raised sliding partitions allow pale daylight to enter; this light, penetrating the steam and smoke, dominates the whole upper third of the picture surface. Only the ruddy reflections on the lifting rods which accompany the line of rollers connect the upper zone with the lower one, which is filled with light from the incandescent iron. The interaction of different sources of light had been a *leitmotif* in Menzel's painting from the very beginning, and the way the groups of figures in the *Iron-rolling Mill* slip from the area of reflected lights into neutral shadow is masterly – for example the workmen eating on the right, who are shielded from the roller by a battered piece of sheet metal. The space is ordered along a great diagonal running from right-hand front to left-hand back corner. The eye is led to a huge

flywheel in the distance, which crowns the main group like the arch over an altarpiece, and is echoed in the arm of the worker with uplifted tongs. The dense throng of figures and implements diminishes on the left-hand side, where the gaze can traverse the space to its full depth.

The *Iron-rolling Mill* is a complex picture of complex relationships both of practical teamwork and of social division. *Das Maschinen-zeitalter* (The machine age), the title of a novel by Bertha von Suttner published in 1899, could also be the title of this picture. The simultaneous appearance of three different shifts gives it a cyclical character and introduces a sense of time. The classicising pathos of the traditional title *Modern Cyclops* – which was not Menzel's own – suggests an ambivalent attitude towards the 'heroism of modern life' (as Baudelaire would call it): to educated contemporaries this creation of Menzel's intense curiosity appeared to waver eerily between tribute and threat. CK

1 *The Fire* (*L'Incendie*), 1851, Musée du Petit Palais, Paris.

2 Menzel gave the description in April 1879 to the director, Max Jordan, for a new edition of the Nationalgalerie catalogue; see Washington 1996, p. 289.

Adolph Menzel

46 *The Garden of Prince Albert's Palace (Palaisgarten des Prinzen Albrecht)*, 1846/76

Oil on canvas, 68 × 86 cm

Signed bottom left: *Ad. Menzel*

Inv. no. A I 989

PROVENANCE Exhibited several times from 1885 onwards; at that time the Berlin banker Hermann Frenkel was the owner of the picture. In 1903 the Nationalgalerie acquired a first option on its sale, which was exercised in 1906

REFERENCE Washington 1996, no. 164

For Prince Albert of Prussia Schinkel had converted a Baroque palace on Wilhelmstraße, which a hundred years later the SS and its secret police made their headquarters. The building thus desecrated was destroyed by bombs in 1944 and never rebuilt.

Menzel lived in the vicinity for a time and painted his view of the palace and garden twice. The first is a small picture dated 1846 (Nationalgalerie, Berlin), showing part of the roof and the tops of a few trees, otherwise only clouds. About the second, much larger picture, Menzel recounted: 'I painted the oil study *Prince Albert's Garden* in 1846 from the balcony of the flat I was then living in, directly from nature – except for the foreground, which, along with the navvies taking a siesta, is made up. Really two year-dates are appropriate to the picture, because thirty years later I removed the air, which I didn't like, and painted it afresh in 1876. Then later the picture passed into other hands.'[1]

Calling such a large picture a 'study' was an archaism, employing its earlier meaning as any representation of reality for its own sake. It surely recalls the powerful 'sketches' of Constable, whose pictorial language the *Palace Garden* seems to echo: in his old age Menzel recollected some pictures by Constable he had seen in Berlin in 1839! The phrase 'painted … directly from nature' is worth noting: positions at windows and on balconies, of which Menzel was so manifestly fond, combine the advantages of both open air and studio, and the precipitous perspective tends to heighten perception. Disruptions and disturbances of every kind were always welcome to Menzel. The work-

46

men resting in the bright summer light were added from drawings he had made in 1845 of a 'building site from two storeys up'.[2]

But Menzel's claim that he had repainted only the 'air', in other words the sky, does not seem entirely credible. He overworked several of his works after many decades to the point of making them unrecognisable. This picture, too, bears to a large extent the stamp of a late work, as becomes very clear if one compares the light, sweeping application, apparent in places, of the small version and the compacted density, almost roughness, of the paint of the larger one. The tempera technique which he increasingly preferred changed Menzel's manner of painting just as much as the change in subjects did: by 1876 he had long ceased to paint open landscape spaces of this kind. CK

1 'Fortsetzung der Randnotizen' (continuation of marginal notes), written on 28 October 1887 for Max Jordan, Director of the Nationalgalerie.

2 Four drawings and an offset in the Kupferstichkabinett, Staatliche Museen, Berlin.

47

Adolph Menzel

47 The Supper at the Ball (Das Balsouper), 1878

Oil on canvas, 71 x 90 cm

Signed bottom left: *Adolph Menzel Berlin 1878*

Inv. no. A I 902

PROVENANCE Commissioned by the Berlin banker Adolf Thiem in 1876 (but no doubt already started at that point); Thiem owned the picture until at least 1888. Later it passed into the hands of Emil Meiner in Leipzig, who also owned Menzel's *Piazza d'Erbe in Verona* (1884, Gemäldegalerie Neue Meister, Dresden). Meiner tried in vain to sell *The Supper at the Ball* to the Städelsches Kunstinstitut in Frankfurt. Acquired in 1906 by the Nationalgalerie

REFERENCE Washington 1996, cat. 167

NOTES

1 In 1876 Menzel received an advance payment from the future owner: see Claude Keisch and Marie Ursula Riemann-Reyher, '"Menzliches Allzumenzliches". Jüngst erworben: "Recipisse" und "Nichtzuvergessendes"', in *Museums Journal*, XI, no. IV, 1997, pp. 84–6.

2 'Notizen für meine Hinterbliebenen', in Gisold Lammel, *Adolph Menzel. Schriften und Aufzeichnungen*, Münster and Hamburg 1995, p. 75.

3 Max Jordan, 'Adolf Menzel', in *Kunst für Alle*, XX, 1904–5, pp. 265–71, at p. 269.

4 Max Jordan, *Das Werk Adolph Menzels 1815–1905*, Munich 1905, p. 79.

5 Adolf Rosenberg, 'Ein neues Bild von Adolf Menzel', *Kunstchronik* XIV, no. 17, 1879, cols. 265–70, at col. 266.

With the *Iron-rolling Mill* (cat. 45) and *The Supper at the Ball* Menzel's limitless curiosity recorded the opposite social poles of the Gründerzeit, or early German Empire. This picture of the upper classes immediately followed that of the workers: it was already under way in September 1876.[1] It represents the supreme achievement in a long series of works, extending from the large gouache *Salon Concert* (*Salonkonzert*, 1851; Neue Pinakothek, Munich) to *The Aftermath of the Court Banquet* (*Nach Schluß des Hoffestes*), one of his last oil paintings (1889; Muzeum Narodwe, Poznan). Whether it was contemporary middle-class evening parties, historic balls or court dances at Berlin Castle, the juxtaposition of glamour and chaos, convention and formlessness, suited his fascination for collapsing orders of every kind. His animated throngs of people in the soft candlelight resemble those in street scenes in sunlight.

While the large coronation picture painted for William I in 1865 (see further cat. 45) was his only royal commission, Menzel was from that time forward *persona grata* at court. The rigorous withdrawal of his art into the private domain was accompanied by a constant stream of new public honours. When *The Supper at the Ball* was painted he had been a member of the Senate of the Academy and a Knight of the Order of Merit for some years. Right up to the last years of his life he regularly attended the great court balls, of which he made a special study. He did not hesitate to make sketches then and there, sometimes standing on a table to do so. As is also apparent from their style, the ball studies created over many years form a group of works apart, and they were kept in a 'red folder' in a black locker in the studio.[2]

The Supper at the Ball provides a synthesis of these observations, although only a few of these drawings were used directly for the picture. The spatially complex scene, overflowing as it is with details, was composed on the canvas itself, where Menzel's late work emerged essentially without compositional designs or prior oil sketches. 'The subjects of the picture,' a contemporary wrote, 'gradually congregate in the work, seemingly of their own volition.'[3] Hence a mosaic-like, confusing jumble which, though by Impressionist standards it must have seemed a weakness, is nonetheless a plausible image of a society.

'The court has withdrawn to its reserved rooms,'[4] and the second refreshments for the guests are being served at the buffet. The right-hand half of the picture belongs to the ladies, the left-hand side is the gentlemen's domain. There are awkwardnesses and distractions everywhere. The courtesies exchanged cannot disguise the fact that everyone is in everyone else's way, and do not mask the general alienation. An early critic perceptively caught the metaphorical level of the work when he wrote that the 'storming of the buffet' during the long interval between the dances – which is literally what is depicted – was the 'moment when in the mill of the crowd the right of the individual comes into its own'.[5] Isolation and dissolution of identity become one and the same thing in the general disorientation, and what Baudelaire would call tragic becomes in Menzel's work grotesque.

For such a multiple composition, spilling over in the foreground, the large format of a ceremonial picture (or of a picture of an historic current event) might be expected, but instead it is compressed into very modest dimensions. Likewise the expectation of recognising well-known contemporaries is disappointed: although every single face has an individual physiognomy, none is intended as a portrait. Even the ballroom, opening on to a vaguely indicated picture gallery, never existed in such a form at Berlin Castle, where one might have expected to find it. It is a neo-Baroque invention. Architecture and jewellery merge into a painterly whole with the rustling of the dresses, the bustling, turning, twisting and nodding of the guests, and the many gradations of the candlelight, colouring everything with a warm yellowish sheen.

The picture was first exhibited in Paris in 1879. Edgar Degas was so impressed by it that he sketched a copy of it in oil from memory (Musée d'art moderne et contemporain, Strasbourg). The critic Louis Gonse found himself reminded of Hogarth and Daumier. CK

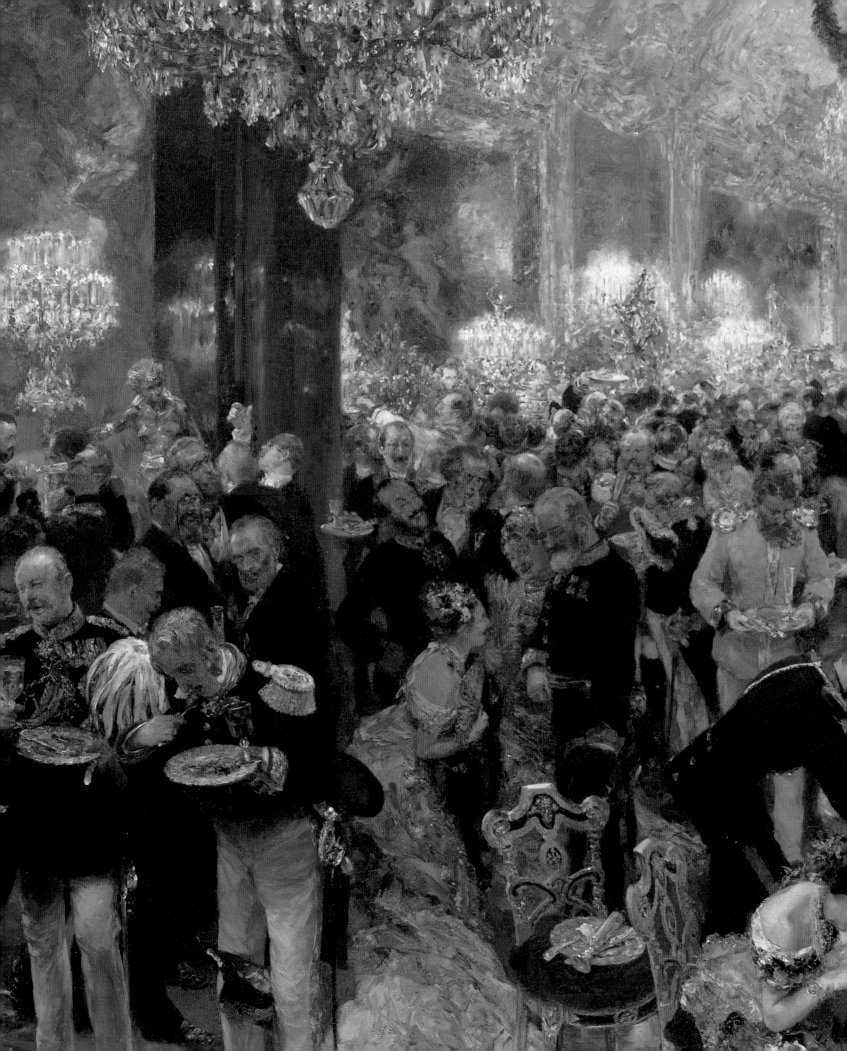

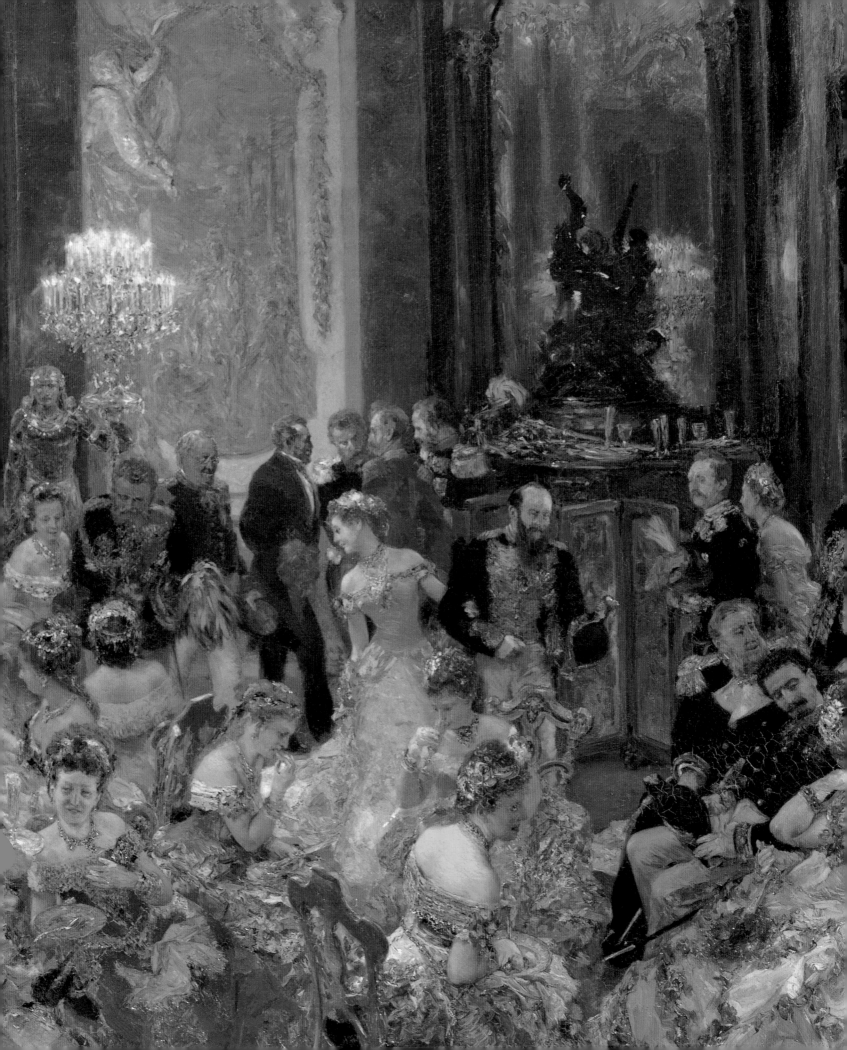

Anton von Werner

1843–1915

48 *A Billet outside Paris (Im Etappenquartier vor Paris)*, 1894

Oil on canvas, 120 × 158 cm

Signed bottom left: *AvW. 1894*

Inv. no. A 1521

PROVENANCE Purchased the year it was painted, 1894, the Nationalgalerie's first picture by Werner

REFERENCES Werner 1913, p. 13; Berlin–Munich 1993, p. 301 f., no. 42

The picture reconstructs a situation from the Franco-Prussian War of 1870–1, a quarter of a century earlier. Werner's success was closely associated with that war: Prussian victory, and the subsequent establishment of the German Empire, brought about a need for representational imagery of the new state, which Werner was better equipped than any other artist to fulfil. In his youth he had been interested in subjects from the Middle Ages and the Reformation, but soon turned wholly to the more recent past, painting the ceremonial triumphs of the new nation's history, full of staffage and portraits. At the same time he initiated a long career in art politics, as the Director of the Academy of Art and as the President of the Association of Berlin Artists, to be depended upon to the end for his defence of conservative principles. His most celebrated portrayals included the proclamation of Empire at Versailles in 1871 (1877; fig. 19, p. 30), the Berlin Congress in 1878 (1881) and – in panorama format – the Battle of Sedan, the decisive battle of the Franco-Prussian War (1883). In addition, as the events portrayed grew increasingly remote, he began to paint novelistic episodes, anecdotal pictures of the day-to-day life of the war, admittedly in grander formats than were traditional for genre painting – a revaluation of pictures of everyday life that French painting had been fighting for since Courbet.

A Billet outside Paris refers back to a recollection of the painter's own. In the autumn of 1870 he had been commissioned by the Schleswig-Holstein Kunstverein (Art association) to paint a large picture of *General Moltke with his Staff outside Paris (Moltke mit seinem*

Stabe vor Paris, completed 1873; Kunsthalle, Kiel), and, although he had been found unfit for service himself, he wanted to collect study material on the spot. On 24 October, while quartered just outside Versailles with some soldiers in the requisitioned Château de Brunoy, he drew this cheerfully innocuous scene in his sketchbook, reproduced in the painting with only slight modifications: fuel collected from the garden is being put on the fire, two lancers are singing Schumann's *Lied 'Das Meer erglänzte weit hinaus'* at the piano ('At that time it was very popular with all the military bands,' the painter recalled in a description of the episode for the Nationalgalerie), and the concierge who had stayed behind in the château is drawn by the song to the door with her little daughter. 'The interior of the house, furnishing etc,' Werner added, 'was still quite intact at that time in October, shortly after the seige of Paris had begun, and the mantel clocks so often mentioned and other baubles had not as yet gone missing.'[1] 'Often mentioned' means mentioned in later reports of looting and theft by the German troops. In the meantime the horrors of the four-month siege of the French capital had become known, but the lively cosiness of the German military in the occupied villa gives no hint of that. The slovenly way in which the soldiers have settled down amidst the alien splendour without wiping their muddy boots was seen by contemporaries as amusing, but not reprehensible – for a reflection of their native culture, in the form of music, was unbenighting this foreign territory. The impression conveyed is of a dispassionate, factual representation of what was there to be seen: with detached virtuosity, apparently concerned above all to present things true to life, everything is shown in equal detail, down to the sole of a boot that has been badly repaired; there is not a hint of drama, not even in the intended contrast between the fire in the hearth with its ruddy reflections and the wintry white of the sky outside the loggia.

However much they tend to render war innocuous, as a succession of dramatic, thoughtful or humorous moments, Werner's pictures do not make the enemy appear despicable or demonise him – unlike the increasingly hate-filled propaganda that was to build up on both sides of the Rhine in the years leading up to 1914. However, such an approach helped to

preserve the *status quo,* which was favourable to Germany. A few years earlier, in a picture of a similar size, *Taken Prisoner (Kriegsgefangen,* 1886; Berlinische Galerie, Berlin), depicting a French prisoner of war taking leave of his young wife, Werner had shown one of the German escort party taking her nurseling from her so that they should be able to embrace – proof of the 'kindness and tender-heartedness of the national character … which could never quite be denied even in the rough, wild time of war and amidst an implacable enemy', as the critic Ludwig Pietsch wrote at the time.[2] Another large composition depicts Crown Prince Frederick William of Prussia paying his last respects to the fallen French general Douay. Patriotic pictures of this kind became popular. By 1895 one could already buy a slightly reduced reproduction of *A Billet outside Paris* in the form of a tapestry. CK

1 Berlin–Munich 1993, p. 310.

2 Quoted Berlin–Munich 1993, p. 304, in the text on no. 415.

Escaping to Italy

Paradoxical as it may sound, art begins only where looking stops. The artist is distinguished not by a special gift for looking, not by the fact that he is able to see more, or to see more intensely … he is distinguished rather by the fact that the peculiar gift of his nature makes him able to pass from visual perception directly to visual expression; his relationship to nature is not a visual relationship, but an expressive relationship. That is where the wonder of art lies … one must point out all the more resolutely the error of thinking that what has come into being through art can be understood in any way other than through art ….

Conrad Fiedler, *Über den Ursprung der künstlerischen Tätigkeit*

(On the origin of artistic activity), 1887

We must not be too naturalistic. That is really not painting's task; but it sets out to create awareness of certain formal phenomena and atmospheres [*Stimmungen*], to make us feel them, and in expression it will certainly always borrow from nature, but it is not slavishly bound to it.

Arnold Böcklin to A. von Salis, 1870

Just as it is the task of poetry to engender thoughts in us, and that of music to express or conjure up feelings, painting should elevate us. A work of art should tell us something and cause the viewer to think, just as much as a poem, and make an impression on him, just as much as a piece of music.

Arnold Böcklin to Adolf Frey, undated

Sometimes my life seems like a dream to me. How does it come about that my pictures stand there so firm and tangible, and I am like a swaying reed? Often I look a hundred years ahead and walk through old galleries and see my own pictures hanging serenely on the walls. I am destined for greatness, I know that … I will always suffer, but my works will live for ever.

Anselm Feuerbach, letter to his stepmother, 2 November 1855

Like the Nazarenes before them, German artists of the second half of the
nineteenth century continued to make their way to Italy. There, they adopted
Italian themes, used Italian models and revived classical styles. They returned to
Germany infrequently, some with great reluctance and then only for brief periods.
The frock-coated, philistine north could not compete with the south, where
Antiquity remained a living presence and the image of the ancient deities could still
be detected in the turn of a beautiful peasant woman's head, the flawless body of
a peasant boy. Nonetheless, these so-called *Deutschrömer*, or 'German Romans',
captured the attention of influential critics and collectors at home and were
among the most influential German artists of the day. Their idealising paintings and
sculptures served as a foil to the naturalism that was increasingly dominant in
Germany, and anticipated the Symbolism that would become important there at
the end of the century. Their very presence in Italy attested to that deep spiritual
affinity between Germany and Italy to which generations of Germans swore, whether or not they
themselves had made the trip south. The Italy the 'German Romans' depicted in their timeless and
frequently melancholic works could be seen as a kind of idealised Germany where pure feeling and
ideal beauty still held sway.

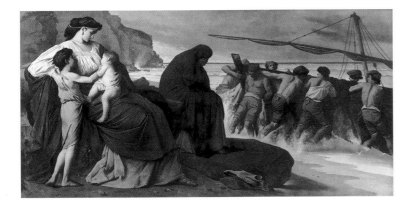

Anselm Feuerbach was steeped in
classicism from youth – his father was a
Classics professor – and his most
ambitious paintings are high-minded
allegories cast in the visual language of
Antiquity. He was not immune to the
sensual beauty of Italy, however, whether
of its landscapes or of its people, as
depictions of his haughty, mysterious
mistress Nanna Risi (see cat. 49) confirm.
Such statuesque models also served to
evoke for him the timeless world of

Mediterranean civilisation, as in *Medea* of 1870 (fig. 47), a monumental figure of melancholy and
impenetrable solitude, gazing out to sea for ever. If Hans van Marées was all but unknown at the time
of his death, the leader of the 'German Romans', Arnold Böcklin (see fig. 46), was hugely famous
throughout German-speaking Europe during his lifetime. He was
extravagantly praised for his depictions of a primitive, sun-
drenched land where nymphs and satyrs gambolled and
centaurs battled (fig. 48). By the time of his death, however, a
violent reaction had set in among modernists. Julius Meier-Graefe
argued passionately that the problem with German art was
Böcklin himself: until his influence was overthrown in favour of
more purely formal values, German art could not advance. Seen
as an impediment to modernism in Germany, in fact Böcklin
influenced the course of modern art in Italy, where Giorgio de
Chirico (1888–1978), who would originate Metaphysical
painting, strongly felt his influence. CR

Anselm Feuerbach

1829–1880

49 *Nanna*, 1861

Oil on canvas, 64 × 51 cm

Signed bottom left: *AFeuerbach*

Inv. no. A 1757

PROVENANCE From the collection of the critic Conrad Fiedler, a friend of the sculptor Adolf von Hildebrand, and for many years a patron of Hans von Marées; his essays – including *Über die Beurteilung von Werken der bildenden Kunst*, (On the evaluation of works of art) – had a considerable impact. He also owned works by Arnold Böcklin, Franz von Lenbach and Hans Thoma. Acquired in 1902

REFERENCE Ecker 1991, no. 359

Feuerbach grew up in an intellectual climate that was influenced in equal measure by late Romantic passion and classical scholarship, and from a very early age he withdrew from modern society. A fulfilled human life was for him to be sought instead among the heroes of mythology and literature – rather than of history – but also among the Italian common people, in all their character. He had already lived in Rome for four years when he met Anna (Nanna) Risi, a shoemaker's wife, in the spring of 1860; she became his model and his mistress for the next five years. Admiring her severe majesty, he used her as a model for a Madonna, for his first *Iphigeneia* and for a first version of his monumental *Symposium* (*Das Gastmahl*, 1867–9; Staatliche Kunsthalle, Karlsruhe; second version 1871–4; Nationalgalerie, Berlin), as well as for idealised three-quarter-length and bust portraits in the costume and spirit of the High Renaissance. Here only the sharp angle of the head, emphasizing his beloved's profile, reveals that this relatively simple picture was posed. The simple shift serves to make the costly jewellery with which Nanna enjoyed decking herself all the more striking. Then, in 1865, she left Feuerbach, and he was in despair. She had run off 'with a rich Englishman'. Before knowing Feuerbach she had been a model for Frederick, later Lord Leighton. CK

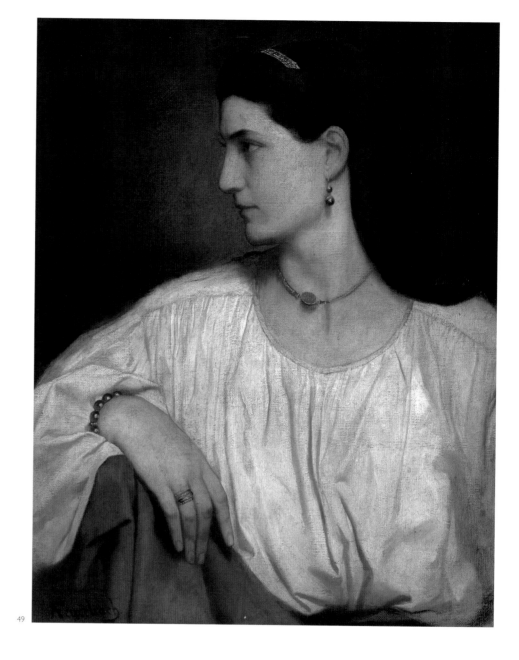

49

Anselm Feuerbach

50 *Memento of Tivoli* (*Ricordo di Tivoli*), 1866–7

Oil on canvas, 194 × 131 cm

Signed bottom left: *A. Feuerbach 67*

Inv. no. A 1732

PROVENANCE As cat. 49. Commissioned by Conrad Fiedler. 'Fiedler is pleased with his picture,' the artist wrote to his stepmother on 3 February 1868

REFERENCE Ecker 1991, no. 437

For a year Feuerbach hesitated to part with the picture he had completed in January 1867,[1] which, he had already written, was 'brilliantly carefree and sincere … so that with it I will create a stir everywhere …'.[2] It is an 'idyll', a category of painting with which Feuerbach was intensely preoccupied in the 1860s. Far removed from real-life genre painting (compare cat. 43), and utterly unconcerned with social issues, Feuerbach's picture idealises the children it represents by setting them outside time: the girl's costume is just about contemporary – though the valuable jewellery at her neck strikes

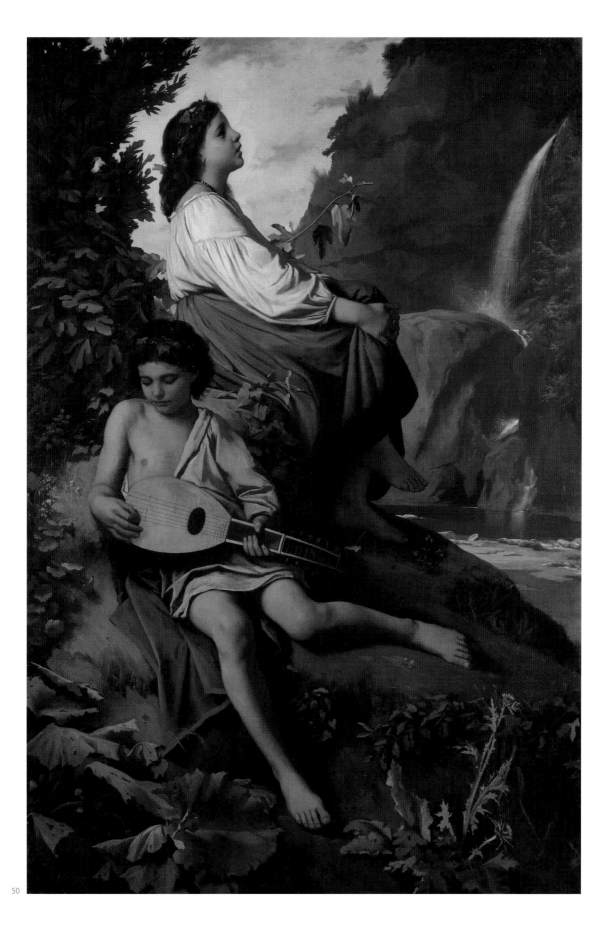

50

an alien note – but beside her a boy reclines in a classical Roman tunic. Action is replaced by atmosphere. The solemn, elegiac mood is carried into space by their music, to which the waterfall adds an heroic counterpoint. Rather as if a painting by Friedrich (cat. 7, 9) has been turned inside out, the figures assume the main role. However, the customary roles of the sexes (see further cat. 51) are here surprisingly reversed: the boy is lost in thought, while the girl is extroverted.

Also in 1867 Feuerbach painted *Children on the Beach* (*Kinder am Strand*; Georg Schäfer Museum, Schweinfurt) as a pendant, though it is somewhat smaller, and in the following year *Memento of Tivoli* was repeated for Baron von Schack of Munich, Feuerbach's most important patron at that time. CK

1 Letters to his stepmother, Henriette Feuerbach, 01.02.1867, 03.01.1868.

2 Letter to his stepmother, 21.04.1866.

Arnold Böcklin

1827–1901

51 *Landscape in the Campagna (Campagna-Landschaft)*, c. 1859

Oil on canvas, 88 × 105 cm

Signed bottom right (not by the artist): *A. Böcklin pinxt. 1860*

Inv. no. A 11112

PROVENANCE Given by the bookseller and publisher Hermann Nabel, Berlin, who had owned the picture for 25 years, in 1911

REFERENCE Andree 1998, no. 122

Arnold Böcklin lived and worked in Rome from 1850 to 1857, finding, on this first visit to Italy, that despite the extreme poverty with which he initially had to contend the place really suited him. Unlike Richter (see cat. 17), he returned to Italy several times for prolonged stays: altogether Böcklin spent about thirty years of his life in Italy.

Landscape in the Campagna was painted in Munich from the studies made during his time in Rome, but above all from memory. It is an image of the Campagna landscape evolved from a compilation of impressions. Böcklin, in any case, would never convert the landscapes he sketched directly from nature into a picture, not even during the time he was in Italy. He always attempted in the painting to deepen the general impression he had felt. These were not landscapes recalled nostalgically or that he had actually visited. Well versed in classical literature, he painted pictures instinct with longing for the landscape of myth.

Again in contrast to Richter, who generally placed figures about some business at the centre of his pictures, Böcklin took pains over the nature of the southern landscape itself. During the 1850s he was constantly working variations on the motif of a large clump of bushes or trees reaching down to the ground, exaggerated into heroic proportions. Generally it is positioned centrally in the picture. Here its large, physical mass, enclosing dark, almost completely black areas, closes off the foreground (together with an unclearly defined stone wall). For this foreground Böcklin referred back to a composition he had seen in the work of his older friend and fellow painter in Rome Karl Heinrich Dreber (known as Franz-Dreber): a stretch of rocky ground practically upended in a myopic view emphasising the rugged beauty of the almost barren place. In other works, such as *Panic Fear* (*Panisches Schrecken*; Neue Pinakothek, Munich) painted in 1858, the slanting foreground has become the determining factor in the picture.

At the right-hand edge Böcklin's picture, like Richter's, gives a view across the countryside, with the small figure of a shepherd on the horizon. The contrast between the sun-saturated landscape and the shady coolness of the bushes must have fascinated Böcklin, as it is found in almost all his pictures from this period.

By the mid-1850s Böcklin had also begun to animate his landscapes with mythological creatures, endowing them with timelessness. Although in this picture of about 1859 no such creatures are to be seen, they seem to be absent only momentarily. The 'surreal' feeling is even stronger than in many pictures that do contain figures. The brilliant blue of the sky, contrasting with the dark, mysterious clumps of foliage, contributes to this impression. In another, slightly earlier landscape a faun can suddenly be spotted in such bushes, and at about the same time that this work was painted Konsul Carl Wedekind of Hanover refused to pay for Böcklin's murals for him, because, he maintained, Böcklin had introduced grimacing faces into the landscapes. It was through this mythical dimension, whether visible or not, that Böcklin came to the 'unreal', dream-like Symbolist scenes for which he is well known. AW

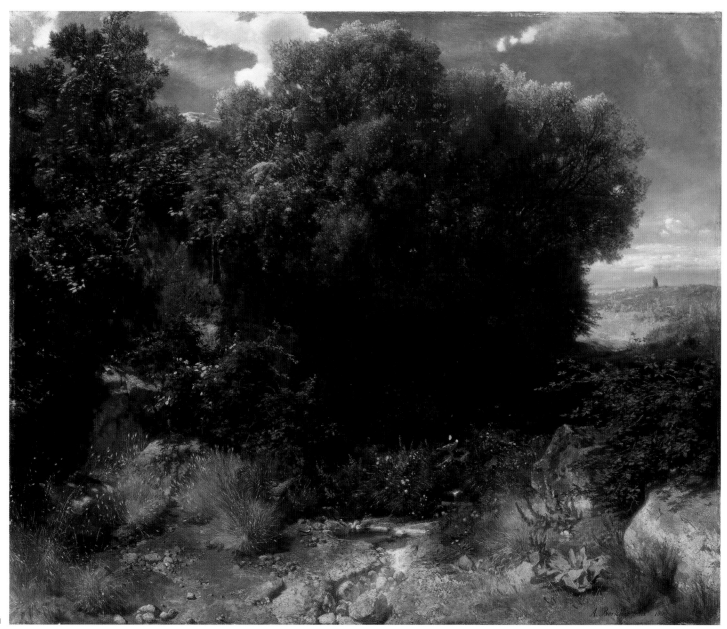

51

Arnold Böcklin

52 Honeymoon (Hochzeitsreise), 1878

Oil on canvas, 80 × 59.5 cm

Signed at the bottom on a stone: *AB*

Inv. no. A I 1099

PROVENANCE Acquired in 1910 from the dealer Gurlitt, Berlin; the work first belonged to Mathilde von Guaita, a collector of Böcklin's pictures

REFERENCE Andree 1998, no. 321

NOTES

1 Andree 1998, p. 402.

2 *Begegnung mit Caroline. Briefe von Caroline Schlegel-Schelling*, Leipzig 1984, p. 230, letter dated 21.10.1799.

Triton and Nereid, Ulysses and Calypso, a faun and a nymph, Ruggiero and Angelica – many of Böcklin's pictures depict couples, the vast majority of them figures from literature or mythology. Among the few contemporary couples he painted were himself and his wife Angela – or, at a more abstract level, their honeymoon.

Böcklin first painted the subject in 1875; this is a second version of the theme, of which he gave a comprehensive account when writing in July 1878 to Mathilde von Guaita, the picture's first owner: 'I hope you find expressed here what I have attempted to put into it. The young woman is looking into the small, enclosed valley, which ends in the lake with an idyllic shore. This is intended to be the picture of the life she wishes for, walking quietly on the arm of her beloved – even if considerable effort is involved – then resting in peaceful solitude. But the man is whistling away into the distance to the furthermost reaches of the vaulting sky, full of the joys of living. His spouse will go along with him – albeit always with a yearning for Paradise.'[1] The same idea can be found in another, though very different, *Honeymoon* (Städelsche Institut, Frankfurt), created about 1890. Here the husband is offering his bride the world, with a gesture which Böcklin seems to have borrowed from another of his own pictures, *God showing Paradise to Adam* (*Gottvater weist Adam das Paradies*; Kunstmuseum, Dortmund).

Böcklin's explanation of the picture's content reiterates a common idea of the roles of the sexes. Schiller, for example, had already directed the man 'out into hostile life' in his '*Lied von der Glocke*' (Song of the bell), while envisaging for the woman a narrow place in the domestic domain. (In their emancipatory phase the early German Romantics at Jena, Wilhelm Schegel, Ludwig Tieck, Friedrich Schelling, had laughed at the *Glocke* until they nearly fell off their chairs, according to Caroline Schlegel.)[2] But Friedrich, too, in *Chalk Cliffs on Rügen* (*Kreidefelsen auf Rügen*; 1818–19; Stiftung Oskar Reinhart, Winterthur), a surprisingly similar picture commemorating his own honeymoon, had shown a woman in a long red dress looking and pointing into the deep while a man in *altdeutsch* (Old German) garb looks out to sea and thinks of far-off places – and a second one studies plants. In both Böcklin's and Friedrich's pictures there are two trees, a strong one and a weaker one, which reach towards one another, and in

both there is a far distance – in Böcklin's picture, as a valley with a river running through it, it is a symbol of life or even of paradise, while in Friedrich it is a threshold separating the figures from the future. In both cases the couple stand at the start of the path they will share. But what distinguishes Böcklin's narrow valley from an abyss? The prospect to which the woman looks fearfully is both dark and narrow. The similarity in composition to a woodcut after a drawing by Friedrich, *Woman at the Precipice* (*Frau am Abgrund*), a metaphor of the end of life, is striking. Böcklin, like Friedrich, painted symbolic landscapes, rich in allegory, and Böcklin's work is close to Friedrich's in its fine, poetic touch, although Böcklin opted for stronger, purer hues.

Böcklin's mythological couples, Triton and Nereid for example, often behave according to the same social pattern, which therefore seems to be dictated by nature, things having been this way since before time began. At the same time he conveys through such couples an antique sensual delight and closeness to nature, qualities that Schiller had seen as foregone in the poem '*Die Götter Griechenlands*' (The gods of Greece), which Böcklin illustrated in a grisaille. Another picture by Böcklin treating of these themes was *The Elysian Fields* (*Die Gefilde der Seligen*; lost in 1945), painted for the Nationalgalerie in 1877–8, at the same time as *Honeymoon*. AW

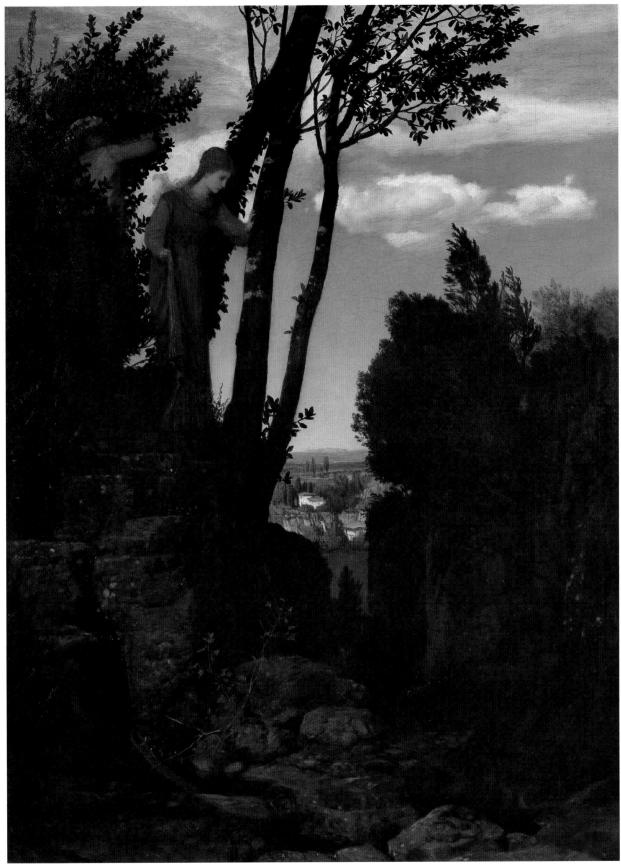

53

Hans von Marées

1837–1887

53 *Saint Philip and the Eunuch* (*Philippus and der Kämmerer*), 1869

Oil on canvas, 62 × 29 cm

Inv. no. A I 769

PROVENANCE The picture was probably delivered to the artist's friend and patron Conrad Fiedler immediately after it was painted. Many pictures from Fiedler's estate (by Feuerbach, Böcklin and Thoma as well by Marées) came to the Nationalgalerie; its director Hugo von Tschudi had belonged in his youth to Marées's circle of admirers in Rome. Bequeathed in 1902 to the Nationalgalerie by Fiedler's widow, Mary Balling-Fiedler

REFERENCES Gerlach-Laxner 1980, no. 93; Munich 1987, no. 34

This rarely depicted episode is from chapter 8 of the Acts of the Apostles, which recounts the spreading of the Gospel. On the road to Gaza, whither he had been sent by an angel, the Apostle Philip met 'a man of Ethiopia, an eunuch of great authority under Candace queen of the Ethiopians, who had full charge of her treasure', who sought to have a passage from the Prophet Isaiah explained to him; as it prophesied the sacrifice of Jesus, he asked at the end to be baptised. Biblical subjects tend otherwise to be rare in Marées's work, and when he did choose them – notably in the triptych *The Three Horsemen* (*Die drei Reiter*; second version 1885–7, Neue Pinakothek, Munich)[1] – the religious content was certainly of secondary importance. Horses always feature in them, however. Marées had trained in Berlin and Munich as a military painter, and horses, robust and expressive, are a leitmotif in his painting throughout his career. To them he imparted dynamism, while striving rather for balance in his human figures. Contemporary with this early work is another equestrian subject, *Saint Martin* (*Der heilige Martin*; Stiftung Oscar Reinhart, Winterthur).

Two men, two horses, all four difficult to distinguish – as the Bible text requires, Philip has pulled himself up into the eunuch's small chariot. By the time he embarked on the painting – probably as a guest of his patron Conrad Fiedler on the Crostewitz estate near Leipzig over two

54

or three months in the autumn of 1869 – the thirty-two-year-old artist had been copying Old Masters in Italy for several years, then had travelled in Spain, France and Holland. In *Saint Philip and the Eunuch* the dark glow of the colour, the romantic passion of the powerful horses and the impulsive vigour of the brushwork testify to the deep impression Rembrandt and Delacroix had made on him. With Baroque weight, but without Baroque decoration, the brush is used to create swathes of colour, many of which, in particular the whites, remain disconnected on the picture surface. Inspiration from the lyrical, diffuse atmosphere of Venetian

landscapes by Giorgione, Titian or their circle is also evident. The way that colour will glow mysteriously out of impenetrable darkness in Marées's later work in tempera on panel is anticipated here. CK

1 Only a *Saint George* (Nationalgalerie, Berlin) has been preserved from the first version (1880–2).

Hans von Marées

54 *Oarsmen (Ruderer)*, 1873

Oil on canvas, 136 × 167 cm

Inv. no. A I 1024

PROVENANCE Like the artist's other oil sketches for his Naples frescos this remained in Naples, where it was owned consecutively by two engineers, first Petersen then Storrer. Later Gabriele Palumbo, Naples. Reacquired by Adolf von Hildebrand, who in 1907 donated it to the Nationalgalerie

REFERENCES Gerlach-Laxner 1980, no. 120/14a; Munich 1987, no. 46

After three years in Germany, in 1873 Marées returned to 'classic ground', where he had lived previously for years; he was never to leave it again, settling at first in Florence, but soon afterwards in Rome. In Italy to the end of his life he would pursue his vision of a timeless earthly paradise in painting that was 'poor' in form but rich in colour, turning his back on the economic fever of the German Gründerzeit and Bismarck's aggressive politics, and not least the disturbance of exhibitions and art associations. He interposed his patron Conrad Fiedler between the art trade and himself. But even if isolation fitted his elitist ideals, like his fellow 'German Romans' Feuerbach and Böcklin Marées was reluctant to abandon making monumental pictures that required display space and presupposed an organised audience: even though he had no hope of a commission and no end purpose in view, he persisted all his life with schemes for new triptychs with symbolical frames. His first love, though, was for fresco, which in his mind had sealed a romantic bond between art and the people since the beginning of the nineteenth century, even though in reality it was entirely dependant on high patronage.

Marées's first and only commission in this field augured well, because it came from a private individual and was intended for a special public. The young German zoologist Anton Dohrn had set up a marine observation station in Naples, and allocated one room in the building for a *Gesamtkunstwerk*, a 'total' art work combining frescos and sculpture with learned discussion – and with a fine prospect over the blue of the bay, which the pictorial decoration was to continue. There were also to be books on display in the room, and finally music and cultural events for a select scientific and literary circle. Marées planned his frescos in conjunction with the sculptor Adolf von Hildebrand, his close friend ten years his junior, and quite contrary to his usual habit he completed them in a few months – indeed with rather too great facility, in the opinion of Conrad Fiedler, who was paying for them.

Surprisingly enough, the theme is not historical, religious or allegorical, but more a kind of large-scale *allégorie réelle* as Courbet understood it, in which the metaphorical dimension does not compromise the realism of what is depicted. The nearby sea, the object of the Stazione Zoologica's research, was the starting point – and underneath the frescoed room was actually an aquarium. However, the pictures do not explore the water itself, but the coast and its inhabitants. One fresco distributed over several sections of wall, resembling a panorama, depicts the departure of fishermen; another a fishing boat pushed into the water; a third the evening foregathering of learned men with their friends, the artists; yet another shows a paradisiacal orange grove with gardeners and seated women. Dynamic force alternates with static peace, diagonals with verticals, open spaces with forms crowding the surface.

In every case, immediately before Marées had his assistants apply plaster to a section of wall on which he was to work *a fresco* – for which a sure hand is needed – he made practice 'sketches' in oil of the relevant part of the composition, always in the final size: generally the sketches are of single figures, but the dynamics of these oarsmen could be practised only on the whole group of four. The radiant, unbroken colours of this picture – making a glorious *tricolore*! – were painted at the same time as works by Manet and Monet. In all these 'sketches' for Naples there is an unaffected realism, undisturbed by any classicist references. The colour suggests air, light and wind round the animated, massive bodies, even though they fill the whole surface (in the fresco itself they seem small against the huge sky and wide expanse of water). Even in the sketches the rhythm of the whole of the fresco is anticipated – in the parallel diagonals, which in the fresco are braced against stake-like uprights and extended horizontals. Marées insisted on a systematic, theoretically grounded working practice, and yet a chord of veiled, visionary dreaminess sounds in his work, which teeters between geometric rigour and the mystic. CK

Hans von Marées

55 *Self-portrait with Yellow Hat* (*Selbstbildnis mit gelbem Hut*), 1874

Oil on canvas, 97 × 80 cm

Inv. no. A II 858

PROVENANCE In 1875, when Marées left the San Francesco monastery near Florence where he had been living with the sculptor Adolf von Hildebrand, he left a number of pictures behind, which Hildebrand discovered in poor condition in 1907. From among these this self-portrait was acquired at an unknown date by the manufacturer Max Silberberg in Breslau (Wroclaw), who owned an extensive collection of French and German art of the later nineteenth century. Bought for the Nationalgalerie at auction at Paul Graupe in Berlin in 1935. In 1999 returned to Max Silberberg's daughter-in-law and heiress, Gerta Silberberg, in a programme of reparation to Jewish victims of persecution by the Nazis. Repurchased in 2000 for the Nationalgalerie

REFERENCES Gerlach-Laxner 1980, no. 124; Munich 1987, no. 54

'The noble-minded person honours the powerful person in himself, as well as the one who has power over himself, who knows how to talk and to hold his tongue, who joyfully exercises strictness and hardness towards himself, and has respect first and foremost for strict, hard people.'[1] Marées would have recognised himself in this and similar sentences by his contemporary Friedrich Nietzsche. His very large number of self-portraits show him as both solemn and austere – untouched by the ostentation typical of the Gründerzeit, the early years of the German Empire. They demonstrate the self-mastery and reserve of a man dedicated to the things of the mind – martyr and hero in one. Marées in fact subordinated everything to his artistic mission, of which he was, with reason, deeply convinced. This influenced both his quarrelsome behaviour towards his patron Conrad Fiedler and his predilection for being surrounded by devoted pupils. His uncompromising insistence on a long working process without regard for the expectations of a client or the requirements of exhibition had the same origin. Like Cézanne, in later years Marées had to endure the suspicion that he lacked the will to complete his work.

When, in this picture, the thirty-six-year-old artist painted himself in an evening landscape in Tuscany, posing deliberately in front of a laurel tree, he had under his belt the major achievement of a cycle of frescos in Naples (see cat. 54). He had been living since the end of the previous year with his friend the sculptor Adolf von Hildebrand in a deconsecrated monastery near Florence, there painting four self-portraits within as many months, all half-lengths set out-of-doors. That is unusual in German painting, but explicable — it was inspired by Italian Renaissance portraiture. A brush can be seen in his hand only in the very last of his series of self-portraits;[2] all the rest, including the present *Self-portrait with Yellow Hat*, show him without the attributes of his craft. Therefore the fame to which the laurel refers must be of a higher kind, a status which is already attained before any achievement. He sits facing the viewer, straight as a ramrod, motionless, very alert, unmistakably authoritarian. In deciding on a frontal view, it is possible that he had in mind Dürer's Christ-like self-portrait of 1500 (Alte Pinakothek, Munich), which he had surely known in Munich over many years. The stick which he is grasping with both hands sets viewers at a distance, as does the endless stretch from the hands up the elongated torso to the head. But its restless gaze directed piercingly at the viewer breaks out from the figure's almost threatening silence — a Van Gogh gaze from deep eye-sockets under concentrated eyebrows. This is the focus of his act of self-exploration. The landscape, however, releases the tension by virtue of its multiplicity, and above all by the melancholy peace of its evening light, which creates an afterglow behind the hill and between the laurel branches, but also by the evocative effect of the very gently differentiated tones of the background, which merge transparently one into another and lead into the deep shadow without blotting or breaking their continuum. The dreamy landscape is the polar opposite of the Nietzschean severity. CK

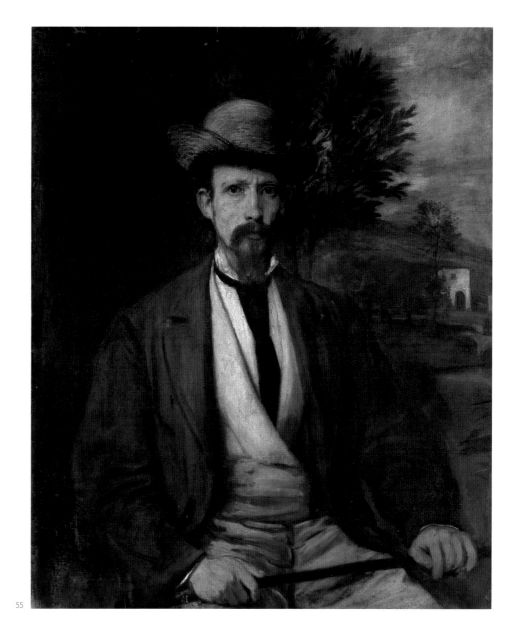

55

1 Friedrich Nietzsche, *Werke in zwei Abteilungen*, Leipzig 1910–, VII, p. 240.

2 In the Neue Pinakothek, Munich, 1882–3.

'Pure Painting'

According to my principle it does not depend on the 'what', but on the 'how' – unfortunately for the critics, journalists and the great masses, to whom the what is the main thing, because some of them find in it the subject about which they can expatiate to their heart's content, and others also find in it something they can chatter about; but the how is something that, first, very few people understand, and, secondly, that can hardly be described, nor does it need to be, for it is of course painted, and each person should look at it himself, and if he is the right person, he will find what he is looking for.

Wilhelm Leibl to his mother, 3 June 1876

The high artistic value of a work is entirely dependent on the method of representation, and in determining the value it can always only be a matter of whether the artist's ability is for pure art or popular, that is, academic art. The layman always judges by the extent to which the subjects depicted immediately arouse interest in themselves, and therefore curtly describes all purely artistic works which do not treat incidents, subjects or people that are of interest to him as dull, or lacking spirit. Indeed for the layman the spirit resides in the subject.

Wilhelm Trübner, *Die Verwirrung der Kunstbegriffe*

(The confusion of artistic ideas), 1898

In pictorial representation everything can be beautiful, including things that are not beautiful in life, for example an ugly girl, or an old woman; for in art it is not a question of what is depicted, but only of how it is depicted, and the beauty must lie in the painting itself, not in the subject.

Wilhelm Trübner, *Das Kunstverständnis von heute*

(Art as it is understood today), 1892

In Nature

I see no outlines

That's clear;

So I am truly

On the right track,

Forming my figure

Just from dots of colour

With paintbrush hair!

Hans Thoma, '*Malerlied*' (Painter's song)

from *Im Herbste des Lebens* (In the autumn of my life), 1909

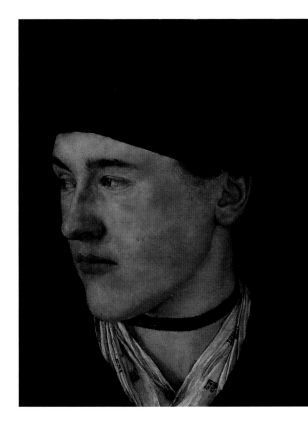

Gustave Courbet was a sophisticated, worldly Parisian, and a master of self-promotion. When he visited a slightly provincial Munich in 1869, it was not only the audacious, freely painted canvases he exhibited that startled the young artists he met there. He performed for them, too, painting pictures at speed in public as he carried on vivid, opinionated conversations, a constant supply of beer at his side. They were dazzled. Everything they had heard about Courbet from artists such as Hans Thoma, who had visited him in Paris the previous year, was true! Of course, these young painters, led by Wilhelm Leibl, were looking to be dazzled, looking for a new way of painting that would free them from the strictures of academic technique. In Courbet, they discovered a model for the directness of approach which they sought for their own art. Courbet's bravado they construed as an uncompromising honesty which validated their own youthful earnestness.

Fig. 49
WILHLEM LEIBL
Girl with Black Kerchief (Mädchen mit schwarzem Kopftuch), 1879
Oil on canvas,
Nationalgalerie,
Staatliche Museen zu Berlin

Before the year was out Leibl was in Paris himself, meeting Courbet again, and perhaps Manet as well. He met there Louis Eysen, too, who was no less taken with Courbet's art. Only the looming Franco-Prussian War forced him to return home, where he brought word of what he had seen of modern French painting to artists such as Wilhelm Trübner. For the most advanced Paris painters, he might have reported, the brutally direct application of paint, the establishment of wholly new kinds of compositional order, were of greater importance than any symbolic or allegorical meaning a painting might be meant to impart. Indeed, meaning resided not in the motif depicted but in the act of painting itself, in the clarity of vision and steadiness of purpose that the painter brought to his task.

These contacts proved decisive in providing direction for a generation of young artists gathered around Leibl. They turned to simple scenes of peasant life and portraits set in the domestic realm, unspectacular local landscapes and humble still lifes. They concentrated their efforts on ways of slowly, methodically rendering form and colour on canvas. The enamel-like surfaces demanded by the academy were replaced by often heavily worked canvases in which the painterly gesture was evident. The new sympathy for peasant life was matched by a growing distrust of sophisticated city life and the art-world machinations it bred. For his part, Leibl retreated to the Bavarian countryside, where he painted the grand and simple rituals of peasant life. There, like Cézanne in Provence, he could carry on his painterly quest in solitude and with reverence. CR

Fig. 50
GUSTAVE COURBET
Woman with a Parrot, 1866
Oil on canvas, 51 × 77 cm,
The Metropolitan Museum of Art, New York, H.O. Havemeyer Collection,
Bequest of Mrs H.O. Havemeyer, 1929

Wilhelm Leibl

1844–1900

56 *Peasant Boy* (*Bauernjunge*), early 1870s

Oil on canvas, 83 × 68 cm

Inv. no. A 1727

PROVENANCE Acquired in 1902 from David Heinemann, Munich

REFERENCE Waldmann 1930, p. 124, no. 140

NOTES

1 Wilhelm Leibl to his mother, 3 June 1876; quoted from Ruhmer 1984, p. 48.

2 Ibid., p. 52.

The subject is unspectacular: a thin, rather shy boy on a chair too high and deep for him. Whether the picture remained unfinished, or was always intended as an oil study, is not known. In the early 1870s 'studies', and 'studies of heads' in particular, were a central focus of interest in the 'Leibl circle'.

The 'Leibl circle' is the name given after the event to a loose group of friends that had gathered round Leibl, as the most gifted among them, even while he was still a student. They were united by an experience that was crucial for all of them, the 1869 International Art Exhibition in Munich. French artists including Edouard Manet and Gustave Courbet were among the exhibitors. Courbet himself came to Munich and mixed with the young painters. He was enthusiastic about Leibl's portrait of Frau Gedon (*Bildnis der Frau Gedon*; Neue Pinakothek, Munich), raising both the esteem in which Leibl was held and Leibl's own confidence. In an historical section of the exhibition the pictures of Frans Hals were a source of general fascination (Courbet made a copy of *Malle Babbe* while in Munich).

At the end of 1869 Leibl went to Paris. While there he obtained lucrative portrait commissions, took part successfully in the Salon, was in contact with Courbet and probably with Manet, and continued with his studies. In the Louvre he again saw and admired the sketch-like painting of Frans Hals, whose influence is still perceptible in this picture. He returned to Munich in autumn 1870, and once again became the leader of a circle of young painters. In 1873 he left the town for the country.

The effort of the Leibl circle to attain artistic truth was concentrated in portrait or figure painting, and it was in this they were most successful. In contrast to the current academic style, where the beauty of the painting was dependant on the beauty or fascination of the object painted, the Leibl circle emphasised the artist's handling, his manipulation of the brush or the spatula, as the basis for aesthetic appreciation. Hence the term 'pure painting' (*reinmalerish* or *reinkünstlerisch*), with which he and his friends are particularly associated. 'According to my principle it does not depend on the "what", but on the "how" – unfortunately for the critics, journalists and the great masses, to whom the what is the main thing … the how is something that, first, very few people understand and,

secondly, can hardly be described, nor does it need to be, for it is of course painted ….'[1]

Not only does the sketch-like/unfinished appearance of this portrait of a peasant boy underline the intrinsic value of the pure painted surface, but the reality of this child, both perceived and presented, is strictly painterly. Social commitment did not enter into it. Leibl chose his peasant models for their raw beauty. His handling of colour, the craft of his painting, the whole business of his art was to be true to this beauty – the artist's idea of beauty. The fight against empty virtuosity, the commitment to honest, substantial craft, was later taken up by younger artists, Corinth for example, who was a great admirer of Leibl.

The peasant boy's face is painted light on light, with hardly any highlight or shade, as was often the case in Leibl's studies of heads in the early 1870s. One immediately notices a mark on the upper torso for which there is no reason – no more than for the mark on the wall in Menzel's *Balcony Room* (cat. 28). And 'purely painterly' means specifically the opposite of linear. The form is not determined by the contour, which may not even be defined. The brushstroke applied to the surface determines the boundary of the form.

Not many years later Leibl changed his practice. He began to paint, with agonising exhaustiveness, in the presence of the sitter, a variety of pictures of peasants in the detailed style of the Renaissance masters. In the 1880s he returned to a painterly, sketch-like manner, but at a new level. In each and every method of working that he used, though, Leibl was concerned solely with the external appearance of the person. He avoided forceful gestures and any attempt to paint psychology: as he put it, in a fundamental statement, 'I paint human beings as they are, so the soul is there in any case.'[2] Our own, later, sensitivity to body language may bear him out, perceiving the awkward instability and gawky vulnerability of the boy hanging rather than sitting on the big chair. AW

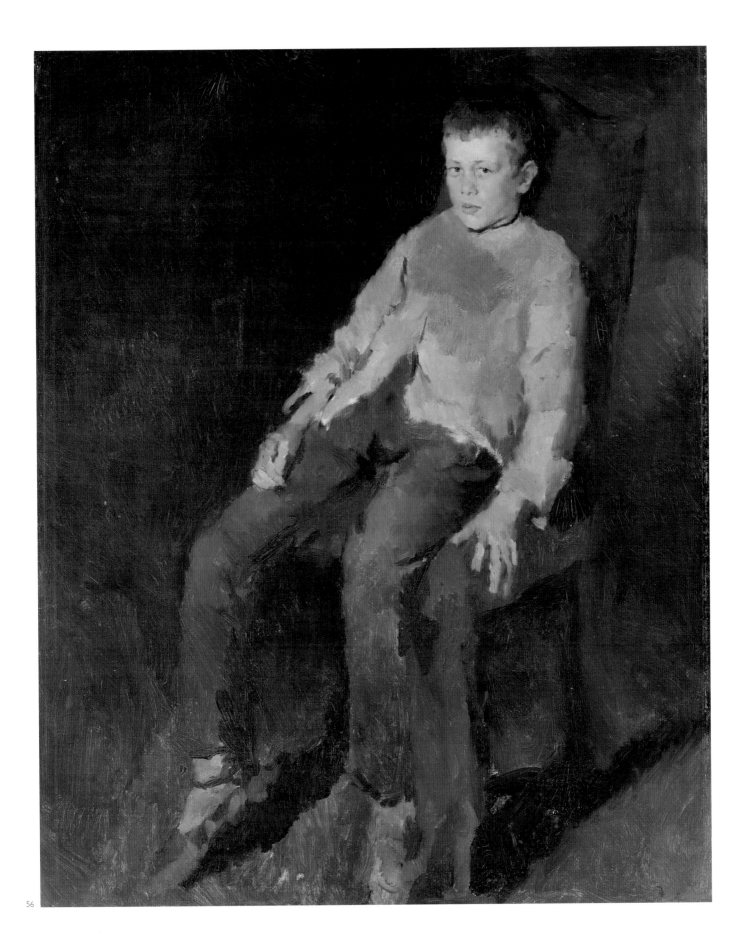

Wilhelm Leibl

57 Burgomaster Klein (Porträt des Bürgermeisters Klein), c. 1871

Oil on canvas, 87 × 67 cm

Signed bottom right: [illegible]

Inv. no. A I 928

PROVENANCE Acquired in 1906 from the sitter's son-in-law, Justizrat Leibl, in St. Johann an der Saar

REFERENCE Waldmann 1930, p. 41, no. 115

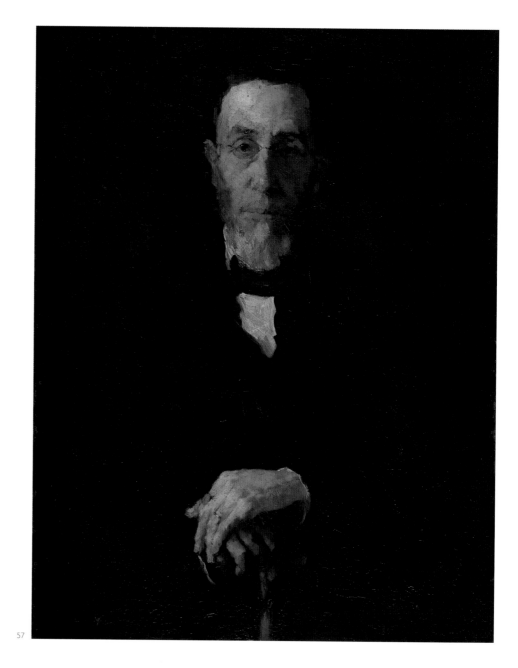

57

The view of Burgomaster Klein is strictly frontal: the cast of shadow down the bridge of his nose, set precisely in the centre line of the picture, is continued in the walking stick at bottom. His dark clothes merge almost completely with the background, emphasising the contrast to the highlights of the face and hands.

Like his painter friends, Leibl studied and copied pictures and details from pictures in the Alte Pinakothek in Munich – Flemish painting first and foremost. But Leibl must also have seen in the gallery Albrecht Dürer's highly charged frontal self-portrait of 1500, and, seemingly, recalled its format for the portrait of Burgomaster Klein. However, the comparison makes the differences clear: Leibl's depiction is less pregnant with meaning, and the effect of his portrait is more private and domestic, composed but not official.

Concentration on the face and hands as the true purveyors of expression in the human being has a long tradition. Around 1870, however, it meant a rejection of garrulous detail. At the 1869 International Art Exhibition in Munich Leibl's friend Courbet had noted a concentration on narrative in German painting: 'Good painting is virtually unknown in Germany. Exact reproduction of historical costume is still very important. Painting has declined almost to anecdote.'[1] Courbet and Leibl were of one mind in rejecting both the historical subjects prevalent in contemporary German painting and sentimental genre pictures.

Leibl's new method and great skill was in painting directly on to the canvas, without preliminary drawing, using short, broad brushstrokes. By this means he could produce, for example, a countenance like this, animated by the play of the light over it. The hands too, so important to Leibl, are given form in varied,

extremely fine shades of colour by a few, sure strokes of the brush. Later on, Leibl more than once cut up pictures he regarded as unsuccessful, sparing only isolated parts, among which the hands were always included. More single-mindedly still than Courbet, Leibl placed the human figure at the centre of his art. He wanted to reproduce the pure reality of the human being without psychological interpretation, without 'painting the soul', and to capture it using colour alone.

Klein was burgomaster or mayor in Brebach near Saarbrücken, and he was the father-in-law of Leibl's elder brother Ferdinand. It was from his family that the picture was acquired for the Nationalgalerie. AW

1 Courbet to Castagnary, 20.11.1869, quoted in Hamburg–Frankfurt 1978–9, p. 377.

Wilhelm Trübner

1851–1917

58 *On the Sofa (Auf dem Kanapee)*, 1872

Oil on canvas, 52 × 45 cm

Signed bottom left: *W. Trübner. 4. 1872*

Inv. no. A 1 645

PROVENANCE Acquired in 1899 from the artist

REFERENCES Trübner 1907; Rosenhagen 1909, p. 71, pl. 6; Rohrand 1972, I, pp. 171ff., 249f., no. G 331

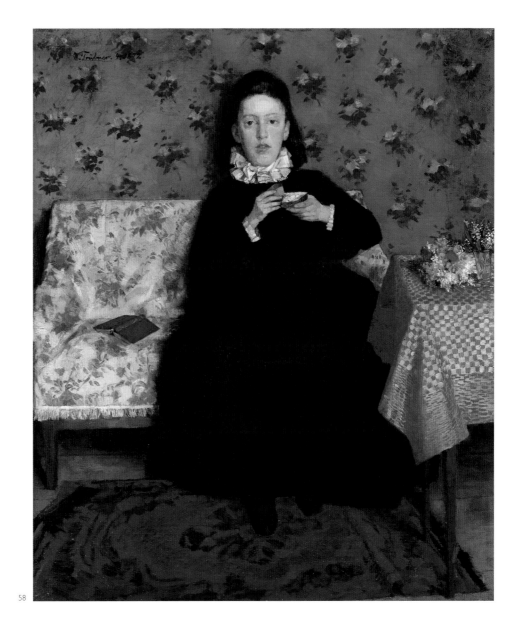

58

The spring of 1872 was a period of particularly intense activity for the two Munich art students Wilhelm Trübner and Carl Schuch. Above all their new acquaintance with the slightly older painter Wilhelm Leibl, who had only just left the Academy, brought new inspiration. In his search for 'truth' Leibl appeared to be completely free of all dogma. He impressed the younger artists deeply with his highly developed work ethic, and his encouragement and influence were critically important. 'Soon we also got to know Leibl's friends: Thoma, Hirth, Alt, Haider, Sperl, Schider and Sattler, and from that time on we associated with them daily. In April 1872 I painted *Girl on the Sofa* during a trip to Heidelberg and in May of the same year Leibl painted a portrait of me in Munich.'[1]

On the Sofa, Trübner's brilliant youthful masterpiece, was created in a brief phase of rest and seclusion during this turbulent stage of his life. Various influences, successfully combined, can be recognised in the work, which he painted far away from his friends' critical eyes in his native city of Heidelberg: the refined technique of the 'Leibl school', the example of seventeenth-century Dutch painting – including the 'Hals' ruff at the girl's neck – and the enduring impact of the paintings of Courbet and Manet which Trübner had seen in Munich in 1869.

He had studied a similar frontal, close-up view of the subject and such directness in viewing it in Leibl's works (cat. 56, 57). By contrast, however, Trübner's picture is executed with the delicacy of a still life. Different patterns, which do not really go together, animate the background around the large, still silhouette of the girl's dress – the wonderful grey blue of the wallpaper, the strikingly red check tablecloth

and the splash of colourful flowers over it, the floral pattern of the loose cover on the sofa, the dark red carpet. Like most works by the Leibl circle, this has no literary associations, no story, but finds its fulfilment unusually clearly in the beauty of its surface.

The strict concentration on the texture of the picture, worked in a painterly manner, is excitingly modern. Manet's example seems to have been directly influential. In conversations with Trübner in 1872, Thoma had much to say about 'Manet, whose pictures he had seen with great interest in Paris'.[2] But Trübner himself was already familiar with Manet's work by that time – with his unmodelled figures like still lifes, his

disturbingly matter-of-fact juxtapositions of people with things. In this portrait the girl's expressionless face has hardly any greater optical weight than the hands, the flowers or the slice of bread. Such portraits in which the lack of interest in the sitters was noticeable were often disliked by relatives and patrons. But for the young Trübner and his friends the meaning of painting lay solely in painting itself. AW

1 Wilhelm Trübner, 'Aus meinem Leben', in *Kunst und Künstler*, vi, 1908, p. 4.

2 Georg Fuchs, *Wilhelm Trübner und sein Werk*, Munich and Leipzig 1908, p. 30f.

Hans Thoma

1839–1924

59 *The Rhine at Laufenburg (Der Rhein bei Laufenburg)*, 1870

Oil on canvas, 56 × 46 cm

Signed bottom right: *H Th 70*

Inv. no. A 11100

PROVENANCE Acquired in 1910 from the publisher and bookseller Hermann Nabel of Berlin and Munich

REFERENCES: Thode 1909, pp. XVIII, XLIV, 27; Freiburg im Breisgau 1989, p. 23f.

'A few admittedly not very important commissions, e.g. pictures of the four Upper Rhine Black Forest towns of Waldshut, Laufenburg, Säckingen and Rheinfelden, and a larger picture illustrating Hebel's *Morgenstern* [Morning star], provided me with sufficient funds to be able to move on in November 1870 – to Munich.'[1] *The Rhine at Laufenburg*, though apparently not a particularly inspiring commission, is one of the few townscapes by Thoma that we know.

However, neither in this nor in the other three views did Thoma simply show a view of the town concerned. The powerful curve of the river at this spot, and the Black Forest hills in the background, make this more a scenic panorama than a townscape. With landscape Thoma felt more at home.

The houses of the little town crowd together on the rocky peninsula, the parish church rises in the background and the castle occupies the other bank of the river – this is an idyll, a beauty spot, a place one should stand and admire. The two men with a dog looking over the picturesque countryside from the raised bank in the foreground fulfil this role, resembling carefree walkers rather than hikers. They stand casually with their hands in their pockets, the slighter man pointing to the waterfall, so drawing the viewer's attention to this special feature.

The two onlookers are not in any way Romantic gazers, like those in Friedrich's paintings (see cat. 7, 9). They are contemplating a scene from nature, not the cosmos. It is a pretty spectacle, not a sublime one. The life of the people in this small town is probably quite comprehensible, and as limited on all sides as the structure of the picture. 'Throughout the

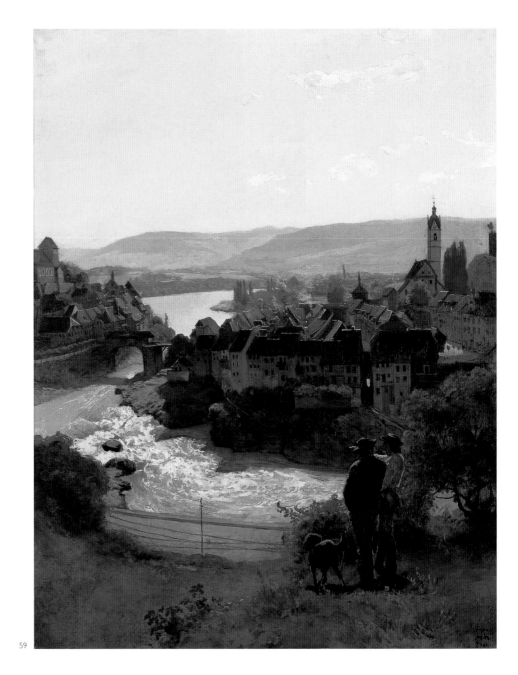

59

summer I was with my mother and sister in Säckingen. The total peace which the artist needs descended on me again – I lived again at one with nature and saw much beauty everywhere; I succeeded in being without desire, I mean without any ambition.'[2] A few months later Thoma was in Munich with the money he had acquired, and the ambition which had been numbed by disappointment at lack of recognition resurfaced.

Despite two journeys to Italy Thoma was always a painter of the 'German essence' and of the German landscape, and so this early commission fits easily into his subsequent oeuvre. Like Böcklin, around 1900 Thoma had a very high reputation, bolstered by a nationalist interpretation of his works, against which there was soon a reaction. The art historian Henry Thode, a friend of Thoma's, played a key role in the artist's promotion (and later demotion). AW

1 Hans Thoma, *Im Herbste des Lebens*, Munich 1909, p. 41.

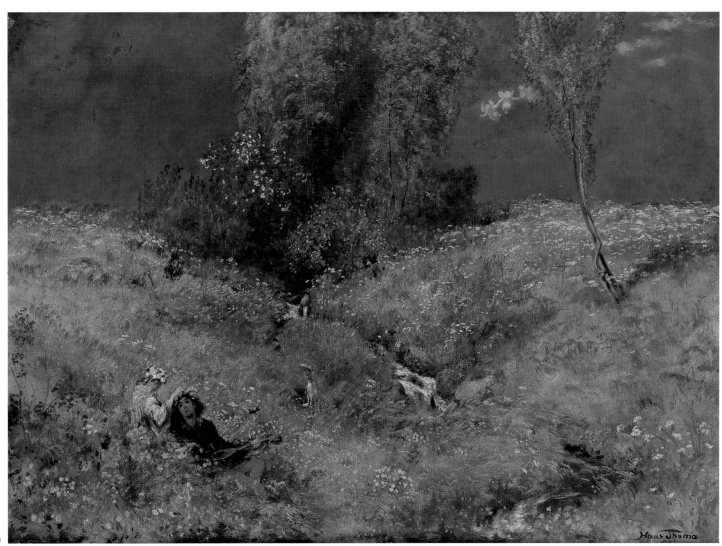

60

Hans Thoma

60 *Summer (Sommer)*, 1872

Oil on canvas, 76 × 104 cm

Signed bottom right: *Hans Thoma. 1872*

Inv. no. A II 510

PROVENANCE Acquired in 1926 from Johannes Noll, Frankfurt; the first owner was the art historian Dr. Adolf Bayersdorfer, Munich

REFERENCES Thode 1909, pp. XXI, 44; Freiburg im Breisgau 1989, p. 162, no. 123

Summer reproduces a powerful impression of nature, distilled as in a dream. Like Böcklin (cat. 51), Thoma paints a close-up of ground rising from foreground immediately to horizon, virtually plunging the viewer into the picture. But in comparison with *Campagna Landscape* this view is poetic and lovely. The inlet in a welcoming hilly landscape conveys security.

The sloping meadows in a rich variety of shades of green, enlivened with dabs of lighter colour and surmounted by a clump of trees, are further enriched against the brilliant deep blue of the sky. Though they might at a fleeting glance be taken for a summer cloud, the dancing *amoretti* in the sky beside the trees reinforce the hallucinatory impression. Further, the youth singing to a lute and the girl crowning him with a wreath of flowers wear Renaissance clothing, overstepping once again the bounds of a straightforward depiction of nature.

Böcklin's influence is apparent not only in the composition, but also in the combination of green and deep blue, and the use of appropriate figures to give enhancement to the landscape. The burbling brook, the reference to love and music and the blooming landscape mutually reinforce one another in a lush harmony.

Thoma recalled that he talked mainly about technical problems with Böcklin after meeting him in Munich in 1871. 'I enjoyed meeting up with Böcklin. His love of colour experiment – whenever he came to my studio he had coloured tufts of wool in his jacket pocket – and his technical empiricism fell on fertile ground with me.'[1] This brilliantly coloured picture originally belonged to Adolf Bayersdorfer, subsequently a curator at the Munich galleries, a friend and adviser to both artists. AW

1 Hans Thoma, *Im Winter des Lebens*, Jena 1919, p. 58f.

Hans Thoma

61 Bunch of Wild Flowers (Feldblumenstrauß), 1872

Oil on canvas, 77 × 55 cm

Signed bottom right: *HThoma. 1872*

Inv. no. A II 146

PROVENANCE Acquired in 1916 from a private collector, Alexander Gerlach, Frankfurt am Main

REFERENCES Thode 1909, pp. XXI, 46; Freiburg im Breisgau 1989, p. 37f.

61

'No, what I am writing is not the story of my life. – May these colourful memories be regarded more as a bunch of wild flowers, loosely tied together without system or purpose, plucked from the surface that spreads over the deeper abyss of existence.'[1] For Thoma the 'bunch of wild flowers' was not only a subject for painting, but a literary metaphor. It meant both the object and the manner of its representation. It meant simple and artless, not artificially contrived, neither elegant nor conveying pathos – and as such an image of his life. He assigned almost religious value to the 'honest' depiction both of his life and of the flowers. Perhaps it is not by chance that there is a self-portrait under this picture: the X-ray shows the bunch of flowers superimposed on the painter's features.

In April 1868 Thoma visited Courbet in his Paris studio with his painter friend Otto Scholderer, and also saw Courbet's large private exhibition of his own work. 'Among the younger French artists the Courbet exhibition made the greatest impression on me. There were about 200 pictures in it. This freedom in creating did me good. It was something complete, this was really painting for me. Things became so clear to me, as if they were my own things. Now I thought I could paint my own pictures.'[2]

In Courbet's studio Thoma saw wild flowers realistically painted in forceful colours and thick impasto, like the embodiment of rampant natural forces. Courbet did not so much depict them as convey in paint the impression they made. Thoma's flowers have a similar simplicity of motif and clear pictorial construction, but his bunches are not only more delicate, they are more disciplined. Frequently their unruliness is curbed by narrow vases.

Thoma's more controlled, withheld way of looking at things is apparent again in his technique. Thoma did not paint directly with impasto oil-paint *alla prima* like Courbet and Leibl; he valued finesse and the building up of colour in transparent layers. He stayed with the technique he had admired when a student with Hans Canon: 'His method consisted in modelling the form and lighting it with heightened white against a darker ground. The colouring was achieved by glazes, which glowed like enamel and often indeed produced a surprising effect.'[3] All this made Thoma suspect to the Leibl circle: his 'glazes and other artifices', as he himself reported, seemed to Leibl 'like sins'. AW

1 Hans Thoma, *Im Herbste des Lebens*, Munich 1909, p. 42f.

2 Hans Thoma, *Im Winter des Lebens*, Jena 1919, p. 43.

3 H.E. Busse: *Hans Thoma, sein Leben in Selbstzeugnissen, Briefen und Berichten*, Berlin 1942, p. 35.

4 Thoma 1909, as note 1, p. 49.

Louis Eysen

1843–1899

62 *The Artist's Mother (Die Mutter des Künstlers), c.* 1877

Oil on canvas, 54 × 42 cm

Inv. no. A I 707

PROVENANCE Donated in 1901 by M. Levy, Berlin

REFERENCE Zimmermann 1963, pp. 26f., 88

Like many other painters of his generation, Louis Eysen underwent his decisive artistic experience in Paris. He wrote home from there in 1869: 'Courbet is our man! What do you think about the fact that I have finally managed to shake hands with this foremost painter of the century!'[1] Eysen also got to know Leibl and Thoma in Paris, and continued to be on friendly terms with both painters from then on. However, his contact with his fellow artists was intermittent: from 1870 Eysen led a retired life, working as a landscape painter in Frankfurt am Main and nearby Kronberg, and later on, for health reasons, in Merano as well.

In his slender oeuvre there are very few portraits, but they include this unusual, surprisingly modern picture of his mother in an armchair, busy with some needlework. Eysen chose a familiar subject – he spent his life, essentially, with his mother and sister – for his novel approach. The picture's effect is determined by the narrow palette of colours – yellow/brown and green – and by the clear structure, a grid of verticals and horizontals formed by the edges of the bookshelf, the chest of drawers and the brown stripes of the corners. Breathing simplicity and tranquillity, it is all quiet poetry.

The curtailment of the woman's figure at the bottom of the picture, and of the chair at right, which seems so accidental, is surprisingly (if coincidentally) similar to such cut-offs in the art of Edgar Degas. The device serves in the same way to draw the viewer right into the scene, as if it were close enough to touch. The contrast of the darker colours of the foreground against the light background with its clear lines has the effect of making the silhouette of the mother almost blur and shimmer. Her grey-black dress is composed of shifting, swaying tones, but the books on the shelf can

62

be picked out clearly. The picture seems to be influenced by the recent art of photography, and the focus is on the bookshelf. AW

1 Quoted Zimmermann 1963, p. 10.

Carl Schuch

1846–1903

63 *Still Life with Partridges and Cheese (Stilleben mit Rebhühnern und Käse)*, after 1884

Oil on canvas, 76 × 63 cm

Signed bottom left: *CSchuch*

Inv. no. A 1 1010

PROVENANCE Acquired in 1907 with two other works by the same artist from the dealer Eduard Schulte, Berlin

REFERENCES Hagemeister 1913, p. 155; Dortmund 2000, no. 32

NOTES

1 Hagemeister 1913, p. 150.

2 Carl Schuch, 'Aus einem Tagebuch Karl Schuchs', *Kunst und Künstler*, x, no. 6, 1912, p. 300.

3 Dortmund 2000, p. 94.

4 Hagemeister 1913, p. 170.

Of all those in Leibl's 'circle' Schuch was the most committed to colour. He studied colour combinations and differences to an extreme limit of sensibility. He applied his studies particularly to his still lifes, where he was freer to arrange the subject to his satisfaction, and to handle colour in relative abstraction.

His colourism reached a peak in the still lifes of his Paris years, the twelve years following 1882, when he closed down his Venice studio. In Paris he came into closer contact with modern French painting: 'Monet,' he said admiringly, 'is the Rembrandt of *plein-air* painting: I mean that he has the same importance for the light of day as Rembrandt has for chiaroscuro, the light of indoors.'[1] In fact, Rembrandt and French painting of the earlier nineteenth century – Daubigny, Corot, Millet – lay closer to Schuch's own heart.

Schuch passed the summer months of 1884 and 1885 in the Netherlands. We know from his diaries that he spent time in Scheveningen, Amsterdam and The Hague, where he studied both seventeenth-century Dutch painters and the work of his contemporaries of the Hague School. As in previous years, he carefully analysed the colour composition and palette of the pictures he admired. 'I have put together a dossier under the excellent names of Daubigny, Troyon, Corot and others, and there I compile all my observations and passing notes. Descriptions of pictures, lighting, the composition of the palette and so forth. The dossier is getting bigger.'[2] The notebooks from the years 1883 to 1885 have survived, full of observations and precise descriptions of the 'palettes' of artists who interested him. Schuch studied colours in isolation and combination as if working on a theory of chromatic harmony, making notes and plans on palettes of his own for pictures as yet unpainted. For Schuch the use of colour was not simply to reproduce the 'colour reflection' of things. It had its own value, obeying intrinsic aesthetic laws that were independent of contingent objects. Pictures were to a large extent a kind of colour arithmetic.

Although *Still Life with Partridges and Cheese* still has the cool colouring typical of the Leibl circle, it also has a French *noblesse*. Like an Old Master, the picture is composed in brown and grey; and for this reason the red on one of the jam jars on the right-hand edge shines out the more strongly, answered in a weak echo from the opposite corner by the signature. The plane on which the few objects – a covered cheese dish, birds, jars, onions – are distributed is barely defined; the white of the pieces of cheese is the real focus of the picture. As here, Schuch liked to work out subtle gradations in white and grey, often referring to sequences of colour in his notebooks: 'Lovely vivid white – warm grey – warm grey with intense body – white like Corot – milky white'.[3]

Still Life with Partridges and Cheese conveys the delicacy – in more than one sense of the word – of Schuch's painting. This delicacy is often accompanied by a kind of morbidity in the colours and forms, and during the 1880s Schuch's art became markedly self-referential, as he concentrated on seeking the sublime. His friend Karl Hagemeister, later his biographer, commented that 'perception gave way increasingly to feeling, and in this respect Schuch resembles the great masters'.[4] Hagemeister found an explanation for this in the degenerative illness to which Schuch would eventually succumb.

'Pure painting' of the kind that Schuch adopted from the Leibl circle is the antithesis of drawn, linear art. It is inimical to contour, because contour is not perceptible in real life. As Schuch observed, in nature air and light stream over the outlines of things, virtually obliterating them, and he therefore painted edges with no more definition than fluff. He composed his pictures in colour and constructed them with visible, expressive, but not vigorous brushstrokes. The equilibrium of this unusual diagonal composition is also dependant on colour. AW

Embracing the French Avant-garde

The consensus which binds these painters together in our disrupted age and makes them into a collective force lies in their determination not to aim at the faithful reproduction of images, but to draw the line at a general impression. Once this impression has been caught and recorded, they say their contribution is over and done with ….Thus what essentially makes them different from their predecessors is the question whether a work is more or less finished. The subject depicted is the same, but the means used to convey it have changed, many would say for the worse.

Jules Castagnary, 'L'Exposition du Boulevard des Capucines',

Le Siècle, Paris, 29 April 1874

Whether people's eyes changed I do not know, but a different sun travelled across the sky, making all colours appear different and, in particular, casting quite different shadows.

Jacob Burckhardt to Heinrich Wölfflin, 29 August 1886

Under the catchphrases *plein air* painting and Impressionism is summed up what was new about the way Manet reproduced nature. This newness is of crucial importance for modern painting and is a constituent of it that can no longer be removed …. Painterly representation represents things as they seem, not as they are. The development of painting consists in its increasing ability to represent in this way. Every means leading closer to this goal means progress.

Hugo von Tschudi, *Edouard Manet*, 1902

A large part of the German notion of Impressionism, indeed the milder and better part of it, has a strong whiff of the pharmacy. Stimuli of the retina, analysis of the spectrum, the problem of complementary colours and the divisionist principle are the terms in which criticism of this new art is expressed. Hence the conviction has formed in the minds of many lay people that you have to be a physicist, an optician or a scholar to appreciate the Impressionists' pictures.

Julius Meier-Graefe, 'Über Impressionismus' (On Impressionism), *Kunst für Alle*, 1909

From the 1860s young German artists kept an eye on developments in advanced French painting. In 1868 Hans Thoma visited Courbet in Paris. The following year, Courbet and Manet exhibited in Munich, and Courbet visited, attracting the intense admiration of Wilhelm Leibl and his circle of friends. By the end of 1869, Leibl himself was in Paris where he showed at the Salon. Max Liebermann often travelled to the French capital, living there from 1874 to 1878, and was committed to making modern French art known to German artists and vice versa. From 1900 onwards, Secession exhibitions in Berlin and elsewhere included avant-garde French works.

The Nationalgalerie played a vital role in promoting this interest in French art. When he became Director in 1896, Hugo von Tschudi (1851–1911) made it clear that he would modernise his institution. He soon travelled to Paris, where he began acquiring modern French paintings, returning in the summer of 1896 with Edouard Manet's *In the Conservatory* of 1879 (fig. 51). Other modern masterpieces followed, including Cézanne's *Mill on the Couleuvre at Pontoise* of 1881

Fig. 51 EDOUARD MANET
In the Conservatory (Au jardin d'hiver), 1879
Oil on canvas, 115 × 150 cm, Nationalgalerie, Staatliche Museen zu Berlin

(cat. 68), acquired in 1897, the first painting by Cezanne to be purchased by a museum anywhere in the world. These paintings were soon joined by works by Renoir, Monet, Pissarro and Degas. The small but distinguished group of French Impressionist paintings that Tschudi acquired for Berlin represented the first attempt by any museum to form a meaningful collection in this field, and the initiative proved to be widely influential.

It was not without controversy. Conservative artists and academicians opposed the Nationalgalerie's new direction. Emperor William II held that true German art should glorify the nation and celebrate its achievements. He once spoke of Paris as a whorehouse and suspected that a love of modern French art implied support for a host of dangerous new ideas that were, to his mind, intrinsically anti-German. He insisted that Tschudi clear any purchases of French painting with him. The embattled Director had allies, however, including Liebermann, who advised him on such acquisitions, and a small group of wealthy and cosmopolitan Berlin collectors, many of them Jewish. They would buy and donate modern French works to the Nationalgalerie, knowing that, under William II, this was the only way they could enter the collection.

In 1909 the issue came to a head when Tschudi wished to purchase a further group of French pictures, including an important late Delacroix. The Emperor effectively vetoed the sale and forced Tschudi's resignation. The ousted Director left to take up a similar position in Munich, taking with him works by Gauguin and Van Gogh that he had hoped to introduce into the Nationalgalerie. In Munich he soon acquired another major Manet, *Luncheon in the Studio* (fig. 52), and inevitably provoked new controversy. CR

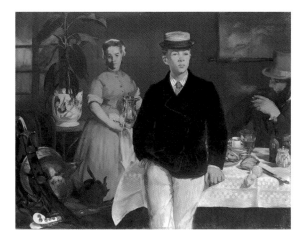

Fig. 52 EDOUARD MANET
Luncheon in the Studio (Déjeuner dans l'atelier), 1868
Oil on canvas, 118 × 154 cm, Neue Pinakothek,
Bayerische Staatsgemäldesammlungen, Munich

Gustave Courbet

1819–1877

64 The Source of the Lison
(La Source du Lison), 1864

Oil on canvas, 65.5 x 80.5 cm

Signed bottom left: G. Courbet

Inv. no. NG 11/69

PROVENANCE Donated in 1969 by Eduard von Schwartzkoppen, Berlin trading company, Frankfurt. The catalogue of the Courbet retrospective in Paris in 1882 (which calls the picture Source de la Loue) indicates Henri Hecht in Paris as its owner at that time. Later owned by Félix Gérard senior in Paris; Mme Chevalier; Mme Mauger; C.P.; Georges Petit; M. Groux; Galerie Fritz Nathan, Zurich

REFERENCE Fernier 1977, I, no. 3881

NOTES

1 Courbet to Pierre-Joseph Proudhon, 08.12.1864.

2 Julius Meyer, Geschichte der modernen französischen Malerei seit 1789 zugleich in ihrem Verhältnis zum politischen Leben, zur Gesittung und Literatur, Leipzig 1867, p. 622.

3 Klaus Herding, 'Egalität und Autorität in Courbets Landschaftsmalerei', Städel-Jahrbuch, v, 1975, pp. 159–87.

4 Cf. Courbet – artiste et promoteur de son œuvre, exhib. cat., ed. Jörg Zutter and Petra ten-Doesschate Chu, Musée cantonal des Beaux-Arts, Lausanne, and Nationalmuseum, Stockholm, 1998–99.

5 See Werner Hofmann, 'Courbets Wirklichkeiten', in Hamburg–Frankfurt 1978–9, pp. 589–613, especially p. 609f.

6 Fantastic Landscape with Anthropomorphic Rocks (Paysage fantastique aux roches anthropomorphes), after 1864?, in private ownership in 1977; see Gustave Courbet, exhib. cat., Grand Palais, Paris, 1977–8, no. 81.

Courbet estimated that he painted some forty landscapes in 1864.[1] His landscapes were regarded by the German critic Julius Meyer as the 'purest' realisation of his genius, by virtue of 'that faithfulness to nature in colour that Courbet achieves through the power of his simply and amply applied paint …. Here there is nothing tentative, no artifice, no petty devices of "frottage" or glazes. He applies colour beside colour with a broad brush directly from the palette exactly as he wants it on the canvas, full and heavy, and uniformly for shaded areas and highlights, for foreground and background. And thus, progressing from the depths to the brightest lights, he completes the whole picture in the simplest manner ….'[2] But Meyer predicted 'a future' for Courbet only in so far as he 'achieves the vivid glow of light and colour in the simplest way', for his figures showed the 'common trait of his nature', which led him to err towards the 'ugly', and he suffered from a 'weakness of imagination' – Meyer was reacting to Courbet's democratic sympathies. Today one can recognise the political resonance of the landscapes, too,[3] but at the time French critics shared Meyer's opinion, and Courbet's landscapes were also more successful commercially,[4] which created a demand for numerous repeats and variants.

This applied to pictures of the Loue and its tributary the Lison, which flowed quietly through deep, wooded valleys around Courbet's native town of Ornans in the Franche-Comté, the green of the surrounding foliage reflected on the smooth surface of their waters. The sources of both rivers were within easy reach of the town, and Courbet painted both repeatedly, particularly in 1863 and 1864. He is supposed to have completed many of these pictures from nature in no more than two hours. It is not certain which of the two rivers the Berlin picture depicts, and over the course of time it has been given various titles. It may even be intended as a free variant making no claim to topographical accuracy.

It is clear that the mysterious darkness of the cave arouses subliminal erotic feelings, and that an ancient fertility symbolism is at work in the cascading water of the spring.[5] How closely Courbet associated landscape with the human form is made manifest in a painting of rocks from this period that is explicitly anthropomorphic.[6] But for Courbet the interchangeability of body and nature was not merely symbolic but rooted in the act of painting, for his colours and their application were not specific to individual objects but could equally and without modification designate any number of things, animate or inanimate. The consistent texture and unifying facture of the Berlin picture depend on the use of the spatula, which Courbet took pride in handling with virtuoso control. The colouring, indeed, is not tied even to the natural sources of light, but takes on an emerald green in the water and golden and pink tones in the rocks that are suggestive of artificial illumination. Playfully distributed red dots reinforce the colouring still further. The picture is a celebration of its own painting. CK

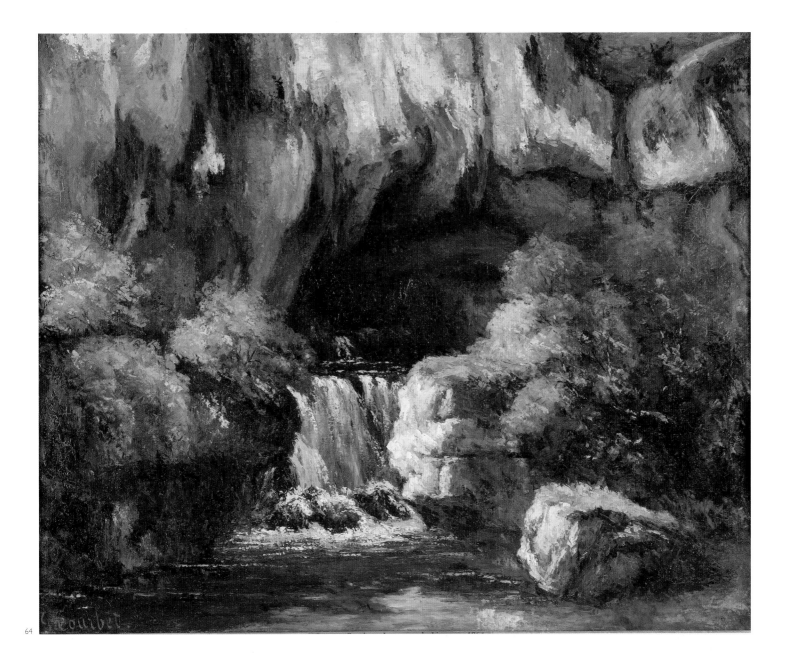

64

Claude Monet

1840–1926

65 *St-Germain-l'Auxerrois*, 1867

Oil on canvas, 79 x 98 cm

Signed bottom right (at a later date): *66 Claude Monet*
Inv. no. A I 984

PROVENANCE From the collection of the singer
Jean-Baptiste Faure in Paris; to the dealer Paul Durand-
Ruel. Acquired in 1906 with funds donated by the
bankers Karl Hagen and Karl Steinbart

REFERENCE Wildenstein 1974–91, I, no. 84

NOTES

1 Wildenstein 1974–91, V (1991), p. 188, letter 2687.

2 Marc Elder, *A Giverny, chez Claude Monet*, Paris 1924,
p. 55f.

3 Emile Zola, *Schriften zur Kunst. Die Salons von
1866–1896*, Frankfurt am Main 1988, p. 106.

4 Ibid., p. 279.

On 27 April 1867 Claude Monet applied to the imperial superintendant for art for permission to set up his easel under the colonnade of the Louvre: '… une autorisation spéciale pour me faire des vues de Paris des fenêtres du Louvre, et notamment de la colonnade extérieure, ayant à faire une vue de St Germain-l'Auxerrois' (a special authorisation for me to make views of Paris from the windows of the Louvre, and particularly from the external colonnade, with a view of St-Germain-l'Auxerrois).[1] Monet wanted to paint there in the open air, as had been the habit of a group of painter friends thirty years previously at Barbizon outside Paris. But Monet's subject was not tranquil nature, wooded groves and grazing cattle, but the busy city, its hurrying people, its rush and its speed.

That spring Monet painted three views from the Louvre colonnade: *Le Quai du Louvre* (Gemeentemuseum, The Hague), *Le Jardin de l'Infante* (Allen Memorial Art Museum, Oberlin College, Ohio) and this painting. The picture combines the old and the new, convention and innovation, in a way that can hardly be appreciated today. Most prominent is an architectural monument, the former royal parish church, with a late Gothic façade. In tension with it in the foreground on the right is a large block of residential flats, quite modern at that time, of the type that had recently begun to line Paris's wide boulevards. The arbitrarily cut, even chance aspect of this townscape is similar to that of the architectural photographs that were only just then being offered for sale, and might have been influenced by them. The clarity and instantly comprehensible character of Monet's view are in keeping with an expected interest in the architecture. On the other hand the undelineated contours and shadows of blue were new and disorientating at the time.

The greatest novelty of the picture, and the one that aroused the anger of critics and public, was the cursory representation of the busy throng of people under the flowering chestnut trees. Monet submitted the three views to the annual Salon in 1869, and as expected they were rejected. So he presented them to the public in the window of the Latouche art materials shop in the rue Lafayette, as he had done the previous year. To his surprise, and to his face, they provoked a reactionary response from his much admired hero Daumier, as Monet

recorded: '"Latouche," he shouted loudly, "won't you remove this abomination from your shop window?" I turned pale, I was winded as if I'd been punched in the chest. Daumier! The great Daumier! A god in my eyes!'[2]

Presumably Daumier was angered by the tiny, epigrammatic, blobby figures. Daumier himself frequently summarised the figures in his pictures and caricatures, reducing them to types, but they remained individual beings. But Monet captured the anonymity of the scurrying crowd. He might have found a precedent for such an extreme reduction not least in Japanese art. Since 1862 there had been an East Asian shop in the rue de Rivoli, regularly frequented by the foremost painters and a variety of art lovers, including Zola, Whistler and many of the Impressionists. Emile Zola showed more understanding of Monet's intent. About this picture in 1868 he commented: 'He loves views of our towns, the grey-white marks the houses form against the bright sky; on the streets he loves the people busily moving to and fro in their overcoats.'[3]

Monet did not paint his next great architectural picture, the *Boulevard des Capucines*, which also shows a hurrying throng of people viewed from above, until 1873. He showed it at the first Impressionist exhibition, in 1874. It was still the summarily indicated figures that alienated people most. The critic Louis Leroy described them as 'spittle marks'. These diagrammatic, faceless little figures must have had the effect of a culture shock in the artist's day.

By 1897 Impressionism was common property. Zola deplored its trivialisation: 'Oh, how many lances have I broken for the triumph of small touches of colour! … Would that I could have foreseen the terrible misuse that was to be made of that entirely right and proper victory by the divisionist method of painting. In the Salon now there is nothing but splotches of colour, a portrait is nothing but a single splotch, figures are nothing but several splotches, trees, houses, continents and seas are all nothing but splotches.'[4] AW

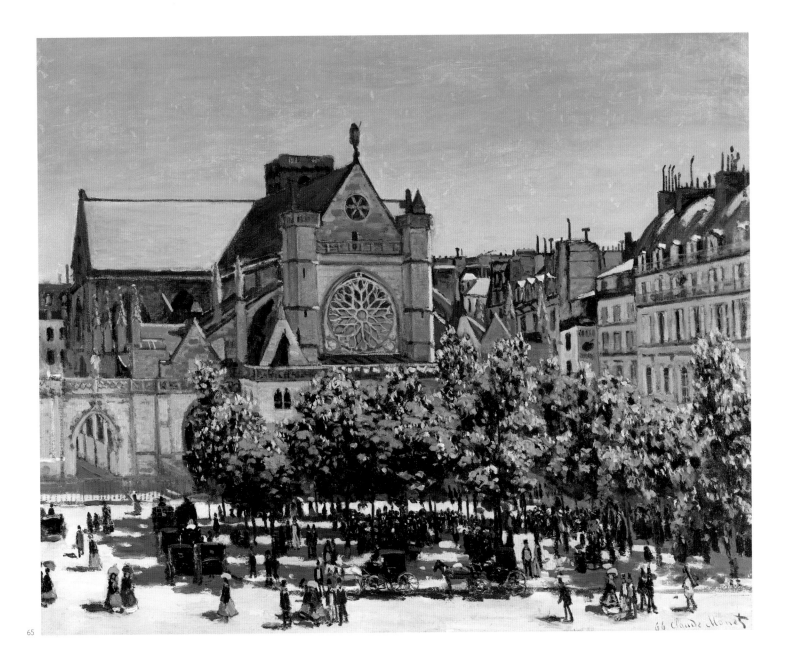

65

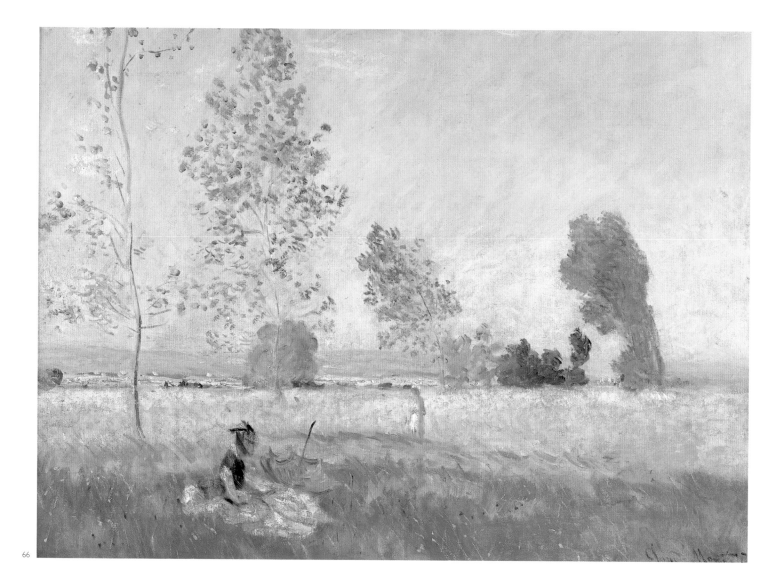

66

Claude Monet

66 *Summer (Eté)*, 1874

Oil on canvas, 57 × 80 cm

Signed bottom right: *Claude Monet 74*

Inv. no. A I 1013

PROVENANCE In the collection of the singer Jean-Baptiste Faure in Paris from 1875. To the dealer Paul Durand-Ruel at the end of 1906. Acquired for the Nationalgalerie in 1907 by Hugo von Tschudi with funds donated by the Berlin bankers Karl Hagen and Karl Steinbart

REFERENCE Wildenstein 1974–91, no. 341

In his 1867 view of St-Germain-l'Auxerrois (cat. 65) Monet was still hesitating between a correct, chiaroscuro architectural view and a dissolution of the figures in light. The bright, luminous *Summer*, painted seven years later, could serve as a manifesto for Impressionism.

In the spring of 1874 Monet and his friends had exhibited their pictures, rejected by the official Salon, at the premises of the photographer Nadar in Paris for the first time. A newspaper review by Louis Leroy referring to Monet's picture *Impression – soleil levant,* painted in 1873, led to the mocking sobriquet 'Impressionist', and the name would stick. Renoir and Monet spent the summer of 1874 at Argenteuil on the Seine, where Monet painted this view of a broad meadow shimmering in the sun, with misty blue hills in the distance. To convey grass, trees, hills and figures he used short, particularly thin, delicate strokes of colour, which convincingly reproduce the bright light and atmosphere. Monet's wife Camille, his son Jean and further away a third figure create accents with their bright clothing but are not depicted with any greater precision than the trees swaying in the wind or the coloured shadows on the yellow grass.

At almost the same time Hans Thoma in Munich also painted a picture entitled *Summer* (cat. 60), under Böcklin's influence. Thoma's richly coloured Symbolist work was compared to modern French art with special approbation or with deprecation, depending on the critic's stance. On closer consideration these two pictures, at least, are surprisingly similar. In both cases the subsidiary role of the figures obviates any suggestion of genre painting. A fleeting moment is as timeless as a lasting one. As Leroy had rightly recognised, Monet was concerned

67

with reproducing the pure impression, '*la sensation première*'. In essence Thoma and Böcklin, too, were concerned with exactly the same thing. However, they internalised the first 'sensation' and sought to transmute it into life again later in the studio. Monet and his friends quickly painted it there and then.

In the 1870s both the Impressionists and the Symbolists were interested in the physiological laws of optics. The researches of Hermann von Helmoltz in Berlin, which had been translated into French as early as the 1860s, were discussed by German and French artists and scholars alike. What Jules Castagnary, one of the few critics benevolent towards them,

wrote about the Impressionists in 1874 reads as if it was intended for Böcklin and the young Thoma. 'They are impressionists to the extent that they do not reproduce a landscape, but the impression provoked by the landscapeSeen from this standpoint they have left reality behind in order to enter a realm of pure idealismThe subject depicted is the same, but the means used to convey it have changed, many would say for the worse.'[1] AW

1 Jules Castagnary, 'L'Exposition du Boulevard des Capucines', *Le Siècle*, Paris, 29.04.1874, quoted from Stephan Koja, *Claude Monet*, exhib. cat., Österreischische Galerie, Vienna, 1996, p. 211.

Edouard Manet

1832–1883

67 *Villa at Rueil (Maison de Rueil)*, 1882

Oil on canvas, 71.5 x 92.3 cm

Signed bottom left: *Manet 1879*

Inv. no. A 1970

PROVENANCE Acquired in 1905 from Paul Durand-Ruel in Paris. Hugo von Tschudi applied in 1906 to the Emperor for permission to accept it as a donation, naming the banker Karl Hagen of Berlin as the donor

REFERENCE Rouart and Wildenstein 1975, no. 407

Already seriously ill, Edouard Manet spent the last summer of his life at the country house of the playwright Eugène Labiche at Rueil near Paris. In his choice of subject he was restricted to his immediate confines, but produced nonetheless some truly great pictures.

Hugo von Tschudi, the Director of the Nationalgalerie, described *Villa at Rueil* in his application to the Emperor to accept the donation of the painting as a 'picture that is completely classical in its impact because of the balanced maturity of the view, the unerring technique and the beauty of the brushwork'.[1]

The sun-dappled wall of the villa forms the picture's backdrop, running parallel to the picture plane and reducing the foreground to a narrow strip. Virtually nothing can be seen of the roof of the house and nothing at all of the sky. Against the light yellow wall of the house the window shutters appear blue, and so the light purple path conjoins house and the garden with lawn, bushes and flower-beds both spatially and in colour. The colour harmony of the yellow, blue and greens determines the whole picture, although the foreground flowers are calculated touches of red, too, picked up by the red of the frieze running along the wall. This carefully co-ordinated, strict composition – so light and sunny in its effect – justifies the term 'classical', but also provokes comparison with Japanese woodcuts. In Hokusai's views of Mount Fuji, for instance, there is the same flatness, so foreign to traditional Western art, and the same un-mediated crop at the picture edges. In Japanese woodcuts Manet could also have found the motif of a tree standing with only its trunk visible at the centre of the picture. Cut-off sections of trees became a popular *japonisme* in west European painting a little later, for example in Monet's pictures or in those of Van Gogh and Hodler. AW

1 Central Archives, Staatliche Museen zu Berlin, Gen. 37, vol. VIII, 1247/06.

Paul Cézanne

1839–1906

68 *Mill on the Couleuvre at Pontoise (Moulin à la Couleuvre à Pontoise)*, 1881

Oil on canvas, 73.5 × 91.5 cm

Inv. no. A I 606

PROVENANCE First owned by Julien Tanguy, an artist's materials merchant ('le père Tanguy') who from 1873 accepted Cézanne's pictures as security for money owed. Owned next, though this has not been fully confirmed, by the painter and writer Jacques-Emile Blanche. By the time the picture was shown in Brussels in 1890 at an exhibition of Les Vingt it belonged to the journalist Robert de Bonnières, who subsequently sold it to the dealer Paul Durand-Ruel. From him Hugo Tschudi acquired it for the Nationalgalerie, a donation in July 1897 from the merchant Wilhelm Staudt (died 1906) making possible this first purchase of a Cézanne by any museum, nine years before the artist's death. The purchase was immediately noted in France

REFERENCES Rewald, Feilchenfeldt and Warman 1986, no. 483; Paris–London–Philadelphia 1995, no. 75; Berlin 2000, no. 8

Fourteen years after the Berlin art world had shaken its head over the exhibition in 1883 of paintings by Manet, Monet, Sisley and other Impressionists owned by the legal historian Carl Bernstein and his wife Felicie, the purchase of a Cézanne for the Nationalgalerie was a further step into modernity. The picture in question, *The Mill on the Couleuvre at Pontoise*, is one of the few works by Cézanne that can be dated precisely. It was painted during Cézanne's six-month stay in 1881 at Pontoise, close to the 'humble but colossal'[1] older friend who had set him on the path to Impressionism a few years earlier, Camille Pissarro. Pissarro, too, painted this water mill, at least twice. One of many in this cereal-growing area, the Moulin des Etannets on the rue des Deux Ponts is still standing, and Cézanne reproduces it, as usual, with surprising accuracy, even if the building appears to be much taller in his painting. In the strict frontal view, which has a disembodying effect, every window can be counted, and even the little shelter for ducks at the front, to which an old photograph testifies, can be recognised. The ducks swimming on the water seem

intruders in the work of Cézanne, who generally excluded all living creatures from his landscapes, but perhaps they are a gesture towards Pissarro, who loved such everyday touches.

Accuracy and formal rigour are not mutually exclusive. All receding orthogonals seem to rise to vertical. The foreground surface extends uninterrupted from one edge of the picture to the other; parallel horizontals curtail the picture space. There is no 'lead-in', no repoussoir, and the ground hardly looks as if it could be walked on. The structure of verticals and horizontals is typical of Cézanne's style around 1880; but in fact all the verticals are slightly askew, and the horizontals in the foreground slant a little, gaining spatiality. Curving brushstrokes which suggest the swelling ground are repeated more loosely in the clouds. This technique of bracing the picture surface by repetition and variation can be observed in Cézanne's work throughout the decades. Cézanne thought 'depth arises from a juxtaposition of the vertical and horizontal surfaces, and that in fact is perspective'.[2]

The colourism of the *Mill at Pontoise* depends on a constantly repeated interchange of ochre, green and blue with very few gradations. The painter's favourite expression, 'modulating' colour (consciously opposed to the usual term 'modelling' forms) is appropriate here. But '… Cézanne, placing his small brushstrokes, teases with the multiplicity of all the systems he brings into play, and yet remains supremely systematic. The instinct which always guided him gave him infinite plenitude here, too …'.[3] Every stroke and curve on the pale ground retains its individual value, like a script, refusing to amalgamate into a thicker mark when two or three strokes intersect. Although this is a picture Cézanne parted with soon after working on it, and allowed to be exhibited, it has no final polish, and communicates the act of its painting as a process that can never quite be resolved. CK

1 Cézanne to Emile Bernard, undated (1905): *Paul Cézanne: Briefe*, ed. John Rewald, Zurich 1962, p. 295.

2 Cézanne in conversation with Jean Royère, quoted in *Gespräche mit Cézanne*, ed. P. Michael Doran, Zurich 1982, p. 232.

3 Julius Meier-Graefe, *Entwicklungsgeschichte der modernen Kunst*, Stuttgart 1904, I, p. 169.

Secession

For us there is no one and only right direction in art, but it seems to us that every work, whatever tendency it may belong to, in which honest sensibility is embodied is a work of art. Only commercial routine and the superficial pretence of those who see art as no more than a source of revenue are in principle excluded.

Max Liebermann, at the opening of the first exhibition of the Berlin Secession, 1899

The painter's talent does not reside in the slavish copying of nature, but in the power with which he is able to reproduce the impression that nature has evoked in him. Only a strong artistic personality is capable of convincing us of the veracity of the depiction.

Max Liebermann, at the opening of the Berlin Secession exhibition of 1907

'Nature': we are surrounded and entwined by it – incapable of extricating ourselves from it, and incapable of penetrating more deeply into it.

Lovis Corinth, *Gesammelte Schriften* (Collected works), Berlin 1920

Corinth was a born painter: he was one of the chosen few who lived only in and for art. The truth of Goethe's words 'Die and be tranformed' are demonstrated in him as in few people. The gods had given him rare gifts, they brought his personality to full fruition, and even extreme illness was not able to conquer him before he had brought his work to a triumphant conclusion.

Max Liebermann, at the opening of the Corinth retrospective in Berlin, February 1926

In Berlin I became an authority …. And how could it be otherwise, as commercial activities in Berlin were excellent, the dealers were intelligent and eager to acquire new art, and furthermore the young Emperor had an aversion to everything new, so that we were also surrounded by the radiance of a martyr's crown.

Lovis Corinth, *Selbstbiographie* (Autobiography), 1926

The 1890s saw the formation of Secession movements in German-speaking Europe. These were independent exhibiting societies, often run by artists and free from the control of local art academies and academicians. The various Secession exhibitions, usually held annually, became leading venues for the display of progressive art. Avant-garde French artists were often invited to participate as well. Munich's Secession was founded in 1892, Vienna's in 1897, and Berlin's the following year, in 1898. Impressionists like Max Liebermann and Max Slevogt and Expressionists like Lovis Corinth and the young Max Beckmann all participated in the movement. In broad terms, Secession has come to designate the range of progressive, anti-academic styles that were emerging in German art at the turn of the twentieth century.

The specific impetus for the founding of the Berlin Secession was the 1898 rejection from an official exhibition of a painting by Walter Leistikow (1865–1908). Leistikow, a painter of moody landscapes (fig. 54), was a leader in progressive art circles in Berlin and a founder member of the Gruppe der Elf (Group of Eleven), an exhibition society formed in 1892. The Eleven now re-formed as the Berlin Secession with Liebermann as the first President and Leistikow as Secretary. It could count on the support of the Nationalgalerie director, Hugo von Tschudi, of the influential critic Julius Meier-Graefe and of prominent dealers such as Paul Cassirer. The first exhibition was held in 1899 and the next year advanced French works were included as well. At the height of its influence, the Berlin Secession was the most important forum for the display of avant-garde art in Germany.

The Secession movement was anti-academic, international in outlook, and pitted itself against the rigidly conservative art policy of the Emperor. This was especially true in Berlin, the capital, where the bombastic painter of imperial grandeur, Anton von Werner, held power. Close to the Emperor, he promoted inflexible academic training and nationalistic art at the service of the state. The 'cosmopolitanism' of the Secession movement was inimical to him. The Berlin Secession was open to a variety of artistic tendencies. By 1910, however, confronted with the emerging Expressionist movement, it began rejecting such paintings from its exhibitions and adopted a more conservative stance. The young Turks whose works had been refused broke away to form the Neue (new) Secession. By 1913, the influence of the original Berlin Secession was at an end and it survived in name alone.

Fig. 53
LOVIS CORINTH
Self-portrait with Skeleton (*Selbstbildnis mit Skelett*), 1896
Oil on canvas, Städtische Galerie im Lenbachhaus, Munich

Fig. 54
WALTER LEISTIKOW
Lake Grünewald (*Grünewaldsee*), 1895
Oil on canvas
Nationalgalerie, Staatliche Museen zu Berlin

Fritz von Uhde

1848–1911

69 *Little Heathland Princess* (*Heideprinzeßchen*), 1889

Oil on canvas, 140 × 111 cm

Signed bottom right: *F. v. Uhde 1889*

Inv. no. A II 841

PROVENANCE Acquired in 1934 from Dr. Adolf Kohner of Budapest; in his collection since 1908. Originally owned by Otto Julius Bierbaum, who published numerous articles and essays about Fritz von Uhde between 1889 and 1908, and the first book about him in 1893

REFERENCE Munich 1999, no. 29

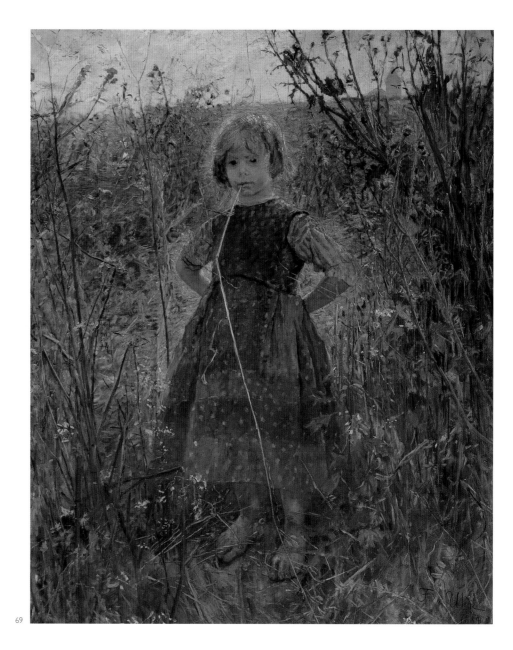

69

We see, close-up and full-length, a country girl about six years of age. With her upper body taut, her hands behind her back, she seems self-confident and at the same time a little apprehensive because of the exposed situation in which she finds herself. A straw is dangling as casually from her mouth as a cigarette from the mouth of a dandy. The picture's size also contributes to the impression that the child is staring back at the viewer.

In the second half of the nineteenth century 'urchins' were a regular fixture in annual art shows. Over time there was a transition from the sentimental to a more sober realism, which had its counterpart in the social criticism in modern literature.

In the same year, 1889, Uhde also painted *The Nursery* (*Kinderstube*) and *The Picture Book* (*Das Bilderbuch*; both Hamburger Kunsthalle, Hamburg), using as models his much cherished daughters, who were about the same age as this girl. In all three pictures Uhde was attempting to capture accurately children's individuality, as the first owner of *The Heathland Princess*, the critic Julius Bierbaum, appreciated: 'As a painter of children, for example, Uhde is extraordinarily distinguished. He does not depict them as sweetly as used to be popular, in other words not as amusing or charming dolls, but with extreme, very strict naturalness.'[1] Even so, this picture's title, at least, seems like a concession to the romance of the urchin. It implies a narrative and at the same time ironises. But the glamour of 'princess' also relates to the strange light which surrounds her like an aura.

The closeness between children and nature is another chord the picture strikes. The girl is surrounded by vegetation, with the line of the horizon over her head. She stands not in a flowery meadow, but on uncultivated heathland. The thicket of prickly plants reinforces the connotation of anarchy. The profile of a church, symbol of moderation, rule and law in the adult world, is discernible in the distance.

A crucial experience for Uhde was his journey to Holland in 1882. In his own words, it enabled him 'to look at nature with his own eyes and to gain an understanding of the paintings of the French'.[2] Like Liebermann before him (see further cat. 70), in Holland Uhde turned away from the chiaroscuro studio painting he had practised in Munich to work *sur le motif* with brighter and purer colours. *The Little Heathland Princess* was, no doubt, painted in the studio, as Liebermann's larger-format pictures also were, but it was still meant to be '*plein-air*' painting, with the objective of conveying light, air and as much immediacy as possible. Something more elemental was needed in art. The subject of an unaffected child out of doors amidst nature was eminently suitable when the goal was to paint directly, unconstrained by convention, in bright colour.

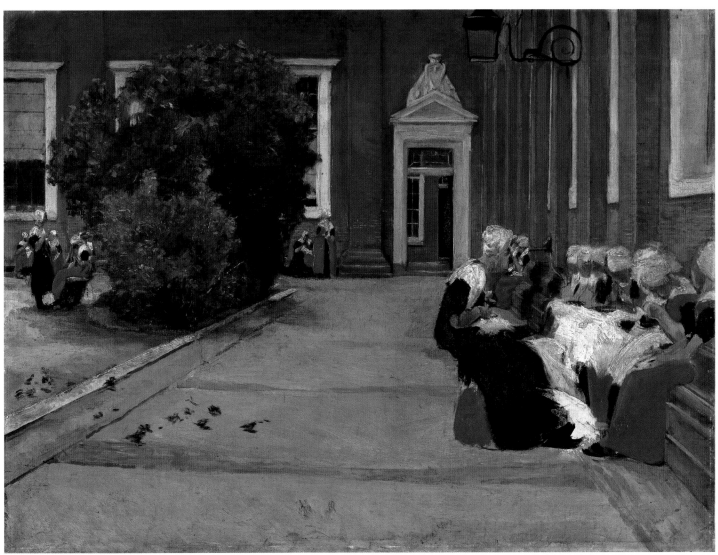

70

At the end of the nineteenth century the break with academic tradition and the search for new expressive forms set in motion throughout Europe a number of break-away or 'secession' movements. Uhde, Slevogt (see cat. 72) and Corinth (see cat. 73–75) were at the forefront of the Munich Sezession, founded in 1892. Uhde also became a corresponding member of the Berlin Secession, instituted in 1898, of which Liebermann (see cat. 70, 71) was President. AW

1 Otto Julius Bierbaum, *Fritz von Uhde*, Munich 1893, p. 39.

2 Quoted from Bettina Brand, *Fritz von Uhde. Das religiöse Werk zwischen künstlerischer Intention und Öffentlichkeit*, Heidelberg 1983, p. 6.

Max Liebermann

1847–1935

70 *Amsterdam Orphan Girls (Amsterdamer Waisenmädchen)*, 1876

Oil on canvas, 67 × 89.5 cm

Inv. no. A II 387

PROVENANCE Acquired in 1923 from the Director General of the Berlin Museums, Wilhelm Bode. He in turn is meant to have obtained the picture in exchange 'for a wonderful length of gold velvet of east Asian origin which he had bought in Italy for his wife for 350 lire' (*Berliner Tageblatt*, 23.06.1927)

REFERENCE Eberle 1995–6, 1, no. 1876/25

In 1876 Liebermann spent five months in Holland, and from then on visited the country almost every year until the outbreak of the First World War. He had found there the physical, social and cultural environment that he needed for his painting. In the summer of 1876 he systematically copied pictures and details of pictures by Frans Hals in Haarlem. He was especially fascinated by the free, lively manner of the artist's late pictures of 'regents' or governors of orphanages and old people's homes. On the reverse side of one of these copies there is a first sketch for *Playtime at the Amsterdam Orphanage* (*Freistunde im Amsterdamer Waisenhaus*; Städelmuseum, Frankfurt): on his way back from Haarlem to Amsterdam that day Liebermann had by chance glanced into

the playground of the town's orphanage, and was so riveted by the scene that he instantly recorded it.

Subsequently he made further, more elaborate studies. Liebermann's enthusiasm for Holland was shared by Wilhelm Bode, the Director General of Museums in Berlin, who bought this one for himself. It convincingly reproduces the first, intense impression: the interplay of colours which caught Liebermann's eye – the green of the trees against the brick-red of the walls; the flicker of light and the harmonious movement of the girls – their calm, untroubled movement in their own enclosed, cherished realm. The girls are dressed in red and black, Amsterdam's city colours.

It is not only in theme that Liebermann's studies of the Amsterdam orphanage are close to the pictures he copied after Frans Hals. Both Liebermann and Bode admired the suggestive power of Hals's sketch-like, atmospheric painting, his apparently accidental compositions, the unerring accuracy of his lightning brushwork, and what Liebermann called his 'genius for capturing the momentary'.[1] *Playtime in the Amsterdam Orphanage* displays the self-same brilliant capture of the momentary.

It was only five years later, in 1881, that Liebermann began the execution in his Munich studio of his large picture of the subject (Städelsches Institut, Frankfurt), using not only these sketches but also careful figure studies, for which he borrowed a dress from the Amsterdam orphanage. By this time the French Impressionists were already convinced that a first momentary record could produce a valid picture, regularly painting in the open air in the 1870s. Although they had opened themselves to the charge of not 'finishing', they had broken down the distinction between a study and an exhibitable picture. Liebermann, however, at this point paid scarcely any attention to their work, seeing himself as a naturalist. AW

1 Max Liebermann, *Die Phantasie in der Malerei. Schriften und Reden*, Frankfurt am Main 1978, p. 40.

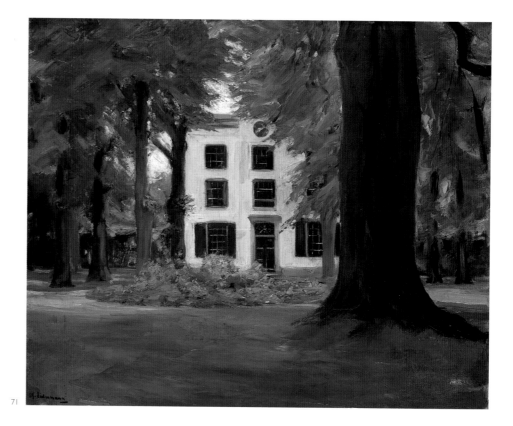

71

Max Liebermann

71 *Villa at Hilversum (Landhaus in Hilversum)*, 1901

Oil on canvas, 65 × 80 cm

Signed bottom left: *M. Liebermann*

Inv. no. A II 158

PROVENANCE Donated in 1917 by Eduard Arnhold, an important collector and benefactor of the Nationalgalerie, on the occasion of the artist's seventieth birthday. Arnhold had the picture from the equally important Berlin collection of Albrecht Guttmann

REFERENCE Eberle 1995–6, II, no. 1901/1

Liebermann modified his painting from about 1900 away from naturalism with a social bias towards Impressionism and more intimate subjects. Although he did not paint the city, nor did he go to France, but kept to his annual study trips to Holland, he allowed himself to be influenced by French Impressionism, lightening and brightening his palette. The importance to him of Manet's art in particular cannot be overestimated. Liebermann collected Manet and wrote articles about him. Manet became every bit as much Liebermann's artistic model as Frans Hals had been.

Very soon after it was painted *Villa at Hilversum* was linked to Manet's *Villa at Rueil* (cat. 67), with which Liebermann was possibly familiar before 1900. The subject of the *haut bourgeois* villa was a modern one, but, more than that, in Liebermann's picture his young friend and fellow painter Erich Hancke rightly recognised 'the ennobling influence of Manet's painterly sensitivity, indeed of his approach to nature as to a still life'.[1] The villa was 'the house of the art historian Jan Bredius in Hilversum (near the Zuidersee). Liebermann often went there to paint from Laren and Leiden in the summer of 1901.[2] Jan Bredius was the father of Abraham Bredius, the renowned Rembrandt scholar and Director of the Mauritshuis in The Hague; Bode (see cat. 70) also knew him well.

The key words France and Holland, Manet and Rembrandt, exactly describe Liebermann's particular path to a German Impressionism. AW

1 Erich Hancke, *Max Liebermann. Sein Leben und seine Werke*, Berlin 1914, p. 402.

2 Ludwig Thormaelen, *Katalog NG 1918*, p. 67f.

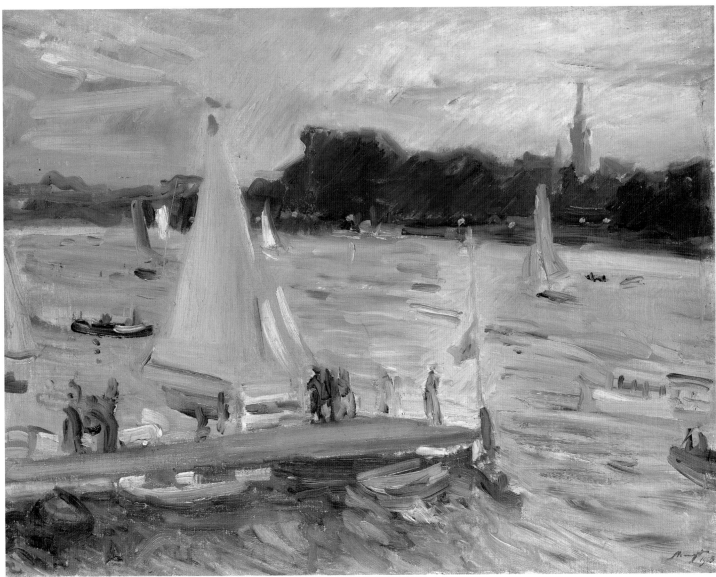

72

Max Slevogt

1868–1932

72 *Sailing Boats on the Alster,*
Evening (Segelboote auf der Alster
am Abend), 1905

Oil on canvas, 58.5 × 76 cm

Signed bottom right: *Slevogt 1905*

Inv. no. A II 1022

PROVENANCE Acquired in 1951 from the dealer
Herbert Klewer, Berlin

REFERENCE Imiela 1968, pp. 142f., 392, note 5

Alfred Lichtwark, Director of the Hamburger
Kunsthalle, keenly promoted art education and
also commissioned work. In the early 1900s
some thirty artists painted for him portraits of
well-known Hamburg citizens or views of the
city and its surroundings. The 'collection of
Hamburg pictures' was intended to encourage
a sense of cultural and historical identity, but
Lichtwark also hoped, by the use of familiar
subjects, to induce an open-minded attitude
towards more modern art among his visitors.
Hence there are analogous pictures of the
Alster in Hamburg also by Max Liebermann
(1910) and Pierre Bonnard (1913).

Slevogt was actually commissioned to paint
a portrait of Senator William Henry O'Swald

for the Kunsthalle. This and some other land-
scapes of the Alster were incidentals.

Liebermann's response to the Alster was to
paint Hamburg's elegant ladies in their boats. But
for Slevogt humanity had little pictorial interest:
he painted the atmosphere, the blurring of con-
tours on the opposite bank, the mirroring of
water and sky, the modulation of colours in the
evening light. His is an airy, animated scene, cap-
tured in bold brushwork and brilliant colour. His
Hamburg, too, though, is a leisure spot, with
only the distant lights and towers connoting
the town. AW

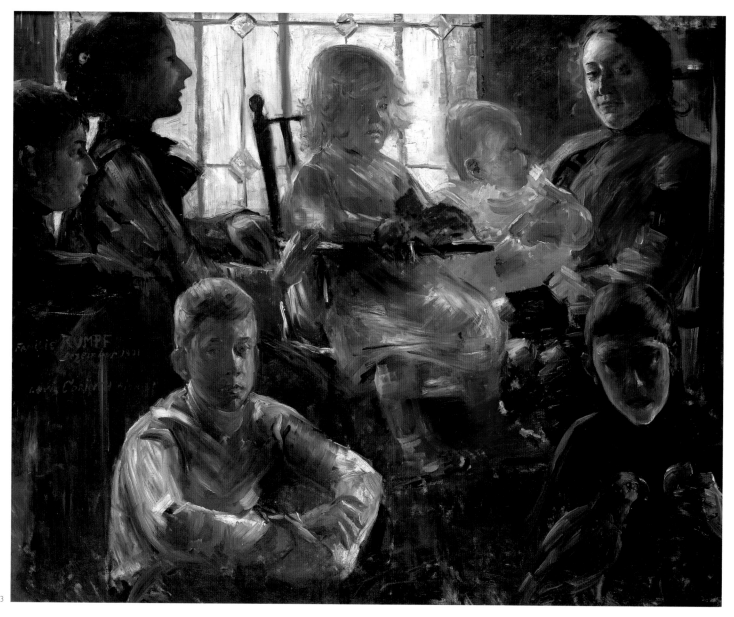

73

Lovis Corinth

1856–1925

73 *The Rumpf Family (Familie Rumpf)*, 1901

Oil on canvas, 113 × 140 cm

Signed centre left: *Familie Rumpf, Dezember 1901 Lovis Corinth pinx.*

Inv. no. A II 596

PROVENANCE Acquired in 1927 from the Rumpf family

REFERENCE Berend-Corinth 1992, no. 219

In October 1901 Corinth moved from Munich to Berlin; Slevogt (see cat. 72) followed soon after. Liebermann (see cat. 70, 71) and Walter Leistikow, who lent his studio to Corinth, played some part in these moves, hoping thereby to boost the Berlin art scene and strengthen the Secession. Earlier in the year the Berlin critic Hans Rosenhagen, in a hotly disputed article, had raised the question whether Munich or Berlin was Germany's leading art centre. Opinion came out generally in favour of Berlin.

Immediately on arrival Corinth opened a successful 'school of painting for life drawing and portraits' specially for women. One of the first applicants was Charlotte Berend, whom he subsequently married. In December 1901 he exhibited at the Cassirer gallery, and early the next year was elected to the committee of the Berlin Secession. The pace of Corinth's entry into the cultural life of Berlin was furious.

Leistikow introduced Corinth to literary and artistic Berlin, among whom was the landscape and architectural painter Fritz Rumpf, whose newly built villa in Potsdam was itself a meeting point. Initially Corinth often spent several days at a time at the house. He painted a fair number of family and group pictures around this time, but the *Rumpf Family* is one of the most

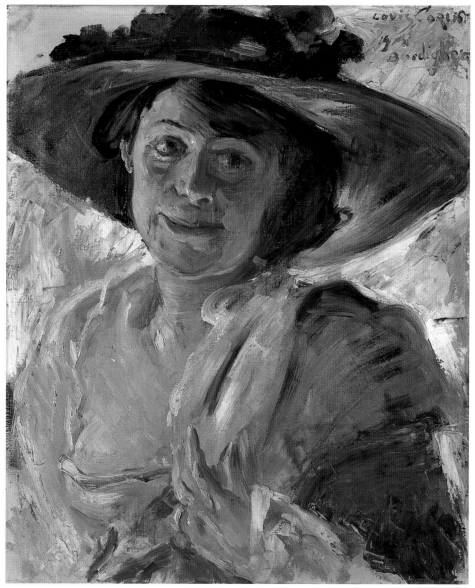

74

Lovis Corinth

74 Woman in a Rose-trimmed Hat (Frau mit Rosenhut), 1912

Oil on canvas, 60 × 50 cm

Signed top left: *Lovis Corinth 1912 in Bordighera*

Inv. no. A II 1033

PROVENANCE Acquired in 1952 through the dealer Klever, Berlin

REFERENCE Berend-Corinth 1992, no. 519

In the spring of 1912, Corinth, who had suffered a stroke the previous December at the age of fifty-three (see further cat. 75), travelled with his wife to Bordighera on the Italian Riviera to convalesce. The nature of his future life and the issue of whether he could ever again practise as an artist were still in doubt. At Bordighera, as Charlotte Berend-Corinth relates, they took part in the local flower pageant in an open, decorated carriage.

'Lovis and I were very excited and cheerful when we returned to our hotel room. I took off my coat and put my white fur cape over one shoulder and talked animatedly about the parade.'[1] Obviously the palpable and visible embodiment of such intense enjoyment of life inspired Corinth with a new will to work after weeks of illness. His wife's bubbling enthusiasm and liveliness prompted him to paint spontaneously, to attack the portrait almost feverishly, and indeed it announces a new, more expressive phase of his work.

Corinth established the portrait in rapid, lively brushstrokes and light rococo colours – blue, yellow, white and red. 'Lovis painted the picture until darkness fell. The wide open windows gave a good light. The following day the picture was quickly finished.'[2] AW

1 *Lovis Corinth, Bildnisse seiner Frau, Einführung Carl Georg Heise. Erinnerungen an die Entstehung der Bilder von Charlotte Berend-Corinth*, Stuttgart 1958, p. 17.

2 Ibid., p. 18.

engaging. Cleverly arranged, skilfully lit and silhouetted, Rumpf's wife and six children are shown in the dining-room of their villa. Corinth painted the master of the house separately the same year (Berlinische Galerie, Berlin).

The picture's *contre-jour* lighting is one of its main effects. Corinth had tried out the device a little earlier, in a portrait of his uncle, Friedrich (Ostpreußisches Landesmuseum, Lüneburg). He painted the Rumpf family in the morning only, when the light coming through the mullioned window behind sharply outlined the contours of the two foreground children and shadowed the sitters' turning or frontal faces.

There is something theatrical about the sym-metrical arrangement of the mother and baby on the right, the two bigger children on the left, balanced against one another on either side of the slightly monstrous, pink-cheeked girl in the centre, at whose feet the two foreground boys sit. None of the figures relates to any other, although three look towards the viewer. Charlotte Berend-Corinth later commented that 'at the Rumpfs in Potsdam things were very formal',[1] but Corinth was undoubtedly more concerned with resolving a painting problem than producing a psychological profile. AW

1 *Lovis Corinth, Eine Dokumentation*, compiled and annotated by Thomas Corinth, Tübingen 1979, p. 379.

Lovis Corinth

75 *Samson Blinded*
(*Der geblendete Simson*), 1912

Oil on canvas, 130 × 105 cm

Signed top left: *Lovis Corinth 1912*

Inv. no. A III 668

PROVENANCE Acquired in 1980; on loan from a private collector since 1958

REFERENCE Berend-Corinth 1992, no. 520

NOTE

1 Lovis Corinth, *Selbstbiographie*, Leipzig 1926, p. 123.

In 1910 Corinth painted himself as *The Victor* (*Der Sieger*, location unknown), in splendid armour, carrying a lance, and before him his young wife scantily clad and bearing a laurel wreath. In 1911 he depicted himself as an armed *Standard-bearer* (*Der Fahnenträger*; Muzeum Narodwe, Poznan). Both pictures affirm and adjure unassailable strength. But at the end of 1911 Corinth suffered a stroke, which permanently undermined his defiantly swaggering self-image.

Corinth had hardly regained his strength before he found consolation for his new, humiliated situation in a heavily symbolic form of self-portrayal, exalting his misfortune. In forging it he was able to draw upon the nineteenth-century cult of the artist genius. Since the Romantic period the life and suffering of the true artist had been conceived as part of a special destiny; elevated to mythical status, the artist became a hero, and measured himself and his sufferings and work against earlier heroic example. Identification with Christ himself, the *imitatio Christi*, or with Samson, an Old Testament prefiguration of Christ, has formed part of the self-perception of German artists from the important precedent of Dürer to Beckmann and on to Beuys.

Samson (Judges 13–16) was deprived of his supernatural strength, after he had been betrayed, by the cutting off of his wondrous hair. His enemies, the Philistines, gouged out his eyes and cast him in chains. As his hair grew again his strength returned, and erupted in anger. Having been fetched out for the Philistines' amusement during a feast, Samson took his revenge on his enemies by throwing down the pillars supporting their banqueting hall – a story of loss and protest, of the recovery of strength after wounding, of victory and of destruction that was highly relevant to Corinth's own condition.

Corinth repeated the groping right hand of Samson from an earlier drawing of *Job and his Friends* (*Hiob und seine Freunde*; Kupferstichkabinett, Staatliche Museen zu Berlin), made in February 1912. In the despondent period immediately after his stroke Corinth, well versed in the Bible, compared himself with Job, the archetype of humility and patience.[1] By the summer of 1912 he would transform this resignation into angry despair, into menacing revolt. This Samson storms forward like a wounded animal. Yet at the same time the painting is a preliminary to to a further development, the lightened, more spiritual *Ecce Homo* of 1925 (Kunstmuseum, Basle), the first preparatory studies for which were made at the same time as *Samson* was being painted.

The colours in *Samson Blinded* are heavy and earthy, with dominant dull browns and greens. It was presumably Corinth himself who painted over the gilded frame with a greenish colour to remove any celebratory sheen. Up until the time of his stroke he had a strikingly vital disposition, which he managed to revive to an even greater pitch in his portrait of his wife, *Woman in a Rose-trimmed Hat* (cat. 74). *Samson Blinded* might be said to be that portrait's emotional pendant. The muscular, unclothed figure of Samson, his bound hands outstretched, his face distorted in pain and anger, makes as powerful and intense impression on the viewer as *Woman in a Rose-trimmed Hat*, though Samson is frightening and threatening in his proximity. This Samson is frightfully wounded, but even in adversity strong, and – as a personification of Corinth the painter – creative, undeterred in his artistic resolution.

In 1893 Corinth had painted Samson's betrayal by Delilah (*Simson und Delila*; location unknown), a brilliant demonstration of his handling of light, and in 1907 *The Capture of Samson* (*Gefangennahme Simsons*; Städtische Galerie, Mainz). In 1902 his Secessionist counterpart in Berlin, Max Liebermann, exhibited a large picture of *Samson and Delilah* (*Simson und Delila*; Städelsches Institut, Frankfurt); the subject was in the air, and was treated in literature and opera (by Camille Saint-Saens) as well. But no other contemporary picture bespeaks personal emotion in the same way as Corinth's *Samson*, or projects such raw feeling into paint. AW

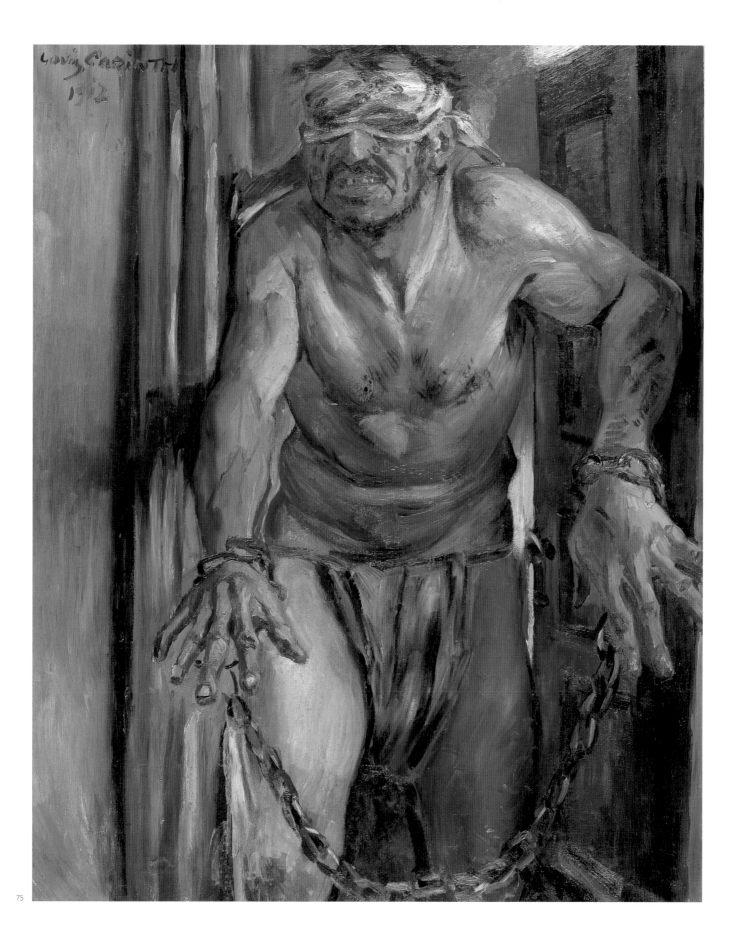

Max Beckmann

1884–1950

76 'Small' Deathbed Scene (Kleine Sterbeszene), 1906

Oil on canvas, 110 × 71 cm

Signed top right: *HBSL 06*

Inv. no. B 53/25

PROVENANCE The signature is a coded dedication (*Herr Beckmann seiner Liebsten*: Mr Beckman to his dearest love) to the artist's first wife, the painter and (from about 1912) singer Minna Beckmann-Tube, whom he married in 1906. Even after their divorce in 1925 the picture remained in her possession. Acquired in 1952 from the Galerie Meta Nierendorf, Berlin

REFERENCES Göpel 1976, no. 62; Munich–Berlin–St Louis–Los Angeles 1984–5, no. 6

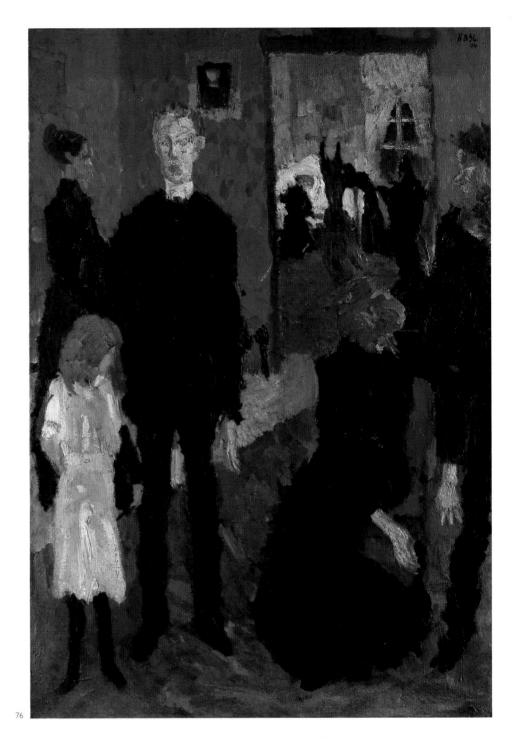

76

In an unparallelled *tour de force*, going still further in this respect than his contemporary Picasso, Max Beckmann transposed the entire stock of motifs and symbols of a thousand years of painting into a modern idiom; in so doing he bent the prevailing rules of interpretation and instituted a subjective rhetoric of his own. When his mother died of cancer, in 1906, Beckmann, aged twenty-two, had already painted a Crucifixion scene, *Drama* (destroyed by fire in 1943). Soon after her death, or perhaps in anticipation of the expected event, he painted the *'Large' Deathbed Scene* (*Große Sterbeszene*; Staatsgalerie moderner Kunst, Munich), a dramatic and graphic close-up view of nude and half-naked mourners round the uncovered corpse. The *'Small' Deathbed Scene* is instead a work of psychological *intimisme*. The deathbed room with the lamenting women is pushed into the background, while in the foreground bewilderment and isolation rule. These figures' inability to express themselves or even to communicate with their neighbours is implicit in the dark clothing they wear for the function; only the red (and nearby yellow) of the back wall silently shrieks their smothered feelings. If the application of the colours may recall Vuillard – Beckmann had visited Paris and was in the process of joining the Berlin Secession – the colouring itself, the composition overall, and particular figures such as the stiff female in profile on the left and the man beside her with a mask-like pallor (presumably a self-portrait), are dependant on the example of Edvard Munch. (Munch is supposed to have praised the *'Large' Deathbed Scene*, which was exhibited at the Cassirer gallery in Berlin at the same time as his own pictures.)

Drawings in his diary show how the young artist used sarcasm to defend himself against the depressing constrictions of the world around him. Thus he categorised literature into particular 'styles and moods': Maupassant moods, Prévost moods etc. He divided the 'Maeterlinck mood' into two kinds, describing the first as follows (entry 29 August 1903): 'Highly fashionable. Horror. Death. Pity with a dash of metaphysics'. Against such formulae the *'Small' Deathbed Scene* deploys raw emotionalism. CK

Max Beckmann

77 Conversation (Unterhaltung), 1908

Oil on canvas, 177 × 168.5 cm

Signed top right: *HBSL 08*

Inv. no. B 598

PROVENANCE The acronym in the signature expands to *Herr Beckmann seiner Liebsten* (Mr Beckman to his dearest love, that is, Minna Beckmann-Tube, who is included in the picture). The picture belonged temporarily (*c.* 1924) to the Berlin dealer Paul Cassirer, then must have been returned to the painter, then passed to Minna Beckmann-Tube, from whom Beckmann had meanwhile separated, and later to the artist's son, Dr. Peter Beckmann. Purchased in 1963 from the dealer and collector Günther Franke of Munich, who had made Beckmann's acquaintance in 1921 and acquired many works by him

REFERENCES Göpel 1976, no. 88; Munich– Berlin– St Louis–Los Angeles 1984–5, no. 7

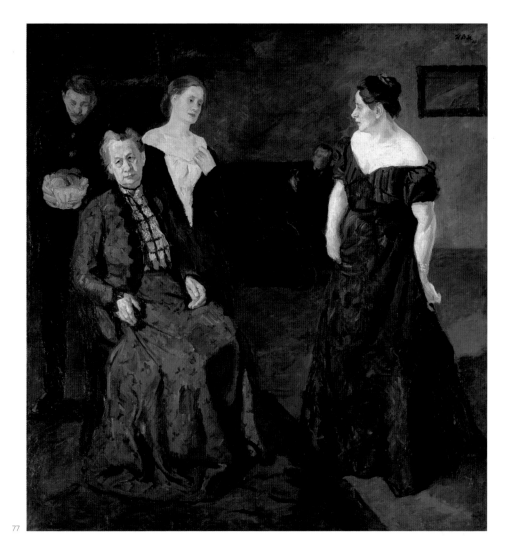

77

The format of this picture is well known from Baroque family portraits: each figure had its place, determined by gender and social position, in an action that was triggered by a minor event such as the arrival of the letter or the entry of a stranger. It seldom upset the relations between them. This is not the case in *Conversation*, also entitled *Society I* (*Gesellschaft I*). (The variants *Society II* and *Society III* followed in 1911 and in his final year in Berlin, 1914.) As so often, Beckmann used his own family as a prototype for troubled humanity, and resorted to a large format. He himself sits as a spectator against the back wall of the large room, which seems to be an empty entrance hall; for Beckmann, particularly in his early painting, making spatial depth palpable was very important, and even in 1914 he vehemently rejected 'the principle of flatness' in the work of Matisse or the Cubists. In the foreground group Minna, his pregnant wife, née Tube, a pale apparition with open bodice, stands behind the dignified, seated figure of her mother Minna Tube née Römpler, the widow of an army chaplain. A great vacuum – animated only by the figure of the painter, 'distanced' in every sense of the word – separates them from Minna's sister, Annemarie (Anni), who turns towards them animatedly, with an almost hostile expression; but their eyes do not meet. All lines run at an angle, all stability is challenged. In this

social group an agreed hierarchy cannot be discerned and the relations seem equivocal. The figures are frozen in a diffused disquiet, which has its counterpart in the tumultuous, ecstatically gesticulating figures in Beckmann's large pictures of contemporary catastrophe such as *The Battle* (*Die Schlacht*, 1907; private collection) or *Scene from the Fall of Messina* (*Szene aus dem Untergang von Messina*, 1909; private collection).

Beckmann always sought 'to form from our time, with all its confusion and fragmentation, archetypes who could be for us today what their gods and heroes were to humanity in the past'.[2] But he always avoided letting any individual hero have the last word. A year after painting *Conversation*, in a picture four metres high entitled *Resurrection* (*Auferstehung*, Staatsgalerie, Stuttgart), Beckmann would

combine a dramatic resurrection of the dead with a domestic scene: in the foreground we recognise once again the artist with his wife and mother-in-law, registering barely any surprise at the advent of the Apocalypse. The syncopation of everyday life and the sublime is typical of Beckmann. CK

1 Max Beckmann, 'Das neue Programm', *Kunst und Künstler*, XII, 1914, p. 301.

2 Max Beckmann, 'Gedanken über zeitgemäße und unzeitgemäße Kunst', *Pan*, II, 1912, pp. 499ff., at p. 502.

Bibliography and Further Reading

Besides the authors, titles or exhibition catalogues referred to in the text (given first in the short form in which they are cited) other works, particularly in English, have been included to enable the reader to read further in the subject of nineteenth-century German art. Exhibition catalogues are listed under city of exhibition. References to Frankfurt alone are to Frankfurt am Main.

GENERAL WORKS AND OTHER WORKS NOT SPECIFIC TO THE CATALOGUE SECTIONS

Atlanta 1989
Art in Berlin 1815–1989, exhib. cat., High Museum of Art, Atlanta; Seattle and London, 1989

Belting 1998
Hans Belting, *The Germans and Their Art: A Troublesome Relationship*, New Haven and London 1998

Belting 1999
Hans Belting, *Identität im Zwiefel. Ansichten der deutschen Kunst*, Cologne 1999

Sabine Benecke, *Im Blick der Moderne. Die 'Jahrhundertaustellung deutscher Kunst 1775–1875' in der Berliner Nationalgalerie 1906*, Berlin 1999

Berlin 1997
Unter den Linden, exhib. cat., ed. B. Verwiebe, Berlin 1997

Berlin–Los Angeles–New York–London–Geneva 1993–5
Caspar David Friedrich to Ferdinand Hodler: A Romantic Tradition. Nineteenth-Century Paintings from the Oskar Reinhart Foundation, Winterthur, exhib. cat., Alte Nationalgalerie, Berlin; Los Angeles, New York, London and Geneva, 1993–5

Ed. P. Betthausen et al., *The Romantic Spirit: German Drawings, 1780–1850, from the Nationalgalerie Berlin and the Kupferstich-kabinet, Dresden*, New York and London 1988

Birmingham 2000
Kingdom of the Soul: Symbolist art in Germany 1870–1920, exhib. cat., English edn, City Museum and Art Gallery, Birmingham; Frankfurt and Stockholm, 2000

P. Bloch, *Bildwerke 1780–1910 aus den Beständen der Skulpturengalerie und der Nationalgalerie, Berlin* 1990

R. Cardinal, *German Romantics in Context*, London 1975

G.A. Craig, *The Politics of the Prussian Army, 1640–1945*, Oxford 1955

'Der Deutschen Kunst ...' 1998
'Der Deutschen Kunst ...'. Nationalgalerie und nationale Identität, 1876–1998, ed. C. Rückert and S. Kuhrau, Leipzig 1998

Dorgerloh 1999
Hartmut Dorgerloh, *Die Nationalgalerie in Berlin. Zur Geschichte des Gebäudes auf der Museumsinsel 1841–1970. Mit einem Verzeichnis der Pläne und Entwürfe bis 1945 von Barbara Götze* (Die Bauwerke und Kunstdenkmäler von Berlin, supplement 13), Berlin 1999

Edinburgh–London–Munich 1994–5
The Romantic Spirit in German Art 1790–1990, exhib. cat., ed. K. Hartley et al., Royal Scottish Academy, Edinburgh; Hayward Gallery, London; Haus der Kunst, Munich, 1994–5

H. von Einem, *Deutsche Malerei des Klassizismus und der Romantik, 1790 bis 1840*, Munich 1978

L. Eitner, *Neoclassicism and Romanticism 1750–1850, An Anthology of Sources and Documents*, New York 1989

G. Eley and D. Blackbourn, *The Peculiarities of German History: Bourgeois Society and Politics in Nineteenth Century Germany*, New York 1984

R.J. Evans, *Society and Politics in Wilhelmine Germany*, London 1978

R.J. Evans, *Rethinking German History: Nineteenth-Century Germany and the Origins of the Third Reich*, London 1987

Konrad Fiedler, *On Judging Works of Visual Art*, trans. H. Schaeffer-Simmern and F. Mood, Los Angeles 1957

U. Finke, *German Painting from Romanticism to Expressionism*, London 1974

F. Fischer, *From Kaiserreich to Third Reich: Elements of Continuity in German History 1871–1945*, London 1986

Forster-Hahn 1996a
Françoise Forster-Hahn, 'Shrine of Art or Signature of a New Nation? The National Gallery(ies) in Berlin 1848-1968', in Wright 1996, pp. 79–99

Forster-Hahn 1998
Françoise Forster-Hahn, 'Museum moderner Kunst oder Symbol der neuen Nation? Die Gründungsgeschichte der Nationalgalerie', in 'Der Deutschen Kunst ...' 1998

Gaehtgens 1992
Thomas W. Gaehtgens, *Die Berliner Museumsinsel im Deutschen Kaiserreich*, Munich 1992

Galerie der Romantik 1986
Galerie der Romantik, Katalog der Nationalgalerie Berlin, ed. Peter Krieger, Berlin 1986

B. Grimschitz, *Deutsche Bildnisse von Runge bis Menzel*, Vienna 1941

Joachim Grossman, *Künstler, Hof und Bürgertum. Leben und Arbeit von Malern in Preussen 1786–1840*, Berlin 1994

Hamburg 1977
Runge in seiner Zeit, exhib. cat., ed. Werner Hofmann, Hamburger Kunsthalle, Hamburg, 1977

Hemingway and Vaughan 1998
Ed. A. Hemingway and W. Vaughan, *Art in Bourgeois Society 1790–1850*, Cambridge 1998

W.O. Henderson, *The Rise of German Industrial Power 1834–95*, Liverpool 1975

Hofmann 1999
Werner Hofmann, *Wie deutsch ist die deutsche Kunst? Eine Streitschrift*, Leipzig 1999

Honisch 1979
Dieter Honisch, *Die Nationalgalerie, Berlin*, Recklinghausen 1979

Justi 1920
Ludwig Justi, *Deutsche Malkunst im neunzehnten Jahrhundert. Ein Führer durch die Nationalgalerie*, Berlin 1920

Justi 1932
Ludwig Justi, *Von Runge bis Thoma*, Berlin 1932

C. Kay, *Educating the Bourgeoisie: Alfred Lichtwark and Modern Art in Hamburg, 1886–1914*, Ph.D., Yale University, 1994

K. Lang, *The German Monument 1790–1914: Subjectivity, Memory, and National Identity*, Ph.D., University of California, 1996

J. Langbehn, *Rembrandt als Erzieher. Von einem Deutschen*, Leipzig 1890 and Weimar 1943

Leipzig–Houston 2000
Romantics, Realists and Revolutionaries. Masterpieces of Nineteenth Century German Paintings from the Museum of Fine Arts, Leipzig, exhib. cat., ed. E.P. Bowron, Museum of Fine Arts, Leipzig, and Museum of Fine Arts, Houston, 2000

R. Lenman, *Artists and Society in Germany 1850–1914*, Manchester 1997

G. Lindemann, *History of German Art: Painting, Sculpture and Architecture*, New York 1971

London 1968
Nineteenth-Century German Drawings and Watercolours, exhib. cat., Victoria and Albert Museum, London, 1968

Maaz 1999
Bernhard Maaz, *Die Alte Nationalgalerie*, Berlin 1999

F. Meinecke, *Cosmopolitanism and the National State*, trans. R.B. Kimber, intro. F. Gilbert, Princeton 1970

Munich 1998b
Die Nacht, exhib. cat., Haus der Kunst, Munich 1998

New Haven 1970
German Painting of the Nineteenth Century, exhib. cat., Yale University Art Gallery, New Haven, 1970

New York 1981
German Masters of the Nineteenth Century: Paintings and Drawings from the Federal Republic of Germany, exhib. cat., Metropolitan Museum of Art, New York, 1981

Nochlin 1966
Linda Nochlin, *Realism and Tradition in Art 1848–1900, Sources and Documents*, Englewood Cliffs NJ 1966

Paret 1988
Peter Paret, *Art as History: Episodes in the Culture and Politics of Nineteenth Century Germany*, Princeton 1988

Plessen 1992
Marie-Louise von Plessen, *Die Nation und ihre Museen*, Frankfurt 1992

L. Pramer, *The Romantic Period in Germany*, London 1970

A. Ramm, *Germany 1789–1919. A Political History*, London 1967

Rave 1949
Paul Ortwin Rave, *Deutsche Malerei des 19. Jahrhunderts*, Berlin 1949

Rave 1965
Paul Ortwin Rave, *Kunst in Berlin*, Berlin 1965

Rave 1968
Paul Ortwin Rave, *Die Geschichte der Nationalgalerie Berlin*, Berlin 1968

J. Remark, *The Gentle Critic: Theodore Fontane and German Politics*, Syracuse NJ 1964

R. Rosenblum, *Modern Painting and the Northern Romantic Tradition, Friedrich to Rothko*, London 1975

F. Russell, *The Horizon Concise History of Germany*, New York 1973

J.J. Sheehan, *German Liberalism in the Nineteenth Century*, Chicago 1978

Ed. W. von Schierbrand, *The Kaiser's Speeches: Forming a Character Portrait of Emperor Wilhelm II*, New York 1966

Heinrich Sieveking, *Fuseli to Menzel – Drawings and Watercolours in the Age of Goethe*, Munich 1998

F. Stern, *The Politics of Cultural Despair. A Study in the Rise of Germanic Ideology*, Los Angeles 1974

H.J. Syberberg, *Von Glück und Unglück der Kunst in Deutschland nach dem letzten Kreige*, Munich 1990

Traeger 1975
Jörg Traeger, *Philipp Otto Runge und sein Werk. Monographie und kritischer Katalog*, Munich 1975

H. von Tschudi, *Ausstellung deutscher Kunst aus der Zeit von 1775–1875 in der Königlichen Nationalgalerie: Berlin 1906*, Munich 1906

William Vaughan, *Romanticism and Art* (World of Art), London 1994

William Vaughan, *German Romantic Painting*, New Haven and London 1994

H.-U. Wehler, *The German Empire 1871–1914*, trans. K. Taylor, Oxford 1985

Ed. G.P. Weisberg, *The European Realist Tradition*, Bloomington 1982

Wright 1996
Ed. G. Wright, *The Formation of National Collections of Art and Archaeology* (Studies in the History of Art 47), Washington, D.C., 1996

ROMANTIC LANDSCAPE

Berlin 1981a
Karl Friedrich Schinkel, Architektur. Malerei. Kunstgewerbe, exhib. cat., ed. H. Börsch-Supan and L. Grisebach, Nationalgalerie, Berlin (West) 1981

Berlin 1981b
Karl Friedrich Schinkel 1781–1841, exhib. cat., Staatliche Museen zu Berlin, Berlin (East) 1981

Börsch-Supan 1974
H. Börsch-Supan, *Caspar David Friedrich*, Munich and London 1974

Börsch-Supan and Jähnig 1973
H. Börsch-Supan and K.W. Jähnig, *Caspar David Friedrich. Gemälde, Druckgraphik und bildmäßige Zeichnungen*, Munich 1973

L.D. Ettlinger, *Caspar David Friedrich*, London 1967

Hanfstaengel 1937
E. Hanfstaengel, 'Vier neue Bilder von Caspar David Friedrich in der Nationalgalerie', *Jahrbuch der Preußischen Kunstsammlungen*, 1937, p. 217

Hinz 1974
Sigrid Hinz, *Caspar David Friedrich in Briefen und Bekenntnissen*, Berlin 1974

Hoch 1987
K.W. Hoch, *Caspar David Friedrich und die böhmischen Berge*, Dresden 1987

Werner Hofmann, *Caspar David Friedrich*, London 2000

Joseph Leo Koerner, *Caspar David Friedrich and the Subject of Landscape*, London 1990

London 1991
Karl Friedrich Schinkel: A Universal Man, exhib. cat., ed. Michael Snodin, Victoria and Albert Museum, London, 1991

Charles Sala, *Caspar David Friedrich and Romantic Painting*, Paris 1997

Schmied 1975
W. Schmied, *Caspar David Friedrich*, Cologne 1975

Sumowski 1970
W. Sumowski, *Caspar David Friedrich Studien*, Wiesbaden 1970

Waagen 1844/1980
G.F. Waagen, *Karl Friedrich Schinkel als Mensch und Künstler*, Berlin 1844, reprinted Berlin 1980

Wolfradt 1924
W. Wolfradt, *Caspar David Friedrich und die Landschaft der Romantik*, Berlin 1924

NAZARENES AND ROMANTICS

Andrews 1964
K. Andrews, *The Nazarenes, A Brotherhood of German Painters in Rome*, Oxford 1964

Dresden 1984
Ludwig Richter und sein Kreis. Ausstellung zum 100. Todestag, exhib. cat., Staatliche Kunstsammlungen, Dresden 1984

Frankfurt 1977
Die Nazarener, exhib. cat., Städelsches Kunstinstitut, Frankfurt 1977

Friedrich 1937
K.J. Friedrich, *Die Gemälde Ludwig Richters*, Berlin 1937

W. Gesse, *Die heroische Landschaft von Koch bis Böcklin*, Strasbourg 1930

Howitt 1886
M. Howitt, *Johann Friedrich Overbeck. Sein Leben und Schaffen. Nach seinen Briefen und andern Documenten des handschriftlichen Nachlasses* (ed. Franz Binder), 2 vols., Freiburg im Breisgau 1886

Justi 1923
L. Justi, *Neu erworbene Bilde von Schnorr in der Nationalgalerie*, Leipzig 1923

Karlsruhe 1996
Moritz von Schwind: Meister der Spätromantik, exhib. cat., Staatliche Kunsthalle, Karlsruhe, 1996

Leipzig 1994
Julius Schnorr von Carolsfeld, exhib. cat., ed. H. Guratzsch, Museum der bildenden Künste, Leipzig, 1994

Lübeck 1989
Johann Friedrich Overbeck 1789–1869, exhib. cat., ed. A. Blühm and G. Gerkens, Museum für Kunst und Kulturgeschichte der Hansestadt, Lübeck, 1989

Lutterotti 1985
Otto R. von Lutterotti, *Joseph Anton Koch 1768–1839. Leben und Werk. Mit einem vollständigen Werkverzeichnis*, Vienna and Munich 1985

Munich 1985
Deutsche Romantiker, exhib. cat., Munich 1985

Neidhardt 1991
H.J. Neidhardt, *Ludwig Richter*, Leipzig 1991

Schnorr von Carolsfeld 1886
Julius Schnorr von Carolsfeld, *Briefe aus Italien*, Gotha 1886

Stoessl 1924
Moritz von Schwind, *Briefe*, ed. Otto Stoessl, Leipzig 1924

Stuttgart 1989
Joseph Anton Koch. Ansichten der Natur, exhib. cat. by C. von Holst, Staatsgalerie, Stuttgart 1989

COLOUR, LIGHT AND AIR

Berlin 1976
Moderne Cyklopen. 100 Jahre "Eisenwalzwerk" von Adolph von Menzel, exhib. cat. by M.U. Riemann-Reyher, Nationalgalerie and Kupferstichkabinett, Berlin, 1976

Berlin 1980
Adolph Menzel. Gemälde, Zeichnungen, exhib. cat., Nationalgalerie, Berlin (East) 1980

Berlin–Munich 1990
Carl Blechen. Zwischen Romantik und Realismus, exhib. cat., ed. Peter-Klaus Schuster, Nationalgalerie, Berlin, and Munich, 1990

Bierhaus-Rödinger 1978
E. Bierhaus-Rödinger, *Carl Rottmann 1797–1850. Monographie und kritischer Werkkatalog*, Munich 1978

Bremen 1967
H. Bock, *Berliner Biedermeier von Blechen bis Menzel: Gemälde, Handzeichnungen, Aquarelle, Druckgraphik aus dem Besitz Berliner Museen und der Kunsthalle Bremen*, exhib. cat., Kunsthalle, Bremen, 1967

Forster-Hahn 1977
F. Forster-Hahn, 'Adolph Menzel's "Daguerreotypical" Image of Frederick the Great: A Liberal-Bourgeois Interpretation of German History', *The Art Bulletin*, LIX, June 1977, pp. 242–61

Forster-Hahn 1982
Françoise Forster-Hahn, 'Aspects of Berlin Realism: From the Prosaic to the Ugly', in *The European Realist Tradition*, ed. G.P. Weisberg, Bloomington 1982, pp. 124–44

Forster-Hahn 1993
F. Forster-Hahn, 'Adolph Menzel's *Balkonzimmer*: Room Without a View', *Künstlerischer Austauch – Artistic Exchange. Proceedings of the XXVIII International Congress of Art History 15–20 July 1992*, ed. T.W. Gaehtgens, Berlin 1993, pp. 749–62

Hamburg 1999
Menzels Atelierwand, exhib. cat., ed. J. Howaldt and S. Hauschild, Hamburg 1999

G. Heider, *Carl Blechen*, Leipzig 1971

Kirstein 1919
G. Kirstein, *Das Leben Adolph Menzels*, Leipzig 1919

Lammel 1992
Exzellenz lassen bitten. Erinnerungen an Adolph Menzel, ed. Gisold Lammel, Leipzig 1992

Meier-Graefe 1906
Julius Meier-Graefe, *Der junge Menzel. Ein Problem der Kunstökonomie Deutschlands*, Leipzig 1906

Munich 1998a
Landschaft als Geschichte: Carl Rottmann 1797–1850. Hofmaler König Ludwigs I, exhib. cat., ed. C. Heilmann and E. Rödiger-Diruf, Munich 1998

Rave 1940
Paul Ortwin Rave, *Karl Blechen, Leben, Würdigungen, Werk,* Berlin 1940

H. von Tschudi, *Aus Menzels jungen Jahren,* Berlin 1906

Washington 1996
Adolph Menzel 1815–1905. Between Romanticism and Impressionism, exhib. cat., ed. C. Keisch and M. U. Riemann-Reyher, English edn, National Gallery of Art, Washington, D.C., 1996–7 (German edn: *Adolph Menzel 1815–1905. Das Labyrinth der Wirklichkeit,* exhib. cat., Alte Nationalgalerie, Berlin, 1996)

I. Wirth, *Mit Adolph Menzel in Berlin,* Munich 1965

C. With, 'Adolph Menzel and the German Revolution of 1848', *Zeitschrift für Kunstgeschichte,* XLII, 1979

Wolff 1914
Ed. H. Wolff, *Adolph von Menzel: Briefe,* intro. O. Bie, Berlin 1914

BIEDERMEIER REALISM

J. Bark, *Biedermeier – Vormärz Bürgerlicher Realismus,* Stuttgart 1984

Dresden–Munich 1990–1
Ferdinand von Rayski 1806–1890. Ausstellung zum 100. Todestag, exhib. cat., Albertinum, Dresden, and Lenbachhaus, Munich, 1990–1

Feuchtmüller 1996
Rupert Feuchtmüller, *Ferdinand Georg Waldmüller 1793–1865. Leben. Schriften. Werke,* Vienna and Munich 1996

W. Geismeier, *Biedermeier. Das Bild vom Biedermeier. Zeit und Kultur des Biedermeier,* Leipzig 1979

Hentzen 1973
A. Hentzen, 'Spiegelungen', in *Festschrift für H. Swarzenski,* Berlin 1973

Georg Himmelheber, *Biedermeier 1815–1835: Architecture, Painting, Sculpture, Decorative Arts, Fashion,* Munich 1989

Hummel 1954
G. Hummel, *Der Maler Johann Erdmann Hummel. Leben und Werk,* Leipzig 1954

J.C. Jensen, *Carl Spitzweg,* Cologne 1971

K. Kötschau, *Rheinische Malerei in der Biedermeierzeit,* Düsseldorf 1926

Munich 1988
Biedermeierzeit Glück und Ende: Die gestörte Idylle, 1815–1848, exhib. cat., Munich 1988

Munich–Vienna 1990
Klaus Albracht Schröder, *Ferdinand Georg Waldmüller,* exhib. cat., Munich, and Kunstforum Länderbank, Vienna, 1990

Geraldine Norman, *Biedermeier Painting, 1815–1848 – Reality observed in Genre, Portrait and Landscape,* London 1987

Rave 1942
Paul Ortwin Rave, 'Die Granitschale im Lustgarten', *Zeitschrift des Vereins für die Geschichte Berlins,* 59. Jahrgang, no. 3, Berlin 1942

Rave 1959
Paul Ortwin Rave, 'Zur Aufstellung der großen Granitschale vor dem Alten Museum in Berlin', in *Festschrift Friedrich Winkler,* Berlin 1959

Roennefahrt 1960
G. Roennefahrt, *Carl Spitzweg. Beschreibendes Verzeichnis seiner Gemälde, Ölstudien und Aquarelle,* Munich 1960

E. Scheyer, *Schlesische Malerei der Biedermeierzeit,* Frankfurt 1965

Schuster 1993
Peter-Klaus Schuster, 'Gaertner und die geistige Mitte Berlins. Zu einer Neuerwerbung für die Nationalgalerie', in *Jahrbuch Preußischer Kulturbesitz,* XXX, 1993

Walter 1943
Maräuschlein Walter, *Ferdinand von Rayski. Sein Leben und sein Werk,* Bielefeld and Leipzig 1943

A. Wilkie, *Biedermeier,* London 1987

Wirth 1979
I. Wirth, *Eduard Gaertner,* Berlin 1979

THE KAISERZEIT

For Menzel see the section Colour, Light and Air

Berlin–Munich 1993
Anton von Werner. Geschichte in Bildern, exhib. cat., ed. D. Bartmann, Deutsches Historisches Museum, Berlin, 1993 and Munich, 1993

T.W. Gaehtgens, *Anton Werner, Die Proklamierung des Deutschen Kaiserreiches. Ein Historienbild im Wandel preussischer Politik,* Frankfurt 1990

Werner 1913
Anton von Werner, *Erlebnisse und Eindrücke 1870–1890,* Berlin 1913

ESCAPING TO ITALY

Andree 1998
R. Andree, *Arnold Böcklin. Die Gemälde,* 2nd revised edn, with contributions by Alfred Berner et al., Munich and Basle 1998

Basle–Stuttgart 1977
Arnold Böcklin 1827–1901. Gemälde, Zeichnungen, Plastiken, Ausstellung zum 150. Geburtstag, exhib. cat., Kunstmuseum, Basle, and Stuttgart, 1977

Darmstadt 1977
Arnold Böcklin 1827–1901, exhib. cat., Magistrat der Stadt, Darmstadt, 1977

A.-S. Domm, *Der 'klassische' Hans von Marées und die Existenzmalerei Anfang des 20. Jahrhunderts,* Munich 1989

Ecker 1991
J. Ecker, *Anselm Feuerbach. Leben und Werk. Kritischer Katalog der Gemälde, Ölskizzen und Ölstudien,* Munich 1991

Gerlach-Laxner 1980
Uta Gerlach-Laxner, *Hans von Marées. Katalog seiner Gemälde,* Munich 1980

S.L. Hirsh, 'Arnold Bocklin's Images of Death', *Arts Magazine,* February 1991

Karlsruhe 1976
Anselm Feuerbach, Gemälde und Zeichnungen, exhib. cat., Staatliche Kunsthalle, Karlsruhe, 1976

Hans von Marées, *Briefe,* ed. A.-S. Domm, Munich and Zurich 1987

Munich 1987
Hans von Marées, exhib. cat., ed. C. Lenz, Neue Pinakothek, Munich, 1987

'PURE PAINTING'

Dortmund 2000
Cézanne Manet Schuch. Drei Wege zur autonomen Kunst, exh. cat., Dortmund, 2000

Freiburg in Breisgau 1989
Hans Thoma. Lebensbilder, exhib. cat., Freiburg im Breisgau, 1989

Hagemeister 1913
K. Hagemeister, *Karl Schuch. Sein Leben und seine Werke,* Berlin 1913

Heidelberg 1994
Wilhelm Trübner 1851–1917, exhib. cat., Kurpfalzisches Museum der Stadt Heidelberg, 1994

A. Langer, *Wilhelm Leibl,* Leipzig 1961

Munich–Cologne 1994
Wilhelm Leibl zum 150. Geburtstag, exhib. cat., ed. G. Czynmek and C. Lenz, Neue Pinakothek, Munich, and Wallraf-Richartz Museum, Cologne, 1994

Rohrand 1972
Klaus Rohrand, *Wilhelm Trübner, Werkverzeichnis,* 2 vols., Kiel 1972

Röhrle 1996
Wilhelm Leibl 1844–1900. Briefe, ed. B. Röhrle, Hildesheim, Zurich and New York 1996

Rosenhagen 1909
Hans Rosenhagen, *Wilhelm Trübner (Klassiker der Kunst),* Bielefeld 1909

Ruhmer 1984
Eberhardt Ruhmer, *Der Leibl-Kreis und die Reine Malerei,* Rosenheim 1984

Thode 1909
Henry Thode, *Thoma. Des Meisters Gemälde* (Klassiker der Kunst), Stuttgart and Leipzig 1909

Trübner 1907
Wilhelm Trübner, *Personalien und Prinzipien,* Berlin 1907

Waldmann 1930
E. Waldmann, *Wilhelm Leibl, Gesamtverzeichnis seiner Gemälde,* 2nd edn, Berlin 1930

Zimmermann 1963
W. Zimmermann, *Der Maler Louis Eysen,* Frankfurt 1963

EMBRACING THE FRENCH AVANT-GARDE

W. Becker, *Paris und die deutsche Malerei, 1750–1840*, Munich 1971

Berlin 2000
Cézanne in Berlin. 28 Werke aus den Staatlichen Museen und aus Privatbesitz, exh. cat., ed. C. Keisch, Nationalgalerie, Berlin, 2000

Berlin–Munich 1996
Manet bis Van Gogh, Hugo von Tschudi und der Kampf um die Moderne, exhib. cat., ed. Johann Georg Prinz von Hohenzollern and Peter-Klaus Schuster, Nationalgalerie, Berlin, and Neue Pinakothek, Munich, 1996

Hamburg–Frankfurt 1978–9
Courbet und Deutschland, exhib. cat., Hamburger Kunsthalle, Hamburg, and Städelsches Institut, Frankfurt, 1978–9

Peter Krieger, *Die französischen Impressionisten in der Nationalgalerie*, in *Speculum*, XVI, no. 3, May–June 1964, pp. 28–34

Julius Meier-Graefe, *Edouard Manet*, Munich 1912

Peter Paret, 'The Tschudi Affair', *Journal of Modern History*, LIII, 1981

Paris–London–Philadelphia 1995–6
Cézanne, exh. cat., ed. F. Cachin and J.J. Rishel, Grand Palais, Paris; Tate Gallery, London; Museum of Art, Philadelphia, 1995–6

B. Paul, *Hugo von Tschudi und die moderne französische Kunst im Deutschen Kaiserreich*, Mainz 1993

Rewald, Feilchenfeldt and Warman 1986
J. Rewald, W. Feilchenfeldt, J. Warman, *The Paintings of Paul Cézanne. A Catalogue Raisonné*, 2 vols., New York 1986

Rouart and Wildenstein 1975
D. Rouart and D. Wildenstein, *Edouard Manet. Catalogue raisonné*, Lausanne and Paris 1975

Wildenstein 1974–91
D. Wildenstein, *Claude Monet. Biographie et catalogue raisonné*, 5 vols., Lausanne 1974–91

SECESSION

S. Barron and W.-D. Dube, *German Expressionism: Art and Society 1909–1923*, London 1997

Berend-Corinth 1992
C. Berend-Corinth, *Lovis Corinth, Die Gemälde, Werkverzeichnis*, Munich 1992

Hans Belting, *Max Beckmann: Tradition as a Problem in Modern Art*, New York 1989

K. Boskamp, *Studien zum Frühwerk von Max Liebermann mit einem Katalog der Gemälde und Ölstudien von 1866–1889*, Zurich and New York 1994

Ed. B.C. Buenger, *Max Beckmann: Self Portrait in Words: Collected Writings and Statements 1903–1950*, Chicago and London 1997

Ed. G. Busch, *Max Liebermann. Vision der Wirklichkeit. Ausgewählte Schriften und Reden*, Frankfurt 1993

M.F. Deshmukh, 'Art and Politics in Turn-of-the-Century Berlin: The Berlin Secession and Kaiser Wilhelm II', in *The Turn of the Century: German Literature and Art 1890–1915*, ed. G. Chapple and H.H. Schulte, Bonn 1981

Eberle 1995–6
M. Eberle, *Max Liebermann 1847–1935. Werkverzeichnis der Gemälde und Ölstudien*. 2 vols., I.1865–1899, Munich 1995; II. 1900–1935, Munich 1996

L.D. Ettlinger, 'Julius Meier-Graefe: An Embattled German Critic', *Burlington Magazine*, CXVII, 1975, pp. 672–4

Forster-Hahn 1996b
F. Forster-Hahn, ed., *Imagining Modern German Culture 1889–1910* (Studies in the History of Art 53, Symposium Papers XXXI), Washington, D.C., 1996

Göpel 1976
E. and B. Göpel, *Max Beckmann. Katalog der Gemälde* (Schriften der Max Beckmann Gesellschaft III), Berne 1976

Hamburg 1997
Max Liebermann. Der Realist und die Phantasie, ed. J.E. Howoldt and B. Frenssen, exhib. cat., Hamburger Kunsthalle, Hamburg 1997

Imiela 1968
H.-J. Imiela, *Max Slevogt*, Karlsruhe 1968

Maria Makela, *The Munich Secession: Art and Aesthetics in Turn-of-the-Century Munich*, Princeton and Oxford 1990

K. Moffett, *Meier-Graefe as Art Critic*, Munich 1987

Munich 1999
Fritz von Uhde. Vom Realismus zum Impressionismus, exhib. cat., Neue Pinakothek, Munich, 1999

Munich–Berlin–St Louis–Los Angeles 1984–5
Max Beckmann – Retrospektive, exhib. cat., Haus der Kunst, Munich; Nationalgalerie, Berlin; St Louis Art Museum; Los Angeles County Museum of Art, 1984–5

New York 1964
Lovis Corinth: a Retrospective Exhibition, exhib. cat., Gallery of Modern Art, New York, 1964

New York–London 1965
Max Beckmann 1884–1950: Paintings, Drawings, and Graphic Work, exhib. cat., Museum of Modern Art, New York, and Tate Gallery, London, 1965

Paret 1980
Peter Paret, *The Berlin Secession: Modernism and its Enemies in Imperial Germany*, Cambridge MA and London 1980

St Louis–London 1996–7
Lovis Corinth, exhib. cat., ed. Peter-Klaus Schuster et al., English edn, St Louis Art Museum and Tate Gallery, London; Munich and Berlin, 1996–7

Peter Selz, *Max Beckmann*, New York 1996

Anna Teut, *Max Liebermann: Gartenparadies am Wannsee*, Munich 1999

C. Vinen, *Ein Protest deutsche Künstler*, Jena 1911

Vienna–Hanover 1992–3
Lovis Corinth, exhib. cat., ed. Klaus Albrecht Schröder; Kunstforum der Bank Austria, Vienna, and Hanover, 1992–3

Washton Long 1993
Ed. Rose-Carol Washton Long, *German Expressionism. Documents from the End of the Wilhelmine Empire to the Rise of National Socialism*, Los Angeles and London 1993

J. Werner, *Die Berliner Sezession, Berlin als Zentrum der deutschen Kunst von der Jahrhundertwende bis zum Ersten Weltkrieg*, Frankfurt, Berlin and Vienna 1977

Index